¶ THE ELEMENTS *of* TYPOGRAPHIC STYLE

Fourth edition (version 4.2)

Robert Bringhurst

❦ HARTLEY & MARKS, *Publishers*

This version of the fourth edition includes updates to pages 57, 105, 181, 192,
243, 293, 306–7, 309, 318, 321, 351, 360, 364–7, 373, 375, 388–9, 392–3, and 396.

HARTLEY & MARKS, PUBLISHERS

- PO Box 84332
 Seattle, WA 98124
 USA

- 400–948 Homer Street
 Vancouver, BC V6B 2W7
 Canada

Designed & typeset in Canada;
printed & bound in China.

∞

for my colleagues & friends

in the worlds of letters:

writers & editors,

type designers, typographers,

printers & publishers,

shepherding words and books

on their lethal and innocent ways

CONTENTS

— Everything written symbols can say has already passed
by. They are like tracks left by animals. That is why the masters
of meditation refuse to accept that writings are final. The aim is
to reach true being by means of those tracks, those letters, those
signs – but reality itself is not a sign, and it leaves no tracks. It
doesn't come to us by way of letters or words. We can go toward
it, by following those words and letters back to what they came
from. But so long as we are preoccupied with symbols, theories
and opinions, we will fail to reach the principle.

— But when we give up symbols and opinions, aren't we left
in the utter nothingness of being?

— Yes.

　　　凡て文字言語に渉るは、理の迹なり。全く正理に
非ず。其の迹に因りて、迹無き物を悟るべし。故に禪
家には不立文字と云はずや。凡て見る事聞く事意識に
落つるに因りて、心には自在を得るの道理を知れども、
更に心の如く成りがたく、学術も聖経賢伝を暗記する
人多しと云へども、道を見付ける人なき故、聖賢に至
る人少なり。兎にも角にも此の意念と云ふ大病、霊明
の開くる期有るべからず。
　　　意念を去り、恃む所を離る時は、唯寓然とし
て取認なし。如何して正理に至らん。
　　　容易　　　

KIMURA KYŪHO, *Kenjutsu fushigi hen*
[*On the Mysteries of Swordsmanship*] (1768)

A true revelation, it seems to me, will emerge only from stubborn
Siamo convinti che una grande rivelazione può uscire soltanto dalla
concentration on a solitary problem. I am not in league with in-
testarda insistenza su una stessa difficoltà. Non abbiamo nulla in co-
ventors or adventurers, nor with travelers to exotic destinations.
mune coi viaggiatori, gli sperimentatori, gli avventurieri. Sappiamo che
The surest – also the quickest – way to awake the sense of wonder
il piú sicuro – e piú rapido – modo di stupirci è di fissare imperterriti
in ourselves is to look intently, undeterred, at a single object.
sempre lo stesso oggetto. Un bel momento quest' oggetto ci sembrerà –
Suddenly, miraculously, it will reveal itself as something we have
miraculoso – di non averlo visto mai.
never seen before.

CESARE PAVESE, *Dialoghi con Leucò* (1947)

FOREWORD

There are many books about typography, and some of them are models of the art they teach. But when I set myself to compile a simple list of working principles, one of the benchmarks I first thought of was William Strunk and E.B. White's small masterpiece, *The Elements of Style*. Brevity, however, is the essence of Strunk & White's manual of literary technique. This book is longer than theirs, and for that there is a cause.

Typography makes at least two kinds of sense, if it makes any sense at all. It makes visual sense and historical sense. The visual side of typography is always on display, and materials for the study of its visual form are many and widespread. The history of letterforms and their usage is visible too, to those with access to manuscripts, inscriptions and old books, but from others it is largely hidden. This book has therefore grown into something more than a short manual of typographic etiquette. It is the fruit of a lot of long walks in the wilderness of letters: in part a pocket field guide to the living wonders that are found there, and in part a meditation on the ecological principles, survival techniques and ethics that apply. The principles of typography as I understand them are not a set of dead conventions but the tribal customs of the magic forest, where ancient voices speak from all directions and new ones move to unremembered forms.

One question, nevertheless, has been often in my mind. When all right-thinking human beings are struggling to remember that other men and women are free to be different, and free to become more different still, how can one honestly write a rulebook? What reason and authority exist for these commandments, suggestions and instructions? Surely typographers, like others, ought to be at liberty to follow or to blaze the trails they choose.

Typography thrives as a shared concern – and there are no paths at all where there are no shared desires and directions. A typographer determined to forge new routes must move, like other solitary travelers, through uninhabited country and against the grain of the land, crossing common thoroughfares in the silence before dawn. The subject of this book is not typographic solitude, but the old, well-traveled roads at the core of the tradition: paths that each of us is free to follow or not, and to enter and leave when we choose – if only we know the paths are there and have a sense

of where they lead. That freedom is denied us if the tradition is concealed or left for dead. Originality is everywhere, but much originality is blocked if the way back to earlier discoveries is cut or overgrown.

If you use this book as a guide, by all means leave the road when you wish. That is precisely the use of a road: to reach individually chosen points of departure. By all means break the rules, and break them beautifully, deliberately and well. That is one of the ends for which they exist.

Letterforms change constantly yet differ very little, because they are alive. The principles of typographic clarity have also scarcely altered since the second half of the fifteenth century, when the first books were printed in roman type. Indeed, most of the principles of legibility and design explored in this book were known and used by Egyptian scribes writing hieratic script with reed pens on papyrus in 1000 BCE. Samples of their work sit now in museums in Cairo, London and New York, still lively, subtle and perfectly legible thirty centuries after they were made.

Writing systems vary, but a good page is not hard to learn to recognize, whether it comes from Táng Dynasty China, the Egyptian New Kingdom or Renaissance Italy. The principles that unite these distant schools of design are based on the structure and scale of the human body – the eye, the hand and the forearm in particular – and on the invisible but no less real, no less demanding and no less sensuous anatomy of the human mind. I don't like to call these principles universals, because they are largely unique to our species. Dogs and ants, for example, read and write by more chemical means. But the underlying principles of typography are, at any rate, stable enough to weather any number of human fashions and fads.

It is true that typographers' tools are presently changing with considerable force and speed, but this is not a manual in the use of any particular typesetting system or medium. I suppose that most readers of this book will set most of their type in digital form, using computers, but I have no preconceptions about which brands of computers, or which versions of which proprietary software, they may use. The essential elements of style have more to do with the goals typographers set for themselves than with the mutable eccentricities of their tools. Typography itself, in other words, is far more device-independent than PostScript, which is the computer language used to render these particular letters, and the design of these pages, into typographic code. If I

have succeeded in my task, this book should be as useful to artists and antiquarians setting foundry metal by hand and pulling proofs on a flat-bed press, as to those who check their work on a screen or laser printer, then ship it to high-resolution digital output devices by transferring the electronic files.

Typography is the craft of endowing human language with a durable visual form, and thus with an independent existence. Its heartwood is calligraphy – the dance, on a tiny stage, of the living, speaking hand – and its roots reach into living soil, though its branches may be hung each year with new machines. So long as the root lives, typography remains a source of true delight, true knowledge, true surprise.

As a craft, typography shares a long common boundary and many common concerns with writing and editing on the one side and with graphic design on the other; yet typography itself belongs to neither. This book in its turn is neither a manual of editorial style nor a textbook on design, though it overlaps with both of these concerns. The perspective throughout is first and foremost typographic – and I hope the book will be useful for that very reason to those whose work or interests may be centered in adjacent fields.

<div align="center">*</div>

Typographically, much has happened since the first edition of this book appeared, in 1992. Typography nevertheless remains what it was: a living cultural inheritance, which each new generation hopes to enrich. So beneath the roiling surface much is actually the same. I am indebted now, as I was when writing the first draft, to the conversation and example of many friends – including Kay Amert, Stan Bevington, John Dreyfus, Crispin Elsted, Glenn Goluska, Peter Koch, Victor Marks, George Payerle, Adrian Wilson, Hermann Zapf. A number of these are with us no longer, but all of us are richer because of how they spent their lives.

In twenty years, I have put this book through about a dozen major and minor revisions. Librarians at the St Bride Printing Library in London, the Bancroft Library in Berkeley, and countless other institutions have been perennially helpful. New friends and colleagues, readers and translators have also offered useful advice. Many who have done so are mentioned in the afterword, page 373. I am grateful to them all.

<div align="right">R.B.</div>

Historical
Synopsis

RENAISSANCE (15th & 16th centuries): modulated stroke; humanist [oblique] axis; crisp, pen-formed terminals; serifs adnate or abrupt; large aperture; italic equal to and independent of roman.

LEGEND:

These charts show first and foremost the axis of the *stroke,* which is the axis of the pen that makes the letter. It is often very different from the slope (if any) of the lettershape itself. A pen that points northwest can make an upright letter or a letter that slopes to the northeast.

BAROQUE (17th century): modulated stroke; variable axis; adnate serifs; lachrymal terminals; moderate aperture; italic subsidiary to roman and closely allied to it. A secondary vertical axis often develops in Baroque letters – but the *primary* axis of the penstroke is normally oblique.

12

Historical Synopsis

NEOCLASSICAL (18th century): modulated stroke; rationalist [vertical] axis; refined, adnate serifs; lachrymal terminals; moderate aperture; italic fully subjugated to roman.

TERMINOLOGY:
- **abrupt**: joining the stem at a sharp angle
- **adnate**: flowing into the stem
- **aperture**: the opening in letters such as C, G, a, c, e, s
- **lachrymal**: shaped like a teardrop
- **modulated**: cyclically varying from thick to thin

ROMANTIC (18th & 19th centuries): hypermodulated stroke; intensified rationalist axis; abrupt, thin serifs; round terminals; small aperture; fully subjugated italic. In Neoclassical and Romantic letters alike, the *primary* axis is usually vertical and the *secondary* axis oblique.

REALIST (19th & early 20th centuries): unmodulated stroke; implied vertical axis; small aperture; serifs absent or abrupt and of equal weight with main strokes; italic absent or replaced by sloped roman.

GEOMETRIC MODERNIST (20th century): unmodulated stroke; bowls often circular (no axis); moderate aperture; serifs absent or of equal weight with main strokes; italic absent or replaced by sloped roman. The modeling, however, is often much more subtle than it first appears.

14

LYRICAL MODERNIST (20th century): rediscovery of Renaissance
form: modulated stroke; humanist axis; pen-formed serifs and terminals;
large aperture; italic partially liberated from roman.

POSTMODERNIST (late 20th & early 21st century): frequent parody
of Neoclassical, Romantic or Baroque form: rationalist or variable axis;
sharply modeled serifs and terminals; moderate aperture. (There are many
kinds of Postmodernist letter. This is one example.)

rigo Habraam numerā

ı a moſaica lege(ſeptim

r)ſed naturalı fuit ratio

idit enim Habraam dec

m quoqʒ gentium patr

ıs oés gentes hoc uidelıc

m eſt:cuius ille iuſtıtiæ

us eſt:qui poſt multas

ʾimum omnium diuinc

ɔ naſcerétur tradidit:ue

gnum:uel ut hoc quaſ

ſuos imitari conaretʾ:au

um nobis modo eſt.Po

Roman type cut in 1469 by Nicolas Jenson, a French typographer working in Venice. The original is approximately 16 pt. The type is shown here as Jenson printed it, but at twice actual size. This is the ancestor of the type (Bruce Rogers's Centaur) shown at the top of page 12.

THE GRAND DESIGN

1.1 FIRST PRINCIPLES

1.1.1 *Typography exists to honor content.*

1

Like oratory, music, dance, calligraphy – like anything that lends its grace to language – typography is an art that can be deliberately misused. It is a craft by which the meanings of a text (or its absence of meaning) can be clarified, honored and shared, or knowingly disguised.

In a world rife with unsolicited messages, typography must often draw attention to itself before it will be read. Yet in order to be read, it must relinquish the attention it has drawn. Typography with anything to say therefore aspires to a kind of statuesque transparency. Its other traditional goal is durability: not immunity to change, but a clear superiority to fashion. Typography at its best is a visual form of language linking timelessness and time.

One of the principles of durable typography is always legibility; another is something more than legibility: some earned or unearned interest that gives its living energy to the page. It takes various forms and goes by various names, including serenity, liveliness, laughter, grace and joy.

These principles apply, in different ways, to the typography of business cards, instruction sheets and postage stamps, as well as to editions of religious scriptures, literary classics and other books that aspire to join their ranks. Within limits, the same principles apply even to stock market reports, airline schedules, milk cartons, classified ads. But laughter, grace and joy, like legibility itself, all feed on meaning, which the writer, the words and the subject, not the typographer, must generally provide.

In 1770, a bill was introduced in the English Parliament with the following provisions:

… all women of whatever age, rank, profession, or degree, whether virgins, maids, or widows, that shall … impose upon, seduce, and betray into matrimony, any of His Majesty's subjects, by the scents, paints, cosmetic washes, artificial teeth, false hair, Spanish wool, iron stays, hoops, high heeled shoes [or] bolstered hips shall incur

the penalty of the law in force against witchcraft ... and ... the marriage, upon conviction, shall stand null and void.

The function of typography, as I understand it, is neither to further the power of witches nor to bolster the defences of those, like this unfortunate parliamentarian, who live in terror of being tempted and deceived. The satisfactions of the craft come from elucidating, and perhaps even ennobling, the text, not from deluding the unwary reader by applying scents, paints and iron stays to empty prose. But humble texts, such as classified ads or the telephone directory, may profit as much as anything else from a good typographical bath and a change of clothes. And many a book, like many a warrior or dancer or priest of either sex, may look well with some paint on its face, or indeed with a bone in its nose.

1.1.2 *Letters have a life and dignity of their own.*

Letterforms that honor and elucidate what humans see and say deserve to be honored in their turn. Well-chosen words deserve well-chosen letters; these in their turn deserve to be set with affection, intelligence, knowledge and skill. Typography is a link, and it ought, as a matter of honor, courtesy and pure delight, to be as strong as the others in the chain.

Writing begins with the making of footprints, the leaving of signs. Like speaking, it is a perfectly natural act which humans have carried to complex extremes. The typographer's task has always been to add a somewhat unnatural edge, a protective shell of artificial order, to the power of the writing hand. The tools have altered over the centuries, and the exact degree of unnaturalness desired has varied from place to place and time to time, but the character of the essential transformation between manuscript and type has scarcely changed.

The original purpose of type was simply copying. The job of the typographer was to imitate the scribal hand in a form that permitted exact and fast replication. Dozens, then hundreds, then thousands of copies were printed in less time than a scribe would need to finish one. This excuse for setting texts in type has disappeared. In the age of photolithography, digital scanning and offset printing, it is as easy to print directly from handwritten copy as from text that is typographically composed. Yet the typographer's task is little changed. It is still to give the illusion of

superhuman speed and stamina – and of superhuman patience and precision – to the writing hand.

Typography is just that: idealized writing. Writers themselves now rarely have the calligraphic skill of earlier scribes, but they evoke countless versions of ideal script by their varying voices and literary styles. To these blind and often invisible visions, the typographer must respond in visible terms.

In a badly designed book, the letters mill and stand like starving horses in a field. In a book designed by rote, they sit like stale bread and mutton on the page. In a well-made book, where designer, compositor and printer have all done their jobs, no matter how many thousands of lines and pages they must occupy, the letters are alive. They dance in their seats. Sometimes they rise and dance in the margins and aisles.

Simple as it may sound, the task of creative non-interference with letters is a rewarding and difficult calling. In ideal conditions, it is all that typographers are really asked to do – and it is enough.

1.1.3 *There is a style beyond style.*

Literary style, says Walter Benjamin, "is the power to move freely in the length and breadth of linguistic thinking without slipping into banality." Typographic style, in this large and intelligent sense of the word, does not mean any particular style – my style or your style, or Neoclassical or Baroque style – but the power to move freely through the whole domain of typography, and to function at every step in a way that is graceful and vital instead of banal. It means typography that can walk familiar ground without sliding into platitudes, typography that responds to new conditions with innovative solutions, and typography that does not vex the reader with its own originality in a self-conscious search for praise.

From part 2 of Benjamin's essay on Karl Kraus, in *Illuminationen* (Frankfurt, 1955). There is an English translation in Walter Benjamin, *Reflections,* ed. Peter Demetz (New York, 1978).

Typography is to literature as musical performance is to composition: an essential act of interpretation, full of endless opportunity for insight or obtuseness. Much typography is far removed from literature, for language has a multitude of uses, including packaging and propaganda. Like music, typography can be used to manipulate rather than nourish emotions and behavior. But this is not where typographers, musicians or other human beings show us their finest side. Typography at its best is a slow performing art, worthy of the same informed appreciation that we sometimes give to musical performances, and capable of giving similar enrichment and pleasure in return.

The same alphabets and page designs can be used for a biography of Mohandas Gandhi and for a manual on the use and deployment of biological weapons. Writing can be used both for love letters and for hate mail, and love letters themselves can be used for manipulation and extortion as well as to bring delight to body and soul. Evidently there is nothing inherently noble and trustworthy in the written or printed word. Yet generations of men and women have turned to writing and printing to house and share their deepest hopes, perceptions, dreams and fears. It is to them, not to the extortionist – nor to the opportunist or the profiteer – that the typographer must answer.

1.2 TACTICS

1.2.1 *Read the text before designing it.*

The typographer's one essential task is to interpret and communicate the text. Its tone, its tempo, its logical structure, its physical size, all determine the possibilities of its typographic form. The typographer is to the text as the theatrical director to the script, or the musician to the score.

1.2.2 *Discover the outer logic of the typography in the inner logic of the text.*

A novel often purports to be a seamless river of words from beginning to end, or a series of unnamed scenes. Research papers, textbooks, cookbooks and other works of nonfiction rarely look so smooth. They are often layered with chapter heads, section heads, subheads, block quotations, footnotes, endnotes, lists and illustrative examples. Such features may be obscure in the manuscript, even if they are clear in the author's mind. For the sake of the reader, each requires its own typographic identity and form. Every layer and level of the text must be consistent, distinct, yet (usually) harmonious in form.

The first task of the typographer is therefore to read and understand the text; the second task is to analyze and map it. Only then can typographic interpretation begin.

If the text has many layers or sections, it may need not only heads and subheads but running heads as well, reappearing on every page or two-page spread, to remind readers which intellectual neighborhood they happen to be visiting.

Novels seldom need such signposts, but they often require typographic markers of other kinds. Peter Matthiessen's novel *Far Tortuga* (New York, 1975; designed by Kenneth Miyamoto) uses two sizes of type, three different margins, free-floating block paragraphs and other typographic devices to separate thought, speech and action. Ken Kesey's novel *Sometimes a Great Notion* (New York, 1964) seems to flow like conventional prose, yet it shifts repeatedly in mid-sentence between roman and italic to distinguish what characters say to each other from what they say in silence to themselves.

The Grand Design

In poetry and drama, a larger typographic palette is sometimes required. Some of Douglass Parker's translations from classical Greek and Dennis Tedlock's translations from Zuni use roman, italic, bold, small caps and full caps in various sizes to emulate the dynamic markings of music. Robert Massin's typographic performances of Eugène Ionesco's plays use intersecting lines of type, stretched and melted letters, inkblots, pictograms, and a separate typeface for each person in the play. In the works of other artists such as Guillaume Apollinaire and Guy Davenport, boundaries between author and designer sometimes vanish. Writing merges with typography, and the text becomes its own illustration.

See for example Aristophanes, *Four Comedies* (Ann Arbor, Michigan, 1969); Dennis Tedlock, *Finding the Center* (New York, 1972; 2nd ed., Lincoln, Nebraska, 1999); Eugène Ionesco, *La Cantatrice chauve* (Paris, 1964), and *Délire à deux* (Paris, 1966).

The typographer must analyze and reveal the inner order of the text, as a musician must reveal the inner order of the music he performs. But the reader, like the listener, should in retrospect be able to close her eyes and see what lies inside the words she has been reading. The typographic performance must reveal, not replace, the inner composition. Typographers, like other artists and craftsmen – musicians, composers and authors as well – must as a rule do their work and disappear.

1.2.3 *Make the visible relationship between the text and other elements (photographs, captions, tables, diagrams, notes) a reflection of their real relationship.*

If the text is tied to other elements, where do they belong? If there are notes, do they go at the side of the page, the foot of the page, the end of the chapter, the end of the book? If there are photographs or other illustrations, should they be embedded in the text or should they form a special section of their own? And if the photographs have captions or credits or labels, should these sit close beside the photographs or should they be separately housed?

If there is more than one text – as in countless publications

issued in India, Canada, Switzerland, Belgium and other multilingual countries, or the multilingual manuals that are a feature of global enterprise – how will the separate but equal texts be arrayed? Will they run side by side to emphasize their equality (and perhaps to share a single set of illustrations), or will they be printed back-to-back, to emphasize their distinctness?

No matter what their relation to the text, photos or maps must sometimes be grouped apart from it because they require a separate paper or different inks. If this is the case, what typographic cross-references will be required?

These and similar questions, which confront the working typographer on a daily basis, must be answered case by case. The typographic page is a map of the mind; it is frequently also a map of the social order from which it comes. And for better or for worse, minds and social orders change.

1.2.4 *Choose a typeface or a group of faces that will honor and elucidate the character of the text.*

This is the beginning, middle and end of the practice of typography: choose and use the type with sensitivity and intelligence. Aspects of this principle are explored throughout this book and considered in detail in chapters 6, 7 and 11.

Letterforms have tone, timbre, character, just as words and sentences do. The moment a text and a typeface are chosen, two streams of thought, two rhythmical systems, two sets of habits, or if you like, two personalities, intersect. They need not live together contentedly forever, but they must not as a rule collide.

The root metaphor of typesetting is that the alphabet (or in Chinese, the entire lexicon) is a system of interchangeable parts. The word *form* can be surgically revised, instead of rewritten, to become the word *farm* or *firm* or *fort* or *fork* or *from,* or with a little more trouble, to become the word *pineapple.* The old compositor's typecase is a partitioned wooden tray holding hundreds of such interchangeable bits of information. These subsemantic particles, these bits – called *sorts* by letterpress printers – are letters cast on standardized bodies of metal, waiting to be assembled into meaningful combinations, then dispersed and reassembled in a different form. The compositor's typecase is one of the primary ancestors of the computer – and it is no surprise that while typesetting was one of the last crafts to be mechanized, it was one of the first to be computerized.

22

But the bits of information handled by typographers differ in one essential respect from the computer programmer's bits. Whether the type is set in hard metal by hand, or in softer metal by machine, or in digital form with a computer, every comma, every parenthesis, every *e*, and in context, even every empty space, has style as well as bald symbolic value. Letters are microscopic works of art as well as useful symbols. They mean what they are as well as what they say.

Typography is the art and craft of handling these doubly meaningful bits of information. A good typographer handles them in intelligent, coherent, sensitive ways. When the type is poorly chosen, what the words say linguistically and what the letters imply visually are disharmonious, dishonest, out of tune.

1.2.5 *Shape the page and frame the textblock so that it honors and reveals every element, every relationship between elements, and every logical nuance of the text.*

Selecting the shape of the page and placing the type upon it is much like framing and hanging a painting. A cubist painting in an eighteenth-century gilded frame, or a seventeenth-century still-life in a slim chrome box, will look no sillier than a nineteenth-century text from England set in types that come from seventeenth-century France, asymmetrically positioned on a German Modernist page.

If the text is long or the space is short, or if the elements are many, multiple columns may be required. If illustrations and text march side by side, does one take precedence over the other? And does the order or degree of prominence change? Does the text suggest perpetual symmetry, perpetual asymmetry, or something in between?

Again, does the text suggest the continuous unruffled flow of justified prose, or the continued flirtation with order and chaos evoked by flush-left ragged-right composition? (The running heads and sidenotes on the recto (righthand) pages of this book are set flush left, ragged right. On the verso (lefthand) pages, they are ragged left. Leftward-reading alphabets, like Arabic and Hebrew, are perfectly at home in ragged-left text, but with rightward-reading alphabets like Latin, Greek or Thai, ragged-left setting emphasizes the end, not the beginning, of the line. This makes it a poor choice for extended composition.)

Shaping the page goes hand in hand with choosing the type, and both are permanent typographical preoccupations. The sub-

ject of page shapes and proportions is addressed in greater detail in chapter 8.

1.2.6 *Give full typographic attention even to incidental details.*

Tactics

Some of what a typographer must set, like some of what any musician must play, is simply passage work. Even an edition of Plato or Shakespeare will contain a certain amount of routine text: page numbers, scene numbers, textual notes, the copyright claim, the publisher's name and address, and the hyperbole on the jacket, not to mention the passage work or background writing that is implicit in the text itself. But just as a good musician can make a heart-wrenching ballad from a few banal words and a trivial tune, so the typographer can make poignant and lovely typography from bibliographical paraphernalia and textual chaff. The ability to do so rests on respect for the text as a whole, and on respect for the letters themselves.

Perhaps the principle should read: Give full typographic attention *especially* to incidental details.

1.3 SUMMARY

There are always exceptions, always excuses for stunts and surprises. But perhaps we can agree that, as a rule, typography should perform these services for the reader:

- *invite the reader into the text;*
- *reveal the tenor and meaning of the text;*
- *clarify the structure and the order of the text;*
- *link the text with other existing elements;*
- *induce a state of energetic repose, which is the ideal condition for reading.*

While serving the reader in this way, typography, like a musical performance or a theatrical production, should serve two other ends. It should honor the text for its own sake – always assuming that the text is worth a typographer's trouble – and it should honor and contribute to its own tradition: that of typography itself.

24

2.1 HORIZONTAL MOTION

An ancient metaphor: thought is a thread, and the raconteur is a spinner of yarns – but the true storyteller, the poet, is a weaver. The scribes made this old and audible abstraction into a new and visible fact. After long practice, their work took on such an even, flexible texture that they called the written page a *textus,* which means cloth.

The typesetting device, whether it happens to be a computer or a composing stick, functions like a loom. And the typographer, like the scribe, normally aims to weave the text as evenly as possible. Good letterforms are designed to give a lively, even texture, but careless spacing of letters, lines and words can tear this fabric apart.

Another ancient metaphor: the density of texture in a written or typeset page is called its *color.* This has nothing to do with red or green ink; it refers only to the darkness or blackness of the letterforms in mass. Once the demands of legibility and logical order are satisfied, *evenness of color* is the typographer's normal aim. And color in the typographic sense depends upon four things: the design of the type, the spacing between the letters, the spacing between the words, and the spacing between the lines. None is independent of the others.

2.1.1 *Define the word space to suit the size and natural letterfit of the font.*

Type is normally measured in picas and points (explained in detail on pages 300–301 & 342–3), but horizontal spacing is also measured in *ems,* and the em is a sliding measure. One em is a distance equal to the type size. In 6 point type, an em is 6 points; in 12 pt type it is 12 points, and in 60 pt type it is 60 points. Thus a one-em space is *proportionately* the same in any size.

12 pt em	18 pt em	24 pt em	36 pt em

Typesetting machines generally divide the em into units. Ems of 18, 36 or 54 units, for example, are commonly found in the older machines. In newer devices, the em is generally a thousand units. Typographers are more likely to divide the em into simple fractions: half an em, a third of an em, and so on, knowing that the unit value of these fractions will vary from one machine to the next. Half an em is called an *en*.

If text is set ragged right, the *word space* (the space between words) can be fixed and unchanging. If the text is *justified* (set flush left and right, like the text in this book), that space must usually be elastic. In either case, the size of the ideal word space varies from one circumstance to another, depending on factors such as letterfit, type color, and size. A loosely fitted or bold face will need a larger interval between the words. At larger sizes, when letterfit is tightened, the spacing of words can be tightened as well. For a normal text face in a normal text size, a typical value for the word space is a quarter of an em, which can be written M/4. (A quarter of an em is typically about the same as, or slightly more than, the set-width of the letter t.)

Language has some effect on the word space as well. In highly inflected languages, such as Latin, most word boundaries are marked by grammatical tags, and a smaller space is therefore sufficient. In English and other uninflected languages, good word spacing makes the difference between a line that has to be deciphered and a line that can be efficiently read.

The word space native to the text font used in this book has a width of 227 units, or 227 thousandths of an em. The composition software is instructed to allow a minimum word space of 85%. That is 193 units: just under a fifth of an em. The maximum word space could be set to as much as 150% (340 units – just over a third of an em) – but in fact, it is set to 115%.

If the text is justified, a reasonable *minimum* word space is a fifth of an em (M/5), and M/4 is a good average to aim for. A reasonable maximum in justified text is M/3. But for loosely fitted faces, or text that is set in a small size, M/3 is often a better average to aim for, and a better minimum is M/4. In a line of widely letterspaced capitals, on the other hand, a word space of M/2 or more may be required.

2.1.2 *Choose a comfortable measure.*

Anything from 45 to 75 characters is widely regarded as a satisfactory length of line for a single-column page set in a serifed text face in a text size. The 66-character line (counting both letters and spaces) is widely regarded as ideal. For multiple-column work, a better average is 40 to 50 characters.

If the type is well set and printed, lines of 85 or 90 characters will pose no problem in discontinuous texts, such as bibliogra-

phies, or, with generous leading, in footnotes. But even with generous leading, a line that averages more than 75 or 80 characters is likely to be too long for continuous reading.

A reasonable working minimum for justified text in English is the 40-character line. Shorter lines may compose perfectly well with sufficient luck and patience, but in the long run, justified lines averaging less than 38 or 40 characters will lead to white acne or pig bristles: a rash of erratic and splotchy word spaces or an epidemic of hyphenation. When the line is short, the text should be set ragged right. In large doses, even ragged-right composition may look anorexic if the line falls below 30 characters, but in small and isolated patches – ragged marginal notes, for example – the minimum line (if the language is English) can be as little as 12 or 15 characters.

These line lengths are in every case averages, and they include empty spaces and punctuation as well as letters. The simplest way of computing them is with a copyfitting table like the one on page 28. Measure the length of the basic lowercase alphabet – abcdefghijklmnopqrstuvwxyz – in any face and size you are considering, and the table will tell you the average number of characters to expect on a given line. In most text faces, the 10 pt roman alphabet will run between 120 and 140 points in length, but a 10 pt italic alphabet might be 100 points long or even less, while a 10 pt bold might run to 160. The 12 pt alphabet is, of course, about 1.2 times the length of the 10 pt alphabet – but not exactly so unless it is generated from the same master design and the letterfit is unchanged.

On a conventional book page, the measure, or length of line, is usually around 30 times the size of the type, but lines as little as 20 or as much as 40 times the type size fall within the expectable range. If, for example, the type size is 10 pt, the measure might be around 30 × 10 = 300 pt, which is 300/12 = 25 picas. A typical lowercase alphabet length for a 10 pt text font is 128 pt, and the copyfitting table tells us that such a font set to a 25-pica measure will yield roughly 65 characters per line.

2.1.3 *Set ragged if ragged setting suits the text and the page.*

In justified text, there is always a trade-off between evenness of spacing and frequency of hyphenation. The best available compromise will depend on the nature of the text as well as on the specifics of the design. Good compositors like to avoid consecutive

When *all* the spaces in the text are elastic – the white spaces *inside the letterforms themselves* as well as the spaces between letters and the spaces between words – justification can be smoother and more complete. This idea is older than Gutenberg. See pp 190–93.

AVERAGE CHARACTER COUNT PER LINE

		10	12	14	16	18	20	22	24	26	28	30	32	34	36	38	40
Read down,	80	40	48	56	64	72	80	88	96	104	112	120	128	136	144	152	160
in the left	85	38	45	53	60	68	76	83	91	98	106	113	121	129	136	144	151
column:	90	36	43	50	57	64	72	79	86	93	100	107	115	122	129	136	143
lowercase	95	34	41	48	55	62	69	75	82	89	96	103	110	117	123	130	137
alphabet length	100	33	40	46	53	59	66	73	79	86	92	99	106	112	119	125	132
in points.	105	32	38	44	51	57	63	70	76	82	89	95	101	108	114	120	127
Read across,	110	30	37	43	49	55	61	67	73	79	85	92	98	104	110	116	122
in the top row:	115	29	35	41	47	53	59	64	70	76	82	88	94	100	105	111	117
line length	120	28	34	39	45	50	56	62	67	73	78	84	90	95	101	106	112
in picas.	125	27	32	38	43	48	54	59	65	70	75	81	86	91	97	102	108
	130	26	31	36	41	47	52	57	62	67	73	78	83	88	93	98	104
	135	25	30	35	40	45	50	55	60	65	70	75	80	85	90	95	100
	140	24	29	34	39	44	48	53	58	63	68	73	77	82	87	92	97
	145	23	28	33	37	42	47	51	56	61	66	70	75	80	84	89	94
	150	23	28	32	37	41	46	51	55	60	64	69	74	78	83	87	92
	155	22	27	31	36	40	45	49	54	58	63	67	72	76	81	85	90
	160	22	26	30	35	39	43	48	52	56	61	65	69	74	78	82	87
	165	21	25	30	34	38	42	46	51	55	59	63	68	72	76	80	84
	170	21	25	29	33	37	41	45	49	53	57	62	66	70	74	78	82
	175	20	24	28	32	36	40	44	48	52	56	60	64	68	72	76	80
	180	20	23	27	31	35	39	43	47	51	55	59	62	66	70	74	78
	185	19	23	27	30	34	38	42	46	49	53	57	61	65	68	72	76
	190	19	22	26	30	33	37	41	44	48	52	56	59	63	67	70	74
	195	18	22	25	29	32	36	40	43	47	50	54	58	61	65	68	72
	200	18	21	25	28	32	35	39	42	46	49	53	56	60	63	67	70
	210	17	20	23	27	30	33	37	40	43	47	50	53	57	60	63	67
	220	16	19	22	25	29	32	35	38	41	45	48	51	54	57	60	64
	230	15	18	21	24	27	30	33	36	40	43	46	49	52	55	58	61
	240	15	17	20	23	26	29	32	35	38	41	44	46	49	52	55	58
	250	14	17	20	22	25	28	31	34	36	39	42	45	48	50	53	56
	260	14	16	19	22	24	27	30	32	35	38	41	43	46	49	51	54
	270	13	16	18	21	23	26	29	31	34	36	39	42	44	47	49	52
	280	13	15	18	20	23	25	28	30	33	35	38	40	43	45	48	50
	290	12	15	17	20	22	24	27	29	32	34	37	39	41	44	46	49
	300	12	14	17	19	21	24	26	28	31	33	35	38	40	42	45	47
	320	11	13	16	18	20	22	25	27	29	31	34	36	38	40	43	45
	340	10	13	15	17	19	21	23	25	27	29	32	34	36	38	40	42
	360	10	12	14	16	18	20	22	24	26	28	30	32	34	36	38	40

hyphenated line-ends, but frequent hyphens are better than sloppy spacing, and ragged setting is better yet.

Narrow measures – which make good justification extremely difficult – are commonly used when the text is set in multiple columns. Setting ragged right under these conditions will lighten the page and decrease its stiffness, as well as preventing an outbreak of hyphenation.

Rhythm and Proportion

Many unserifed faces look best when set ragged no matter what the length of the measure. And monospaced fonts, which are common on typewriters, always look better set ragged, in standard typewriter style. A typewriter (or a computer-driven printer of similar quality) that justifies its lines in imitation of typesetting is a presumptuous, uneducated machine, mimicking the outward form instead of the inner truth of typography.

❧ When setting ragged text with a computer, take a moment to refine your software's understanding of what constitutes an honest rag. The software may be predisposed to invoke a minimum as well as a maximum line. If permitted to do so, it will hyphenate words and adjust the word spaces regardless of whether it is ragging or justifying the text. Ragged setting with these parameters tends to produce an orderly ripple down the righthand side, making the text look like a neatly pinched piecrust. All very well if that is what you want – but it may not be. With some texts, unless the measure is very narrow, you may prefer the greater variations of a hard rag. This means fixed word spaces, no minimum line, inflexible letterspacing, and no hyphenation beyond what is inherent in the text. In a hard rag, hyphenated linebreaks may occur in words like self-consciousness, which are hyphenated anyway, but they cannot occur without manual intervention in words like *hyphenated* or *pseudosophisticated,* which aren't.

2.1.4 *Use a single word space between sentences.*

In the nineteenth century, which was a dark and inflationary age in typography and type design, many compositors were encouraged to stuff extra space between sentences. Generations of twentieth-century typists were then taught to do the same, by hitting the spacebar twice after every period. Your typing as well as your typesetting will benefit from unlearning this quaint Victorian habit. As a general rule, no more than a single space is required

29

after a period, a colon or any other mark of punctuation. Larger spaces (e.g., en spaces) are *themselves* punctuation.

The rule is sometimes altered, however, when setting classical Latin and Greek, romanized Sanskrit, phonetics or other kinds of texts in which sentences begin with lowercase letters. In the absence of a capital, a full *en space* (M/2) between sentences may be welcome.

2.1.5 *Add little or no space within strings of initials.*

Names such as W. B. Yeats and J. C. L. Prillwitz need hair spaces, thin spaces or no spaces at all after the intermediary periods. A normal word space follows the *last* period in the string.

2.1.6 *Letterspace all strings of capitals and small caps, and all long strings of digits.*

Acronyms such as CIA and PLO are frequent in some texts. So are abbreviations such as CE and BCE or AD and BC. The normal value for letterspacing these sequences of small or full caps is 5% to 10% of the type size. If your software sees the em as 1000 PostScript units, that means 50 to 100 units of letterspacing.

With digital fonts, it is a simple matter to assign extra width to all small capitals, so that letterspacing occurs automatically. The width values of full caps are normally based on the assumption that they will be used in conjunction with the lower case, but good letterspacing of caps can still be automated through a well-made kerning table (see pages 33–34).

In titles and headings, extra letterspacing is often desirable. Justified lines of letterspaced capitals are generally set by inserting a normal word space (M/5 to M/4) between letters. This corresponds to letterspacing of 20% to 25% of the type size. But the extra space between letters will also require more space between lines. A Renaissance typographer setting a multi-line head in letterspaced text-size capitals would normally set blanks between the lines: the hand compositor's equivalent of the keyboard operator's extra hard return, or double spacing.

There is no generalized optimum value for letterspacing capitals in titles or display lines. The effective letterspacing of caps in good classical inscriptions and later manuscripts ranges from 5% to 100% of the nominal type size. The quantity of space is far less important than its balance. Sequences like LA or AVA may

need no extra space at all, while sequences like NN and HIH beg to be pried open.

WAVADOPATTIMMILTL
WAVADOPATTIMMILTL

Letterspaced caps, above; badly kerned and unletterspaced, below.

Many typographers like to letterspace all strings of numbers as well. Spacing is essential for rapid reading of long, fundamentally meaningless strings, such as serial numbers, and it is helpful even for shorter strings such as phone numbers and dates. Numbers set in pairs need not be letterspaced; strings of three or more may need a little air. This is the rationale behind the old European habit of setting phone numbers in the form oo oo oo instead of ooo-oooo.

2.1.7 *Don't letterspace the lower case without a reason.*

A man who would letterspace lower case would steal sheep, Frederic Goudy liked to say. If this wisdom needs updating, it is chiefly to add that a woman who would letterspace lower case would steal sheep as well.

Nevertheless, like every rule, this one extends only as far as its rationale. The reason for not letterspacing lower case is that it hampers legibility. But there are some lowercase alphabets to which this principle doesn't apply.

Headings set in exaggeratedly letterspaced, condensed, unserifed capitals are now a hallmark, if not a cliché, of postmodern typography. In this context, secondary display can be set perfectly well in more modestly letterspaced, condensed, unserifed lower case. Moderate letterspacing can make a face such as lowercase Univers bold condensed more legible rather than less. Inessential ligatures are, of course, omitted from letterspaced text.

wharves and wharfingers

Lowercase Univers bold condensed, letterspaced 10%.

It would be possible, in fact, to make a detailed chart of lowercase letterforms, plotting their inherent resistance to letterspacing.

Near the top of the list (most unsuitable for letterspacing) would be Renaissance italics, such as Arrighi, whose structure strongly implies an actual linkage between one letter and the next. A little farther along would be Renaissance romans. Still farther along, we would find faces like Syntax, which echo the forms of Renaissance roman but lack the serifs. Around the middle of the list, we would find other unserifed faces, such as Helvetica, in which nothing more than wishful thinking bonds the letters to each other. Bold condensed sanserifs would appear at the bottom of the list. Letterspacing will always sabotage a Renaissance roman or italic. But when we come to the other extreme, the faces with no calligraphic flow, letterspacing of lowercase letters can sometimes be of genuine benefit.

Because it isolates the individual elements, letterspacing has a role to play where words have ceased to matter and letters are what count. Where letters function one by one (as in acronyms, website URLS and e-mail addresses) letterspacing is likely to help, no matter whether the letters are caps, small caps or lower case.

Outside the domain of roman and italic type, the letterspacing of text has other traditional functions. Blackletter faces have, as a rule, no companion italic or bold, and no small caps. The simplest methods of emphasis available are underlining and letterspacing. The former was the usual method of the scribes, but letterspacing is easier for letterpress printers. In digital typography, however, underlining is just as easy as letterspacing and sometimes does less damage to the page.

In Cyrillic, the difference between lower case and small caps is more subtle than in the Latin or Greek alphabets, but small caps are nonetheless important to skilled Cyrillic typographers. In former days, when Cyrillic cursive type was scarce and small caps almost nonexistent, Cyrillic was routinely set like fraktur, with letterspaced upright (roman) lower case where the small caps and the cursive (italic) would have been. Improved Cyrillic types have made that practice obsolete.

2.1.8 *Kern consistently and modestly or not at all.*

Inconsistencies in letterfit are inescapable, given the forms of the Latin alphabet, and small irregularities are after all essential to the legibility of roman type. *Kerning* – altering the space between selected pairs of letters – can increase consistency of spacing in a word like Washington or Toronto, where the combinations Wa

and To are kerned. But names like Wisconsin, Tübingen, Tbilisi and Los Alamos, as well as common words like The and This, remain more or less immune to alteration.

Hand compositors rarely kern text sizes, because their kerning pairs must be manually fitted, one at a time. Computerized typesetting makes extensive kerning easy, but judgment is still required, and the computer does not make good judgment any easier to come by. Too little kerning is preferable to too much, and inconsistent kerning is worse than none.

In digital type, as in foundry type, each letter has a standard width of its own. But computerized typesetting systems can modify these widths in many ways. Digital fonts are generally kerned through the use of *kerning tables,* which can specify a reduction or increase in spacing for every possible pair of letters, numbers or symbols. By this means, space can be automatically added to combinations like HH and removed from combinations like Ty. Prefabricated kerning tables are now routine components of well-made digital fonts, but they still sometimes require extensive editing to suit individual styles and requirements. If you use an automatic kerning program, test it thoroughly before trusting its decisions, and take the time to repair its inevitable shortcomings.

Kerning tables generally subtract space from combinations such as Av, Aw, Ay, 'A, 'A, L', and all combinations in which the first element is T, V, W or Y and the second element is anything other than b, h, k or l. Not all such combinations occur in English, but a good kerning table will accommodate names such as Tchaikovsky, Tmolos, Tsimshian, Vázquez, Chateau d'Yquem and Ysaÿe.

The table also normally adds space to sequences like f', f), f], f?, f!, (f, [f, (J and [J. In some italics, space must also be added to *gg* and *gy.* If your text includes them, other sequences – *gf, gj, qf, qj,* for instance – may need attention as well.

Especially at larger sizes, it is common to kern combinations involving commas and periods, such as r, / r. / v, / v. / w, / w. / y, / y. But use care in kerning combinations such as F. / P. / T. / V. Capitals need their space, and some combinations are easy to misread. P.F. Didot may be misread as R E Didot if too enthusiastically kerned.

Numbers are often omitted from kerning tables, but numbers often need more kerning than letters do. Most fonts, both metal and digital, are equipped with *tabular figures* – figures that all have identical set-width, so columns of typeset figures will align. If you are forced to use such a font, heavy kerning will be required. A good text font will give you *proportional figures* instead. A digital

Rhythm and Proportion

There is more about kerning tables on pp 203–7.

Top

Töpf

(*f*")

w, f'

font in the OpenType format may offer you four choices: proportional and tabular lining (titling) figures, and proportional and tabular old-style (text) figures. No matter how the figures are cut, when used in text, they are likely to need some kerning, to each other and to the en dash.

1740–1900 **1740–1900**

Unkerned Sabon numerals, left, and well-kerned numerals, right

L'An

L'An

Whatever kerning you do, make sure it does not result in collisions with diacritics. Wolf can and should be kerned a little more than Wölfflin in most faces, and Tennyson more than Tête-à-tête. Also beware the composite effect of sequential kerns. The apostrophes in L'Hôtel and D'Artagnan can be brought up fairly close, but in L'Anse aux Meadows, two close kerns in a row will bring the caps on either side of the apostrophe into collision.

A kerning table written expressly for one language will need subtle alteration before it can do justice to another. In English, for example, it is normal to kern the combinations 'd 'm 'r 's 't, which appear in common contractions. In French, 'a 'â 'e 'é 'è 'ê 'o 'ô are kerned instead – but lightly. In Native American texts, apostrophes can appear in many other contexts. For Spanish, one kerns the combinations '¿ and "¿. For German, a careful typographer will take space out of the combinations ‚T „T ‚V „V ‚W „W and may add some space to ‚J and „J. Many well-made fonts now include multiple kerning tables for different languages – invoked from within the composition software by specifying the language of the text.

The letter *c* is not perhaps a full-fledged member of the German alphabet, and in former times it was largely restricted, in German, to words borrowed from Latin and to the ligatures *ch* and *ck*. English-speaking readers often find these combinations kerned too close for comfort in German-made fonts – or they find the right sidebearing of the *c* too close-cut to begin with. In fonts from the Netherlands, unusually tight kerning is common in the sequence *ij* instead.

Binomial kerning tables are powerful and useful typographic tools, but they eliminate neither the need nor the pleasure of making final adjustments by hand. Names like T.V.R. Murti and T.R.V. Murti, for example, pose microscopic typographic problems that no binomial kerning table can solve.

's

a'a

"¿

A *sidebearing* is the precise amount of breathing space a letter carries with it on the left or right.

34

2.1.9 *Don't alter the widths or shapes of letters without cause.*

Type design is an art practiced by few and mastered by fewer – but font-editing software makes it possible for anyone to alter in a moment the widths and shapes of letters to which an artist may have devoted decades of study, years of inspiration and a rare concentration of skill. The power to destroy such a type designer's work should be used with caution. And arbitrarily condensing or expanding letterforms is the poorest of all methods for fitting uneditable copy into unalterable space.

In many fonts, the exclamation mark, question mark, semicolon and colon need a wider left sidebearing than manufacturers have given them, but the width of any character should be altered for one purpose only: to improve the set of the type.

Typographic letters are made legible not only by their forms and by the color of the ink that prints them but also by the sculpted empty space between and around them. When type is cast and set by hand, that space is physically defined by blocks of metal. When the type is reduced to a *face,* photographically or digitally stored, the letter still has a room of its own, defined by its stated body height and width, but it is a virtual room. In the world of digital type, it is very easy for a designer or compositor with no regard for letters to squish them into cattle trains and ship them to the slaughter.

letterunfit **letterfit**

When letters are maltreated in this way, their reserve of legibility is sapped. They can do little in their turn except shortchange and brutalize the reader.

2.1.10 *Don't stretch the space until it breaks.*

Lists, such as contents pages and recipes, are opportunities to build architectural structures in which the space between the elements both separates and binds. The two favorite ways of destroying such an opportunity are setting great chasms of space that the eye cannot leap without help from the hand, and setting unenlightening rows of dots (*dot leaders,* they are called) that force the eye to walk the width of the page like a prisoner being escorted back to his cell.

The following examples show two among many ways of han-

dling a list. Splitting titles and numbers apart, setting one flush left and the other flush right, with or without dot leaders, would only muffle the information:

*Horizontal
Motion*

2.2 VERTICAL MOTION

2.2.1 *Choose a basic leading that suits the typeface, text and measure.*

Time is divisible into any number of increments. So is space. But for working purposes, time in music is divided into a few proportional intervals: halves, quarters, eighths, sixteenths and so on. And time in most music is carefully measured. Phrasing and rhythm can move in and out of phase – as they do in the singing of Billie Holiday and the trumpet solos of Miles Davis – but the force of blues phrasing and syncopation vanishes if the beat is actually lost.

Space in typography is like time in music. It is infinitely divisible, but a few proportional intervals can be much more useful than a limitless choice of arbitrary quantities.

The metering of horizontal space is accomplished almost unconsciously in typography. You choose and prepare a font, and you choose a measure (the width of the column). When you set the type, the measure fills with the varied rhythm of repeating letter shapes, which are music to the eye.

Vertical space is metered in a different way. You must choose not only the overall measure – the depth of the column or page – but also a basic rhythmical unit. This unit is the leading, which is the distance from one baseline to the next.

Eleven-point type *set solid* is described as 11/11. The theoretical face of the type is 11 points high (from the top of *d* to the bottom of *p,* if the type is full on the body), and the distance

from the baseline of line one to the baseline of line two is also 11 points. Add two points of lead (interlinear space), and the type is set 11/13. The type size has not changed, but the distance from baseline to baseline has increased to 13 points, and the type has more room to breathe.

The text of the book you are reading, to take an example, is set 10/12 × 21. This means that the type size is 10 pt, and the added lead is 2 pt, giving a total leading of 12 pt, and the line length is 21 picas.

If the vertical increment, baseline to baseline, is *less* than the size of the type, you have *negative* leading – something all too easy to achieve with digital type. A short burst of u&lc (upper & lower case) advertising copy or a title may prosper with negative leading, if the extenders interweave instead of colliding, but negative leading of caps falls readily into cliché, because there are no extenders to interact.

this is negative leading in lower case AND NEGATIVE LEADING IN CAPS

Continuous text is very rarely set with negative leading, and only a few text faces read well when set solid. Most text requires positive leading. Settings such as 9/11, 10/12, 11/13 and 12/15 are routine. Longer measures need more lead than short ones. Dark faces need more lead than light ones. Faces that are large on the body need more lead than those that are small. Faces like Bauer Bodoni, with substantial color and a rigid vertical axis, need much more lead than faces like Bembo, whose color is light and whose axis is based on the writing hand. And unserifed faces often need more lead (or a shorter line) than their serifed counterparts.

Extra leading is also generally welcome where the text is thickened by superscripts, subscripts, mathematical expressions, or the frequent use of full capitals. A text in German would ideally have a little more lead than the same text in Latin or French, purely because of the increased frequency of capitals.

bip
Irf

Bauer Bodoni above, Monotype Centaur below, both set 36/36.

bip
Irf

2.2.2 *Add and delete vertical space in measured intervals.*

For the same reason that the tempo must not change arbitrarily in music, leading must not change arbitrarily in type.

Pages and columns are set most often to uniform depth, but ragged depths are better in some situations. A collection of short

texts, such as catalogue entries, set in multiple-column pages, is likely to look better and read more easily if the text is not sawed into columns of uniform depth. A collection of short poems is bound to generate pages of varying depth as well – and so much the better.

Continuous prose offers no such excuse for variation. It is therefore usually set in pages of uniform depth, designed in symmetrical pairs. The lines and blocks of text on facing pages in this format should align, and the lines on the front and back of the leaf (the recto and verso pages) should align as well. Typographers check their reproduction proofs by holding them up to the light in pairs, to see that the text and crop marks match from page to page. Press proofs are checked in the same way, by holding them up to the light to see that textblocks *back each other up* when the sheet is printed on both sides.

Headings, subheads, block quotations, footnotes, illustrations, captions and other intrusions into the text create syncopations and variations against the base rhythm of regularly leaded lines. These variations can and should add life to the page, but the main text should also return after each variation precisely on beat and in phase. This means that the total amount of vertical space consumed by each departure from the main text should be an even multiple of the basic leading. If the main text runs 11/13, intrusions to the text should equal some multiple of 13 points: 26, 39, 52, 65, 78, 91, 104 and so on.

Subheads in this book are leaded in the simplest possible way, with a *white line* (that is, in keyboard terms, a hard return) before and after. They could just as well be leaded asymmetrically, with more space above than below, so long as the total additional lead is equivalent to an even number of text lines.

If you happen to be setting a text 11/13, subhead possibilities include the following:

- subheads in 11/13 small caps, with 13 pt above the head and 13 pt below;
- subheads in 11/13 bold u&lc, with 8 pt above the head and 5 pt below, since 8 + 5 = 13;
- subheads in 11/13 caps with 26 pt above and 13 pt below;
- one-line subheads in 14/13 italic u&lc, with 16 pt above the head and 10 pt below. (The negative leading is merely to simplify coding in this case. If the heads are one line long, no cramping will occur.)

Vertical Motion

2.2.3 *Don't suffocate the page.*

Most books now printed in the Latin alphabet carry from 30 to 45 lines per page. The average length of line in most of those books is 60 to 66 characters. In English and the Romance languages, a word is typically assumed to average five letters plus a space. Ten or eleven such words fit on a line of 60 to 66 characters, and the page, if it is full, holds from 300 to 500 words.

Outside these conventional boundaries lie many interesting typographic problems. If the text deserves the honor, a handsome page can be made with very few words. A page with 17 lines of 36 characters each, as an example, will carry only 100 words. At the other extreme, a page with 45 lines of 70 characters each will carry 525 words. If you want more than 500 words to the page, it is time to consider multiple columns. A two-column book page will comfortably carry 750 words. If it must, it can carry a thousand.

However empty or full it may be, the page must breathe, and in a book – that is, in a long text fit for the reader to live in – the page must breathe in both directions. The longer the line, the more space necessary between lines. Two columns of short lines are therefore more compact than a single column of long lines.

2.3 BLOCKS & PARAGRAPHS

2.3.1 *Set opening paragraphs flush left.*

The function of a paragraph indent is to mark a pause, setting the paragraph apart from what precedes it. If a paragraph is preceded by a title or subhead, the indent is superfluous and can therefore be omitted, as it is here.

2.3.2 *In continuous text, mark all paragraphs after the first with an indent of at least one en.*

Typography like other arts, from cooking to choreography, involves a balance between the familiar and the unfamiliar, the dependably consistent and the unforeseen. Typographers generally take pleasure in the unpredictable length of the paragraph while accepting the simple and reassuring consistency of the paragraph indent. The prose paragraph and its verse counterpart, the stanza, are basic units of linguistic thought and literary style. The typographer must articulate them enough to make them

clear, yet not so strongly that the form instead of the content steals the show. If the units of thought, or the boundaries between thoughts, look more important than the thoughts themselves, the typographer has failed.

ॐ Ornaments can be placed in the paragraph indents, but few texts actually profit from ornamentation.

Paragraphs can also be marked, as this one is, by drop lines, but dropline paragraphs grow tiresome in long texts. They also increase the labor of revisions and corrections. ¶ Pilcrows, boxes and bullets can be used to mark the breaks in a stream of continuous text, sometimes with excellent results. This format is more economical of space than conventional indented paragraphs, but again, extra labor and expense may arise with emendations and corrections.

Outdented paragraphs and indented paragraphs are the two most obvious possibilities that remain. And outdented paragraphs bring with them other possibilities, such as the use of enlarged marginal letters.

All these variants, and others, have their uses, but the plainest, most unmistakable yet unobtrusive way of marking paragraphs is the simple indent: a white square.

How much indent is enough? The most common paragraph indent is one em. Another standard value is *one lead.* If your text is set 11/13, the indent would then be either 11 pt (one em) or 13 pt (one lead). One en (half an em) is the practical minimum.

Where the line is long and margins are ample, an indent of 1½ or two ems may look more luxurious than one em, but paragraph indents larger than three ems are generally counterproductive. Short last lines followed by new lines with large indents produce a tattered page.

Block paragraphs open flush left and are separated vertically from their neighbors by extra lead, usually a white line. Block paragraphs are common in business letters and memos, and because they suggest precision, crispness and speed, they can be useful in short documents of other kinds. In longer sequences, they may seem soulless and uninviting.

2.3.3 *Add extra lead before and after block quotations.*

Block quotations (like the one on pages 17–18 of this book) can be distinguished from the main text in many ways. For instance:

by a change of face (usually from roman to italic), by a change in size (as from 11 pt down to 10 pt or 9 pt), or by indention.

Combinations of these methods are often used, but one device is enough. If your paragraph indent is modest, you may for consistency's sake want to use the same indent for quotations. And even if your block quotations are set in a size smaller than normal text, you may want to leave the leading unchanged. If the main text runs 10/12, the block quotations might run 10/12 italic or 9/12 roman. If you prefer greater density or are eager to save space, you might set them 9/11 or 9/10½.

However the block quotations are set, there must be a visible distinction between main text and quotation, and again between the quotation and subsequent text. This usually means a white line or half-line at the beginning and end of the block. But if the leading within the quotation differs from that of the main text, these blanks before and after the quotation have to be elastic. They afford the only opportunity for bringing the text back into phase.

Suppose your main text is 11/13 and a five-line block quotation set 10/12 intervenes. The depth of the quotation is $5 \times 12 = 60$. This must be bulked up to a multiple of 13 to bring the text back into phase. The nearest multiple of 13 is $5 \times 13 = 65$. The remaining space is $65 - 60 = 5$, and $5/2 = 2.5$, which is not enough. Adding 2.5 points before and after the quotation will not give adequate separation. The next multiple of 13 is $6 \times 13 = 78$, which is better: $78 - 60 = 18$, and $18/2 = 9$. Add 9 pt lead before and after the quotation, and the text will realign.

2.3.4 *Indent or center verse quotations.*

Verse is usually set flush left and ragged right, and verse quotations within prose should not be deprived of their chosen form. But to distinguish verse quotations from surrounding prose, they should be indented or centered on the longest line. Centering is preferable when the prose measure is substantially longer than the verse line. The following passage, for example, is centered on the first and longest line.

> *God guard me from those thoughts men think*
> *In the mind alone;*
> *He that sings a lasting song*
> *Thinks in a marrow bone.*

Suppose your main text is set on a 24-pica measure and you have decided to set verse quotations in italic at the text size. Suppose that the longest line in your quotation measures 269 points. The indent for this quotation might be computed as follows: $24 \times 12 = 288$ pt, which is the full prose measure, and $288 - 269 = 19$ pt, which is the difference between the measure and the longest verse line. The theoretically perfect left indent for the verse quotation is $19/2 = 9.5$ pt. But if another indent close to 9.5 pt is already in use, either for block quotations in prose, or as a paragraph indent, then the verse quotation might just as well be indented to match.

Suppose however that the longest line in the verse is 128 points. The measure, again, is 288 points, and $288 - 128 = 160$. Half of 160 is 80 points. No other indent in the vicinity of 80 points is likely to be in use. The verse quotation would then be indented by precisely that amount.

2.4 ETIQUETTE OF HYPHENATION & PAGINATION

The rules listed below are traditional craft practice for the setting of justified text. Except for the last rule, they are all programmable, but the operation of these rules necessarily affects the spacing of words and thus the texture and color of the page. If decisions are left to the software, they should be checked by a trained eye – and no typesetting software should be permitted to compress, expand or letterspace the text automatically and arbitrarily as a means of fitting the copy. Copyfitting problems should be solved by creative design, not fobbed off on the reader and the text nor cast like pearls before machines.

For a brief discussion of software justification engines, which now do most of the work, see §9.4, page 191.

2.4.1 *At hyphenated line-ends, leave at least two characters behind and take at least three forward.*

Fi-nally is conventionally acceptable line-end hyphenation, but final-ly is not, because it takes too little of the word ahead to the next line.

2.4.2 *Avoid leaving the stub-end of a hyphenated word, or any word shorter than four letters, as the last line of a paragraph.*

2.4.3 *Avoid more than three consecutive hyphenated lines.*

2.4.4 *Hyphenate proper names only as a last resort unless they occur with the frequency of common nouns.*

2.4.5 *Hyphenate according to the conventions of the language.*

In English we hyphenate *cab-ri-o-let* but in French *ca-brio-let*. The old German rule which hyphenated *Glockenspiel* as *Glok-kenspiel* was changed by law in 1998, but when *össze* is broken in Hungarian, it still turns into *ösz-sze*. In Spanish the double consonants *ll* and *rr* are never divided. (The only permissible hyphenation in the phrase *arroz con pollo* is thus *arroz con po-llo*.) The conventions of each language are a part of its typographic heritage and should normally be followed, even when setting single foreign words or brief quotations.

2.4.6 *Link short numerical and mathematical expressions with hard spaces.*

All you may see on the keyboard is a space bar, but typographers use several invisible characters: the word space, fixed spaces of various sizes (em space, en space, thin space, figure space, etc) and a *hard space* or *no-break space*. The hard space will stretch, like a normal word space, when the line is justified, but it will not convert to a linebreak. Hard spaces are useful for preventing linebreaks within phrases such as *6.2 mm, 3 in., 4 × 4*, or in phrases like *page 3* and *chapter 5*.

 When it is necessary to break longer algebraic or numerical expressions, such as $a + b = c$, the break should come at the equal sign or another clear logical pause.

2.4.7 *Avoid beginning more than two consecutive lines with the same word.*

2.4.8 *Never begin a page with the last line of a multi-line paragraph.*

The typographic terminology is telling. Isolated lines created when paragraphs *begin* on the *last* line of a page are known as *orphans*. They have no past, but they do have a future, and they need not

Hart's Rules for Compositors (39th ed., 1983) includes a good, brief guide to hyphenation and punctuation rules for several European languages. Its fat successor, the Oxford Style Manual (2003) includes many more rules but less information. It is almost always worthwhile, however, to consult a style manual written in and for the language at issue – e.g., for French, the old Lexique des règles typographiques en usage à l'imprimerie nationale (Paris, 1990), and for German, Friedrich Forssman & Ralf de Jong's Detailtypografie (Mainz, 2004) or Hans Peter Willberg & Friedrich Forssman's Lesetypografie (Mainz, 2005).

trouble the typographer. The stub-ends left when paragraphs *end* on the *first* line of a page are called *widows*. They have a past but not a future, and they look foreshortened and forlorn. It is the custom – in most, if not in all, the world's typographic cultures – to give them one additional line for company. This rule is applied in close conjunction with the next.

2.4.9 *Balance facing pages by moving single lines.*

Pages with more than two columns often look best with the columns set to varying depths. This is the vertical equivalent of ragged-right composition. Where there are only one or two main text columns per page, paired columns and facing pages (except at the end of a chapter or section) are usually set to a uniform depth.

Balance facing pages not by adding extra lead or puffing up the word space, but by exporting or importing single lines to and from the preceding or following spreads. The same technique is used to avoid widows, and to extend or shorten any chapters that would otherwise end with a meager few lines on the final page. But this balancing should be performed with a gentle hand. In the end, no spread of continuous text should have to run more than a single line short or a single line long.

2.4.10 *Avoid hyphenated breaks where the text is interrupted.*

Style books sometimes insist that both parts of a hyphenated word must occur on the same page: in other words, that the last line on a page must never end with a hyphen. But turning the page is not, in itself, an interruption of the reading process. It is far more important to avoid breaking words in those locations where the reader is likely to be distracted by other information. That is, whenever a map, a chart, a photograph, a pull-quote, a sidebar or other interruption intervenes.

2.4.11 *Abandon any and all rules of hyphenation and pagination that fail to serve the needs of the text.*

3.1 SIZE

3.1.1 *Don't compose without a scale.*

The simplest scale is a single note, and sticking with a single note draws more attention to other parameters, such as rhythm and inflection. The early Renaissance typographers set each book in a single font – that is, one face in one size – supplemented by hand-drawn or specially engraved large initial letters for the openings of chapters. Their pages show what sensuous evenness of texture and variety of rhythm can be attained with a single font of type: very much greater than on a typewriter, where letters have, more often than not, a single width and a single stroke-weight as well as a single size.

In the sixteenth century, a series of common sizes developed among European typographers, and the series survived with little change and few additions for 400 years. In the early days, the sizes were known by their names rather than numbers, but measured in points, the traditional series is this:

6 7 8 9 10 11 12 14 16 18 21 24 30 36 48 60 72

This is the typographic equivalent of the diatonic scale. But modern equipment makes it possible to set, in addition to these sizes, all the sharps and flats and microtonal intervals between. Twenty-point, 22-point, 23-point, and 10½-point type are all available for the asking. The designer can now choose a new scale or tone-row for every piece of work.

These new resources are useful, but rarely all at once. Use the old familiar scale, or use new scales of your own devising, but limit yourself, at first, to a modest set of distinct and related intervals. Start with one size and work slowly from there. In time, the scales you choose, like the faces you choose, will become recognizable features of personal style.

A few examples
of the many older
names for type
sizes:

5 pt, *pearl*
5½ pt, *agate*
6 pt, *nonpareil*
7 pt, *minion*
8 pt, *brevier*
9 pt, *bourgeois*
10 pt, *long primer*
11 pt, *small pica*
12 pt, *pica*
14 pt, *english*
18 pt, *great primer*

3.2.1 *Use titling figures with full caps, and text figures in all other circumstances.*

So the date is 23 August 1832; it could be 3:00 AM in Apartment 6-B, 213-A Beacon Street; it is 27° C or 81° F; the price is $47,000 USD or £28,200; the postal codes are NL 1034 WR Amsterdam, SF 00170 Helsinki 17, Honolulu 96814, London WC1 2NN, New Delhi 110 003, Toronto M5S 2G5, and Dublin 2.

١ ٢ ٣

٤ ٥ ٦ ٧

٨ ٩ ٠

The arabic numerals of Latin script (below) are derived from the Indian numerals of Arabic script (above).

BUT IT IS 1832 AND 81° IN FULL CAPITALS.

Arabic numerals are known in Arabic as Indian numerals, *'arqām hindiyya* (أرقام هندية) because the Arabs obtained them from India. They entered the scribal tradition of Europe in the thirteenth century. Before that (and for many purposes afterward) European scribes used roman numerals, written in capitals when they occurred in the midst of other capitals, and in lowercase in the midst of lowercase letters. Typographers have naturally inherited this custom of setting roman numerals so that they harmonize with the words:

1 2 3

4 5 6 7

8 9 0

Arabic script is written right to left, but the numerals used with that script are written left to right, like Latin.

Number xiii lowercase AND XIII UPPERCASE
AND THE NUMBER XIII IN SMALL CAPITALS
and the roman numeral xiii in italic

When arabic numerals joined the roman alphabet, they too were given both lowercase and uppercase forms. Typographers call the former *text figures, hanging figures, lowercase figures,* or *old-style figures* (OSF for short) and make a point of using them whenever the surrounding text is set in lowercase letters or small caps. The alternative forms are called *titling figures, ranging figures* or *lining figures,* because they range or align with one another and with the upper case.

Text 1234567890 figures
TITLING 1234567890 FIGURES
FIGURES 1234567890 WITH SMALL CAPS
Italic text 1234567890 figures

Text figures were the common form in European typography between 1540 and 1800. But in the mid-eighteenth century, when European shopkeepers and merchants were apt to write more numbers than letters, handwritten numerals developed proportions of their own. These quite literally middle-class figures entered the realm of typography in 1788, when a British punchcutter named Richard Austin cut a font of three-quarter-height lining figures for the founder and publisher John Bell.

Bell letters and 1234567890 figures in roman *and 1234567890 in italic*

In the nineteenth century, which was not a great age for typography, founders stretched these figures up to cap height, and titling figures became the norm in commercial typography. Renaissance letterforms were revived in the early twentieth century, and text figures found their way back into books. But in news and advertising work, titling figures remained routine. In the 1960s, phototypesetting machines with their truncated fonts once again made text figures difficult to find. The better digital foundries now offer a wide selection of fonts with text figures and small caps. These are often sold separately and involve extra expense, but they are essential to good typography. It is better to have one good face with all its parts, including text figures and small caps, than fifty faces without.

It is true that text figures are rarely useful in classified ads, but they are useful for setting almost everything else, including good magazine and newspaper copy. They are basic parts of typographic speech, and they are a sign of civilization: a sign that dollars are not really twice as important as ideas, and numbers are not afraid to consort on an equal footing with words.

It is also true that a number of excellent text faces, both serifed and unserifed, were originally issued without text figures. Examples include Adrian Frutiger's Méridien, Eric Gill's Gill Sans, Paul Renner's Futura, Hans Eduard Meier's Syntax, Hermann Zapf's Comenius and Optima, and Gudrun Zapf-von Hesse's Carmina. In several of these cases, text figures were part of the original conception or even the finished design but were scuttled by the foundry. Many such missing components have belatedly been issued in digital form. With any text face that is missing text figures, it is reasonable to enquire whether commercial intimidation or, in effect, commercial censorship may not have played a role.

During most of the nineteenth and twentieth centuries, lining figures were widely known as 'modern' and text figures as 'old-style.' Modernism was preached as a sacred duty, and numbers, in a sense, were actually deified. Modernism is nothing if not complex, but its gospel was radical simplicity. Many efforts were made to reduce the Latin alphabet back to a single case. (The telegraph and teletype, with their unicameral alphabets, are also products of that time.) These efforts failed to make much headway where letters were concerned. With numbers, the campaign had considerable success. Typewriters soon came to have letters in both upper and lower case but numbers in upper case alone. And from typewriters have come computer keyboards.

Typographic civilization seems, nonetheless, determined to proceed. Text figures are again a normal part of type design – and have thus been retroactively supplied for faces that were earlier denied them. However common it may be, the use of titling figures in running text is illiterate: it spurns the truth of letters.

3.2.2 *For abbreviations and acronyms in the midst of normal text, use spaced small caps.*

This is a good rule for just about everything except two-letter geographical acronyms and acronyms that stand for personal names. Thus: 3:00 AM, 6:00 PM, the ninth century CE, 450 BC to AD 450, the OAS and NATO; World War II or WWII; but JFK and Fr J.A.S. O'Brien, OMI; HMS *Hypothesis* and USS *Ticonderoga*; Washington, DC, and Mexico, DF; and J.S. Bach's Prelude and Fugue in B♭ minor, BWV 867.

Many typographers prefer to use small caps for postal abbreviations (San Francisco, CA 94119), and for geographical acronyms longer than two letters. Thus, the USA, or in Spanish, *los EEUU,* and Sydney, NSW. But the need for consistency intervenes when long and short abbreviations fall together. From the viewpoint of the typographer, small caps are preferable in faces with fine features and small x-height, full caps in faces with large x-height and robust form.

Genuine small caps are not simply shrunken versions of the full caps. They differ from large caps in stroke-weight, letterfit, and internal proportions as well as in height. Any good set of small caps is designed as such from the ground up. Thickening, shrinking and squashing the full caps with digital modification routines will produce only a parody.

Sloped small capitals – A B C D E F G – have been designed and cut for relatively few faces in the history of type design, but they are less rare now than ever before. They can be faked with digital machinery, by sloping the roman small caps, but it is better to choose a face (such as this one, Robert Slimbach's Minion) which includes them, or to live without. Sloped (italic) text figures, on the other hand, are part of the basic requirement for typographic literacy, and they are now available for most good text fonts.

3.2.3 *Refer typographic disputes to the higher courts of speech and thinking.*

Type is idealized writing, and its normal function is to record idealized speech. Acronyms such as CD and TV or USA and UFO are set in caps because that is the way we pronounce them. Acronyms like UNESCO, ASCII and FORTRAN, which are pronounced not as letters but as words, are in the process of becoming precisely that. When a writer accepts them fully into her speech and urges readers to do likewise, it is time for the typographer to accept them into the common speech of typography by setting them in lower case: Unesco, Ascii (or ascii) and Fortran. Other acronymic words, such as *laser* and *radar,* have long since traveled the same road.

Logograms pose a more difficult question. An increasing number of persons and institutions, from archy and mehitabel to PostScript and TrueType, come to the typographer in search of special treatment. In earlier days it was kings and deities whose agents demanded that their names be written in a larger size or set in a specially ornate typeface; now it is business firms and mass-market products demanding an extra helping of capitals, or a proprietary face, and poets pleading, by contrast, to be left entirely in the vernacular lower case. But type is visible speech, in which gods and men, saints and sinners, poets and business executives are treated fundamentally alike. Typographers, in keeping with the virtue of their trade, honor the stewardship of *texts* and implicitly oppose private ownership of *words.*

Logotypes and logograms push typography in the direction of hieroglyphics, which tend to be looked at rather than read. They also push it toward the realm of candy and drugs, which tend to provoke dependent responses, and away from the realm of food, which tends to promote autonomous being. Good typography is like bread: ready to be admired, appraised and dissected before it is consumed.

3.3.1 *Use the ligatures required by the font, and the characters required by the language, in which you are setting type.*

f + f + i → ffi

Lâm-alif ligatures, like the one above, are essential in Arabic script. The *pi-tau, chi-rho* and *mu-alpha-iota* ligatures below are optional forms from Matthew Carter's Wilson Greek.

π + τ → πτ

χ + ρ → χρ

μ + α + ι → μαι

In most roman faces the letter f reaches into the space beyond it. In most italics, the *f* reaches into the space on both sides. Typographers call these overlaps *kerns*. Only a few kerns, like those in the arm of the *f* and the tail of the *j*, are implicit in a normal text font, while others, like the overlap in the combination *To,* are optional refinements, independent of the letterforms.

Reaching into the space in front of it, the arm of the f will collide with certain letters – b, f, h, i, j, k, l – and with question marks, quotation marks or parentheses, if these are in its way.

Most of the early European fonts were designed primarily for setting Latin, in which the sequences fb, fh, fj, fk do not occur, but the sequences ff, fi, fl, ffi, ffl are frequent. The same set of ligatures was once sufficient for English, and these five ligatures are standard in traditional roman and italic fonts. As the craft of typography spread through Europe, new regional ligatures were added. An fj and æ were needed in Norway and Denmark for words such as *fjeld* and *fjord* and *nær*. In France an œ, and in Germany an ß (*eszett* or double-s) were required, along with accented and umlauted vowels. Double letters which are read as one – *ll* in Spanish, *ij* in Dutch, and *ch* in German, for example – were cast as single sorts for regional markets. An ffj was needed in Iceland. New individual letters were added, like the Polish ł, the Spanish ñ, and the Danish and Norwegian ø. Purely decorative ligatures were added to many fonts as well.

English continues to absorb and create new words – *fjord, gaffhook, halfback, hors d'œuvre* – that call for ligatures beyond the Latin list. As an international language, English must also accommodate names like *Youngfox, al-Hajji* and *Asdzą́ą́ Yołgai.* These sometimes make demands on the roman alphabet which earlier designers didn't foresee. In the digital world, some of these compound characters and ligatures can, in effect, take care of themselves. In text work, there is no burning need for a specially crafted fb or fh ligature when the digital forms can be cleanly superimposed, but in display work, such ligatures can be crucial. Recent type designers, alive to these polylingual demands on the alphabet, have often simplified the problem further by designing faces in which no sequence of letters involves a collision.

æœ as Ch Ct ff ffi ffl fi fl fr
ij is ll q₃ St Sch Sh Si Sl Sp SS ß Ssi Ssl St Sz us
Æ Œ æ œ _æ œ_ ß ß ff fi fl ffi ffl _ffi ffl_
Ch St _Ch St_ fh fi fl ff ft _Sh Si Sl SS St_

Top two lines: Ligatures from an italic font cut in the 1650s by Christoffel van Dijck. _Lower two lines:_ Ligatures from Adobe Caslon, a digital face by Carol Twombly, after William Caslon, dating from about 1750. These are Baroque typefaces. As such, they include a set of ligatures with _f_ and a second set formed with the _long s_ (ſ, _ſ_). Long s and its ligatures were normal in European typography until late in the eighteenth century, though fonts designed to do without them were cut as early as the 1640s.

Separation of the letters _f_ and _i_ is sometimes crucial. In Turkish, _i_ with a dot and _ı_ without – or in capitals, _İ_ and _I_ – are two different letters. To set Turkish well, you need a face whose _f_ is designed so it does not disguise the difference.

This does not do away with the question of the five Latin ligatures. Older typefaces – Bembo, Garamond, Caslon, Baskerville and other distinguished creations – are, thankfully, still with us, in metal and in digital revivals. Many new faces also perpetuate the spirit of these earlier designs. These faces are routinely supplied with the five basic ligatures because they require them. And for digital typographers, software is available that will automatically insert them.

ff fi fl ffi ffl

ff fi fl ffi ffl

Bembo, set with ligatures (_above_) and without (_below_)

If your software is inserting ligatures automatically, take a moment to verify two things: (1) that the software is inserting all the ligatures you want _and_ none that you do not want; (2) that all these ligatures are staying where they're put.

Good OpenType digital fonts usually include the five Latin ligatures (ff, ffi, ffl, fi, fl), and many include the two Scandinavian ligatures (ffj, fj). There may also be a set of ornamental and old-fashioned forms (ct, ſp, ſt, Th; fi, fk, fl, ffi, ffl, etc) – and sometimes there are more archaic ligatures (*quaints,* as typographers call them) in italic than in roman. Where such a profusion of ligatures is present, they are usually divided into classes: *basic* and *discretionary.* If your software is conversant with OpenType fonts, it can be told to use the ligatures from either class or from both. But the classes are not always well defined. For now at least, fonts in the 'Adobe Originals' series all have the Th ligature misclassified as basic, not discretionary. Unless you edit the fonts to fix this error, you cannot get fi, fj, ff and ffi without getting Th also. If you *want* the Th ligature, this is fine. But Th has a different pedigree than fi and its brethren. Stylistically, it belongs to a different register. These two registers can certainly be paired; they should not be arbitrarily blurred together.

Some software that inserts ligs automatically may also strip them out again as soon as the type is letterspaced. If you let such software justify a text by adding space between the letters, you may find ligatures present in one line and missing in the next. The solution for this is twofold: (1) good software and (2) intelligent justification. Ligatures should go where they are needed and then stay no matter what.

3.3.2 *If you wish to avoid ligatures altogether, restrict yourself to faces that don't require them.*

It is quite possible to avoid the use of ligatures completely and still set beautiful type. All that is required is a face with non-kerning roman and italic *f* – and some of the finest twentieth-century faces were deliberately equipped with just this feature. Aldus, Melior, Mendoza, Palatino, Sabon, Trajanus and Trump Mediäval, for example, all set handsomely without ligatures. Full or partial ligatures do exist for these faces, and the ligatures may add a

fi fi *fi fi* fi fi *fi fi*

Ligatured and unligatured combinations in Sabon (*left*) and Trump Mediäval (*right*). In faces such as these, *f*-ligatures are optional – and in most such faces, only a partial set of ligatures exists.

touch of refinement – but when ligatures are omitted from these faces, no unsightly collisions occur.

The choice is wider still among sanserifs. Ligatures are important to the design of Eric Gill's Gill Sans, Ronald Arnholm's Legacy Sans, Martin Majoor's Scala Sans and Seria Sans but irrelevant to many unserifed faces. (Dummy ligatures, consisting of separate letters, are usually present on digital versions of those fonts, but using these dummies has no visible effect.)

3.4 TRIBAL ALLIANCES & FAMILIES

3.4.1 *To the marriage of type and text, both parties bring their cultural presumptions, dreams and family obligations. Accept them.*

Each text, each manuscript (and naturally, each language and each alphabet) has its own requirements and expectations. Some types are more adaptable than others in meeting these demands. But typefaces too have their individual habits and presumptions. Many of them, for instance, are rich with historical and regional connections – a subject pursued at greater length in chapter 7. For the moment, consider just the sociology of typefaces. What kinds of families and alliances do they form?

The union of uppercase and lowercase roman letters – in which the upper case has seniority but the lower case has the power – has held firm for twelve centuries. This constitutional monarchy of the alphabet is one of the most durable of European cultural institutions.

Ornamental initials, small caps and arabic figures were early additions to the roman union. Italics were a separate tribe at first, refusing to associate with roman lower case, but forming an alliance of their own with roman (not italic) capitals and small caps. Sloped caps developed only in the sixteenth century. Roman, italic and small caps formed an enlarged tribal alliance at that time, and most text families continue to include them.

Bold and condensed faces became a fashion in the nineteenth century, partially displacing italics and small caps. Bold weights and titling figures have been added retroactively to many earlier faces (Bembo and Centaur for example), though they lack any historical justification. Older text faces, converted from metal to digital form, are usually available in two fundamentally different versions. The better digital foundries supply authentic reconstruc-

Aa

BbB

CcC

Dd

EeEe

Ff

	Primary:	roman lower case	1.1
	Secondary:	Roman Upper Case	2.1
		ROMAN SMALL CAPS	2.2
		roman text figures: 123	2.3
		italic lower case	2.4
Tribal	Tertiary:	*True Italic (Cursive) Upper Case & Swash*	3.1
Alliances		*italic text figures: 123*	3.2
and		*SLOPED SMALL CAPS*	3.3
Families		Roman Titling Figures: 123	3.4
		bold lower case	3.5
	Quaternary:	*False Italic (Sloped) Upper Case*	4.1
		Bold Upper Case	4.2
		BOLD SMALL CAPS	4.3
		bold text figures: 123	4.4
		bold italic lower case	4.5
	Quintary:	*Italic Titling Figures: 123*	5.1
		Bold False Italic (Sloped) Upper Case	5.2
		bold italic text figures: 123	5.3
		Bold Titling Figures: 123	5.4
	Sextary:	***Bold Italic Titling Figures: 123***	6.1

tions; others supply the fonts without small caps, text figures and other essential components, and usually burden them instead with an inauthentic bold.

Among recent text faces, two basic family structures are now common. The simplified model consists only of roman, italic and titling figures, in a range of weights – light, medium, bold and black, for example. The more elaborate family structure includes small caps and text figures, though these are sometimes present only in the lighter weights.

A family with all these elements forms a hierarchical series, based not on historical seniority but on general adaptability and frequency of use. And the series works the way it does not so much from force of custom as from the force of physiology. The monumentality of the capitals, the loudness of the bold face, the calligraphic flow and (most of the time) slope of the italic, stand out effectively against a peaceful, largely perpendicular, roman ground. Reverse the order and the text not only looks peculiar, it causes the reader physical strain.

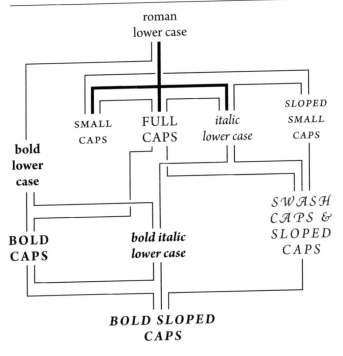

The chart at left is a grammatical road map of a conventional large family of type. (The heavy rules show the extent of the basic nuclear family.) The typographer can move directly along any of the lines – e.g., from roman lower case to bold lower case or to small or full caps. A sudden shift from roman lower case to bold caps or sloped caps short-circuits the conventions of typographic grammar.

Fonts in such a family are called into use through an unwritten grammar of editorial and typographic rules, and each font is reached by natural, non-arbitrary routes from certain other fonts. The typographer can intervene in this process at will, and alter it to any degree. But good type is good because it has natural strength and beauty. The best results come, as a rule, from finding the best type for the work and then guiding it with the gentlest possible hand.

The standard North American reference on the editorial tradition is the *Chicago Manual of Style,* now in its 16th edition (2010).

3.4.2 *Don't use a font you don't need.*

The marriage of type and text requires courtesy to the in-laws, but it does not mean that all of them ought to move in, nor even that all must come to visit.

Boldface roman type did not exist until the nineteenth century. Bold italic is even more recent. Generations of good typographers were quite content without such variations. Font manufacturers nevertheless now often sell these extra weights as part of a basic

package, thereby encouraging typographers – beginners especially – to use bold roman and italic whether they need them or not.

Bold and semibold faces do have their value. They can be used, for instance, to flag items in a list, to set titles and subheads u&lc in small sizes, to mark the opening of the text on a complex page, or to thicken the texture of lines that will be printed in pale ink or as dropouts (negative images) in a colored field. Sparingly used, they can effectively emphasize numbers or words, such as the headwords, keywords and definition numbers in a dictionary. They can also be used (as they often are) to shout at readers, putting them on edge and driving them away; or to destroy the historical integrity of a typeface designed before boldface roman was born; or to create unintentional anachronisms, something like adding a steam engine or a fax machine to the stage set for *King Lear*.

3.4.3 *Use sloped romans sparingly and artificially sloped romans more sparingly still.*

It is true that most romans are upright and most italics slope to the right – but flow, not slope, is what really differentiates the two. Italics have a more cursive structure than romans, which is to say that italic is closer to longhand or continuous script. Italic serifs are usually *transitive*; they are direct entry and exit strokes, depicting the pen's arrival from the previous letter and its departure for the next. Roman serifs, by contrast, are generally *reflexive*. They show the pen doubling back onto itself, emphasizing the end of the stroke. Italic serifs therefore tend to slope at a natural writing angle, tracing the path from one letter to another. Roman serifs, especially at the baseline, tend to be level, tying the letters not to each other but to an invisible common staff.

Some italics are more cursive than others; so are some romans. But any genuine italic is routinely more cursive than the roman with which it is paired.

e *e* l *l* m *m* u *u*

Baskerville roman and italic. Baskerville has less calligraphic flow than most earlier typefaces, but the italic serifs are, like their predecessors, *transitive and oblique,* showing the path of the pen from letter to letter. The roman serifs are *reflexive and level,* tying letters to a common line.

Early italic fonts had only modest slope and were designed to be used with upright roman capitals – usually smaller than the caps in the equivalent size of roman. There are some beautiful fifteenth-century manuscript italics with no slope whatsoever, and some excellent typographic versions, old and new, that slope as little as 2° or 3°. Yet others slope as much as 25°.

Italic and roman lived quite separate lives until the middle of the sixteenth century. Before that date, books were set in either roman *or* italic, but not in both. In the late Renaissance, typographers began to use the two for different features in the same book. Typically, roman was used for the main text and italic for the preface, headnotes, sidenotes and for verse or block quotations. The custom of combining italic and roman *in the same line,* using italic to emphasize individual words and mark specific classes of information, developed in the sixteenth century and flowered in the seventeenth. Baroque typographers liked the extra activity this mixing of fonts gave to the page, and the convention proved so useful to editors and authors that no subsequent change of typographic taste has ever driven it entirely away. Modulation between roman and italic is now a basic and routine typographic technique, much the same as modulation in music between major and minor keys. (The system of linked major and minor keys in music is, of course, another Baroque invention.)

Since the seventeenth century, many attempts have been made to curb the cursive, fluid nature of italic and to refashion it on the roman model. Many so-called italics designed in the last two hundred years are actually not italics at all, but sloped romans – otherwise known as *obliques.* And many are hybrids, with some italic and some sloped roman features.

As lowercase italic letterforms mutated toward sloped roman, their proportions changed as well. Most italics (though not all) are 5% to 10% narrower than their roman counterparts. But most sloped romans (unless designed by Eric Gill) are as wide as or wider than their upright roman companions.

Renaissance italics were designed for continuous reading, and modern italics based on similar principles tend to have similar virtues. Baroque and Neoclassical italics were designed to serve as secondary faces only, and are best left in that role. Sloped romans, as a general rule, are even more devotedly subsidiary faces. They have been with us for ten centuries or more, but have rarely succeeded in rising above the status of calligraphic stunts or short-term perturbations of the upright roman.

Harmony and Counterpoint

In addition to families consisting of upright and sloped roman, there are now several families consisting of upright (or nearly upright) and sloped *italic.* In Hermann Zapf's Zapf Chancery (ITC, 1979), the 'roman' is an italic with a slope of 4°. The 'italic' is also an italic, but with swash caps and a slope of 14°. In Eaglefeather Informal (see page 279), the 'roman' is an italic with no slope and the 'italic' is fundamentally the same design with a slope of 10°.

1 adefmpru *adefmpru* [18 pt]

2 **adefmpru** *adefmpru* [16 pt]

3 adefmpru *adefmpru* [24 pt]

4 **adefmpru** *adefmpru* [18 pt]

5 adefmpru *adefmpru* [21 pt]

1 Adrian Frutiger's Méridien roman and italic; **2** Lucida Sans roman and italic, by Kris Holmes & Charles Bigelow; **3** Perpetua roman and its italic – actually a hybridized sloped roman – by Eric Gill; **4** Univers roman and its *oblique* (a pure sloped roman), by Adrian Frutiger; **5** Romulus roman and *oblique* (another pure sloped roman), by Jan van Krimpen.

Typesetting software is capable of distorting letters in many different ways: condensing, expanding, outlining, shadowing, sloping, and so on. If the only difference between a roman and its companion font were slope, the roman font alone would be enough for the computer. Sloped versions could be generated at will. But italic is not sloped roman, and even a good sloped roman is more than simply roman with a slope.

Direct electronic sloping of letterforms changes the weight of vertical and sloped strokes, while the weight of the horizontal strokes remains the same. Strokes that run northwest-southeast in the parent form – like the right leg of the A or the upper right and lower left corners of the O – are rotated toward the vertical when the letter is given a slope. Rotation toward the vertical causes these strokes to thicken. But strokes running northeast-southwest, like the left leg of the A, and the other corners of the O, are rotated farther away from the vertical. Rotation away from the vertical thins them down. Stroke curvature is altered in this translation process as well. The natural inclinations of a calligrapher drawing a sloped roman differ from what is convenient for the machine. Even 'italic' capitals – which nowadays are rarely anything except sloped roman – require individual shaping and editing to reach a durable form.

Through the collaborative efforts of calligraphers, typographers and engineers, software for the design and editing of typographic letterforms continues to improve. As it does, it continues

to mimic more and more closely those subtle and primitive tools that lie at the root of all typography: the stick, the brush, the chisel and the broadnib pen. Rules for transforming roman into good sloped roman forms, instead of into parodies, can surely be derived through close analysis of what the best scribes do. When parts of the procedure can be stated with mechanical precision, they can also be entrusted to machines. But rules for translating roman into *italic* cannot be stated clearly because no such rules exist. The two kinds of letterform have different genealogies, like apples and bananas. They form a common heritage and share an evolutionary source, yet neither one is a direct modification of the other.

A A A O O O

Adobe Caslon roman caps, the same forms sloped electronically, and the true sloped capitals as drawn. Caslon italics have an average slope of 20°.

a a a o o o

Palatino roman, the same roman sloped electronically, and the genuine italic, whose average slope is 9°.

A E M R S T Y

True italic capitals: the swash forms from Robert Slimbach's Minion italic. It is the structure, not the slope, of the letters that marks them as italic.

Once in a while, nevertheless, a typographer will pine for a sloped version of a font such as Haas Clarendon or André Gürtler's Egyptian 505, for which no true italic, nor even a good sloped roman, has been drawn. On such occasions, a sloped roman generated by computer may suffice as a temporary solution. Such occasions should be rare and should involve a few words only, not major blocks of text – and the slope should be modest (perhaps 10° maximum), because less slope yields less distortion.

bbb

Above: display, text and caption cuts of Robert Slimbach's Garamond Premier, all at 36 pt. They are 'the same' face and size but radically different in weight and proportion. *Below*: the same cuts at appropriate relative sizes (30 pt display, 14 pt text, and 8 pt caption).

befig

abefigbop

abefigbopqrsty

3.5 CONTRAST

3.5.1 *Change one parameter at a time.*

When your text is set in a 12 pt medium roman, it should not be necessary to set the heads or titles in 24 pt bold italic capitals. If boldface appeals to you, begin by trying the bold weight of the text face, u&lc, *in the text size*. As alternatives, try u&lc italic, or letterspaced small caps, or letterspaced full caps in the text weight and size. If you want a larger size, experiment first with a larger size of the text face, u&lc in the text weight – or better yet, a lighter cut of the text face. For a balanced page, the weight should *decrease* slightly, not increase, as the size increases.

3.5.2 *Don't clutter the foreground.*

When boldface is used to emphasize words, it is usually best to leave the punctuation in the background, which is to say, in the basic text font. It is the words, not the punctuation, that merit emphasis in a sequence such as the following:

> … on the islands of **Lombok**, **Bali**, **Flores**, **Timor** and **Sulawesi**, the same textiles …

But if the same names are emphasized by setting them in italic rather than bold, there is no advantage in leaving the punctuation in roman. With italic text, italic punctuation normally gives better letterfit and thus looks less obtrusive:

> … on the islands of *Lombok, Bali, Flores, Timor* and *Sulawesi,* the same textiles …

If spaced small caps are used for emphasis – changing the stature and form of the letters instead of their weight or slope, and thereby minimizing the surface disturbance on the page – the question of punctuation does not arise. The punctuation used with small caps is (except for question and exclamation marks) usually the same as roman punctuation; it is only necessary to check it for accurate spacing:

> … on the islands of LOMBOK, BALI, FLORES, TIMOR and SULAWESI, the same textiles …

60

STRUCTURAL FORMS & DEVICES

4.1.1 *Make the title page a symbol of the dignity and presence of the text.*

4

If the text has immense reserve and dignity, the title page should have these properties as well – and if the text is devoid of dignity, the title page should in honesty be the same.

Think of the blank page as alpine meadow, or as the purity of undifferentiated being. The typographer enters this space and must change it. The reader will enter it later, to see what the typographer has done. The underlying truth of the blank page must be infringed, but it must never altogether disappear – and whatever displaces it might well aim to be as lively and peaceful as that original blank page. It is not enough, when building a title page, merely to unload some big, prefabricated letters into the center of the space, nor to dig a few holes in the silence with typographic heavy machinery and then move on. Big type, even huge type, can be beautiful and useful. But poise is usually far more important than size – and poise consists primarily of emptiness. Typographically, poise is made of white space. Many fine title pages consist of a modest line or two near the top, and a line or two near the bottom, with little or nothing more than taut, balanced white space in between.

4.1.2 *Don't permit the titles to oppress the text.*

In books, spaced capitals of the text size and weight are often perfectly adequate for titles. At the other extreme, there is a fine magazine design by Bradbury Thompson, in which the title, the single word BOOM, is set in gigantic bold condensed caps that fill the entire two-page spread. There is a text, set in a tall narrow column *inside the stem* of the big B. The title has swallowed the text, and yet the text has been reborn, alive and talkative, like Jonah from the whale.

For examples of Thompson's work, see Bradbury Thompson, *The Art of Graphic Design* (1988).

Most unsuccessful attempts at titling fall between these two extremes, and their problem is often that the title throws its weight around, unbalancing and discoloring the page. If the title is set in

a larger size than the text, it is often best to set it u&lc in a light titling font or a lightened version of the text font. Inline capitals (like the Castellar initials on pages 64 and 160) are another device that typographers have used since the fifteenth century to get large size without excessive weight.

Openings There are other ways of creating large letters of light weight, but some of these are printerly instead of typographic. First of all, if the budget permits, the typographer can design the work to be printed in two or even in twenty different colors. An inexpensive alternative is the same one your monochrome desktop printer uses to render that colorful file: screening the type: breaking up the solid image with an electronic filter. (Note however that screened text on screen always looks different than screened text on paper.)

10 20 30 40 50
60 70 80 90 100

Screened text. The numbers indicate the percentage of ink coverage permitted by the screen.

4.1.3 *Set titles and openings in a form that contributes to the overall design.*

Renaissance books, with their long titles and ample margins, generally left no extra space at the heads of chapters. In modern books, where the titles are shorter and the margins have been eaten by inflationary pressure, a third of a page sometimes lies vacant just to celebrate the fact that the chapter begins. But space alone is not enough to achieve the sense of richness and celebration, nor is absence of space necessarily a sign of typographic poverty.

Narrow row houses flush with the street are found not only in urban slums but in the loveliest of the old Italian hill towns and Mediterranean villages. A page full of letters presents the same possibilities. It can lapse into a typographic slum, or grow into a model of architectural grace, skilled engineering and simple economy. Broad suburban lawns and wide typographical front yards can also be uninspiringly empty or welcoming and graceful. They can display real treasure, including the treasure of empty

space, or they can be filled with souvenirs of wishful thinking. Neoclassical birdbaths and effigies of liveried slaves, stable boys and faded pink flamingoes all have counterparts in the typographic world.

4.1.4 *Mark each beginning and resumption of the text.*

The simplest way of beginning any block of prose is to start from the margin, flush left, as this paragraph does. On a peaceful page, where the text is announced by a head or subhead, this is enough. But if the text, or a new section of text, begins at the top of a page with no heading to mark it, a little fanfare will probably be required. The same is true if the opening page is busy. If there is a chapter title, an epigraph, a sidenote, and a photograph and caption, the opening of the text will need a banner, a ten-gallon hat or a bright red dress to draw the eye.

Fleurons (typographic ornaments) are often used to flag text openings, and are often printed in red, the typographer's habitual second color. The opening phrase, or entire first line, can also be set in small caps or in bold u&lc. Another excellent method of marking the start of the text, inherited from ancient scribal practice, is a large initial capital: a versal or lettrine. Versals can be treated in many ways. Indented or centered, they can stick up from the text. Flush left, they can be nested into the text (typographers call these drop caps, as opposed to elevated or stick-up caps). If there is room, they can hang in the left margin. They can be set in the same face as the text or in something outlandishly different. In scribal and typographic tradition alike, where the budget permits, versals too are generally red or another color in preference to black.

Elevated caps are easier to set well from a keyboard, but drop caps have closer links with the scribal and letterpress tradition. And the tooling and fitting of drop caps is something typographers do for fun, to test their skill and visual intuition. It is common practice to set the first word or phrase after the versal in caps, small caps or boldface, as a bridge between versal and normal text. Examples are shown on the following page.

In English, if the initial letter is A, I or O, a question can arise: is the initial letter itself a word? The answer to this question must come in the spacing of the text in relation to the versal. If the first word of the text is *Ahead,* for example, excessive space between the initial A and the rest of the word is bound to cause confusion.

OSCULETUR
me osculo oris sui; quia
meliora sunt ubera tua
vino, ¶ fragrantia unguentis
optimis. Oleum effusum
nomen tuum; ideo adoles-
centulae dilexerunt te.

TRAHE ME, post te
curremus in odorem
unguentorum tuorum.
Introduxit me rex in
cellaria sua; exsultabimus et
laetabimur in te, memores
uberum tuorum super
vinum. Recti diligunt te.

« NIGRA SUM, sed
formosa, filiae
Ierusalem, sicut
tabernacula Cedar, sicut
pelles Salomonis. ¶ Nolite
me considerare quod fusca
sim, quia decoloravit me sol.
Filii matris meae pugnave-
runt contra me....»

" ADIURO VOS, filiae
Ierusalem, per
capreas cervosque
camporum, ne suscitetis,
neque evigilare faciatis

dilectam, quoadusque
ipsa velit."

VOX DILECTI MEI;
ecce iste venit, saliens
in montibus, transiliens
colles. ¶ Similis est dilectus
meus capreae, hinnuloque
cervorum. En ipse stat post
parietem nostrum, respi-
ciens per fenestras, pro-
spiciens per cancellos. ¶ En
dilectus meus loquitur mihi.

SURGE, propera, amica
mea, columba mea,
formosa mea, et veni.
¶ Iam enim hiems transiit;
imber abiit, et recessit.
¶ Flores apparuerunt in
terra nostra....

LAVI PEDES MEOS,
quomodo inquinabo
illos? ¶ Dilectus meus
misit manum suam per
foramen, et venter meus
intremuit ad tactum eius.
¶ Surrexit ut aperirem
dilecto meo; manus meae
stillaverunt myrrham, et
digiti mei pleni myrrha
probatissima. ¶ Pessulum
ostii mei....

Passages from the Song of Songs, set in Aldus 10/12 × 10 RR. Elevated cap: Castellar 54 pt. Drop caps: Aldus 42 pt, mortised line by line.

4.1.5 *If the text begins with a quotation, include the initial quotation mark.*

Quotation marks have a long scribal history as editorial signs added after the fact to other people's texts, but they did not come into routine typographic use until late in the sixteenth century. Then, because they interfered with established habits for position-ing large initials, they were commonly omitted from the open-

ings of texts. Some style books still prescribe this concession to convenience as a fixed procedural rule. But digital typography makes it simple to control the size and placement of the opening quotation mark, whether or not the text begins with a versal. For the reader's sake, it should be there.

4.2 HEADINGS & SUBHEADS

4.2.1 *Set headings in a form that contributes to the style of the whole.*

Headings can take many forms, but one of the first choices to make is whether they will be symmetrical or asymmetrical. Symmetrical heads, which are centered on the measure, are known to typographers as *crossheads.* Asymmetrical heads usually take the form of *left sideheads,* which is to say they are set flush left, or modestly indented or outdented from the left. *Right sideheads* work well in certain contexts, but more often as main heads than as subheads. A short, one-line head set flush right needs substantial size or weight to prevent the reader from missing it altogether.

These principles are reversed, of course, when setting leftward-reading scripts such as Arabic and Hebrew.

One way to make heads prominent without making them large is to set them entirely in the margin, like the running heads (in typographic terms, they are *running shoulderheads*) used throughout this book.

4.2.2 *Use as many levels of headings as you need: no more and no fewer.*

As a rule it is best to choose a predominantly symmetrical or asymmetrical form for subheads. Mixing the two haphazardly leads to stylistic as well as logical confusion. But the number of levels available can be slightly increased, if necessary, by judicious combinations. If symmetrical heads are added to a basically asymmetrical series, or vice versa, it is usually better to put the visiting foreigners at the top or bottom of the hierarchical pile. Two six-level series of subheads are shown, by way of example, on the following pages.

In marking copy for typesetting, the various levels of subheads are generally given letters rather than names: A-heads, B-heads, C-heads, and so on. Using this terminology, the heads on the following two pages run from A through F.

⁓ Main Section Title ⁓

Headings and Subheads

I F A MAN walk in the woods for love of them half of each day, he is in danger of being regarded as a loafer; but if he spends his whole day as a speculator, shearing off those woods and making earth bald before her time, he is esteemed an industrious and enterprising citizen.

MAIN CROSSHEAD

▦ The ways by which you may get money almost without exception lead downward. To have done anything by which you earned money *merely* is to have been truly idle or worse.... If you would get money as a writer or lecturer, you must be popular, which is to go down perpendicularly....

Heavy Crosshead

▦ In proportion as our inward life fails, we go more constantly and desperately to the post office. You may depend on it, that the poor fellow who walks away with the greatest number of letters … has not heard from himself this long while.

MEDIUM CROSSHEAD

▦ I do not know but it is too much to read one newspaper a week. I have tried it recently, and for so long it seems to me that I have not dwelt in my native region. The sun, the clouds, the snow, the trees say not so much to me....

Light Crosshead

▦ You cannot serve two masters. It requires more than a day's devotion to know and to possess the wealth of a day.... Really to see the sun rise or go down every day, so to relate ourselves to a universal fact, would preserve us sane forever.

hypethral is from Greek ἐν ὑπαίθρῳ, 'in the open air'

RUN-IN SIDEHEAD Shall the mind be a public arena...? Or shall it be a quarter of heaven itself, an hypethral temple, consecrated to the service of the gods?

Main Section Title

❀ IF I AM TO BE a thoroughfare, I prefer that it be of the mountain brooks, the Parnassian streams, and not the town sewers.... I believe that the mind can be permanently profaned by attending to trivial things, so that all our thoughts shall be tinged with triviality.

MAIN CROSSHEAD

Our very intellect shall be macadamized, as it were: its foundation broken into fragments for the wheels of travel to roll over; and if you would know what will make the most durable pavement, surpassing rolled stones, spruce blocks, and asphaltum, you have only to look into some of our minds....

❦ ORNAMENTED CROSSHEAD ❦

Read not the Times. Read the Eternities.... Even the facts of science may dust the mind by their dryness, unless they are in a sense effaced each morning, or rather rendered fertile by the dews of fresh and living truth.

INDENTED SIDEHEAD

Knowledge does not come to us by details, but in flashes of light from heaven. Yes, every thought that passes through the mind helps to wear and tear it, and to deepen the ruts, which, as in the streets of Pompeii, evince how much it has been used.

Secondary Indented Sidehead

When we want culture more than potatoes, and illumination more than sugar-plums, then the great resources of a world are taxed and drawn out, and the result, or staple production, is not slaves, nor operatives, but ... saints, poets, philosophers....

Run-in Sidehead In short, as a snowdrift is formed where there is a lull in the wind, so, one would say, where there is a lull of truth, an *institution* springs up....

Structural Forms and Devices

The texts on this and the facing page are excerpts from HENRY DAVID THOREAU'S "Life Without Principle," written about 1854 but not published until 1863.

The type on the facing page is Adobe Caslon. On this page, it is recut Monotype Centaur and Arrighi. On each page, five levels of headings are obtained using only two sizes of type.

4.3.1 *If the text includes notes, choose the optimum form.*

Notes If notes are used for subordinate details, it is right that they be set in a smaller size than the main text. But the academic habit of relegating notes to the foot of the page or the end of the book is a mirror of Victorian social and domestic practice, in which the kitchen was kept out of sight and the servants were kept below stairs. If the notes are permitted to move around in the margins – as they were in Renaissance books – they can be present where needed and at the same time enrich the life of the page.

Footnotes are the very emblem of fussiness, but they have their uses. If they are short and infrequent, they can be made economical of space, easy to find when wanted and, when not wanted, easy to ignore. Long footnotes are inevitably a distraction: tedious to read and wearying to look at. Footnotes that extend to a second page (as some long footnotes are bound to do) are an abject failure of design.

Endnotes can be just as economical of space, less trouble to design and less expensive to set, and they can comfortably run to any length. They also leave the text page clean except for a peppering of superscripts. They do, however, require the serious reader to use two bookmarks and to read with both hands as well as both eyes, swapping back and forth between the popular and the persnickety parts of the text.

Sidenotes give more life and variety to the page and are the easiest of all to find and read. If carefully designed, they need not enlarge either the page or the cost of printing it.

Footnotes rarely need to be larger than 8 or 9 pt. Endnotes are typically set in small text sizes: 9 or 10 pt. Sidenotes can be set in anything up to the same size as the main text, depending on their frequency and importance, and on the overall format of the page.

4.3.2 *Check the weight and spacing of superscripts.*

If they are not too frequent, sidenotes can be set with no super-scripts at all (as in this book), or with the same symbol (normally an asterisk) constantly reused, even when several notes appear on a single page. For endnotes, superscript numbers are standard. For footnotes, symbols can be used if the notes are few. (The traditional order is * † ‡ § ‖ ¶. But beyond the asterisk, dagger

and double dagger, this order is not familiar to most readers – and never was.) Numbers are more transparent, and their order is much less easy to confuse.

Many fonts include sets of superscript numbers, but these are not always of satisfactory size and design. Text numerals set at a reduced size and elevated baseline are sometimes the best or only choice. Establishing the best size, weight and spacing for superscripts will, however, require some care. In many faces, smaller numbers in semibold look better than larger numbers of regular weight. And the smaller the superscripts are, the more likely they are to need increased character space.

Superscripts frequently come at the ends of phrases or sentences. If they are high above the line, they can be kerned over a comma or period, but this may endanger readability, especially if the text is set in a modest size.

4.3.3 *Use superscripts in the text but full-size numbers in the notes themselves.*

In the main text, superscript numbers are used to indicate notes because superscript numbers minimize interruption. They are typographic asides: small because that is an expression of their relative importance, and raised for two reasons: to keep them out of the flow of the main text, and to make them easier to find. In the note itself, the number is not an aside but a target. The number in the note should therefore be full size.[1]

To make them easy to find, the numbers of footnotes or endnotes can be hung to the left (like the marginal numbers on the following two pages and the footnote number below). Punctuation, apart from empty space, is not normally needed between the number and text of the note.

$$ab^1$$
$$cd^2$$

1 Ba
2 Dc

4.3.4 *Avoid ambiguity in the numbering and placement of endnotes.*

Readers should never be forced to hunt for the endnotes. As a rule, this means the endnotes should not appear in small clumps at the end of each chapter. It is better to place them together at

This footnote is flagged by a superscript in the text, but the note itself is flagged by an outdented figure, set in the same size as the text of the note. The main text here is 10/12 × 21; this note is 8/11 *and a different cut* (a so-called caption font).

the end of the book. Wherever possible, they should also be numbered sequentially from the beginning to end of the book, and the notes themselves should be designed so the numbers are readily visible. If the notes are numbered anew for each section or chapter or essay, running heads will be needed along with the notes to point the way. If the running heads accompanying the notes say, for instance, "Notes to Pages 44–62," readers will know their way. But if the running heads say something like "Notes to Chapter 5," then chapter 5 must also be identified as such by running heads of its own.

Notes

4.4 TABLES & LISTS

4.4.1 *Edit tables with the same attention given to text, and set them as text to be read.*

Tables are notoriously time-consuming to typeset, but the problems posed are often editorial as much as typographic. If the table is not planned in a readable form to begin with, the typographer can render it readable only by rewriting and redesigning it from scratch.

Tables, like text, go awry when approached on a purely technical basis. Good typographic answers are not elicited by asking questions such as "How can I cram this number of characters into that amount of space?"

If the table is approached as merely one more form of text, which must be made both good to read and good to look at, several principles will be clear:

For graphic alternatives to typographic tables, see Edward R. Tufte, *The Visual Display of Quantitative Information* (2nd ed., 2001) and *Envisioning Information* (1990).

1 All text should be horizontal, or in rare cases oblique. Setting column heads vertically as a space-saving measure is quite feasible if the text is in Japanese or Chinese, but not if it is written in the Latin alphabet.

2 Letterforms too small or too condensed for comfortable reading are not part of the solution.

3 There should be a minimum amount of furniture (rules, boxes, dots and other guide rails for traveling through typographic space) and a maximum amount of information.

4 Rules, tint blocks or other guides and dividers, where they are necessary at all, should run in the predominant reading direction: vertically in the case of lists, indices and some numerical tables, and horizontally otherwise.

A rule located at the edge of a table, separating the first or final column from the adjacent empty space, ordinarily serves no function.

A table, like any other text in multiple columns, must contain within itself an adequate amount of white space.

4.4.2 *Avoid overpunctuating lists.*

A list is an inherently spatial and numerical arrangement. Speakers reciting lists often enumerate on their fingers, and lists set in type often call for equivalent typographic gestures. This means that the list should be clarified as much as possible through spatial positioning and pointing, usually done with bullets, dashes or numerals. (Examples occur on these two pages and throughout this book.) If the numbers are made visible either through position (e.g., by hanging them in the margin) or through prominence (e.g., by setting them in a contrasting face), additional punctuation – extra periods, parentheses or the like – should rarely be required.

Dot leaders (lines of dots leading the eye from one word or number to another) are rarely beneficial in tables.

4.4.3 *Set lists and columns of figures to align flush right or on the decimal.*

The numerals in many fonts are all of equal width, though there is sometimes an alternative, narrower form of the numeral one. This fitted one is generally used when setting figures in the midst of text, while the unfitted one (of standard numeral width) is often used when setting figures in columns. The font itself or the composition software will also include a figure space – a fixed blank space corresponding to the width of a standard, unkerned numeral. This makes it a simple matter to compose lists and columns of figures in rigorous mechanical alignment.

If you use proportionally fitted numerals (always the best choice for text), or kern the numeral permutations in a font with tabular figures, the individual figures will not align in columns or lists, but *columns* of figures can still be aligned. For much tabular matter (e.g., the first table overleaf) this is sufficient. If notes are required in a table with flush-right columns, the superscripts should be hung to the right (as in column 3, line 2 of the first example overleaf) so they will not disrupt the alignment.

100
111
100
111

8	98	998	9.75
9	99	999*	10
10	100	1000	10.25
11	101	1001	10.5

Above: aligning columns of nonaligning figures, with a hanging asterisk.
Below: columns in mixed alignment.

Aster	2 : 3	24 × 36	0.667	$a = 2b$
Valerian	271 : 20	813 × 60	13.550	$6a = c$

4.4.4 *For text and numerals alike, choose harmonious and legible tabular alignments.*

Simple tables and lists of paired items, like the sample tables of contents on page 36, are often best aligned against each other, the left column flush right and the right column flush left. Financial statements and other numerical tables usually follow the opposite pattern: a column of words, on the left, aligns flush left, while the subsequent columns of numbers all align flush right or on the decimal. Any repeating character – a dimension sign or equal sign, for instance – is potentially of use in tabular alignment. But many columns with many different alignments can generate overall visual chaos. Occasionally it is better, in such cases, to set all columns or most columns either flush right or flush left, for the sake of general clarity.

4.5 STARTING *&* STOPPING

4.5.1 *Leave adequate space at the beginning and end of every publication.*

A brief research paper may look its best with no more space at beginning and end than is provided by the standard page margins. The same is rarely true of a book, whose text should generally be, and should seem to be, a living and breathing entity, not aged and shrink-wrapped meat. A chapbook or saddle-stitched booklet can begin directly with the title page. Otherwise, a half-title is customary, preceding the title page. It is equally customary to leave a blank leaf, or at least a blank page, at the end of a book. These blanks provide a place for inscriptions and notes and allow the text to relax in its binding.

4.5.2 *Give adequate space to the prelims.*

Each textual element that belongs in a book should be given the
space that it needs. If the main text is preceded by a tedious parade
of forewords, prefaces, introductions and prologues, it is unlikely
to be read. But a dedication, epigraph or acknowledgment that is
stuffed, like a typographic afterthought, onto the copyright page
is no dedication or acknowledgement or epigraph at all. And a
list of contents that is incomplete (or missing altogether), and
does not have the page to itself, is usually a sign of typographic
desperation – and of disrespect for the reader.

4.5.3 *Balance the front and back matter.*

Books are normally built up from gatherings or signatures –
printed and folded sheets – with each signature forming a unit of
8, 12, 16, 24 or 32 pages. The 16-page signature is by far the most
common. Typographers therefore work to make most of their
books seem divinely ordained and conceived to be some multiple
of 16 pages in length. Seasoned book typographers recite in their
meditations not only the mantra of points and picas – 12, 24, 36,
48, 60, 72 … – but also the mantra of octavo signatures: 16, 32, 48,
64, 80, 96, 112, 128, 144, 160, 176, 192, 208, 224, 240, 256, 272, 288,
304, 320, 336, 352, 368, 384, 400…. These are the actual lengths
of the books that we read.

In a work of continuous prose, the illusion of divine love for
the number sixteen is obtained by straightforward copyfitting.
If the length of the text is accurately measured, the page can be
designed to yield a book of appropriate length. More compli-
cated books are often surrounded by paraphernalia – not only
the standard half-title, title page, copyright page, dedication page
and some blanks, but also perhaps a detailed table of contents,
a list of charts, illustrations and maps, a table of abbreviations,
a page or two of acknowledgements, and a preface, counterbal-
anced by appendices, endnotes, bibliography, index and a colo-
phon. Copyfitting the main text for a volume of this kind may
be highly complex, and room may be taken up or conserved in
the large aura of front and back matter. But for complex books
and simple books alike, it is up to the typographer to balance the
front matter, back matter and text. A wad of blank leaves at the
end of a book is a sign of carelessness, not of kindliness toward
readers who like to take notes.

4.5.3 *Leave no recto blank between the start of the book and the end.*

Most printed books are bound in codex form. They consist of a pile of leaves bound at one edge. Each leaf has two sides, recto and verso. Recto does not mean "right" in the sense of right or left; it means *put forward* (as in *rex,* Latin for *king*). Verso means *turned,* as in *reversed.* In right-reading scripts (such as Latin, in which we write English), the forward or recto page is the right-hand half of the two-page spread: the page that invites you to read it and turn it. The facing page is the verso: the door you have come through, the page you have already turned. You can indeed go backward – one of the wonderful things about books is the freedom they offer, to pause where you please, to reread or rewrite, to skip forward or back – but the natural flow is from what you have read to what you have not. In leftward-reading scripts such as Arabic and Hebrew, this implicit invitation runs the other way: the forward page, the recto, is on the left.

To a bibliographer, the recto page, whether left or right, is the front and the verso the back of the leaf. To a typographer, as to a reader, the recto is a place to start. So typographers like to start chapters on recto pages and to place disjunct and secondary matter – low-voltage illustrations, charts, tables and the like – on verso pages. Other things being equal, a title or illustration that is placed on the recto page will have more prominence than it would if placed on the verso – but with illustrations, other things are seldom entirely equal. Few illustrations are perfectly symmetrical. Given a chance, they will choose their own side of the spread. If placed on the contrary side, the illustrations will look unhappy, and the reader will close the book.

A blank leaf or two at the beginning and end of a book is a symbol of luxury or perhaps a kind of bragging, like a big front lawn. But once the book gets underway, blanks can be a hazard. If space allows, the verso facing a part-title or chapter opening or an important illustration may of course be blank: a moment of rest before a new beginning. A blank *recto,* on the other hand, is a signal to the reader that the journey has come to an end. It is a silent invitation to stop reading and close the book.

(E-books, you will notice, consist of rectos only and follow the same rule: a blank page signals the end of the trip.)

ANALPHABETIC SYMBOLS

5.1 ANALPHABETIC STYLE

5

It falls to the typographer to deal with an increasing herd of flicks, squiggles, dashes, dots and ideographs that travel with the alphabet yet never quite belong. The most essential of these marks – period, comma, parentheses, and the like – are signs of logical pause and intonation, much like the rests and slurs in a musical score. Some, like the dollar and per cent signs, are stylized abbreviations. Others, like the asterisk and the dagger, are silent typographical cross-references. And a few that are normally unspoken have tried to sneak their way into the oral tradition. Speakers who say *quote unquote* or *who slash what* or *That's it, period!* are, of course, proving their debt to these enduring para-literary signs.

Approached through the scribal and typographic tradition, the palette of analphabetic symbols is much more supple and expressive than it appears through the narrow grill of the keyboard. A typographer will not necessarily use more analphabetic symbols per page than a typist. In fact, many good typographers use fewer. But even the most laconic typographer learns to speak this sign language with an eloquence that conventional editing software and the bland computer keyboard – like the typewriter it is modeled on – seems to preclude.

5.1.1 *To invoke the inscriptional tradition, use the midpoint.*

The earliest alphabetic inscriptions have no analphabetic furniture at all, not even spaces between the words. As writing spread through Greece and Italy, spaces appeared between the words, and a further sign was added: the centered dot, for marking phrases or abbreviations. That dot, the *midpoint* or small bullet, remains one of the simplest, most effective forms of typographic punctuation – useful today in lists and letterheads and signage just as it was on engraved marble twenty centuries ago.

Suite 6 · 325 Central Park South

Roman calligraphers lettered their inscriptions with a flat brush held in the right hand. Such a brush – thick in one direc-

tion, thin in the other, like a broadnib pen – produces a *modulated stroke*. That is to say, the weight of the stroke varies predictably with direction. The letter O is an example. Because the brush is held in the scribe's right hand, the strokes are thickest in the northwest/southeast direction, at the natural inclination of the forearm and the hand. Using the same brush, Roman calligraphers also developed the subtle choreography of twists and turns at the stroke-ends that produces the imperial Roman serif. Roman capital letters have retained these forms for two thousand years.

<div align="center">

O · I · M

</div>

<div style="float:left; width:30%;">

活字体
かつじ

In Asian and European scripts alike, modulated strokes are usually serifed and unmodulated strokes are usually not. The traditional scripts of China and Japan are based on the pointed brush instead of the broadpen. Still, a modulated stroke and transitive serifs are clearly present in the *kaisho* (楷書) typeface above, just as in a Renaissance italic. The same glyphs are shown below in an unserifed and unmodulated face. Sanserif is known in Japanese as *goshikku,* from English 'gothic.'

活字体
かつじ

</div>

When the centered dot or midpoint is made in the same way with the same tool, it becomes a small, curved wedge: a clockwise twist of the brush, with a short tail. Falling to the baseline, this tailed dot became our comma. The same inscriptional and calligraphic traditions have left us other useful marks, such as the double dot or colon (:), the virgule (/), the hyphen (-), and the long dash (– or —).

5.1.2 *Use analphabetic symbols and diacritics that are in tune with the basic font.*

A normal font of type now includes about two dozen mutant forms of the few ancient signs of punctuation (period, comma, colon, quotation marks, brackets, parentheses, dashes, and so on). It also includes about a dozen diacritics (acute and grave accents, the circumflex, tilde, ogonek, umlaut, and others), some legal and commercial logograms (@ # $ £ € % ‰ etc) and a few arithmetical symbols. In the ɪѕо Latin character sets (font tables defined by the International Organization for Standardization and now used as a standard by most digital foundries in Europe and North America), analphabetic symbols outnumber the basic Latin alphabet three to one.

On some fonts, these analphabetic characters are beautifully designed; on others they are not designed at all. Often they are simply borrowed from another font, which may have been drawn in a different weight and style.

Several analphabetic characters are notorious for poor design and should always be inspected when assessing a new font. These problem characters include square brackets [], which are often too dark; parentheses (), which are often too symmetrical and

skinny; the asterisk *, the pilcrow ¶ and the section sign §, which are often stiff and bland; and the octothorp or numeral sign #, which is frequently too large for anything more interesting than chain-store propaganda. Fonts equipped with good versions of these characters must often lend them to those without. But not just any good version will do.

a · * § & & ; ' ! ?
1 2 3 4 8 † £ · z

Neoclassical analphabetics, after John Baskerville (*above*) and the neo-humanist analphabetics of Hermann Zapf's Palatino (*below*). Analphabetics differ from one face to another, and from one historical period to another, just as much as the letterforms do – and they differ in essentially the same ways.

a · * § & & ; ' ! ?
1 2 3 4 8 † £ · z

Baskerville, which is an eighteenth-century Neoclassical type-face, requires a Neoclassical asterisk: one with an even number of lobes, each in symmetrical teardrop form. But a twentieth-century neohumanist face like Palatino requires an asterisk with more cal-ligraphic character – sharper, slightly asymmetrical lobes, more likely five than six in number, showing the trace of the broadnib pen. Well-made fonts are distinguished by similar differences in the question and exclamation marks, quotation marks and commas. Not even simple periods are freely interchangeable. Some are elliptical, diamond-shaped or square instead of round. Their weight and fitting varies as well. The *visible invisibility* of the marks of punctuation, which is essential to their function, depends on these details. So, therefore, does the visible invisibil-ity of the typeface as a whole. In the republic of typography, the lowliest, most incidental mark is also a citizen.

5.1.3 *In heads and titles, use the best available ampersand.*

The ampersand is a symbol evolved from the Latin *et*, meaning *and*. It is one of the oldest alphabetic abbreviations, and it has assumed over the centuries a wonderful variety of forms. Contemporary offerings are for the most part uninspired, stolid pretzels: unmusical imitations of the treble clef. Often the italic font is equipped with an ampersand less repressed than its roman counterpart. Since the ampersand is more often used in display work than in ordinary text, the more creative versions are often the more useful. There is rarely any reason not to borrow the italic ampersand for use with roman text.

Shakespeare & Co.
Brown & Son
Smith & Daughter

Trump Mediäval italic (*top*) was designed by Georg Trump, Pontifex roman (*bottom two lines*) by Friedrich Poppl. In both, the italic ampersand is more stylish than the roman.

5.1.4 *Consider even the lowly hyphen.*

It is worth taking a close look at hyphens, which were once more subtle and various than they tend to be today. The hyphen was originally a simple pen stroke, often the thinnest stroke the broad-nib pen could make, at an angle of 20° to 45° above horizontal. To distinguish the hyphen from the comma (which could also be written as a simple, canted stroke), the hyphen was often doubled, like an equal sign heading uphill.

Many Renaissance typographers preferred the canted hyphen with italic and the level hyphen with roman. Others mixed the two at random – one of several techniques once used to give a touch of scribal variety to the typeset page. But after the death of the master printer Robert Estienne in 1559 and of Claude Garamond in 1561, the level hyphen was the norm.

Most hyphens currently offered are short, blunt, thick, and perfectly level, like refugees from a font of Helvetica. This has sometimes been the choice of the designer, sometimes not. The double hyphen designed by Hermann Zapf in 1953 for his type face Aldus, as an example, was omitted when the face was com-

mercially issued in 1954. Foundry Centaur, designed by Bruce Rogers, had a hyphen inclined at 48°, but Monotype replaced it with a level bar when the face was adapted for machine composition in 1929. And the original Linotype issue of W.A. Dwiggins's Electra had a subtly tapered hyphen inclined at 7° from the horizontal; later copies of the face have substituted a bland, anonymous form.

If you are tempted to redesign an existing font, using a digital font editor, the hyphen is a good character to start on. It is a comparatively simple character, and you may be able to restore instead of subvert the designer's original intentions.

A few alternatives to the blunt and level hyphen are also still in circulation, and these are worth stealing on occasion for use with another face. The hyphen in Monotype Poliphilus is canted (as in the original design) at 42°. The hyphen in Monotype Blado (the companion italic to Poliphilus) is canted at 35° and tapered as well. The hyphens in most of Frederic Goudy's text faces are canted at angles ranging from 15° to 50°. Some digital versions preserve this feature; others are more homogenized. Canted and tapered hyphens are also to be found in many of the faces of Oldřich Menhart. (In the original version of Menhart's Figural, for example, the roman hyphen is tapered one way and the italic hyphen the other.) Frederic Warde's Arrighi, José Mendoza's Photina italic, and Warren Chappell's Trajanus all have hyphens that are level but asymmetrically serifed, which gives them a slight angular movement. The hyphen in Bram de Does's Trinité, a model of subtlety, is essentially level and unserifed but has a slight calligraphic lift at one end.

g-h

g-h

Poliphilus & Blado, above; Kennerley below.

g-h

g-h

fine-tuned / eagle-eye

Frederic Warde's Arrighi, left, and Warren Chappell's Trajanus, right

Hyphens also once varied considerably in length, but most now are standardized to a quarter of an em. Sometimes a shorter hyphen is better. Some of Gerard Unger's and Martin Majoor's economical Dutch hyphens (in faces such as Swift and Flora, Scala and Seria) measure no more than a fifth of an em.

Line-end hyphens are often best hung in the right margin, like the line-end hyphens on this and the facing page. This was easy to do for the scribes, who made it a common practice, but

it is tedious to emulate in metal. Digital typography makes it potentially easy once again – though not all typesetting software is equally eager to oblige.

5.2 DASHES, SLASHES & DOTS

Dashes,
Slashes
and Dots

5.2.1 *Use spaced en dashes – rather than close-set em dashes or spaced hyphens – to set off phrases.*

Standard computer keyboards and typewriters include only one dash: the hyphen. Any normal font of text type, either roman or italic, includes at least three. These are the hyphen and two sizes of long dash: the en dash – which is one en (half an em, M/2) in width – and the em dash—which is one em (two ens) wide. Many fonts also include a subtraction sign, which may or may not be the same length and weight as the en dash, and some include a figure dash (equal to the width of a standard numeral). The *three-quarter em* dash and the *three-to-em* dash, which is one third of an em (M/3) in width, are often missing but easy to make.

In typescript, a double hyphen (--) is often used for a long dash. Double hyphens in a typeset document are a sure sign that the type was set by a typist, not a typographer. A typographer will use an em dash, three-quarter em, or en dash, depending on context or personal style. The em dash was the nineteenth-century standard and is still prescribed in many editorial style books, but such long dashes were rare in European printed books before the end of the seventeenth century, when typography was losing its serenity and reserve.

Used as a phrase marker – thus – the en dash is set with a normal word space either side.

5.2.2 *Use close-set en dashes or three-to-em dashes between digits to indicate a range.*

Thus: 3–6 November; 4:30–5:00 PM; 25–30 mm. Set close in this way (and with careful attention to kerning and spacing), the dash stands for the word *to*. The hyphen is too short to serve this function, and in some faces the en dash (which is traditionally prescribed) appears too long. A *three-to-em* (M/3) dash is often the best choice. There is no need to edit the font in order to make such a creature. Typesetting software will happily condense the en or em dash by any desired amount.

When compound terms are linked with a dash in the midst of running prose, confusion can easily arise, and subtle cues of size and spacing can be crucial. A sentence such as *The office will be closed 25 December – 3 January* is a linguistic and typographic trap. When it stands all alone in a schedule or list, the phrase *25 December – 3 January* will be clear, but in running prose it is better both editorially and typographically to omit the dash and insert an honest preposition: *25 December to 3 January.*

Analphabetic Symbols

5.2.3 *Use the em dash to introduce speakers in narrative dialogue.*

The em dash, followed by a thin space (M/5) or word space, is the normal European method of marking dialogue, and it is much less fussy than quotation marks:

> — So this is a French novel? she said.
> — No, he said, it's Manitoban.

Unicode (see p 181) defines a special character [U+2015] as the quotation dash. Fonts containing such a character are rare. The em dash is the typographic norm.

5.2.4 *In lists and bibliographies, use a three-em rule when required as a sign of repetition.*

Set without spaces, a line of true em dashes forms a continuous midline rule. A three-em rule (three consecutive em dashes) is the old standard bibliographical sign for the repetition of a name. For example:

Boas, Franz. *Primitive Art.* Oslo: Ascheoug, 1927. Reissued Cambridge, Mass.: Harvard University Press, 1928; New York: Dover, 1955.
———. *Tsimshian Mythology.* BAE Ann. Rep. 31. Washington, DC: Bureau of American Ethnology, 1916.

In recent years, many scholarly associations have abandoned this style of bibliography, but others have not, and the three-em rule still finds many uses.

5.2.5 *Use the virgule in text and in level fractions, the solidus with split-level fractions.*

The slash, like the dash, is more various in real life than it is on the typewriter keyboard. A normal font of type includes a vertical bar and two slashes of differing inclinations. The steeper slash is the virgule (/), an alternative form of the comma. It is useful in

dates (6/6/13 = 6.vi.13 = 6 June 2013) and in text where a comma or parenthesis might otherwise have been used.

Wednesday / August 3 / 1977
Tibetan Guest House / Thamel / Kathmandu
Victoria University, Toronto / Ontario
he/she hit him/her

The other slash mark on the font is a solidus or fraction bar, used to construct fractions such as $^3/_{32}$. The solidus generally slopes at close to 45° and kerns on both sides. The virgule, not the solidus, is used to construct *level* fractions, such as $2\pi/3$. (Notice, for instance, the difference in slope and kerning between the two slash marks in the type specification 8/9½.)

5.2.6 *Use a dimension sign* (×) *instead of the letter* x *when dimensions are given.*

4×4

A picture may be 26 × 42 cm; studs are 2 × 4 and shelving might be 2 × 10 inches; North American letter paper is 8½ × 11.

5.2.7 *Use ellipses that fit the font.*

Most digital fonts now include, among other things, a prefabricated *ellipsis* (a row of three baseline dots). Many typographers nevertheless prefer to make their own. Some prefer to set the three dots flush ... with a normal word space before and after. Others prefer ... to add thin spaces between the dots. Thick spaces (m/3) are prescribed by the *Chicago Manual of Style,* but these are another Victorian eccentricity. In most contexts, the Chicago ellipsis is much too wide.

i ... j

k. . . .

l. . . , l

l, . . . l

m. . . ?

n. . . !

Flush-set ellipses work well with some faces, but in text work they are usually too narrow. Especially at small sizes, it is generally better to add space (as much as m/5) between the dots. Extra space may also look best in the midst of light, open letterforms, such as Baskerville, and less space in the company of a dark font, such as Trajanus, or when setting in bold face. (The ellipsis generally used in this book is part of the font and sets as a single character.)

In English (but not usually in French), when the ellipsis occurs at the end of a sentence, a fourth dot, the period, is added and the space at the beginning of these four dots disappears.... When the ellipsis combines with a comma, exclamation mark

or question mark, the same principle applies. Otherwise, a word space is required fore and aft. When it combines with other punctuation (as it always does at the end of a sentence) the ellipsis, in English, is also punctuation. On its own, it is a graphic word. The kerning table must include it and the glyphs it may sit next to.

5.2.8 *Treat the punctuation as notation, not expression, most of the time.*

Analphabetic Symbols

Now and again the typographer finds on his desk a manuscript in which the exclamation marks and question marks stand six or nine together. Certain words may be in bold capitals and others may be underlined five times. If the page has been written by hand, the dashes may get longer, and the exclamation marks taller as they go. With sufficient equipment and time, the typographer can actually come close to reproducing what he sees; he can even increase its dramatic intensity in any of several ways. Theatrical typography is a genre that flourished throughout most of the twentieth century, yet whose limits are still largely unexplored.

Most writing and typography nevertheless remain contentedly abstract, like a theater script or a musical score. The script of *Macbeth* does not need to be bloodstained and spattered with tears; it needs to be legible. And the score of Beethoven's *Hammerklavier Sonata* does not need bolder notes to mark fortissimos nor fractured notes to mark the broken chords. The score is abstract code and not raw gesture. The typeset script or musical score is also a performance in its way – but only of the text. The score is silent so the pianist can play. The script can whisper while the actors roar.

William Faulkner, like most American novelists of his generation, typed his final drafts. Noel Polk, a Faulkner specialist who prepared new editions of these novels, found that Faulkner usually typed three hyphens for a long dash and four or five dots for an ellipsis, but that once in a while he hammered away at the key, typing hyphens or dots a dozen or more in a row. Polk decided not to try to replicate Faulkner's keyboard jigs exactly, but he did not want to edit them entirely away. He evolved the rule of converting two, three or four hyphens to an em dash, and five or more hyphens to a two-em dash. Anything up to six dots, he replaced with a standard ellipsis, and he called for seven dots wherever Faulkner had typed seven dots or more.

These are typographic decisions that other editors or typogra-

See Joseph Blotner & Noel Polk, "Note on the Texts," in William Faulkner, *Novels 1930–1945* (New York: Library of America, 1985), p 1021, and *Novels 1936–1940* (1990), p 1108. Photoreproductions of Faulkner's holographs and typescripts have also been published in 25 volumes as *The Faulkner Manuscripts* (New York: Garland, 1986–87).

phers might have made in other ways. But the principle underlying them is sound. That principle is: punctuation is cold notation; it is not frustrated speech; it is typographic code.

Faulkner, we can presume, did not resort to bouts of extravagant punctuation because he was unable to express himself in words. He may, however, have been looking for some of the keys that the typewriter just doesn't have. The typographer's task is to know the vocabulary and grammar of typography, and to put them to meaningful use on Faulkner's behalf.

Dashes,
Slashes
and Dots

5.3 PARENTHESES

5.3.1 *Use the best available brackets and parentheses, and set them with adequate space.*

Typographic parentheses are traditionally pure line, like the virgule (/), the en dash (–) and the em dash (—). They are curved rules – usually portions of perfect circles, with no variation in weight – and in many older fonts they were loosely fitted, or set with plenty of space between them and the text they enclose. Parentheses in the form of swelled rules – thick in the middle and pointed at the ends – first appeared in the early Baroque, faded from view again in the Neoclassic age, and became the fashion, along with lining figures, in the nineteenth century. Many of the best twentieth-century text faces (Bruce Rogers's Centaur and Monotype Bembo, for example) were historical revivals that reasserted the older form.

(abc) (abc)

Monotype Centaur and Monotype Baskerville (*above*), Georg Trump's Trump Mediäval Antiqua and Karl-Erik Forsberg's Berling (*below*).

(abc) (abc)

The parentheses of some recent faces, such as Georg Trump's Trump Mediäval Antiqua and Hermann Zapf's Comenius, are modulated, asymmetrical strokes, based on the natural forms of the broadnib pen. In other recent designs (Zapf's Melior and Zapf International, and Karl-Erik Forsberg's Berling, for example), the parentheses are symmetrically thick in the middle and thin at the ends, like the nineteenth-century standard, but they are stretched into the form of a partial superellipse, which gives them greater tension and poise.

Parentheses in the form of nineteenth-century swelled rules are found by default on many digital fonts and have frequently been added, by mistake or by design, to alphabets with which they don't belong – historical revivals of the printing types of Garamond and Baskerville for example.

If you are forced to work with a font whose parentheses fall below standard, borrow a better pair from elsewhere. And whatever parentheses you use, check that they are not too tightly fitted (as in recent fonts they very often are).

5.3.2 Use upright (i.e., 'roman'), not sloped parentheses, brackets and braces, even if the context is italic.

Parentheses and brackets are not letters, and it makes little sense to speak of them as roman or italic. There are vertical parentheses and sloped ones, and the parentheses on italic fonts are almost always sloped, but vertical parentheses are generally to be preferred. That means they must come from the roman font, and may need extra spacing when used with italic letterforms.

$$(efg) \; (efg)$$

The sloped square brackets usually found on italic fonts are, if anything, even less useful than sloped parentheses. If, perish the thought, there were a book or film entitled *The View from My [sic] Bed,* sloped brackets might be useful as a way of indicating that the brackets themselves are actually part of the title. Otherwise, vertical brackets should be used, no matter whether the text is roman or italic: "The View from My [sic] Bed" and *"the view from my [sic] bed."*

In German type descriptions, *antiqua* means whiteletter and *mediäval* actually means Renaissance – because Renaissance architects and scribes revived and updated romanesque and Carolingian forms from the medieval period. *Trump Mediäval Antiqua* is a type that grows out of late Renaissance forms.

This rule has been broken more often than followed since the end of the 16th century, but it was followed more often than broken by the best of the early typographers who set texts in italic: Aldus Manutius, Gershom Soncino, Ludovico degli Arrighi, Johann Froben, Simon de Colines, Robert Estienne and Henri Estienne the younger. Better teachers would be difficult to find.

5.4.1 *Minimize the use of quotation marks, especially with Renaissance faces.*

Quotation Marks and Other Intrusions

Typographers got by quite well for centuries without quotation marks. In the earliest printed books, quotation was marked merely by naming the speaker – as it still is in most editions of the Vulgate and King James Bibles. In the High Renaissance, quotation was often marked by a change of font: from roman to italic or the other way around. Quotation marks were first cut in the middle of the sixteenth century, and by the seventeenth, some printers liked to use them profusely. In books from the Baroque and Romantic periods, quotation marks are sometimes repeated at the beginning of every line of a long quotation. When these distractions were finally omitted, the space they had occupied was frequently retained. This is the origin of the indented block quotation. Renaissance block quotations were set in a contrasting face at full size and full measure.

"and"

„und"

«et»

»und«

Three forms of quotation mark are still in common use. Inverted and raised commas – "quote" and 'quote' – are generally favored in Britain and North America. But baseline and inverted commas – „quote" – are more widely used in Germany, and many typographers prefer them to take the shape of sloped primes („–") instead of tailed commas („–"). *Guillemets,* otherwise known as *duck-foot quotation marks, chevrons,* or *angle quotes* – «quote» and ‹quote› – are the normal form in France and Italy, and are widely used in the rest of Europe. French and Italian typographers set their guillemets with the points out, «thus», while German-speaking typographers usually set them »the opposite way«. In either case, thin spaces are customary between the guillemets and the text they enclose.

An informative history of punctuation is M.B. Parkes, *Pause and Effect* (1993).

Quotation marks are sufficiently ingrained in modern editorial sign language that it is difficult, in many kinds of texts, to do entirely without them. But many nonprofessional writers overuse quotation marks. Good editors and typographers will reduce their appearance to a minimum, retaining only those that contribute real information.

When quotation marks are used, the question remains, how many should there be? The usual British practice is to use single quotes first, and doubles within singles: *'So does "analphabetic" mean what I think it means?' she said suspiciously.* When this

convention is followed, most quotation marks will be singles and therefore less obtrusive. Common American practice is the reverse: *"So,"* she said, *"does 'analphabetic' mean…?"* This convention ensures that quotation flags will stand out. Any given work should be consistent with itself, but it is possible to choose which convention suits that work, on textual and typographic grounds instead of territorial habit. And the typeface should be part of the equation. Some faces – Matthew Carter's Galliard, for example – have prominent quotation marks; others, such as Dante and Deepdene, have forms that are more discreet.

"say"
"say"

'say'
'say'

5.4.2 *Position quotation marks consistently in relation to the rest of the punctuation.*

Punctuation is normally placed inside a closing single or double guillemet if it belongs to the quotation, and outside otherwise. With other quotation marks, usage is less consistent. Most North American editors like their commas and periods inside the raised commas, "like this," but their colons and semicolons outside. Many British editors prefer to put all punctuation outside, with the milk and the cat. The kerning capabilities of digital typesetters, especially in the hands of advertising typographers, have evolved an intermediate third style, in which closing quotation marks are kerned over the top of commas and periods. Typographically, this is a good idea with some faces in large sizes, but a bad idea with many faces at text sizes, where a kerned quotation mark or apostrophe may look much like a question or exclamation mark.

"in."
"out".

"kern, 'kerning,' kerned."

When quotation marks are not kerned, it makes no *typographic* difference whether they follow commas and periods or precede them. The difference is one of editorial rather than visual discretion. But typographers, like editors, should be consistent, whichever route they choose.

5.4.3 *Omit the apostrophe from numerical plurals.*

Houses are built with 2×4s; children and parents live through the terrible twos; Europeans killed as many Europeans in the 1930s as they did Native Americans and Africans in the 1800s.

5.4.4 *Eliminate other unnecessary punctuation.*

Omit the period after metric units and other self-evident abbreviations. Set 5.2 m and 520 cm but 36 in. or 36″, and in bibliographical references, p 36f, or pp 396–424.

North American editors and typesetters tend to put periods after all abbreviations or (more rarely) after none. The former practice produces a text full of birdshot and wormholes; the latter can cause confusion. As a form of compromise, the Oxford house style, which is widely followed in Britain, has much to commend it. This rule is: use a period only when the word stops prematurely. The period is omitted if the abbreviation begins with the first letter of the word and ends with the last. Thus: Mrs Bodoni, Mr John Adams Jr and Ms Lucy Chong-Adams, Dr McBain, St Thomas Aquinas, Msgr Kuruwezi and Fr O'Malley; but Prof. Czesław Miłosz and Capt. James Cook.

Periods are equally unnecessary in acronyms and other abbreviations written with small or large capitals. Thus: 3:00 AM or PM; 450 BC or BCE; Washington, DC, and Mexico, DF; Vancouver, BC, and Darwin, NT.

In the interests of typographic hygiene, unnecessary hyphens should likewise be omitted. Thus: avant garde, bleeding heart, halfhearted, postmodern, prewar, silkscreen and typeface, in preference to the hyphenated alternatives. (It is good editorial practice, however, to hyphenate compound adjectives unless they can be fused into single words or will stand out as proper nouns. Thus, one goes to the New York Public Library in New York to find twenty-first-century typefaces in limited-edition books but publishes a limited edition in the twenty-first century. And one finds lowercase letters in the lower case.)

Apostrophes are needed for some plurals, but not for others, and inconsistency is better than a profusion of unnecessary marks. Thus: do's and don'ts; the ayes have it but the I's don't; the ewes are coming but the you's are staying home.

5.4.5 *Add punctuation, or preserve it, where it is necessary to meaning.*

The phrase *twenty one night stands* is ambiguous when written, but if the speaker knows what he means, it will be perfectly clear when spoken. Typography answers to vocal inflection in distinguishing *twenty one-night stands* from *twenty-one nightstands.*

In the careful language of science and poetry, hyphens can be more important still. Consider the following list of names: Douglas-fir, balsam fir, Oregon ash, mountain-ash, redcedar, yellowcedar, Atlas cedar, white pine, yellow pine, blue spruce. All these names are correct as they stand. They would be less so if an eager but ignorant editor, or a typographer obsessed with graphic hygiene, tried to standardize the hyphens. The terms are written differently because some are made from nouns that are only borrowed, others from nouns that are generic. The balsam fir is what it claims to be: a fir; the Douglas-fir is not; it is a separate genus waiting for a proper English name. The Oregon ash, likewise, is an ash, but the mountain-ash is not, and the Atlas cedar is a cedar, but redcedar and yellowcedar (or yellow-cedar) are not. The differences, though subtle, are perfectly audible in the speech of knowledgeable speakers (who say **balsam** *fir* and **Douglas-fir** and **moun**tain-**ash** and Oregon *ash*). A good typographer will make the same distinctions subtly visible as well. In the present state of typographic art and editorial convention, this is done not by spattering the page with boldface syllables but by the judicious and subtle deletion or insertion of spaces and hyphens.

5.5 DIACRITICS & THE KEYBOARD

5.5.1 Use the accents and alternate sorts that proper names and imported words and phrases require.

Simplicity is good, but so is plurality. Typography's principal function (not its only function) is communication, and the greatest threat to communication is not difference but sameness. Communication ceases when one being is no different from another: when there is nothing strange to wonder at and no new information to exchange. For that reason among others, typography and typographers must honor the variety and complexity of human language, thought and identity, instead of homogenizing or hiding it.

Typography was once a fluently multilingual and multicultural calling. The great typographers of the fifteenth and sixteenth centuries worked willingly with North Italian whiteletter, Italian or German blackletter, French script, Ashkenazi and Sephardic Hebrew, orthotic and cursive and chancery Greek. One of them, Robert Granjon, worked very skillfully with Arabic as well. The best typographers of recent times have followed their lead. But

typographic ethnocentricity and racism also have thrived in the last hundred years, and much of that narrow-mindedness is institutionalized in the workings of machines. Unregenerate, uneducated fonts and keyboards, defiantly incapable of setting anything beyond the most rudimentary Anglo-American alphabet, are getting scarcer but are still not difficult to find.

Recent digital technology has made it possible for any typographer to create special characters on demand – a luxury most have been without since the seventeenth century. Prepackaged fonts of impeccable design, with character sets sufficient to set any word or name in any European and many Asian languages, and the software to compose and kern these characters, are also now available even to the smallest home and desktop operations. Yet there are large-circulation newspapers in North America still unwilling to spell correctly even the names of major cities, composers and statesmen, or the annual list of winners of the Nobel Prize, for fear of letters like ñ, ł and é.

Neither typographers nor their tools should labor under the sad misapprehension that no one will enjoy or even mention crêpes flambées or aïoli, no one will have a name like Antonín Dvořák, Søren Kierkegaard, Stéphane Mallarmé or Chloë Jones, and no one will live in Óbidos or Århus, in Kroměříž or Øster Vrå, Průhonice, Nagykőrös, Dalasýsla, Kırkağaç or Köln.

5.5.2 *Build or find a keyboard layout – or a panoply of keyboards – that will give you ready access to the characters you need.*

A conventional computer keyboard includes a dozen characters – @ # ^ _ { } | \ ` ~ < > – that most writers and typesetters rarely need, while basic typographic elements such as the en dash, em dash, ellipsis, en space, em space, midpoint, pilcrow, bullet and simple fractions are nowhere to be seen. American standard keyboards, widely sold around the globe, carry no accented characters either – not even the small handful (à é è ï ô) that monolingual writers of English sometimes use. Those letters and many more are almost certainly included in the font, but the font is hidden beneath the keys. The only 'smart' key on the keyboard is, as a rule, the single-&-double quotation mark key ('/") – and its intelligence, which is minimal at best, is all too easily turned off.

By comparison, the California job case – a simple wooden tray with no moving parts, widely used by late nineteenth- and

early twentieth-century hand compositors – is a model of flexibility. It has only 89 compartments, but each of these can be used as the compositor sees fit. The case, in other words, is fully programmable and burdened with no trash.

The keyboard is much younger than the typecase and evidently needs a few more decades to mature. In the meantime, it is faster, even if comparatively brainless – and parts of it can be programmed with relative ease.

If you work routinely in multiple languages, you will probably want to install more than one keyboard language. Then, by flipping a virtual switch, you can type on the same keys in English, Russian and Hebrew, or in Hindi, Cree, Armenian and Thai – not to mention German, Spanish and French. But the keys beneath your fingers will go right on wearing their basic Latin name tags, so the more of these keyboard languages you install, the more arrangements you have to memorize. (Truly programmable keyboards, with little LCD screens in the keys, may not be far away, but we do not have them now.)

If your excursions across the language line are more modest, one keyboard layout may suffice, but you will save yourself a lot of time and frustration if you tailor it to your needs. Your editorial software (i.e., your 'word processor'), and your composition software too, will include an insertion utility – a slow but workable way of inserting single characters from *á* to *ž* and beyond. The software will also probably include some prefabricated keyboard shortcuts for alphabetic or analphabetic characters not present on the keyboard. You can normally change these shortcuts to suit yourself, and you can supplement them with others of your own devising. En dash, em space, and other basic tools of the typographic trade should be where you can find them without any hesitation.

Genuine
Garamond

ABCDEFGHIKL MNOPQ RSTV XYZabcdefghil mnopqrsſtuvxyz

1234567890 ,. ʼ !?;:-⁹᷎

Æ æ ꝏ ff fi fl œ ſſ ſi ſt fl ℞

& ã á à â ç é é è ê ë ẽ í í ì î ï ſ̈ ᵖ

Iuris præcepta ſunt hæc, Honeſté viuere, alterum
non lædere, ſuum cuiq̃; tribuere. Huius ſtudij duæ
ſunt poſitiones, Publicum & priuatum. Publicum
ius eſt, quod ad ſtatum rei Romanæ ſpectat. Priua
tum, quod ad ſingulorum vtilitatem pertinet.
Dicendum eſt igitur de iure priuato, quòd triperti-
tum eſt: collectum eſt enim ex naturalibus præcep-
tis, aut g̃etium aut ciuilibus. Ius naturale eſt quòd

A 42 pt roman titling font (cut *c*. 1530, revised *c*. 1550) and a 16 pt italic
text font (*c*. 1539). Both were cut by Claude Garamond, Paris. The italic
is shown actual size and the roman reduced by about one fifth. Matrices
for the roman font survive at the Plantin-Moretus Museum, Antwerp.

92

6.1 TECHNICAL CONSIDERATIONS

6.1.1 *Consider the medium for which the typeface was originally designed.*

6

Typographic purists like to see every typeface used with the technology for which it was designed. Taken literally, this means that virtually all faces designed before 1950 must be set in metal and printed letterpress, and the majority must be set by hand. Most typographers apply this principle in a more relaxed and complex way, and settle for preserving something rather than everything of a type's original character.

On the technical side, several things can be done to increase the chance that a letterpress typeface will survive translation to digital composition and offset printing.

6.1.2 *When using digital adaptations of letterpress faces, choose fonts that are faithful to the spirit as well as the letter of the old designs.*

Letterpress printing places the letterform *into* the paper, while offset printing lays it on the surface. Many subtle differences result from these two approaches to printing. The letterpress adds a little bulk and definition to the letter, especially in the thin strokes, and increases the prominence of the ends of thin serifs. Metal typefaces are designed to take advantage of these features of letterpress printing.

On the offset press – and in the photographic procedures by which camera-ready art and offset printing plates are prepared – thin strokes tend to get thinner and the ends of delicate serifs are eaten away. In a face like Bembo, for instance, offset printing tends to make features like the feet of i and l, and the heads and feet of H and I, slightly convex, while letterpress printing tends to make them slightly concave.

Faces designed for photographic manipulation and offset printing are therefore weighted and finished differently from letterpress designs. And adapting a letterpress face for digital composition (or vice versa) is a far from simple task.

Ili

Digital fonts poorly translated from metal originals are sometimes too dark or light or blunt throughout, or uneven in stroke weight, or faithless in their proportions. They sometimes lack text figures or other essential components of the original design. But digital translations can also be *too faithful* to the original. They sometimes neglect the subtle adjustments that the shift from three-dimensional letterpress to two-dimensional offset printing requires.

6.1.3 *Choose faces that will survive, and if possible prosper, under the final printing conditions.*

Bembo and Centaur, Spectrum and Palatino, are subtle and beautiful alphabets, but if you are setting 8 pt text with a laser printer on plain paper at 300 dpi, the refined forms of these faces will be rubbed into the coarse digital mud of the imaging process. If the final output will be 14 pt text set directly to plate at 2800 dpi, then printed by good offset lithography on the best coated paper, every nuance may be crystal clear, but the result will still lack the character and texture of the letterpress medium for which these faces were designed.

Some of the most innocent looking faces are actually the most difficult to render by digital means. Optima, for example – an unserifed and apparently uncomplicated face – is (in its authentic form) entirely constructed of subtle tapers and curves that can be adequately rendered only at the highest resolutions.

Faces with blunt and substantial serifs, open counters, gentle modeling and minimal pretensions to aristocratic grace stand the best chance of surviving the indignities of low resolution. Amasis, Caecilia, Lucida Sans, Stone and Utopia, for example, while they prosper at high resolutions, are faces that will also survive under cruder conditions lethal to Centaur, Spectrum, Linotype Didot or almost any version of Bodoni.

6.1.4 *Choose faces that suit the paper you intend to print on, or paper that suits the faces you wish to use.*

Most Renaissance and Baroque types were made to be pressed into robust, lively papers by fairly robust means. They wilt when placed on the glossy, hard-surfaced sheets that came into vogue toward the end of the eighteenth century. Most Neoclassical and Romantic types, on the other hand, were designed to require smooth

papers. Rough, three-dimensional papers break their fragile lines. Geometric Modernist types such as Futura, and overhauled Realist types such as Helvetica, can be printed on rough and smooth papers alike, because they are fundamentally *monochrome*. (That is to say, the stroke is nearly uniform in width.) But the aura of machine precision that emanates from a type like Futura is reinforced by a smooth paper and contradicted (*or* counterbalanced) by a paper that feels homespun.

The types associated with these historical categories are epitomized on pp 12–15 and discussed in more detail in chapter 7.

6.2 PRACTICAL TYPOGRAPHY

6.2.1 *Choose faces that suit the task as well as the subject.*

You are designing, let us say, a book about bicycle racing. You have found in the specimen books a typeface called Bicycle, which has spokes in the O, an A in the shape of a racing seat, a T that resembles a set of racing handlebars, and tiny cleated shoes perched on the long, one-sided serifs of ascenders and descenders, like pumping feet on the pedals. Surely this is the perfect face for your book?

Actually, typefaces and racing bikes are very much alike. Both are ideas as well as machines, and neither should be burdened with excess drag or baggage. Pictures of pumping feet will not make the type go faster, any more than smoke trails, pictures of rocket ships or imitation lightning bolts tied to the frame will improve the speed of the bike.

The best type for a book about bicycle racing will be, first of all, an inherently good type. Second, it will be a good type for books, which means a good type for comfortable long-distance reading. Third, it will be a type sympathetic to the theme. It will probably be lean, strong and swift; perhaps it will also be Italian. But it is unlikely to be carrying excess ornament or freight, and unlikely to be indulging in a masquerade.

6.2.2 *Choose faces that can furnish whatever special effects you require.*

If your text includes an abundance of numerals, you may want a face whose numerals are especially well designed. Palatino, Pontifex, Trump Mediäval and Zapf International, for example, all recommend themselves. If you prefer three-quarter-height lining numerals, your options include Bell, Trajanus and Weiss Antiqua.

If you need small caps, faces that lack them (such as Frutiger and Méridien) are out of the running. If you need a range of weights, Spectrum is disqualified but Frutiger may work. If you need matching phonetics, your options include Stone Serif and Sans, Lucida Sans, and Times Roman. For the sake of a matching Cyrillic, you might choose Arno, Charter, Minion, Lazurski, Quadraat, Warnock, or, among the unserifed faces, Syntax, Myriad, Futura or Quadraat Sans. For the sake of a matching Greek, you might choose Georgia or Palatino, or for the sake of a matching Cherokee, Huronia or Plantagenet. To obtain a perfectly mated sanserif, you might choose Haarlemmer, Legacy, Le Monde, Officina, Quadraat, Relato, Scala, Seria, Stone, or František Štorm's Jannon. These matters are explored in more detail in chapter 11, which addresses individual typefaces.

Special effects can also be obtained through more unorthodox combinations, which are the subject of § 6.5.

6.2.3 *Use what there is to the best advantage.*

If there is nothing for dinner but beans, one may hunt for an onion, some pepper, salt, cilantro and sour cream to enliven the dish, but it is generally no help to pretend that the beans are really prawns or chanterelles.

When the only font available is Cheltenham or Times Roman, the typographer must make the most of its virtues, limited though they may be. An italic, small caps and text figures will help immensely if they can be added, but there is nothing to be gained by pretending that Times Roman is Bembo or Cheltenham is Aldus in disguise.

As a rule, a face of modest merits should be handled with great discretion, formality and care. It should be set in modest sizes (better yet, in one size only) with the caps well spaced, the lines well leaded, and the lower case well fitted and modestly kerned. The line length should be optimal and the page impeccably proportioned. In short, the typography should be richly and superbly *ordinary*, so that attention is drawn to the quality of the composition, not to the individual letterforms. Only a face that warrants close scrutiny should be set in a form that invites it.

Using what there is to best advantage almost always means using less than what is available. Baskerville, Helvetica, Palatino and Times Roman, for example – which are four of the most widely available typefaces – are four faces with nothing to offer

Baskerville roman
and its italic

Helvetica roman
and its oblique

Palatino roman
and its italic

Times New Roman
and its italic

Baskerville is an English Neoclassical face designed in Birmingham in the 1750s by John Baskerville. It has a rationalist axis, thoroughgoing symmetry and delicate finish. There are many digital versions, none of which possesses the homey but fussy buff and polish of the originals.

Helvetica – the one typeface that is famous for being famous – is a twentieth-century Swiss revision of a late nineteenth-century German Realist face. The first weights were drawn in 1956 by Max Miedinger, based on the Berthold Foundry's old Odd-job Sanserif, or Akzidenz Grotesk, as it is called in German. The heavy, unmodulated line and tiny aperture evoke an image of uncultivated strength, force and persistence. The much lighter weights issued since 1990 have done much to reduce Helvetica's coarseness but little to increase its readability.

Palatino is a lyrical modernist face with a neohumanist architecture, which is to say that it is *written*, not drawn, and that it is based on Renaissance forms. It was created in 1948 by Hermann Zapf.

Times Roman – properly Times *New* Roman – is an historical pastiche drawn by Victor Lardent for Stanley Morison in London in 1931. It has a humanist axis but Mannerist proportions, Baroque weight, and a sharp, Neoclassical finish.

one another except public disagreement. None makes a good companion face for any of the others, because each of them is rooted in a different concept of what constitutes a letterform. If the available palette is limited to these faces, the first thing to do is choose *one* for the task at hand and ignore the other three.

6.3 HISTORICAL CONSIDERATIONS

Typography, like other arts, preys on its own past. It can do so with the callousness of a grave robber, or with the piety of un-questioning ancestor worship. It can also do so in thoughtful, enlightened and deeply creative ways.

Roman type has been with us for more than five centuries. Its root components – the roman upper and lower case, basic analphabetic symbols, and arabic numerals – have been with us for much longer yet. There are typographers who resolutely avoid using any typeface designed in an earlier era, but even they must learn something of how the older letterforms functioned, because the ancient forms are living in the new. Typographers who willingly use the old faces, and who wish to use them intelligently, need to know all they can learn about the heritage they enjoy.

6.3.1 *Choose a face whose historical echoes and associations are in harmony with the text.*

Any contemporary library will furnish examples of typographic anachronism. There are books on contemporary Italy and on seventeenth-century France set in typefaces such as Baskerville and Caslon, cut in eighteenth-century England. There are books about the Renaissance set in faces that belong to the Baroque, and books about the Baroque set in faces from the Renaissance. To a good typographer it is not enough merely to avoid these kinds of laughable contradictions. The typographer seeks to *shed light* on the text, to generate insight and energy, by setting every text in a face and form in which it actually belongs.

abc
abc

Baskerville

and Caslon

It is not that good typographers object to mixing centuries and cultures. Many take delight in doing so – especially when they have no other choice. A text from ancient Athens, for example, cannot be set in an ancient Athenian version of roman type. A face designed in North America in the 1990s may well be used instead. Texts from seventeenth-century France or eighteenth-century England also might be set perfectly well in faces of recent

design. But a face that truly suits an historical text is likely to have some fairly clear historical content of its own. There is no typeface *equally suited* to texts from Greek antiquity, the French Baroque and the English Neoclassical period – though faces equally *unsuited* to each of them abound.

The historical affiliations of individual typefaces are discussed in chapters 7 and 11.

6.3.2 *Allow the face to speak in its natural idiom.*

Books that leap historical boundaries and mix historical subjects can pose complex and exciting typographic problems. But often, if a text calls for a Renaissance type, it calls for Renaissance typography as well. This usually means Renaissance page proportions and margins, and an absence of bold face. It may also mean large Renaissance versals, Renaissance style in the handling of quotations, and the segregation of roman and italic. If the text calls for a Neoclassical type, it likewise often calls for Neoclassical page design. When you undertake to use an historical typeface, take the trouble to learn the typographic idiom for which it was intended. (Works of reference that may be useful in solving particular problems are listed in the bibliography, page 375.)

6.4 CULTURAL & PERSONAL CONSIDERATIONS

6.4.1 *Choose faces whose individual spirit and character is in keeping with the text.*

Accidental associations are rarely a good basis for choosing a typeface. Books of poems by the twentieth-century Jewish American poet Marvin Bell, for example, have sometimes been set in Bell type – which is eighteenth-century, English and Presbyterian – solely because of the name. Such puns are a private amusement for typographers; they also sometimes work. But a typographic page so well designed that it attains a life of its own will be based on real affinities, not on a coincidence of names.

abc
abc

Bell roman
and italic

Letterforms have character, spirit and personality. Typographers learn to discern these features through years of working first-hand with the forms, and through studying and comparing the work of other designers, present and past. On close inspection, typefaces reveal many hints of their designers' times and temperaments, and even their nationalities and religious faiths.

Faces chosen on these grounds are likely to give more interesting results than faces chosen through mere convenience of availability or coincidence of name.

If, for example, you are setting a text by a woman, you might prefer a face, or several faces, designed by a woman. Such faces were rare or nonexistent in earlier centuries, but there are now a number to choose from. They include Gudrun Zapf-von Hesse's admirable Alcuin, Carmina, Diotima and Nofret families; Elizabeth Friedländer's Elizabeth; Kris Holmes's Sierra and Lucida; Kris Holmes's and Janice Prescott Fishman's Shannon; Carol Twombly's handsome text face Chaparral and her titling faces Charlemagne, Lithos, Nueva and Trajan; Zuzana Ličko's Journal and Mrs Eaves, and Ilse Schüle's Rhapsodie. For some purposes, one might also go back to the work of Elizabeth Colwell, whose Colwell Handletter, issued by ATF in 1916, was the first American typeface designed by a woman.

But perhaps a text by a French author, or a text dealing with France, might best be set in a French typeface, without regard to the gender of author or designer. The choices include true Garamond, Jannon 'Garamond,' Mendoza, Méridien, Vendôme and many others, but even this abbreviated list covers considerable range. The genuine Garamonds savor of sixteenth-century Paris. Their parent forms owed much to Italy and belonged to the world of Renaissance Catholicism. The parent forms of the Jannon 'Garamonds' are nonconformist; they belong to the Reformation, not the Renaissance. Their creator, Jean Jannon, was a French Protestant who suffered all his life from religious persecution. Vendôme, designed by François Ganeau, is a witty twentieth-century face much indebted to Jannon. Mendoza, designed in Paris in 1990, goes back to the tough humanist roots from which Garamond sprang. Méridien, from the 1950s, is more in touch with the secular spirit of twentieth-century Swiss industrial design, yet it includes a regal, even imperious, upper case and a very crisp and graceful italic. These five different faces invite additional differences in page design, paper and binding as well as different texts, just as different musical instruments invite different phrasings, different tempi, different musical modes or keys.

Even nations such as Greece and Thailand, which have scripts of their own, share in a multinational tradition of type design. Nevertheless, some typefaces seem more redolent of national character than others. Frederic Goudy, for example, is widely regarded as the most ebulliently American of all American type designers.

Garamond roman
and its italic

Jean Jannon's roman
and its italic

Mendoza roman
and its italic

Méridien roman
and its italic

Vendôme roman
and its oblique

Stempel Garamond is the Stempel Foundry's attempt to recreate a text roman and italic designed by Claude Garamond (*c.* 1490–1561). (Compare this type with the reproductions on page 92, showing of some of Garamond's actual work.)

Monotype 'Garamond' 156 is a revival of a type designed by Jean Jannon (1580–1658), the greatest typecutter of the French Baroque. Jannon's type was once misidentified as Garamond's and is still routinely sold under his name.

Mendoza was designed about 1990 by José Mendoza y Almeida. Adrian Frutiger's Méridien and François Ganeau's Vendôme are products of the 1950s. Ganeau – who worked as a painter, sculptor and set designer more than as a typographer – based Vendôme on Jannon's letters, but moved them playfully in the direction of French Neoclassicism.

A sensitive typographer would not choose one of Goudy's faces to set, let us say, the text of the Canadian or Mexican constitution.

This subject is a lifelong study, and for serious typographers it is a lifelong source of discovery and delight. Here it is pursued at greater length in chapter 11. Appendix D (page 347) is a cross-indexed list of type designers.

6.5 THE MULTICULTURAL PAGE

Consistency is one of the forms of beauty. Contrast is another. A fine page, even a fine book, can be set from beginning to end in one type in one size. It can also teem with variety, like an equatorial forest or a modern city.

6.5.1 *Start with a single typographic family.*

Most pages, and most entire documents, can be set perfectly well with only one family of type. But perhaps the page confronting you requires a chapter title, two or three levels of subheads, an epigraph, a text in two languages, block quotations within the text, a couple of mathematical equations, a bar graph, several explanatory sidenotes, and captions for photographs and a map. An extended type family, such as Legacy, Lucida, Quadraat, Seria or Stone, may provide sufficient resources even for this task. Another possibility is Gerard Unger's comprehensive series known as Demos, Praxis and Flora – which is a family with no surname to unite it. Each of these series includes both roman and italic in a range of weights, matching serifed and unserifed forms, and other variations. If you restrict yourself to faces within the family, you can have variety and homogeneity at the same time: many shapes and sizes but a single typographic culture. Such an approach is well suited to some texts, poorly suited to others.

You can also, of course, mix faces at random, by drawing them out of a hat.

Between these two extremes is the wide arena of thoughtful mixing and matching, in which the typographic intelligence often does its most creative work and play.

6.5.2 *Respect the integrity of roman, italic and small caps.*

It has been the normal practice of type designers since the middle of the sixteenth century to offer text faces in the form of a matched

triad, consisting of roman, italic and small caps. Because some of these marriages are more successful than others, it is wise to examine the roman and the italic both separately and together when choosing a text face.

There are several celebrated instances in which an italic designed by one artist has been happily and permanently married to another designer's roman. These matches always involve some redrawing (and the face that is most heavily redrawn is almost always the italic, which is the subsidiary and 'feminine' font in post-Renaissance typography). There are also instances in which a roman and its italic have been designed by the same artist many years apart. But casual liaisons, in which the roman of one family is paired momentarily with the italic of another, have little hope of success. Mixing small caps from one face with full caps from another is even less likely to succeed.

If you use type strictly in the Renaissance manner, treating the roman and italic as separate but equal, not mixing them on the line, you may find that greater latitude is possible. Jan van Krimpen's Lutetia italic mixes well with his later Romanée roman, for example, if the two are not too intimately combined. One is visibly more mature than the other, but they are close in color and structure, and they are patently the work of the same designer.

6.5.3 *Consider bold faces on their own merits.*

The original boldface printing types are the blackletters used by Gutenberg in the 1440s. For the next two centuries, blackletter fonts were widely used not only in Germany but in France, Spain, the Netherlands and England. (That is why blackletter fonts are occasionally sold in the USA as 'Olde English.')

Boldface romans, however, are a nineteenth-century invention. Bold italic is even more recent, and it is hard to find a successful version designed before 1950. Bold romans and italics have been added retroactively to many earlier faces, but they are often simply parodies of the original designs.

Before using a bold weight, especially a bold italic, ask yourself whether you really need it at all. If the answer is yes, you may want to avoid type families such as Bembo, Garamond or Baskerville, to which bold weights have been retroactively added but do not in fact belong. You might, instead, choose a twentieth-century family such as Apollo, Nofret or Scala, in which a range of weights is part of the original design.

If your text face lacks a bold weight, you may also find an appropriate bold close by. Hermann Zapf's Aldus, for example, is a twentieth-century family of Renaissance spirit, limited to roman, italic and small caps. But Aldus is a close cousin of the same designer's Palatino, which does include a bold. It is no surprise that Palatino bold sits comfortably with Aldus text. The two are close enough, in fact, that when Zapf revised these faces in 2005, for reissue as Aldus Nova and Palatino Nova, he gave the same boldface to both.

a aardvark; **b** *balloon*; **3** thirsty

18 pt Aldus roman and italic with 17 pt Palatino bold

Equally interesting results can often be obtained by reaching much farther afield. The normal function of boldface type is, after all, to contrast with the roman text. If the bold is used in small amounts, and bold and roman are not too intimately combined, a difference in structure as well as weight may be an asset. Under these conditions, a typographer is free to choose both roman and bold on their own merits, seeking basic compatibility rather than close genetic connection.

c cinch; **d** *daffodil*; **6** salad

18 pt Sabon roman and italic with Zapf International 17 pt demibold

A text might be set in Sabon, for example, with Zapf International as a titling face and Zapf International demi or heavy for subheads and flags. Structurally, these are very different faces, with very different pedigrees. But Sabon has the calm and steady flow required for setting text, while Zapf International's vitality makes it a good face for titling – and this vitality persists even in the boldest weights. The bold weights of fonts that are closer in structure to Sabon often look splayed and deformed.

Fifteenth-century typographers – Nicolas Jenson for example – rarely mixed fonts except when mixing languages. They loved an even page. Bold roman is therefore an appendage they did happily without. If, nevertheless, you were using one of the fine text faces based on Jenson's single roman font and wanted to embellish it with bold, you might consider using Jenson's kind of bold. The only dark faces he cut were blackletters.

elf elder; flat *flounder*; lví physics

Above: 21 pt Centaur & Arrighi with 16 pt San Marco. Centaur, designed
by Bruce Rogers, is based on the roman that Nicolas Jenson cut at Venice
in 1469. San Marco, designed by Karlgeorg Hoefer, is based on Jenson's
rotundas. ¶ Below: 18 pt Espinosa Nova, designed by Cristóbal Henes-
trosa. This family, based on careful study of 16th-century Mexican originals,
includes a rotunda of its own as an alternate boldface.

*Choosing
and
Combining
Type*

elf elder; flat *flounder*; lví physics

6.5.4 *Choose titling and display faces that reinforce the structure
of the text face.*

Accessory titling faces, display faces and script faces can be chosen
on much the same principles as bold faces. Incestuous similarity
is rarely a necessity, but empathy and compatibility usually are.
A geometrically constructed, high-contrast face such as Bauer
Bodoni, beautiful though it may be, has marginal promise as a
titling face for a text set in Garamond or Bembo, whose contrast
is low and whose structure is fundamentally calligraphic. (Bodoni
mixes far more happily with Baskerville – of which it is not a
contradiction but rather an exaggeration.)

For examples of
script faces, see
pp 278–80.

6.5.5 *Pair serifed and unserifed faces on the basis of their inner
structure.*

When the basic text is set in a serifed face, a related sanserif is
frequently useful for other elements, such as tables, captions or
notes. In complicated texts, such as dictionary entries, it may
also be necessary to mix unserifed and serifed fonts on the same
line. If you've chosen a family that includes a matched sanserif,
your problems may be solved. But many successful marriages
between serifed and unserifed faces from different families are
waiting to be made.

Frutiger Méridien Univers

Suppose your main text is set in Méridien – a serifed roman
and italic designed by Adrian Frutiger. It would be reasonable
to look first of all among Frutiger's other creations for a related
sanserif. Frutiger was a prolific designer of types, both serifed and

The version of
Frutiger used
here is the recent
revision called
Frutiger Next.

unserifed, so there are several from which to choose. Univers is his most widely used sanserif. But another of his unserifed faces – the one to which he gave his own name – is structurally much closer to Méridien and works handsomely as a companion.

Hans Eduard Meier's Syntax is a sanserif much different in structure from either Frutiger or Univers. It is based on serifed Renaissance forms like those of Garamond. It works well with such faces as the Stempel or Adobe Garamonds, or with Sabon, another descendant of Garamond, designed by Meier's contemporary and countryman, Jan Tschichold.

The Multicultural Page

If your choice falls on a more geometric sanserif, such as Futura, a Renaissance roman will hardly suffice as a serifed companion. Many romans based on the work of Bodoni, however, breathe much the same spirit as Futura. They aspire not to calligraphic motion but to geometric purity.

Gabocse escobaG
Gabocse escobaG
Gabocse escobaG

Syntax and Minion, above; Futura and Berthold Bodoni, center; Helvetica and Haas Clarendon, below.

6.6 MIXING ALPHABETS

6.6.1 *Choose non-Latin faces as carefully as Latin ones.*

a א

a א

a א

Mixing Latin letters with Hebrew or Arabic is, in principle, scarcely different from mixing roman with blackletter or serif with sans. Different though they look, and even though they read in different directions, all these alphabets spring from the same source, and all are written with similar tools. Many structural similarities underlie the obvious differences. A book involving more than one alphabet therefore poses some of the same questions posed by a bilingual or polylingual book set entirely in Latin letters. The typographer must decide in each case – after studying the text – whether to emphasize or minimize the differences. In general, the more closely different alphabets are mixed, the more important it

106

becomes that they should be close in color and in size, no matter how superficially different in form.

The Latin, Greek and Cyrillic alphabets are as closely related in structure as roman, italic and small caps. (And in most upright Cyrillic faces, the lower case is close in color and shape to Latin small caps.) Random marriages of Latin and Greek, or Latin and Cyrillic, look just as ungainly and haphazard as random combinations of roman, italic and small caps – but excellent sets of related faces have developed, and a few homogeneous polyglot families have been designed.

Plato and Aristotle both quote
the line of Parmenides that says
πρώτιστον μὲν Ἔρωτα θεῶν μητίσατο
πάντων: "The first of all the gods to
arise in the mind of their mother was

PHYSICAL LOVE."

Греки боготворили природу и
завещали миру свою религию,
то есть *философию и искусство,*
says a character named Shatov in
Dostoevsky's novel *Demons*: "The
Greeks deified nature and bequeathed
to the world their religion, which is
philosophy and art."

Robert Slimbach's Arno roman, italic and small caps, with upright and cursive forms of Arno Cyrillic and Arno Greek.

The text on this page is set in ITC Mendoza 10/13 with 12 pt New Hellenic. On the facing page, the roman and italic are Figural 10/13; the Greek is 10.5 pt Porson. The caps in both Greek have been resized. (The original edition of Cornford's book, printed in 1912, was set in the curious combination of Century Expanded and Porson Greek.)

ΦΥΣΙΣ AS THE SOUL / THE SOUL AS ΓΝΩΣΙΣ. The second proposition of Thales declares that the All is alive, or has Soul in it (τὸ πᾶν ἔμψυχον). This statement accounts for the mobility of φύσις. Its motion, and its power of generating things other than itself, are due to its life (ψυχή), an inward, spontaneous principle of activity. (Cf. Plato, *Laws* 892c: φύσιν βούλονται λέγειν γένεσιν τὴν περὶ τὰ πρῶτα· εἰ δὲ φανήσεται ψυχὴ πρῶτον, οὐ πῦρ οὐδὲ ἀήρ, ψυχὴ Δ' ἐν πρώτοις γεγενημένη, σχεδὸν ὀρθότατα λέγοιτ' ἂν εἶναι διαφερόντως φύσει.)...

It is a general rule that the Greek philosophers describe φύσις as standing in the same relation to the universe as soul does to body. Anaximenes, the third Milesian, says: οἶον ἡ ψυχὴ ἡ ἡμετέρα ἀὴρ οὖσα συγκρατεῖ ἡμᾶς, καὶ ὅλον τὸν κόσμον πνεῦμα καὶ ἀὴρ περιέχει. "As our soul is air and holds us together, so a breath or air embraces the whole cosmos."[1]...

The second function of Soul – knowing – was not at first distinguished from motion. Aristotle says, φαμὲν γὰρ τὴν ψυχὴν λυπεῖσθαι χαίρειν, θαρρεῖν φοβεῖσθαι, ἔτι δὲ ὀργίζεσθαί τε καὶ αἰσθάνεσθαι καὶ διανοεῖσθαι· ταῦτα δὲ πάντα κινήσεις εἶναι δοκοῦσιν. ὅθεν οἰηθείη τις ἂν αὐτὴν κινεῖσθαι. "The soul is said to feel pain and joy, confidence and fear, and again to be angry, to perceive, and to think; and all these states are held to be movements, which might lead one to suppose that soul itself is moved."[2] Sense-perception (αἴσθησις), not distinguished from thought, was taken as the type of all cognition, and this is a form of action at a distance.[3]

1 Frag. 2. Compare Pythagoras' "boundless breath" outside the heavens, which is inhaled by the world (Arist., *Phys.* 213b22), and Heraclitus' "divine reason," which surrounds (περιέχει) us and which we draw in by means of respiration (Sext. Emp., *Adv. Math.* vii.127).

2 *De anima* 408b1.

3 *De anima* 410a25: Those who make soul consist of all the elements, and who hold that like perceives and knows like, "assume that perceiving is a sort of being acted upon or moved and that the same is true of thinking and knowing" (τὸ Δ' αἰσθάνεσθαι πάσχειν τι καὶ κινεῖσθαι τιθέασιν· ὁμοίως δὲ καὶ τὸ νοεῖν τε καὶ γιγνώσκειν).

All such action, moreover, was held to require a continuous vehicle or medium, uniting the soul which knows to the object which is known. Further, the soul and its object must not only be thus linked in physical contact, but they must be *alike* or *akin*....

It follows from this principle that, if the Soul is to know the world, the world must ultimately consist of the same substance as Soul. Φύσις and Soul must be homogeneous. Aristotle formulates the doctrine with great precision:

ὅσοι δ᾽ ἐπὶ τὸ γινώσκειν καὶ τὸ αἰσθάνεσθαι τῶν ὄντων, οὗτοι δὲ λέγουσι τὴν ψυχὴν τὰς ἀρχάς, οἱ μὲν πλείους ποιοῦντες, ταύτας, οἱ δὲ μίαν, ταύτην, ὥσπερ Ἐμπεδοκλῆς μὲν ἐκ τῶν στοιχείων πάντων, εἶναι δὲ καὶ ἕκαστον ψυχὴν τούτων, λέγων οὕτως

γαίῃ μὲν γὰρ γαῖαν ὀπώπαμεν, ὕδατι δ᾽ ὕδωρ,
αἰθέρι δ᾽ αἰθέρα δῖαν, ἀτὰρ πυρὶ πῦρ ἀίδηλον,
στοργῇ δὲ στοργήν, νεῖκος δέ τε νείκεϊ λυγρῷ.

τὸν αὐτὸν δὲ τρόπον καὶ Πλάτων ἐν τῷ Τιμαίῳ τὴν ψυχὴν ἐκ τῶν στοιχείων ποιεῖ· γιγνώσκεσθαι γὰρ τῷ ὁμοίῳ τὸ ὅμοιον, τὰ δὲ πράγματα ἐκ τῶν ἀρχῶν εἶναι.

«Those who laid stress on its knowledge and perception of all that exists, identified the soul with the ultimate principles, whether they recognized a plurality of these or only one. Thus, Empedocles compounded soul out of all the elements, while at the same time regarding each one of them as a soul. His words are,

«With earth we see earth, with water water,
«with air bright air, ravaging fire by fire,
«love by love, and strife by gruesome strife.

«In the same manner, Plato in the *Timaeus* constructs the soul out of the elements. Like, he there maintains, is known by like, and the things we know are composed of the ultimate principles....»[4]

De anima 404b8–18.

The texts on this spread are adapted from F.M. CORNFORD'S *From Religion to Philosophy: A Study in the Origins of Western Speculation* (London, 1912). Some of the Greek quotations have been extended, and some have been moved from the footnotes into the main text. This makes Cornford's prose seem more pedantic and less lucid than it really is, but it poses a harder test for the type and permits a more compact typographic demonstration.

109

Но я предупреждаю вас,

But I'm warning you,

These lines
are from §5
of Akhmatova's
В сороковом
году.

Что я живу в последний раз.

this is my last existence.

Ни ласточкой, ни кленом,

Not as a swallow, not as a maple,

Ни тростником и ни звездой …

not as a cat-tail and not as a star …

The words of Anna Akhmatova in the letters of Vadim Lazurski. The type is Lazurski Cyrillic with its companion roman.

Greek letters, like Greek words, are used for many purposes in non-Greek-speaking countries. Physicists and fraternity members, astronomers and novelists have raided the ancient alphabet for symbols. Because of their frequent use in mathematics and technical writing, a grab-bag of Greek letters lurks somewhere in nearly every digital typesetting system. The μ (mu) is now a standard character in text fonts, while α, β, γ, θ, π, Ω (alpha, beta, gamma, theta, pi, cap omega) and their brethren are usually housed, with other mathematical symbols, in a typographic ghetto called a *pi font* or symbol font. But setting Greek *text* with such a font is a hopeless task. Pi fonts lack the breathing marks and accents used in the classical language, and even the two simple diacritics (*tonos* and *dialytika* – or acute and diaeresis) that survive in modern Greek. Some pi fonts include only ten Greek caps – Γ Δ Θ Λ Ξ Π Σ Φ Ψ Ω – because the others – A B E H Z I K M N O P T Y X – have familiar roman forms, though not in every case the same phonetic value.

A text that includes even a single Greek quotation calls for a Greek text font rather than a pi font. A text font will include the full Greek alphabet with matching punctuation and all the monotonic (modern) or polytonic (classical) diacritics. It will include two forms of lowercase sigma (ς, used at the ends of words, and

σ, used everywhere else). If it is a polytonic font, it will include in addition three sets of long vowels with iota subscripts (ᾄ, ῇ, ᾠ, etc). With luck, the font will include a sensible kerning table as well. This is a lot to ask from an industry in which there is, officially, no culture other than commerce and no purpose except monetary gain. It is a lot to ask, but not by itself enough. In Greek as in any other alphabet, *the face must suit the text.* It must also suit the context, which is likely to be roman and italic.

Choosing and Combining Type

There may be 60,000 fonts of type for the Latin alphabet now on the market in digital form. These comprise some 7,000 families. Perhaps two per cent of them are truly useful for text work – but a hundred families of type is still a very generous number, and the available text faces cover a wide stylistic range. With a little scrounging, one can turn up several dozen fonts of Greek – but again, most will have no potential for text work. (Fewer still will have Greek small caps.) It is therefore often best to choose a Greek font *first,* and then a roman and italic to go with it, even when only a few Greek words or a single Greek quotation is present in the text you are going to set.

Greek small caps are included in Arno, Garamond Premier, and the latest versions of GFS Neohellenic. (See pp 284, 286.)

Two Greeks with eminent credentials – Victor Scholderer's New Hellenic, designed in 1927, and Richard Porson's Porson, designed in 1806 – are shown, in their digital incarnations, on pages 108–9. Porson's Greek was first commissioned by Cambridge University Press, but it became in the twentieth century the favorite Greek at Oxford, while Scholderer's New Hellenic became the favorite Cambridge Greek. New Hellenic in particular has an eminent Renaissance pedigree (see §11.7, page 281).

6.6.2 *Match the continuity of the typography to the continuity of thought.*

A text composed in a single dialect may be full of leaps and holes, while a text that hops and skips through several languages and alphabets may in fact be tracing a path that is perfectly smooth. The continuity, or lack of continuity, that underlies the text should as a rule be revealed, not concealed, in the cloth the typographer weaves.

An author who quotes Greek or Hebrew or Russian or Arabic fluently and gracefully in speech should be permitted to do likewise on the page. Practically speaking, this means that when the alphabets are mixed, they should be very closely balanced both in *color* and in *contrast.*

abyohi ἄβγοθι *abyohi*
abyohi ἄβγοθι *abyohi*

abyohi ἄβγοθι *abyohi*

Victor Scholderer's New Hellenic paired with José Mendoza's Mendoza (*top*), with Peter Matthias Noordzij's Caecilia (*middle*) and with Adobe Jenson (*bottom*). Mendoza is a face with very low contrast (the thicks and thins are nearly the same). New Hellenic and Caecilia have an unmodulated stroke – in other words, no contrast at all. New Hellenic and Adobe Jenson have stylistic compatibility of a different kind. Both stem from the work of Nicolas Jenson, who in 1469 cut the father of this roman and in 1471 the grandfather of this Greek.

Flow and *slope* are other factors to consider, especially when balancing Latin and Greek. Many Greek text faces (the Porson and Didot Greeks for example) are structurally comparable to italics. That is, they are cursive. Some of them are upright nonetheless (like the Didot), while others (like the Porson) slope. When roman, italic and Greek are combined on the page, the Greek may be upright like the roman, or it may harmonize with the italic in flow and slope. It may also stand aloof, with a gait and inclination of its own. A Greek used together with a roman must, after all, look different from, though not antagonistic to, that roman.

6.6.3 *Balance the type optically more than mathematically.*

Two other factors of importance when types sit side by side are their *torso* (x-height) and *extension*. When a long-limbed Greek is paired with a short-limbed Latin, the difference will stand out. Large disparities in x-height are far more obvious still. In metal, this is a harsh typographic constraint. In the digital medium, it is easy to match the torso of any Greek face to that of any Latin face exactly, through microscopic adjustments in size. But an optical, not mathematical, match is the goal. Classical Greek, beneath its cloud of diacritics, needs more room to breathe than roman type. And when setting Greek in footnotes, the minimum practical size is the size at which the accents are still legible.

abyohi *ἄβγοθι* *abyohi*

abyohi *ἄβγοθι* *abyohi*

abyohi *ἄβγοθι* *abyohi*

Top: The Greek of Richard Porson paired with W. A. Dwiggins's Electra.
Middle: Didot Greek paired with Adobe Caslon. *Bottom*: The Bodoni Greek
of Takis Katsoulidis paired with the Esprit roman and italic of Jovica Veljović.
Electra italic and Porson Greek both have a slope of 10°, while the Caslon
italic slopes at 20°. Porson, with its rationalist axis, also has a structural
kinship to Electra. The Didot Greek, though Neoclassical in form, is closer
in color to Caslon. Katsoulidis's more playful Bodoni Greek is closer both
in structure and in spirit to Esprit.

6.7 NEW AND OLD ORTHOGRAPHIES

No writing system is fixed. Even our ways of writing classical Latin
and Greek continue to change, along with our ways of writing and
spelling such rapidly mutating languages as English. But many
languages old to speech are new to writing, and many have not
yet decided their literate form.

In North America, for example, Navajo, Hopi, Tlingit, Cree,
Ojibwa, Inuktitut and Cherokee, among others, have evolved quite
stable writing systems, in which a substantial printed literature
has accrued. But many Native American languages are still being
written in different ways by every scholar and student who hap-
pens by. Some, like Tsimshian, Meskwaki and Kwakwala, already
possess a considerable written literature, but in cumbersome
scripts that even scholars have ceased to use.

Typographers must generally confront these problems piece-
meal. Alphabets are often created by fiat, but it is usually in tiny
increments that real typographic style evolves.

6.7.1 *Add no unnecessary characters.*

Colonial expansion has carried the Arabic script across Africa,
much of Asia and large parts of the Pacific; Cyrillic across north
and central Asia; and the Latin alphabet around the world. For

better or worse, most of those learning to read and write in newly literate languages are exposed to writing in a colonial language first. For readers and typographers alike, the basic Latin, Cyrillic or Arabic alphabet is therefore often the easiest place to start, and the fewer additional symbols required the better. The dream of a common language, imposed upon many minority cultures, has proven for most to be a nightmare. But in a world where there are hundreds of ancestral and classical languages and literatures instead of one or two, prayers for renewed diversification often entail the dream of a common script.

đ ğ

Ђ љ

ﺫ ۇ

> Wa′giên sq!ê′ñgua lā′na hîn sā′wan, "K!wa la t!āla′ñ ł gia′ʟ̣ītc!în."

> Wagyaan sqqinggwa llaana hin saawan, "Kkwa lla ttaalang hl gyadliittsin."

Two versions of one sentence in the Haida language. The first is in the earliest useful system of Haida spelling (established in 1900). The second is in a more recent, simplified orthography. In the older and thornier version, glottalized consonants are marked by exclamations and long vowels by macrons. In the newer version, both are notated by doubling. (Translation: *Then the one in the bow said, 'Let us take it aboard.'*)

6.7.2 *Avoid capricious redefinition of familiar characters.*

3i, i4

7w@n

t′áá Diné

ᐊᑕᖅᐯᑐ

ᑐᐃᕑᐁᐃᐧᑐ·ᗡ

ᑐᐃᕑᐁᐃᐧᑐ·ᗡ

Alphabets for African and Native American languages have time and again been concocted by starting with Latin script and adding the numerals 3, 4 and 7, the dollar and cent signs, or the question and exclamation marks to serve as extra letters, or by redefining the caps and mixing them in with lower case. Even the comma, period, colon, @, % and ampersand have been pressed into service as letters. The result is always a visual obstacle course and an orthographic cartoon, demeaning to the language it represents. Better by far to make new letters by using suitable diacritics, coining suitable digraphs and trigraphs (combinations such as ch, tl, tth) or by creating new characters from scratch. This is how the Latin alphabet has thrived. It is also the method employed by innovators such as Sequoyah (who created the Cherokee script around 1820) and James Evans (whose Cree and Ojibwa syllabic script, devised in the 1830s, was soon adopted and adapted for half a dozen other North American languages).

114

6.7.3 *Add only characters that are visually distinct.*

The texture of a typographic page depends not only on how the type is designed, set and printed, but also on the language, which determines the frequency of different letters. Latin looks smoother than English (and much smoother than German) because it uses fewer ascending and descending letters, no accented characters, and (in the hands of most editors) very few caps. Polynesian languages – Maori and Hawaiian, for example – which are long on vowels and short on consonants, compose into a texture even creamier than Latin, and require an even smaller alphabet.

Most languages need more, not fewer, consonantal characters than the basic Latin alphabet provides. Haida and Tlingit, for example, have four forms of *k*. Since each is lexically significant, each needs a character of its own. Ubykh, which was spoken until recently on the eastern shore of the Black Sea, had only two vowels but at least eighty consonants. The Khoekhoe language of southwest Africa has a modest 31 consonants, but twenty of these consonants are clicks, for which Latin has no established symbols at all.

In Latin script, vowels are easy to elaborate when need be; apart from *y*, the familiar symbols have no extenders. Navajo has twelve forms of *a* – a, aa, ą, ąą, á, áá, áa, aá, ą́, ą́ą́, ą́ą, ąą́ – but these are easily written and read. Typographically, it would be no problem to add another dozen forms.

Consonants are a greater challenge in Latin script, because their extenders get in the way of diacritics. Typographically deficient forms therefore often crop up. Lakhota, for example – the language of the Sioux – requires two forms of *h*. The missionary Stephen Riggs, who published the first Lakhota dictionary and grammar in 1852, marked the second *h* with an overdot: *ḣ*. This character is easily mistaken for *ḣ*. More recent Lakhota orthographies (including the Txakini system, developed by Violet Catches, a native speaker) replace Riggs's dotted *h* with *x*. This is easier to type. More importantly, it is harder to misread.

In the Tlingit language, spoken and written in southern Alaska, northern British Columbia and the Yukon, underscores are used to mark uvular consonants. This may be fine for k̲ and x̲; it is not so fine for g̲. A form like ġ or ǧ or ḡ, though less consistent, is more compact and, once again, harder to misread.

The desire for consistency was not the only factor that led earlier linguists to write g instead of ǧ. The Tlingit alphabet was

Choosing and Combining Type

*Dleit
ḵáach
tle tlél átx̱
ulyeix̱.*

—IX̱T'ÍK' ÉESH

developed, like many early twentieth-century writing systems, using only the keyboard of a North American typewriter. Recent Tlingit publications are typeset with computers using modified fonts of Palatino or Stone, but the iron metaphor of the typewriter has not yet loosed its hold.

New and Old Orthographies

All writing was done by hand in eighteenth-century Mexico, and one of the most impressive fonts ever made for a Native American language was cut there in 1785. It is based on an Otomí writing system devised around 1770 by the Franciscan missionary and linguist Antonio de Guadalupe Ramírez. The type itself was almost certainly cut by Jerónimo Gil and his students at the Academia de San Carlos in Mexico City. Until 1778, when he was assigned to the Mexican mint, Gil was working in Madrid, cutting type for the Biblioteca Real and the master printer Joaquín Ibarra. In 1781 he founded Mexico's first school of engraving.

As a tool of the missionary movement, this Otomí font was used only to transmit Spanish colonial values and ideas to the Otomí, not the other way around. Yet as a gesture of respect for human language, the font itself is still a landmark. (The swordmaker's art is not making war, it is making good swords – in the hope that the better the sword, the better the chance it will help those who touch it learn not to misuse it.)

It appears that the Ramírez font was cut in two sizes and that some characters from the larger size were inadvertently cast on the smaller body. Only one size is shown here (slightly reduced).

Part of the 20 pt Otomí font used in Antonio de Guadalupe Ramírez, *Breve compendio de todo lo que debe saber ... dispuesto en lengua othomí....* (Mexico: Imprenta Nueva Madrileña, 1785). The last two characters, representing nasal vowels, have only lowercase forms. The remainder – two more vowels and seven consonants – are shown as u&lc pairs.

6.7.4 *Don't mix faces haphazardly when specialized sorts are required.*

ʔaX̌'aqə́m is Upper Chehalis, meaning *you will emerge*; ɪntə-næʃənl fənɛɾɪks (*international phonetics*) is English.

If a text involves setting occasional words such as ʔaX̌'aqə́m or ɪntə-næʃənl fənɛɾɪks, it is best to plan for them from the beginning. Two standard phonetic alphabets – the international (IPA) and the Americanist – are widely used, but the extra characters involved have been cut for very few faces. (Huronia, Lucida Sans, Plantagenet, Stone and Times Roman are examples. Stone Phonetic – which is used here – exists in both serifed and unserifed forms.) The two best options are generally these: to set the entire text in

116

a face for which matching phonetic characters are available, so that phonetic transcriptions can enter the text transparently and at will; or to set the main text in a suitably contrasting face, and switch to the phonetic font (along with its matching text font, if required) each time a phonetic transcription occurs.

If contrasting faces are used for phonetic transcriptions and main text, each entire phonetic word or passage, not just the individual phonetic characters, should be set in the chosen phonetic face. Patchwork typography, in which the letters of a single word come from different faces and fonts, is not a solution. Forms such as ʻθatθɛɬi’ and ʻʔeθɔ́n heldéɬi’ (technical transcriptions of the Native Canadian language Chipewyan) or ʻϴraētona’ and ʻUsaδan’ (transcriptions of the ancient Iranian language Avestan) pose a challenge because they mix two alphabets *within a single word*. Such mixtures are almost sure to fail unless all the fonts involved have been designed as a single family. (In these examples, a unified Latin and Greek – Minion Pro – is used.)

Choosing and Combining Type

6.8 BUILDING A TYPE LIBRARY

6.8.1 *Choose your library of faces slowly and well.*

Some of the best typographers who ever lived had no more than one roman font at a time, one blackletter and one Greek. Others had as many as five or six romans, two or three italics, three blackletters, three or four Greeks. Today, the typographer can buy fonts by the thousand over the internet – more fonts than any human could use, yet never a complete selection.

With type as with philosophy, music and food, it is better to have a little of the best than to be swamped with the derivative, the careless, the routine.

The stock fonts supplied with software packages are sometimes generous in number, but they are the wrong fonts for many tasks and people, and most of them are missing essential parts (small caps, text figures, ligatures, diacritics and important analphabetics).

Begin by buying one good face or family, or a few related faces, with all the components intact. And instead of skipping from face to face, attempting to try everything, stay with your first choices long enough to learn their virtues and limitations before you move on.

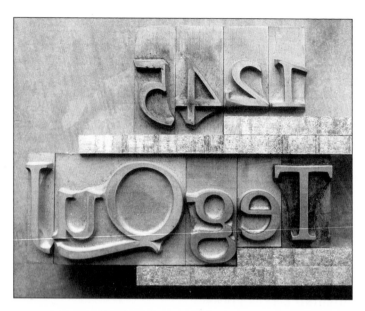

ABOVE: Some 72 pt foundry Palatino, with 12 pt leads. The descending letters are cast on 72 pt bodies, the nondescending on 60 pt bodies. Qu is cast as a ligature, and T is cast with a kern on the right side. BELOW: A 60 pt Michelangelo O, freshly cast on a 48 pt body. (The unit of measurement here is the Didot point, which is roughly 107% the size of the now standard PostScript point. See page 343 for details.)

7

Printing from movable type was first invented not in Germany in the 1450s, as Europeans often claim, but in China in the 1040s. In preference to Gutenberg, we should honor a scholarly engineer by the name of Bì Shēng (畢昇). The earliest surviving works printed in Asia from movable type seem to date from the thirteenth century, but there is a clear account of the typesetting process, and Bì Shēng's role in its development, by the eleventh-century essayist Shĕn Kuò (沈括).

The new technology reached Korea before the middle of the thirteenth century and Europe by the middle of the fifteenth. There it intersected the already long and fertile history of the roman letter. And there typesetting flourished as it had failed to do in China, because of the far smaller number of glyphs European scripts required. Even at the end of the nineteenth century, most printing in China was done by the same method used in the eighth century to make the first printed books: entire pages of text were carved by hand into wooden printing plates. Corrections were made by drilling out the error, installing a wooden plug, and cutting the new characters. Text, in other words, was treated just like woodcut illustrations. To this day, a page of type is known in Chinese as *huóbǎn* (活板), "a living plank."

Shĕn Kuò's account is contained in his *Mèngxī Bǐtán* (夢溪筆談), "Dream Creek Essays." For more, see Denis Twitchett, *Printing and Publishing in Medieval China* (1983) and Thomas F. Carter, *The Invention of Printing in China and Its Spread Westward* (2nd ed., 1955).

7.1 THE EARLY SCRIBAL FORMS

The earliest surviving European letterforms are Greek capitals scratched into stone. The strokes are bony and thin, almost ethereal – the opposite of the heavy substance they are carved in. The letters are made primarily from straight lines, and when curved forms appear, they have a very large *aperture*. This means that forms like S and C and M, which can be relatively open or relatively closed, are about as open as they can get. These early Greek letters were drawn freehand, not constructed with compasses and rule, and they have no serifs – neither the informal entry and exit strokes left by a relaxed and fluent writer, nor the symmetrical finishing strokes typically added to letters by a formal scribe.

In time, the strokes of these letters grew thicker, the aperture lessened, and serifs appeared. The new forms, used for inscriptions throughout the Greek empire, served as models for formal

lettering in imperial Rome. And those Roman inscriptional letters – written with a flat brush, held at an angle like a broadnib pen, then carved into the stone with mallet and chisel – have served in their turn as models for calligraphers and type designers for the past two thousand years. They have a modest aperture, a *modulated* stroke (a stroke whose thickness varies with direction), and they have lively but full and formal serifs.

A B C S P Q R

Trajan, designed by Carol Twombly in 1988, is based on the inscription at the base of Trajan's Column, Rome, carved in 113 CE.

Between the Roman inscriptions and Gutenberg's time, there were many further changes in European letterforms. Narrow rustic capitals, wide uncials and other forms evolved. Writing spread to the farthest corners of Europe, and many regional scripts and alphabets arose. Monastic scribes – who were designers, copyists and archivists as well – kept many of the older letterforms alive. They used them for titles, subheads and initials, choosing newer and more compact scripts for running text. Out of this rich multiplicity of letters, a basic dichotomy evolved: *majuscules* and *minuscules*: large formal letters and smaller, more casual ones: the upper and lower case, as we call them now.

C A R O L U S M A G N U S
Caroline or Carolingian means of the time
of the Emperor Charlemagne: «Big Charles».

Carol Twombly's Charlemagne (*top*), Gudrun Zapf-von Hesse's Alcuin (*middle*) and Gottfried Pott's Carolina (*bottom*) are typefaces based on Carolingian majuscules and minuscules from ninth- and tenth-century European manuscripts.

Many of the old scribal conventions survive in typesetting today. Titles are still set in large, formal letters; large initials mark the beginnings of chapters or sections; small capitals mark an opening phrase. The well-made page is now what it was then: a

window into history, language and the mind: a map of what is being said and a portrait of the voice that is silently speaking.

In the later Middle Ages and the early Renaissance, a well-trained European scribe might know eight or ten distinct styles of script. Each was defined as precisely as a typeface, stored like a font in the human memory, and each had certain uses. Sacred scriptures, legal documents, romance literature, business and personal letters all required different scripts, and particular forms evoked specific languages and regions.

Historical Interlude

When the technology of movable type arrived, Europe was rich with Gothic, Byzantine, Romanesque and humanistic hands, and with a wealth of older letters. They are all still with us in some way, but the humanistic hand, based on the Carolingian minuscule, has become the central form: the roman lower case, evolving into a thousand variations, sports and hybrids, like the willow or the rose.

7.2 THE TYPOGRAPHIC LATIN LETTER

Several systems are in use for classifying typefaces. Some of them use fabricated terms such as 'garalde' and 'didone.' Others rely on familiar but vague labels such as 'old style,' 'modern' and 'transitional.' All these systems work to a certain extent, but all leave much to be desired. They are neither good science nor good history.

Rigorously scientific descriptions and classifications of typefaces are certainly possible, and important research has been under way in this field for several years. Like the scientific study of plants and animals, the infant science of typology involves precise measurement, close analysis, and the careful use of technically descriptive terms.

But letterforms are not only objects of science. They also belong to the realm of art, and they participate in its history. They have changed over time just as music, painting and architecture have changed, and the same historical terms – Renaissance, Baroque, Neoclassical, Romantic, and so on – are useful in each of these fields.

The art history of Latin letterforms is treated in greater detail in a series of essays in *Serif* magazine, issues 1–5 (1994–97).

This approach to the classification of letterforms has another important advantage. Typography never occurs in isolation. Good typography demands not only a knowledge of type itself, but an understanding of the relationship between letterforms and the

other things that humans make and do. Typographic history is just that: the study of the relationships between type designs and the rest of human activity – politics, philosophy, the arts, and the history of ideas. It is a lifelong pursuit, but one that is informative and rewarding from the beginning.

7.2.1 The Renaissance Roman Letter

Renaissance roman letters developed among the scholars and scribes of northern Italy in the fourteenth and fifteenth centuries. Their translation from script to type began in Italy in 1465 and continued for more than a century. Like Renaissance painting and music, Renaissance letterforms are full of sensuous and unhurried

abcefgnopj
abcefgnopj
abcefgnopj
abcefgnopj

Four recent reconstructions of Renaissance roman typefaces. ¶ Centaur (*top*) was designed by Bruce Rogers, Boston, *c.* 1914, after Nicolas Jenson, Venice, 1469. ¶ Bembo (*second*) was cut by Monotype in 1929, based on the design of Francesco Griffo, Venice, 1495. ¶ Adobe Garamond Premier (*third*) was designed by Robert Slimbach, San Jose, in 1988 and revised in 2005, after Claude Garamond, Paris, *c.* 1540. ¶ Van den Keere (*bottom*) is Frank Blokland's reconstruction, made in the mid 1990s, of a font cut for Christophe Plantin by Hendrik van den Keere, Antwerp, in 1575.

light and space. They have served as typographic benchmarks for five hundred years.

The earliest surviving roman punches or matrices may well be Garamond's, cut in Paris in the 1530s. For earlier type, we have no evidence beyond the printed books themselves. The basic structure and form of these early typefaces is clear beyond dispute, but in their subtlest details, all the existing replicas of fifteenth-century Italian type are hypothetical reconstructions.

Like Roman inscriptional capitals, Renaissance roman lowercase letters speak of the tool as well as the grace and assurance with which they were once – and are still, in fact – written. They have a modulated stroke and a humanist axis. This means that the letters have the form produced by a broadnib pen held in the right hand in a comfortable and relaxed writing position. The thick strokes run NW/SE, revealing the axis of the writer's hand and forearm. The serifs are crisp, the stroke is light, and the contrast between thick strokes and thin strokes is generally modest.

In summary, the characteristics of the early Renaissance roman letter are these:

stems vertical
bowls nearly circular
modulated stroke
consistent humanist axis
modest contrast
modest x-height
crisp, oblique head serifs (on letters such as b *and* r)
abrupt, flat or slightly splayed bilateral foot serifs (on letters such as r, l *and* p)
abrupt, pen-formed terminals on the curved strokes of a, c, f, r
rising crossbar in e, *perpendicular to the stroke axis*
the roman font is solitary (there is no italic or bold)

In later Renaissance forms (from 1500 on), the letterforms grow softer, smoother and more self-contained in several ways:

• *head serifs become more wedge-shaped*
• *foot serifs become adnate (flowing smoothly into the stem) instead of abrupt*
• *terminals of* c, f *and* r *become less abrupt and more lachrymal (teardrop-shaped)*
• *crossbar of* e *becomes horizontal*

Rome is located in the midst of Italy. Why is roman type a category separate from italic? It seems a question to which typographers might possess the answer. But the question and the answer both have as much to do with politics and religion as with calligraphy and typography.

Roman type consists of two quite different basic parts. The upper case, which does indeed come from Rome, is based on Roman imperial inscriptions. The lower case was developed in northern Europe, chiefly in France and Germany, in the late Middle Ages, and given its final polish in Venice in the early Renaissance. Nevertheless, it too is Roman in the larger sense. While the roman upper case is a legacy of the Roman Empire, the lower case is a legacy of the Holy Roman Empire, the pagan empire's Christianized successor. It acquired its fundamental form at the hands of Christian scribes, many of them employed during the late eighth century as administrators and teachers by the Holy Roman Emperor Charlemagne.

Italic letterforms, on the other hand, are an Italian Renaissance creation. Some early italics come from Rome, others from elsewhere in Italy, and when they were first converted to type, italics were still full of local flavor and freshness. But the earliest italic fonts, cut between 1500 and 1540, consist of lower case only. They were used with upright roman caps but not in conjunction with the roman lower case.

abcefginoprxyz

abcefginoprxyz

Two revivals of Renaissance italic type. ¶ Monotype Arrighi (*top*) is derived from one of a pair of italics cut in Paris for Frederic Warde, 1925–29, after Ludovico degli Arrighi, Rome, 1524. ¶ Monotype Bembo italic (*bottom*) was cut in London in 1929, based on the work of both Arrighi and Giovanantonio Tagliente, Venice, 1524.

The characteristics of the Renaissance italic letter can be summarized as follows:

stems vertical or of fairly even slope, not exceeding 10°
bowls generally elliptical
light, modulated stroke
consistent humanist axis
low contrast
modest x-height
cursive forms with crisp, oblique entry and exit serifs
descenders serifed bilaterally or not at all
terminals abrupt or lachrymal
italic lower case paired with small, upright roman capitals,
and with occasional swash capitals; italic otherwise fully
independent of roman

Historical
Interlude

Early Renaissance italics are known as *Aldine* italics, in honor of the scholar and publisher Aldus Manutius, who commissioned the first italic type from Francesco Griffo in 1499. Strange to say, in 2012, not a single authentic reconstruction of an Aldine italic appears to be on the market, in either metal or digital form. Monotype Bembo roman and Monotype Poliphilus are both based on Griffo's work, but their companion italics are not; they come from a different age. The digital italic nearest to an Aldine in design is Giovanni Mardersteig's Dante italic, but even this has sloped instead of upright capitals.

Two Aldine italics are reproduced on page 210.

equbdaffglopsþz
abefop*abefop*

Two recent typefaces in the Mannerist tradition. ¶ Poetica (*top*) is a chancery italic based on sixteenth-century models. It was designed by Robert Slimbach and issued by Adobe in 1992. ¶ Galliard (*bottom*), designed by Matthew Carter, was issued by Linotype in 1978. It is based on letterforms cut in the sixteenth century by Robert Granjon.

7.2.3 *The Mannerist Letter*

Mannerist art is Renaissance art to which subtle exaggerations – of length, angularity or tension, for example – have been added. Mannerist typographers, working chiefly in Italy and France early in the sixteenth century, began the practice of using roman and italic in the same book, and even on the same page – though rarely on the same line. It was also during the Mannerist period that sloped roman capitals were first added to the italic lower case.

There are many fine sixteenth-century examples of Mannerist typefaces, including roman titling fonts with long, delicate extenders, chancery italics with even longer and often ornamented extenders, and text faces with short extenders but increased tension in the forms. Digital interpretations of a number of these faces have recently been made. Two significant examples – one ornate and one restrained – are shown on the previous page.

Letterforms in the Mannerist tradition are shown on page 125.

abefop*abefop*

abefop*abefop*

abefop*abefop*

abefop*abefop*

Four revivals of Baroque typefaces. ¶ Monotype 'Garamond' (*top*) is based on fonts cut in France by Jean Jannon, about 1621. ¶ Elzevir (*second*) is based on fonts cut by Christoffel van Dijck at Amsterdam in the 1660s. ¶ Linotype Janson Text (*third*) is based on fonts cut by Miklós Kis, Amsterdam, about 1685. ¶ Adobe Caslon (*bottom*), by Carol Twombly, is based on faces cut by William Caslon, London, in the 1730s.

7.2.4 *The Baroque Letter*

Baroque typography, like Baroque painting and music, is rich
with activity and takes delight in the restless and dramatic play
of contradictory forms. One of the most obvious features of any
Baroque typeface is the large *variation in axis* from one letter
to the next. Baroque italics are *ambidextrous*: both right- and
lefthanded. And it was during the Baroque that typographers
first made a habit of mixing roman and italic *on the same line*.

In general, Baroque letterforms appear more modeled and
less *written* than Renaissance forms. They give less evidence of
the direct trace of the pen. Yet they take many different forms,
and they thrived in Europe throughout the seventeenth century,
endured through much of the eighteenth, and enjoyed an enthu-
siastic revival during the nineteenth.

Baroque letterforms generally differ from Renaissance letters
in the following ways:

*stroke axis of the roman and italic lower case varies widely
within a single alphabet
slope of italic averages 15° to 20° and often varies considerably
within a single alphabet
contrast increased
x-height increased
aperture generally reduced
further softening of terminals from abrupt to lachrymal
roman head serifs become sharp wedges
head serifs of italic ascenders become level and sharp*

7.2.5 *The Rococo Letter*

The historical periods listed here – Renaissance, Baroque and
so on – belong to all the arts, and they are naturally not limited,
in typography, to roman and italic letters. Blackletter and script
types passed through the same phases as well. But the Rococo
period, with its love of florid ornament, belongs almost entirely
to blackletters and scripts.

Roman and italic type was certainly used by Rococo typogra-
phers, who often surrounded their texts with typographic orna-
ments, engraved medallions, and so on. They produced a good
deal of Rococo *typography*, but not much Rococo roman and italic
type. Several romans and italics that might indeed be classified

as Rococo were, however, cut in Amsterdam in 1738–39 by the German-born punchcutter Johann Michael Fleischman. Digital versions of these fonts have recently been released by the Dutch Type Library in 's-Hertogenbosch.

7.2.6 The Neoclassical Letter

Generally speaking, Neoclassical art is more static and restrained than either Renaissance or Baroque art, and far more interested in rigorous consistency. Neoclassical letterforms follow this pattern. In Neoclassical letters, an echo of the broadnib pen can still be seen, but it is rotated away from the natural writing angle to a strictly vertical or *rationalist* axis. The letters are moderate in contrast and aperture, but their axis is dictated by an idea, not by the truth of human anatomy. They are products of the Rationalist era: frequently beautiful, calm forms, but forms oblivious to the more complex beauty of organic fact. If Baroque letterforms are ambidextrous, Neoclassical letters are, in their quiet way, *neitherhanded*.

The first Neoclassical typeface, known as the *romain du roi*

Though he was born and trained in Germany, Fleischman moved to the Netherlands before his 30th birthday and remained there the rest of his life. *Fleischmann* is the normal German spelling of his name; the Dutch form *Fleischman* is the one he chose to use in all his published specimens. The best digital versions of Fleischman's type are published in the Netherlands, but they were created by the German type designer Erhard Kaiser, who christened them *Fleischmann*.

abcefgnopy

CEFOTZ

abcefgnopy

DTL Fleischmann. Note the ornate forms of *g, y* and several of the capitals, and the exaggerated contrast in italic *o*. This exaggerated contrast is typical of the Romantic types cut by Firmin Didot and Giambattista Bodoni after Fleischman's death in 1768. But Romantic types have an obsessively vertical axis. The primary axis of Fleischman's type is oblique. Structurally, these letters belong to the Baroque. But their tendency to ornamentation and exaggeration sets them apart: they are Rococo.

or King's Roman, was designed in France in the 1690s, not by a typographer but by a government committee consisting of two priests, an accountant and an engineer. Other Neoclassical faces were designed and cut in France, England, Italy and Spain during the eighteenth and nineteenth centuries, and some of them have remained in continuous use throughout all subsequent changes of style and fashion.

The American printer and statesman Benjamin Franklin deeply admired the Neoclassical type of his English contemporary John Baskerville, and it is partly due to Franklin's support that Baskerville's type became more important in the United States and France than it ever was in Baskerville's native land. But the connection between Baskerville and America rests on more than Benjamin Franklin's personal taste. Baskerville's letters correspond very closely to the federal style in American architecture. They are as purely and unperturbably Neoclassical as the Capitol Building, the White House, and many another federal and state edifice. (The Houses of Parliament in London and in Ottawa, which are Neogothic instead of Neoclassical, call for typography of a different kind.)

abefop*abefop*

abefop*abefop*

abefop*abefop*

Three twentieth-century revivals of Neoclassical letterforms. ¶ Top: Monotype Fournier, which is based on types cut by Pierre-Simon Fournier, Paris, about 1740. Fournier is closer to the Baroque than any other Neoclassical punchcutter. ¶ Middle: Monotype Baskerville, which is based on the designs of John Baskerville, Birmingham, about 1754. ¶ Bottom: Monotype Bell, based on the types cut in London in 1788 by Richard Austin for the typefounder and publisher John Bell.

In brief, Neoclassical letterforms differ from Baroque letters as follows:

- *predominantly vertical axis in both roman and italic*
- *slope of italic generally uniform, averaging 14° to 16°*
- *serifs generally adnate, but thinner, flatter, more level*

7.2.7 The Romantic Letter

Neoclassicism and Romanticism are not sequential movements in European history. They marched through the eighteenth century and much of the nineteenth side by side: vigorously opposed in some respects and closely united in others. Both Neoclassical and Romantic letterforms adhere to a rationalist axis, and both look much more drawn than written, but it is possible to make some precise distinctions between the two. The most obvious

Four revivals of Romantic letterforms. ¶ Monotype Bulmer (*top*), with its asymmetrical italic *o*, is based on a series of fonts William Martin cut in. London in the early 1790s. ¶ Linotype Didot (*second*), drawn by Adrian Frutiger, is based on fonts Firmin Didot cut in Paris between 1799 and 1811. ¶ Bauer Bodoni (*third*) is based on fonts cut by Giambattista Bodoni at Parma between 1803 and 1812. ¶ Berthold Walbaum (*bottom*) is based on types cut by Justus Erich Walbaum, Weimar, about 1805.

difference is one of contrast. In Romantic letters we will normally find the following:

abrupt modulation of the stroke
vertical axis intensified through exaggerated contrast
hardening of terminals from lachrymal to round
serifs thinner and more abrupt
aperture reduced

This remarkable shift in type design – like all structural shifts in type design – is the record of an underlying change in handwriting. Romantic letters are forms from which the broadnib pen has vanished. In its place is the pointed and flexible quill. The broadnib pen produces a smoothly modulated stroke whose thickness varies with direction, but the pointed quill performs quite differently. The stroke of a flexible quill shifts suddenly from thin to thick to thin again, in response to changes in pressure. Used with restraint, it produces a Neoclassical flourish. Used with greater force, it produces a more dramatic and Romantic one. Dramatic contrast, which is essential to much Romantic music and painting, is essential to Romantic type design as well.

Romantic letters can be extraordinarily beautiful, but they lack the flowing and steady rhythm of Renaissance forms. It is that rhythm which invites the reader to enter the text and read. The statuesque forms of Romantic letters invite the reader to stand outside and *look* at the letters instead.

In Romantic italics, the stroke width is usually greatest at the lower left and upper right of the bowl (as in Bulmer, above) – as if the sloping letter had been made with the shaft of the pen pointing north, not northeast, and the nib horizontal. That is to say, the axis of the *stroke* is vertical, even though the letterform is tilted. If the axis were oblique, the stroke would be thickest halfway down each side (as in Fleischmann, below).

7.2.8 *The Realist Letter*

The nineteenth and twentieth centuries entertained a bewildering variety of artistic movements and schools – Realism, Naturalism, Impressionism, Expressionism, Art Nouveau, Art Deco, Constructivism, Cubism, Abstract Expressionism, Pop Art, Op Art, and many more. Virtually all of these movements have raised waves in the typographic world as well, though not all are important enough to merit a place in this brief survey. One of these movements – one which has not by any means yet expired – is typographic Realism.

The Realist painters of the nineteenth century – Gustave Courbet, François Millet and many others – turned their backs on the subjects and poses approved by the academy. They set out instead to paint ordinary people doing their ordinary tasks. Realist type designers – Alexander Phemister, Robert Besley and others, who

have not achieved the posthumous fame of the painters – worked in a similar spirit. They made blunt and simple letters, based on the script of people denied the opportunity to learn to read and write with fluency and poise. Realist letters very often have the same basic shape as Neoclassical and Romantic letters, but most of them have heavy, slab serifs or no serifs at all. The stroke is often uniform in weight, and the aperture (often a gauge of grace or good fortune in typefaces) is tiny. Small caps, text figures and other signs of sophistication and elegance are usually missing – and if present are usually later additions by another hand.

7.2.9 *Geometric Modernism: The Distillation of Function*

Early modernism took many intriguing typographic forms. One of the most obvious is geometric. The sparest, most rigorous architecture of the early twentieth century has its counterpart in the equally geometric typefaces designed at the same time, often by the same people. These typefaces, like their Realist predecessors, make no distinction between main stroke and serif. Their serifs are equal in weight with the main strokes or are missing altogether. But most Geometric Modernist faces seek purity more than populism. Some show the study of archaic inscriptions, and some include text figures and other subtleties, but their shapes owe more to pure mathematical forms – the circle and the line – than to scribal letters.

abcefgnop
abcefgnop

Two Realist faces. ¶ Akzidenz Grotesk (*top*) was issued by the Berthold Foundry, Berlin, in 1898. It is the immediate ancestor of Morris Benton's Franklin Gothic (1903) and of Helvetica, issued by the Haas Foundry in 1957. ¶ Haas Clarendon (*bottom*), designed in 1951 by Hermann Eidenbenz, is a revival of an earlier Realist face, the first Clarendon, cut by Benjamin Fox for Robert Besley, London, 1845.

7.2.10 *Lyrical Modernism: The Rediscovery of Humanist Form*

Another major phase of modernism in type design is closely
allied with Abstract Expressionist painting. Painters in the twen-
tieth century rediscovered the physical and sensory pleasures of
painting as an act, and the pleasures of making organic instead
of mechanical forms. Designers of type during those years were
equally busy rediscovering the pleasures of *writing* letterforms
rather than drawing them. In rediscovering calligraphy, they
rediscovered the broadnib pen, the humanist axis and humanist
scale of Renaissance letters. Typographic modernism is funda-
mentally the reassertion of Renaissance form. There is no hard
line between modernist design and Renaissance revival.

Examples of
Lyrical Modern-
ist letterforms
are shown
overleaf.

7.2.11 *The Expressionist Letter*

In yet another of its aspects, typographic modernism is rough and
concrete more than lyrical and abstract. Rudolf Koch, Vojtěch
Preissig and Oldřich Menhart are three designers who explored
this path in the early part of the twentieth century. They are
in some respect the typographic counterparts of Expressionist
painters such as Vincent van Gogh and Oskar Kokoschka. More
recent painters and type designers, such as Zuzana Ličko, have
proven that the genre is still richly productive.

Expressionist designers use many different tools. Koch and

abcefgnop
abcefgnop

Two Geometric Modernist typefaces. ¶ Futura (*top*) was designed in
Germany in 1924–26 by Paul Renner. The original design included text
figures and many highly geometric, alternative characters which were
never issued in metal, though The Foundry (London) issued a selection
of them in digital form in 1994. ¶ Memphis (*bottom*) was designed in
1929 by Rudolf Wolf, art director at the Stempel Foundry.

Preissig often cut their own letters in metal or wood. Menhart worked with a pen and rough paper. Ličko has exploited the harsh economies of digital plotting routines, slicing from control point to control point not with a knife, file or chisel but with digitized straight lines.

7.2.12 *Elegiac Postmodernism*

Modernism in type design has its roots in the study of history, the love of pure geometry, the facts of human anatomy, and the pleasures of calligraphy. Like the Renaissance itself, modernism is more than a phase or fad that simply runs its course and expires. It remains very much alive in the arts generally and in type design in particular, though it no longer seems the final word. In the last decades of the twentieth century, critics of architecture, literature

abefop*abefop*

abefop*abefop*

abefop*abefop*

abefop*abefop*

Four neohumanist or Lyrical Modernist faces. ¶ Spectrum (*top*) was designed by Jan van Krimpen in the Netherlands during the 1940s and issued by both Enschedé and Monotype in 1952. ¶ Palatino (*second*) was designed by Hermann Zapf, Frankfurt, 1948–50, and issued by both Stempel and Linotype. ¶ Dante (*third*) was designed by Giovanni Mardersteig, Verona, 1952. ¶ Pontifex (*bottom*) was designed by Friedrich Poppl, Wiesbaden, 1974–6. All but the last were originally cut by hand in steel, like the Renaissance faces that stand behind them.

and music – along with others who study human affairs – all perceived movements away from modernism. Lacking any proper name of their own, these movements came to be called by the single term postmodernism. And postmodernism is as evident in the world of type design as it is in other fields.

Postmodern letterforms, like postmodern buildings, frequently recycle and revise Neoclassical, Romantic and other premodern forms. At their best, they do so with an engaging lightness of touch and a fine sense of humor. Postmodern art is for the most part highly self-conscious, but devoutly unserious. Postmodern designers – who frequently are or have been modernist designers as well – have proven that it is possible to infuse Neoclassical and Romantic form, and the rationalist axis, with genuine calligraphic energy.

abcefghijop
abefop*abefop*

Above: Two Expressionist types – one modernist and one postmodern. Preissig (*top*) was designed in New York in 1924 by the Czech artist Vojtěch Preissig. It was cut and cast in Prague in 1925. Zuzana Ličko's Journal (*bottom*) was designed in Berkeley in 1990 and issued in digital form by Emigre. ¶ *Below*: Two postmodern faces. Esprit (*top*) was designed by Jovica Veljović, Beograd, 1985. Nofret (*bottom*) was designed by Gudrun Zapf-von Hesse, Darmstadt, in 1984. Both types sing, where many postmodern faces merely screech. But the song is elegiac more than lyrical.

abefop*abefop*
abefop*abefop*

Some postmodern faces are highly geometric. Like their predecessors the Geometric Modernist faces, they are usually slab-serifed or unserifed, but often they exist in both varieties at once or are hybrids of the two. They are rarely, it seems, based on the pure and simple line and circle, but almost always on more mannered, often asymmetric forms. And like other postmodern types, they are rich with nostalgia for something premodern. Many of these faces are indebted to older industrial letterforms, including typewriter faces and the ubiquitous factory folk-art of North American highway signs. They recycle and revise not Romantic and Neoclassical but Realist ideas. To this industrial unpretentiousness, however, they often add not only postmodern humor but also the fruits of typographic sophistication: text figures, small caps, large aperture, and subtle modeling and balancing of forms.

Postmodern art, like Neoclassical art, is above all an art of the surface: an art of reflections rather than visions. It has thrived in the depthless world of high-speed offset printing and digital design, where modernism starves. But the world of the scribes, in which the craft of type design is rooted, was a depthless world too. It was the world of the Gothic painters, in which everything is present in one plane. In that respect at least, postmodernism and modernism alike confront the basic task with which typography began. That is the task of answering in two (or little more than two) dimensions to a world that has many.

abefop*abefop*

abefop*abefop*

Two Geometric Postmodern faces: Triplex Sans (*top*) and Officina Serif (*bottom*). Triplex italic was designed by John Downer in 1985. Its companion romans – one with serifs, one without – were designed by Zuzana Ličko in 1989–90, and the full *ménage à trois* was issued in 1990 by Emigre. Officina (ITC, 1990) was designed by Erik Spiekermann. It exists in both serifed and unserifed versions.

7.3.1 *The Linotype Machine*

The Linotype machine, invented in the 1880s by Ottmar Mergenthaler and much modified over the years, is a kind of cross between a casting machine, a typewriter, a vending machine and a backhoe. It consists of a series of slides, belts, wheels, lifts, vises, plungers and screws, controlled from a large mechanical keyboard. Its complex mechanism composes a line of matrices, justifies the line by sliding tapered wedges into the spaces between the words, then casts the entire line as a single metal slug for letterpress printing.

For a good account of the growth of mechanized typesetting, see Richard E. Huss, *The Development of Printers' Mechanical Typesetting Methods* (1973).

Typeface design for the Linotype was restricted by three basic factors. First, kerning is impossible without special compound matrices. (The basic italic *f* in a Linotype font therefore always has a stunted head and tail.) Second, the em is divided into only 18 units, which discourages subtlety of proportion. Third, the italic and roman matrices are usually paired. In most faces, each italic letter must therefore have the same width as its counterpart in roman.

A number of typefaces designed for the Linotype were artistically successful in spite of these constraints. Hermann Zapf's Aldus and Optima, Rudolph Růžička's Fairfield, Sem Hartz's Juliana, and W. A. Dwiggins's Electra, Caledonia and Falcon were all designed for the Linotype machine. Linotype Janson, adapted by Zapf in 1952 from the seventeenth-century originals of Miklós Kis, is another eminent success. Many Linotype faces have nevertheless been modified in the course of digitization, to make use of the kerning capabilities of digital machines and restore the independent proportioning of roman and italic.

7.3.2 *The Monotype Machine*

In 1887, in competition with Mergenthaler, Tolbert Lanston created a machine that stamped individual letters in cold metal and assembled them into lines. This device was soon abandoned for another – built in 1900 by Lanston's colleague John Bancroft – that cast individual letters from molten metal rather than cold-stamping them. It was soon sold worldwide as the Monotype machine. It is two machines in fact, a terminal and an output device, and in this respect resembles most computer-driven type-

setting machines. But the Monotype terminal carries a large mechanical keyboard, including seven full alphabets as well as analphabetics. The keyboard punches holes in a paper tape, like a narrow player-piano roll, by driving pins with compressed air. The output device is the caster, which reads the paper tape by blowing more compressed air through the punched holes, then casts and assembles the letters.

The Monotype em, like the Linotype em, is divided into only 18 units, but italic and roman are independent in width, kerning is possible, and because the type remains in the form of separate letters, typeset lines can be further adjusted by hand. Characters larger than 24 pt are cast individually and left for hand assembly. In fact, the Monotype machine is a portable typefoundry as much as it is a composing machine – and it is increasingly used as such, even though its unit system imposes restrictions on letterform design, and it is incapable of casting in hard metal.

7.3.3 *Two-Dimensional Printing*

From the middle of the fifteenth century to the middle of the twentieth, most roman letters were printed by a technique rooted in sculpture. In this process, each letter is carved at actual size on the end of a steel punch. The punch is then struck into a matrix of softer metal, the matrix is fitted into a mold, and three-dimensional metal type is cast from an alloy of lead, tin and antimony. The cast letters are locked in a frame and placed in a printing press, where they are inked. Their image is then imprinted *into* the paper, producing a tactile and visual image. The color and sheen of the ink join with the smooth texture of crushed paper, recessed into the whiter and rougher fibers surrounding the letters and lines. A book produced by this means is a folding inscription, a flexible sculpture in low relief. The black light of the text *shines out from within* a well-printed letterpress page.

Renaissance typographers reveled in the physical depth and texture they could achieve by this method of printing. Neoclassical and Romantic printers, like Baskerville, often took a different view. Baskerville printed his sheets by letterpress – since he had no other method – but then had them ironed like laundry to remove the sculptural tinge.

With the development of lithography, at the end of the eighteenth century, printing moved another step back toward the two-dimensional world of the medieval scribes. Since the middle

of the twentieth century, most commercial printing has been by two-dimensional means. The normal method is offset photo-lithography, in which a photographic or digital image is etched into a plate, inked, *offset* to a smooth intermediary blanket, then laid flat on the surface of the page.

In the early days of commercial offset printing, type was still set with Linotype or Monotype machines. Proofs were pulled in a letterpress, then cut, pasted and photographed. Type designers saw their work altered by this process. Most letters designed to be printed in three dimensions look weaker when printed in two. But other letters prospered: geometric letters, which evoked the world of the draftsman rather than the goldsmith, and flowing letters recalling the heritage of the scribe.

7.3.4 *Phototype Machines*

Light flashes through the image of a letter carried on glass or photographic film; the size of the letter is altered with a lens; its target location is fixed by a mirror, and it is exposed like any other photographic image onto photosensitive paper or film. Machines that operate on this principle are the natural children of the camera and the offset press. They were designed and pat-ented in the 1890s and were in regular use for setting titles and headlines by 1925, though it was not until the 1960s that they came to dominate the trade.

Just as the sophistication and subtlety of handset type seemed at first to be swept aside when composing machines appeared, so the sophistication slowly achieved with Linotype and Monotype machines seemed to be swept aside by this new technological wave. The photosetters were fast, but they knew nothing of subtle changes in proportion from size to size. Their fonts lacked liga-tures, text figures and small caps. American-made fonts lacked even the simplest accented characters. The choice of faces was poor. And with the sudden, widespread use of these complex but simplistic machines came the final collapse of the old craft system of apprenticeships and guilds.

Phototypesetting machines and their users had only begun to answer these complaints when digital equipment arrived to replace them. Some excellent faces were designed for phototype machines – from Adrian Frutiger's Apollo (1962) to Bram de Does's Trinité (1982) – but in retrospect, the era of phototype seems only a brief interregnum between hot metal and digital

composition. The important innovation of the period was not, after all, the conversion of fonts from metal to film, but the introduction of microcomputers to edit, compose and correct the text and to drive the last generations of photosetting machines.

7.3.5 *Historical Recutting and Twentieth-Century Design*

New typefaces have been designed in vast numbers in the past hundred years, and many old ones have been resuscitated. From 1960 to 1980, most new types and revivals were designed for photosetting, and since 1980, almost all have been planned for digital composition. But most of the older faces now sold in digital form have already passed through another stylistic filter. They were recut in the early twentieth century, either as foundry type or as matrices for the Monotype or Linotype machines. Typography was radically reformed between 1920 and 1950, through the commercial reinvention of typographic history. It is worth looking back at this process to see something of what went on, because its legacy affects us still.

Two separate companies – one based in England, one in America – rose up around the Monotype machine and followed two quite separate development programs. The English company, advised during its heyday by a brilliant scholar named Stanley Morison (1889–1967), cut a series of facsimiles based on the work of Francesco Griffo, Giovanantonio Tagliente, Ludovico degli Arrighi and other early designers. It was Morison who conceived the idea of turning independent Renaissance faces into families by mating one designer's roman with another's formerly self-sufficient italic. The fruits of this enterprise included Poliphilus and Blado (one of Griffo's romans mated with an altered version of one of Arrighi's italics), Bembo (a later version of the same roman, paired with an altered version of one of Tagliente's italics), and the brilliantly successful shotgun marriage of Centaur roman (designed by Bruce Rogers) with the Arrighi italic (designed by Frederic Warde). This program was supplemented by commissioning new faces from artists such as Eric Gill, Alfred Fairbank, Jan van Krimpen and Berthold Wolpe.

Lanston Monotype, as the American company was called, made some historical recuttings of its own and issued many new and historically based faces designed by its own advisor, Frederic Goudy. Other, less systematic campaigns to recreate typographic history in marketable form were mounted by the British arm

of Linotype, under the direction of the English master printer George W. Jones, and by Robert Hunter Middleton at Ludlow Typograph in Chicago.

Several of the larger typefoundries – including ATF (American Type Founders) in the United States, Deberny & Peignot in France, Enschedé in the Netherlands, Stempel in Germany and Grafotechna in Czechoslovakia – continued ambitious programs of their own, lasting in some cases into the 1980s. Revivals of faces by Claude Garamond, Miklós Kis and other early designers came from these foundries during the twentieth century, along with important new faces by designers such as Hermann Zapf, Jan van Krimpen, Adrian Frutiger, Oldřich Menhart and Hans Eduard Meier. Zapf's Palatino, which became the most widely used (and most widely pirated) face of the twentieth century, was cut in steel and cast as a foundry type in 1949–50, while phototype machines and a few cumbersome early computers were humming no great distance away.

Historical Interlude

The earlier history of type design is the history of forms made by individual artists and artisans who began their careers as apprentices and ended them as independent masters and small businessmen. The scale of the industry enlarged in the seventeenth and eighteenth centuries, and questions of fashion increasingly superseded questions of artistry. By the end of the nineteenth century, commercial considerations had changed the methods as well as the taste of the trade. Punches and matrices were increasingly cut by machine from large pattern letters, and calligraphic models were all but unknown.

The twentieth-century rediscovery of the history and principles of typographic form was not associated with any particular technology. It occurred among scholars and artists who brought their discoveries to fruition wherever they found employment: in typefoundries, typesetting-machine companies, art schools and their own small, independent studios.

Despite commercial pressures, the best of the old metal foundries, like the best of the new digital ones, were more than merely market-driven factories. They were cultural institutions, on a par with fine publishing houses and the ateliers of printmakers, potters, weavers and instrument makers. What made them so was the stature of the type designers, living and dead, whose work they produced – for type designers are, at their best, the Stradivarii of literature: not merely makers of salable products, but artists who design and make the instruments that other artists use.

7.3.6 *Digital Typography*

It is much too soon to summarize the history of digital typography, but the evolution of computerized bitmapping, hinting and scaling techniques has proceeded very quickly since the development of the microchip at the beginning of the 1970s. At the same time, the old technologies, freed from commercial duties, have by no means died. Foundry type, the Monotype, the Linotype and letterpress remain important artistic instruments, alongside brush and chisel, pencil, graver and pen.

Typographic style is founded not on any one technology of typesetting or printing, but on the primitive yet subtle craft of writing. Letters derive their form from the motions of the human hand, restrained and amplified by a tool. That tool may be as complex as a digitizing tablet or a specially programmed keyboard, or as simple as a sharpened stick. Meaning resides, in either case, in the firmness and grace of the gesture itself, not in the tool with which it is made.

7.4 THE PLURALITY OF TYPOGRAPHIC HISTORY

Every alphabet is a culture. Every culture has its own version of history and its own accumulation of tradition – and this chapter has dwelt on the recent history of one alphabet only. The Arabic, Armenian, Burmese, Cherokee, Cree, Cyrillic, Devanagari, Georgian, Greek, Gujarati, Hebrew, Japanese, Korean, Malayalam, Tamil and Telugu alphabets and syllabaries – to name only a few – have other histories of their own, in some cases every bit as intricate and long as – or longer than – the history of Latin letterforms. So, of course, has the logographic script of Chinese. These histories have touched at certain points, diverged at others. Here at the beginning of the twenty-first century, a remarkable degree of convergence can be seen. But the challenge and excitement of multilingual typography still lies largely in the fact that different typographic histories momentarily share the page. Typographers working with multiple alphabets are multiply blessed: with a chance to learn the cultural history as well as the typographic technicalities of every script concerned.

The histories of Greek and Cyrillic types are taken up more briefly in chapter 11, and the legacies of some individual typefoundries are summarized in appendix E, page 361.

A book is a flexible mirror of the mind and the body. Its overall size and proportions, the color and texture of the paper, the sound it makes as the pages turn, and the smell of the paper, adhesive and ink, all blend with the size and form and placement of the type to reveal a little about the world in which it was made. If the book appears to be only a paper machine, produced at their own convenience by other machines, only machines will want to read it.

8.1 ORGANIC, MECHANICAL & MUSICAL PROPORTION

A page, like a building or a room, can be of any size and proportion, but some proportions and sizes turn out to be distinctly more pleasing than others to most human beings, and some have quite specific connotations. A brochure that unfolds and refolds in the hand is intrinsically different from a formal memorandum or report that lies motionless and flat, or a handwritten note that folds into quarters and comes in an envelope of distinctive shape and size. All of these are different again from a book, in which the pages flow sequentially in pairs – or are supposed to flow. A book that is too stiffly bound, as most paperbacks are, always has to be pushed.

Much typography is based, for the sake of convenience, on standard industrial paper sizes, from 35 × 45 inch press sheets to 3½ × 2 inch conventional business cards. Some formats, such as the booklets that accompany compact discs, are condemned to especially rigid restrictions of size. But many typographic projects begin with the opportunity and necessity of selecting the dimensions of the page.

There is rarely a free choice. A page size of 12 × 19 inches, for example, is likely to be both inconvenient and expensive because it is just in excess of 11 × 17, which is a standard industrial unit. And a brochure that is 5 × 9 inches, no matter how handsome, might be unacceptable because it is too wide to fit into a standard business envelope (4×9½). But when the realm of practicality has been established, and it is known that the page must fall within certain limits, how is one to choose? By taking whatever is easiest, or biggest, or whatever is the most convenient standard size? By trusting to blind instinct?

Instinct, in matters such as these, is largely memory in disguise. It works quite well when it is trained, and poorly otherwise. But in a craft like typography, no matter how perfectly honed one's instincts are, it is useful to be able to calculate answers exactly. History, natural science, geometry and mathematics are all relevant to typography in this regard – and can all be counted on for aid.

Scribes and typographers, like architects, have been shaping visual spaces for thousands of years. Certain proportions keep recurring in their work because they please the eye and the mind, just as certain sizes keep recurring because they are comfortable to the hand. Many of these proportions are inherent in simple geometric figures – equilateral triangle, square, regular pentagon, hexagon and octagon. And these proportions not only seem to please human beings in many different centuries and countries, they are also prominent in nature far beyond the human realm. They occur in the structures of molecules, mineral crystals, soap bubbles, flowers, as well as books and temples, manuscripts and mosques.

The tables on pages 148–9 list a number of page proportions derivable from simple geometric figures. These proportions occur repeatedly in nature, and pages that embody them recur in manuscripts and books from Renaissance Europe, Táng and Sòng dynasty China, early Egypt, Precolumbian Mexico and ancient Rome. It seems that the beauty of these proportions is more than a matter of regional taste or immediate fashion. They are therefore useful for two purposes. Working and playing with them is a way of developing good typographic instincts, and they serve as useful references in analyzing old designs and calculating new ones.

For comparison, several other proportions are included in the tables. There are several simple numerical ratios, several standard industrial sizes, and several proportions involving four irrational numbers important in the analysis of natural structures and processes. These numbers are $\pi = 3.14159\ldots$, which is the circumference of a circle whose diameter is one; $\sqrt{2} = 1.41421\ldots$, which is the diagonal of a unit square; $e = 2.71828\ldots$, which is the base of the natural logarithms; and $\varphi = 1.61803\ldots$, a number discussed in greater detail on page 155. Certain of these proportions reappear in the structure of the human body; others appear in musical scales. Indeed, one of the simplest of all systems of page proportions is based on the familiar intervals of the diatonic scale. Pages that embody these basic musical proportions have been in common use in Europe for more than a thousand years.

*Organic,
Mechanical
and Musical
Proportion*

Two very useful works on natural form and structure are D'Arcy Thompson, *On Growth and Form* (rev. ed., 1942) and Peter S. Stevens, *Patterns in Nature* (1974). An equally important book on structures made by humans is Dorothy Washburn & Donald Crowe, *Symmetries of Culture: Theory and Practice of Plane Pattern Analysis* (1988).

Sizing and spacing type, like composing and performing music or applying paint to canvas, is largely concerned with intervals and differences. As the texture builds, precise relationships and very small discrepancies are easily perceived. Establishing the overall dimensions of the page is more a matter of limits and sums. In this realm, it is usually sufficient, and often it is better, if structural harmony is not so much enforced as implied. That is one of the reasons typographers tend to fall in love with books. The pages flex and turn; their proportions ebb and flow against the underlying form. But the harmony of that underlying form is no less important, and no less easy to perceive, than the harmony of the letterforms themselves.

The page is a piece of paper. It is also a visible and tangible proportion, silently sounding the thoroughbass of the book. On it lies the textblock, which must answer to the page. The two together – page and textblock – produce an antiphonal geometry. That geometry alone can bond the reader to the book. Or conversely, it can put the reader to sleep, or put the reader's nerves on edge, or drive the reader away.

The textblock is known in Chinese as *yèxīn* (頁心), a useful phrase. *Yè* means 'page'; *xīn* means 'heart and mind.'

Arithmetic and mathematics also drive away some readers, and this is a chapter peppered with both. Readers may well ask whether all this is necessary, merely in order to choose where some letters should sit on a piece of paper and where the paper itself should be trimmed. The answer, naturally, is no. It is not in the least necessary to understand the mathematics in order to perform the actions that the math describes. People walk and ride bicycles without mathematical analyses of these complex operations. The chambered nautilus and the snail construct perfect logarithmic spirals without any need of logarithmic tables, sliderules or the theory of infinite series. The typographer likewise can construct beautiful pages without knowing the meaning of symbols like π or φ, and indeed without ever learning to add and subtract, if he has a well-educated eye and knows which buttons to push on the calculator and keyboard.

The mathematics are not here to impose drudgery upon anyone. On the contrary, they are here entirely for pleasure. They are here for the pleasure of those who like to examine what they are doing, or what they might do or have already done, perhaps in the hope of doing it still better. Those who prefer to act directly at all times, and to leave the analysis to others, may be content in this chapter to study the pictures and skim the text.

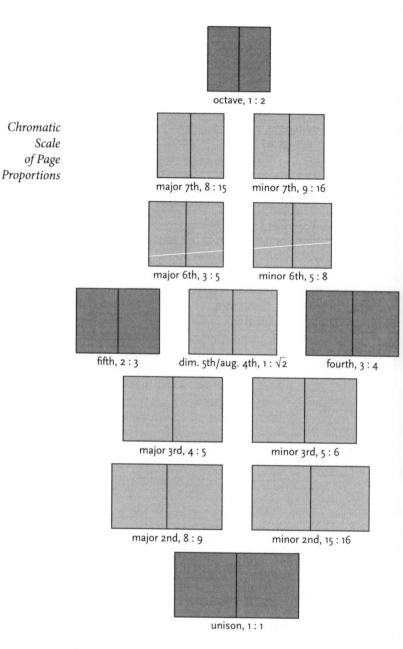

octave, 1 : 2

major 7th, 8 : 15 minor 7th, 9 : 16

major 6th, 3 : 5 minor 6th, 5 : 8

fifth, 2 : 3 dim. 5th/aug. 4th, 1 : √2 fourth, 3 : 4

major 3rd, 4 : 5 minor 3rd, 5 : 6

major 2nd, 8 : 9 minor 2nd, 15 : 16

unison, 1 : 1

Page proportions corresponding to the chromatic scale, from unison (at
the bottom) to octave (at the top). The musical correlations are shown
in detail on the facing page.

octave	1 : 2	1 : 2	c – c′	*double square*
major 7th	8 : 15	1 : 1.875	c – b	
minor 7th	9 : 16	1 : 1.778	c – b♭	*narrow*
major 6th	3 : 5	1 : 1.667	c – a	*books*
minor 6th	5 : 8	1 : 1.6	c – a♭	~ 1 : φ
fifth	2 : 3	1 : 1.5	c – g	
dim. 5th / aug. 4th	1 : √2	1 : 1.414	c – g♭ / c – f♯	*self-replicating page*
fourth	3 : 4	1 : 1.333	c – f	
major 3rd	4 : 5	1 : 1.25	c – e	~ φ : 2
minor 3rd	5 : 6	1 : 1.2	c – e♭	*wide*
major 2nd	8 : 9	1 : 1.125	c – d	*books*
minor 2nd	15 : 16	1 : 1.067	c – d♭	
unison	1 : 1	1 : 1	c – c	*square page*

The value for the diminished 5th/augmented 4th is calculated here according to the system of equal temperament. All other intervals are calculated according to the system of just intonation. The proportions 5:8 and 4:5 are good approximations but not exact equivalents of 1:φ and φ:2.

Page shapes derived from the chromatic scale. Two-page spreads that embody these proportions are shown on the facing page.

The perfect intervals (fifth and fourth) coincide exactly with the favorite page shapes of the European Middle Ages, which are still in use today: the page proportions 2 : 3 and 3 : 4. Renaissance typographers made extensive use of narrower pages, corresponding to the larger impure intervals (major and minor sixth, major and minor seventh).

Each page shape has a counterpart with which it alternates. If a sheet whose proportions are 5 : 8 is folded in half, it produces a sheet whose proportions are 4 : 5. If this is folded once again, it produces another sheet whose proportions are 5 : 8. In the same way, the proportion 1 : 2 alternates with the proportion 1 : 1. The proportion 1 : √2, corresponding to the diminished fifth/augmented fourth of equal temperament, is the only one that alternates with itself.

In musical terms, these alternating proportions form harmonic inversions. (The harmonic inversion of a fifth, for example, is a fourth, and the harmonic inversion of a minor sixth is a major third.) The total of each such pair of intervals is always one octave.

		Page & Textblock Proportions		Sample sizes in inches		
octave	A	Double Square	1 : 2	4.5 × 9	5 × 10	5.5 × 11
	B	Tall Octagon	1 : 1.924	4.7 × 9	5.2 × 10	5.7 × 11
major 7th		8 : 15	1 : 1.875	4.8 × 9		
	C	Tall Hexagon	1 : 1.866			5.9 × 11
	D	Octagon	1 : 1.848	4.9 × 9	5.4 × 10	6 × 11
		5 : 9	1 : 1.8	5 × 9		
minor 7th		9 : 16	1 : 1.778		5.1 × 9	
	E	HEXAGON = 1 : √3	1 : 1.732	4.9 × 8.5	5.2 × 9	6.4 × 11
	F	Tall Pentagon	1 : 1.701	5 × 8.5	5.3 × 9	6.5 × 11
major 6th		3 : 5	1 : 1.667	5.1 × 8.5		
		Legal Sheet	1 : 1.647			8.5 × 14
	G	GOLDEN SECTION	1 : 1.618	5.3 × 8.5	5.6 × 9	6.8 × 11
minor 6th		5 : 8	1 : 1.6	5 × 8		
	H	PENTAGON	1 : 1.539	5.5 × 8.5	5.9 × 9	7.2 × 11
➤ *fifth*		2 : 3	1 : 1.5		6 × 9	7.3 × 11
	Z	ISO = 1 : √2	1 : 1.414	6.4 × 9	7.1 × 10	7.8 × 11
		5 : 7	1 : 1.4			
	J	Short Pentagon	1 : 1.376	6.5 × 9	7.3 × 10	8 × 11
➤ *fourth*		3 : 4	1 : 1.333	6.8 × 9	7.5 × 10	9 × 12
	K	Tall Half Octagon	1 : 1.307	6.9 × 9	7.7 × 10	8.4 × 11
		Letter Sheet	1 : 1.294			8.5 × 11
major 3rd		4 : 5	1 : 1.25	7.2 × 9	8 × 10	8.8 × 11
	L	Half Octagon	1 : 1.207		8.3 × 10	9.1 × 11
minor 3rd		5 : 6	1 : 1.2	7.5 × 9		
	M	Truncated Pentagon	1 : 1.176		8.5 × 10	9.4 × 11
		6 : 7	1 : 1.167	7.7 × 9		
		e : π	1 : 1.156			
	N	Turned Hexagon	1 : 1.155	7.8 × 9	8.7 × 10	9.5 × 11
major 2nd		8 : 9	1 : 1.125	8 × 9	8.9 × 10	9.8 × 11
	O	Tall Cross Octagon	1 : 1.082	8.3 × 9	9.2 × 10	10.2 × 11
minor 2nd		15 : 16	1 : 1.067	8.4 × 9	9.4 × 10	10.3 × 11
	P	Turned Pentagon	1 : 1.051	8.6 × 9	9.5 × 10	10.5 × 11
unison	Q	SQUARE	1 : 1	9 × 9	10 × 10	11 × 11
	R	Broad Pentagon	1 : 0.951	8.9 × 8.5	10 × 9.5	11×10.5
	S	Broad Cross Octagon	1 : 0.924	9.2 × 8.5	10 × 9.2	11×10.1
major 2nd		9 : 8	1 : 0.889	9.6 × 8.5		11 × 9.8
	T	Broad Hexagon	1 : 0.866	9.8 × 8.5	10 × 8.7	11 × 9.5
	U	Full Cross Octagon	1 : 0.829	10.3 × 8.5	10 × 8.3	11 × 9.1
major 3rd		5 : 4	1 : 0.8	10.6 × 8.5		11 × 8.8
		Landscape Letter	1 : 0.773	11 × 8.5	10 × 7.7	

148

	Column Proportions			Sample sizes in picas			
a	Quadruple Square	1 : 4	1 : 4	10 × 40	11 × 44	12 × 48	*double octave*
	1 : √15		1 : 3.873	10 × 39			
	4 : 15		1 : 3.75		12 × 45		*major 14th*
	5 : 18		1 : 3.6	10 × 36	12 × 43		
	9 : 32		1 : 3.556	11 × 39			*minor 14th*
	1 : √12		1 : 3.464	11 × 38		15 × 52	
b	Octagon Wing		1 : 3.414		12 × 41		
	3 : 10		1 : 3.333		12 × 40	15 × 50	*major 13th*
	1 : 2φ		1 : 3.236				
	5 : 16		1 : 3.2			15 × 48	*minor 13th*
	1 : √10		1 : 3.162	12 × 38			
	1 : π		1 : 3.142		14 × 44		
c	Double Pentagon		1 : 3.078	12 × 37	14 × 43	16 × 49	
d	Triple Square	1 : 3	1 : 3	12 × 36	14 × 42	16 × 48	*twelfth*
e	Wide Octagon Wing		1 : 2.993				
z	1 : 2√2 = 1 : √8		1 : 2.828				
f	Pentagon Wing		1 : 2.753		16 × 44		
	1 : e		1 : 2.718	14 × 38		18 × 49	
	3 : 8		1 : 2.667		15 × 40	18 × 48	*eleventh*
	1 : √7		1 : 2.646				
g	Extended Section		1 : 2.618				
h	Tall Octagon Column		1 : 2.613			18 × 47	
i	Mid Octagon Column		1 : 2.514				
	2 : 5		1 : 2.5	16 × 40	18 × 45	20 × 50	*major 10th*
j	Short Octagon Column		1 : 2.414				
	5 : 12		1 : 2.4			20 × 48	*minor 10th*
k	Hexagon Wing		1 : 2.309	16 × 37	20 × 46		
m	Double Truncated Pentagon		1 : 2.252				
	4 : 9		1 : 2.25		20 × 45		*major 9th*
	1 : √5		1 : 2.236	17 × 38		21 × 47	
	5 : 11		1 : 2.2		20 × 44	24 × 53	
	15 : 32		1 : 2.133			24 × 52	*minor 9th*
A	Double Square	1 : 2	1 : 2	18 × 36	21 × 42	24 × 48	*octave*

[The intervals listed in the righthand column on this page are *compound intervals* of the chromatic scale. Octave + minor 2nd = minor 9th; octave + major 3rd = major 10th; octave + 5th = twelfth, etc.]

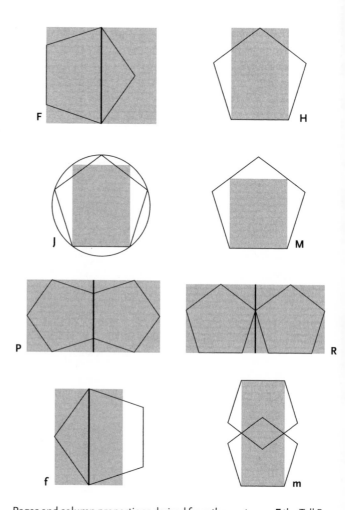

Organic, Mechanical and Musical Proportion

F, P, R and **f** are shown here as two-page spreads, **H, J, M** and **m** as single pages.

Pages and column-proportions derived from the pentagon: **F** the Tall Pentagon page, 1 : 1.701; **H** Pentagon page, 1 : 1.539; **J** Short Pentagon page, 1 : 1.376; **M** the Truncated Pentagon page, 1 : 1.176; **P** Turned Pentagon page, 1 : 1.051; **R** the Broad Pentagon page, 1 : 0.951; **f** Pentagon Wing, 1 : 2.753; **m** the Double Truncated Pentagon, 1 : 2.252. The pentagon page differs by 2% from the North American standard small trade book size, which is half the size of a letter sheet: 5½ × 8½ inches. A more eminent page proportion, the *golden section*, is also present in the pentagon (see page 156). In nature, pentagonal symmetry is rare in inanimate forms. Packed soap bubbles seem to strive for it but never quite succeed, and there are no mineral crystals with true pentagonal structures. But pentagonal geometry is basic to many living things, from roses to sea urchins and starfish.

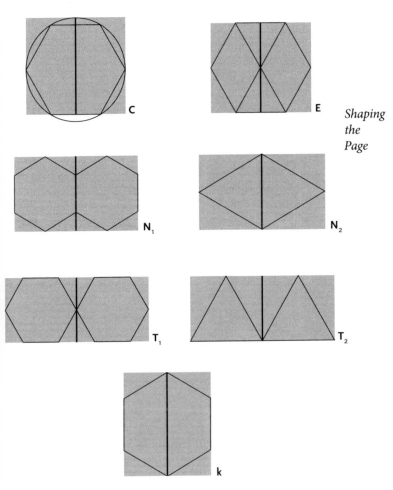

Pages and column-proportions derived from the hexagon: **C** the Tall Hexagon page, 1 : 1.866; **E** Hexagon page, 1 : $\sqrt{3}$ = 1 : 1.732; **N** Turned Hexagon page, 1 : 1.155; **T** Broad Hexagon page, 1 : 0.866; **k** Hexagon Wing, 1 : 2.309. The hexagon consists of six equilateral triangles, and each of these page shapes can be derived directly from the triangle instead. The hexagon merely clarifies their existence as mirror images, like the pages of a book. Hexagonal structures are present in both the organic and the inorganic world – in lilies and wasps' nests, for example, and in snowflakes, silica crystals and sunbaked mudflats. The proportions of the broad hexagon page are within one tenth of one per cent of the natural ratio π/e, while the turned hexagon page (which is the broad hexagon rotated 90°) approximates the ratio e/π. (The hexagon page used in this book is analyzed on page 6.)

All formats on this page are shown as two-page spreads.

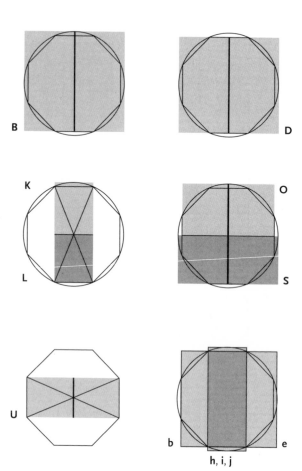

B, **D**, **O**, **S** and **U**
are shown
as two-page
spreads.

Pages and column-proportions derived from the octagon: **B** the Tall Octagon page, 1 : 1.924; **D** Octagon page, 1 : 1.848; **K** Tall Half Octagon page, 1 : 1.307; **L** Half Octagon page, 1 : 1.207; **O** Tall Cross Octagon, 1 : 1.082; **S** Broad Cross Octagon page, 1 : 0.924; **U** the Full Cross Octagon page, 1 : 0.829; **b** Octagon Wing, 1 : 3.414; **e** Wide Octagon Wing, 1 : 2.993; **h, i, j** Tall, Middle and Short Octagon Columns, 1 : 2.613, 1 : 2.514 and 1 : 2.414. The tall half octagon page (**K**), used in Roman times, differs by a margin of 1% from the standard North American letter size. Are proportions derived from the hexagon and pentagon livelier and more pleasing than those derived from the octagon? Forms based on the hexagon and pentagon are, at any rate, far more frequent than octagonal forms in the structure of flowering plants and elsewhere in the living world.

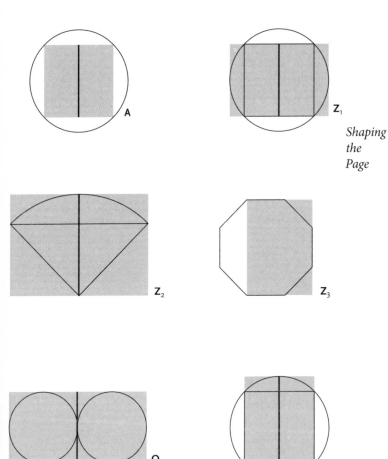

Pages and column-proportions derived from circle and square: **A** Double Square page, $1 : 2$; **Z** the Broad Square page, which is the ISO standard, $1 : \sqrt{2} = 1 : 1.414$; **Q** the Perfect Square; **z** Double ISO, $1 : 2\sqrt{2} = 1 : 2.828$. The proportion $1 : \sqrt{2}$ is that of side to diagonal in a square. A rectangle of these proportions (and no others) can be halved or doubled indefinitely to produce new rectangles of the same proportion. The proportion was chosen for that reason as the basis for ISO (International Organization for Standardization) paper sizes. The A4 sheet, for example, is standard European letter size, 210×297 mm $= 8\frac{1}{4}'' \times 11\frac{5}{8}''$. An $8\frac{1}{2}'' \times 12''$ book page also embodies this proportion.

The ISO or broad square page is latent not only in the square but in the octagon.

Except for Z_3, all formats on this page are shown as two-page spreads.

ISO sheet sizes:

A0 = 841 × 1189 mm	A3 = 297 × 420 mm	
A1 = 594 × 841 mm	A4 = 210 × 297 mm	
A2 = 420 × 594 mm	A5 = 148 × 210 mm	

When a sheet whose proportions are 1 : $\sqrt{2}$ is folded in half, the result is a sheet half as large but with *the same proportions.* Standard paper sizes based on this principle have been in use in Germany since the early 1920s. The basis of the system is the A0 sheet, which has an area of one square meter. Yet precisely because it is *reciprocal with nothing but itself,* the ISO page is, in isolation, the least musical of all the major page shapes. It needs a textblock of another shape for contrast.

The golden section is a symmetrical relation built from asymmetrical parts. Two numbers, shapes or elements embody the golden section when the smaller is to the larger as the larger is to the sum. That is, $a : b = b : (a + b)$. In the language of algebra, this ratio is $1 : \varphi = 1 : (1 + \sqrt{5})/2$, and in the language of trigonometry, it is $1 : (2 \sin 54°)$. Its approximate value in decimal terms is $1 : 1.61803$.

Shaping the Page

The second term of this ratio, φ (the Greek letter *phi*), is a number with several unusual properties. If you *add* one to φ, you get its square ($\varphi \times \varphi$). If you *subtract* one from φ, you get its reciprocal ($1/\varphi$). And if you multiply φ endlessly by itself, you get an infinite series embodying a single proportion. That proportion is $1 : \varphi$. If we rewrite these facts in the typographic form mathematicians like to use, they look like this:

$$\varphi + 1 = \varphi^2$$

$$\varphi - 1 = 1/\varphi$$

$$\varphi^{-1} : 1 = 1 : \varphi = \varphi : \varphi^2 = \varphi^2 : \varphi^3 = \varphi^3 : \varphi^4 = \varphi^4 : \varphi^5 \ldots$$

If we look for a numerical approximation to this ratio, $1 : \varphi$, we will find it in something called the Fibonacci series, named for the thirteenth-century mathematician Leonardo Fibonacci. Though he died two centuries before Gutenberg, Fibonacci is important in the history of European typography as well as mathematics. He was born in Pisa but studied in North Africa. On his return, he introduced Arabic mathematics to North Italian scholars and also arabic numerals to the North Italian scribes.

As a mathematician, Fibonacci took an interest in many problems, including the problem of unchecked propagation. What happens, he asked, if everything breeds and nothing dies? The answer is a logarithmic spiral of increase. Expressed as a series of integers, such a spiral takes the following form:

$0 \cdot 1 \cdot 1 \cdot 2 \cdot 3 \cdot 5 \cdot 8 \cdot 13 \cdot 21 \cdot 34 \cdot 55 \cdot 89 \cdot 144 \cdot 233 \cdot 377 \cdot 610 \cdot 987 \cdot 1,597 \cdot 2,584 \cdot 4,181 \cdot 6,765 \cdot 10,946 \cdot 17,711 \cdot 28,657 \ldots$

Here each term after the first two is *the sum of the two preceding*. And the farther we proceed along this series, the closer

The screened
area represents a
two-page spread
in which each
page embodies
the golden sec-
tion. The root of
the spiral, which
is the navel of
the spread, lies at
the intersection
of the diagonals.
This is a Renais-
sance structure:
precisely
measured and
formed, yet
open-ended,
unconfined. Like
Thoreau's idea
of the mind
(page 66), it
is *hypethral.*
(Compare the
equally elegant
but closed, me-
dieval structure
on page 173 and
the resolutely
linear structure
on page 154.)

G Golden Section, $1 : \varphi = 1 : 1.618....$ In the pentagon, the side s and the chord c embody the golden section. The smaller is to the larger as the larger is to the whole, or $s : c = c : (s + c)$. When two chords intersect, they divide each other in the same proportion: $a : b = b : c$, where $c = a + b$. Moreover, $b = s$. Thus, $a : s = s : c = c : (s + c) = 1 : \varphi$.

An evolving sequence of figures that embody the golden section also defines the path of a logarithmic spiral. And if the lengths of the sides of the figures are rounded off to the nearest whole numbers, the result is a Fibonacci series of integers.

we come to an accurate approximation of the number φ. Thus $5:8 = 1:1.6$; $8:13 = 1:1.625$; $13:21 = 1:1.615$; $21:34 = 1:1.619$, and so on.

In the world of pure mathematics, this spiral of increase, the Fibonacci series, proceeds without end. In the world of mortal living things, of course, the spiral soon breaks off. It is repeatedly interrupted by death and other practical considerations – but it is visible nevertheless in the short term. Abbreviated versions of the Fibonacci series, and the proportion 1 : φ, can be seen in the structure of pineapples, pinecones, sunflowers, sea urchins, snails, the chambered nautilus, and in the proportions of the human body as well.

If we convert the ratio 1 : φ or 1 : 1.61803 to percentages, the smaller part is roughly **38.2**% and the larger **61.8**% of the whole. But we will find the *exact* proportions of the golden section in several simple geometric figures. These include the pentagon, where they are relatively obvious, and the square, where they are somewhat more deeply concealed. Sunflowers, snails and humans who use the golden section *choose* it; they do not invent it.

The golden section was much admired by classical Greek geometers and architects, and by Renaissance mathematicians, architects and scribes, who often used it in their work. It has also been much admired by artists and craftsmen, including typographers, in the modern age. Paperback books in the Penguin Classics series have been manufactured for more than half a century to the standard size of 111 × 180 mm, which embodies the golden section. The Modulor system of the Swiss architect Le Corbusier is based on the golden section as well.

The golden section, 1 : φ, differs by roughly one per cent from the interval of the minor sixth in the chromatic scale. The proportion 5 : 8, which is the arithmetic value of the minor sixth in music, is often used in typography as a rough approximation to the golden section.

If type sizes are chosen according to the golden section, the result is again a Fibonacci series:

(a) 5 · 8 · 13 · 21 · 34 · 55 · 89 ...

These sizes alone are adequate for many typographic tasks. But to create a more versatile scale of sizes, a second or third interlocking series can be added. The possibilities include:

(b) 6 · 10 · 16 · 26 · 42 · 68 · 110 ...
(c) 4 · 7 · 11 · 18 · 29 · 47 · 76 ...

All three of these series – **a**, **b** and **c** – obey the Fibonacci rule (each term is the sum of the two terms preceding). Series **b** is also

related to series **a** by simple doubling. The combination of **a** and **b** is therefore a two-stranded Fibonacci series with incremental symmetry, forming a very versatile scale of type sizes:

(**d**) 6 · 8 · 10 · 13 · 16 · 21 · 26 · 34 · 42 · 55 · 68 ...

The double-stranded Fibonacci series used by Le Corbusier (with other units of measurement) in his architectural work is similarly useful in typography:

(**e**) 4 6½ 10½ 17 27½ 44½ 72
 5 8 13 21 34 55 89 ...

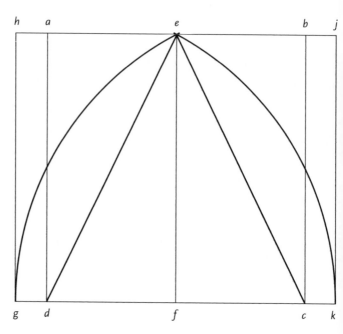

Finding the golden section in the square. Begin with the square *abcd*. Bisect the square (with the line *ef*) and draw diagonals (*ec* and *ed*) in each half. An isosceles triangle, *cde*, consisting of two right triangles, is formed. Extend the base of the square (draw the line *gk*) and project each of the diagonals (the hypotenuse of each of the right triangles) onto the extended base. Now *ce = cg*, and *de = dk*. Draw the new rectangle, *efgh*. This and its mirror image, *ejkf*, each have the proportions of the golden section. That is to say, *eh* : *gh* = *gh* : (*gh* + *eh*) = *ej* : *jk* = *jk* : (*jk* + *ej*) = 1 : φ. (Contrast this with figure Z_2 on page 153.)

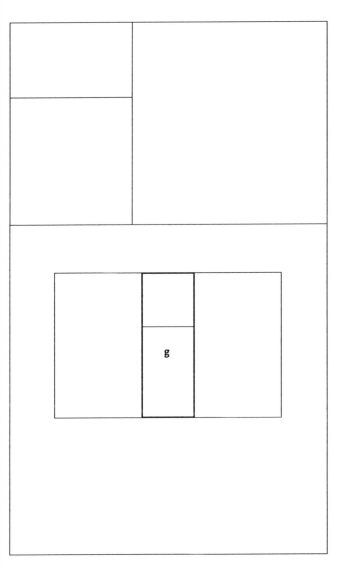

The relation between the square and the golden section is perpetual. Each time a square is subtracted from a golden section, a new golden section remains. If two overlapping squares are formed within a golden-section rectangle, two smaller rectangles of golden-section proportions are created, along with a narrow column whose proportions are $1 : (\varphi + 1) = 1 : 2.618$. This is **g**, the Extended Section, from the table on page 149. If a square is subtracted from this, the golden section is restored.

THIS PARAGRAPH, for instance, is indented according to the golden section. The indent (optical indent, measured to the stem of the versal) is to the remainder of the line as that remainder is to the full measure. The measure is 21 picas, and the indent is 38.2% of that, which is 8 picas.

The amount of *sinkage* (the extra white space allowed at the top of the page) is 7 lines (here equal to 7 picas). Add the extra pica of white space created by indenting the first line, and you have an imaginary 8-pica square of empty space in the upper left corner of the textblock.

The size of the elevated cap is related in turn to the size of the indent and the sinkage. Eight picas is 96 pt, and 61.8% of that is 59.3 pt. But the relationship between 59 or 60 pt type and an 8-pica indent would be difficult to perceive, because a 60 pt letter is not visibly 60 pt high. The initial used has an actual 60 pt cap height instead. Depending on the face, such a letter could be anywhere from 72 to 100 pt nominal size; here it is 84 pt Castellar.

8.3 PROPORTIONS OF THE EMPTY PAGE

8.3.1 *Choose inherently satisfying page proportions in preference to stock sizes or arbitrary shapes.*

The proportions of a page are like an interval in music (an interval is also a proportion). In a given context, some are consonant, others dissonant. Some are familiar; some are also inescapable, because of their presence in the structures of the natural as well as the man-made world. Some proportions also seem particularly linked to living things. It is true that wastage is often increased when an 8½ × 11 inch page is trimmed to 7¾ × 11 or 6¾ × 11, or when a 6 × 9 book page is narrowed to 5⅝ × 9. But an organic page looks and feels different from a mechanical page, and the shape of the page itself will provoke certain responses and expectations in the reader, independently of whatever text it contains.

8.3.2 Choose page proportions suited to the content, size and ambitions of the publication.

There is no one ideal proportion, but some are clearly more ponderous, others more brittle. In general, a book page, like a human being, should not peer down its nose, nor should it sag.

The narrower page shapes require a soft or open spine so that the opened book lies flat, and at smaller sizes, narrower pages are suitable only for text that can be set to a narrow measure. At larger sizes, the narrow page is more adaptable.

For most books with straightforward texts, typographers and readers both gravitate to proportions ranging from the light, agile 5 : 9 [1 : 1.8] to the heavier and more stolid 4 : 5 [1 : 1.25]. Pages wider than 1 : $\sqrt{2}$ are useful primarily in books that need the extra width for maps, tables, sidenotes or wide illustrations, and for books in which a multiple-column page is required.

When important illustrations are involved, these generally decide the shape of the page. Typically, one would choose a page somewhat deeper than the average illustration, both to leave extra blank space at the foot of the page, and to permit the insertion of captions. The e/π or turned hexagon page, 1 : 1.16, for example, which is slightly deeper than a perfect square, is useful for square artwork, such as photographs taken with a square-format camera. The π/e or broad hexagon page, 1 : 0.87, is useful for landscape photographs in the 4 × 5 format, and the full cross octagon page, 1 : 0.83, for landscape photos in the wider format of 35 mm. (Uncropped 35 mm transparencies embody the proportion 2 : 3.) Photographic film has gone the way of metal type, but digital cameras, like digital typesetting machines – and trained photographers, like typographers – remember and use the formats established in earlier times.

8.3.3 Choose page and column proportions whose historical associations suit your intended design.

Early Egyptian scribes (when not writing vertically) tended to write a long line and a wide column. This long Egyptian line reappears in other contexts over the centuries – on Roman imperial writing tablets, in medieval European charters and deeds, and in many poorly designed recent specimens of academic prose. It is a sign, generally speaking, that the emphasis is on the writing instead of the reading, and that writing is seen as an instrument

of power, not an instrument of freedom. Whether oral or visual, longwindedness is very rarely a virtue.

Early Hebrew scribes generally favored a narrower column, and early Greek scribes a column narrower still. But they, like the Egyptians, were making scrolls instead of bound books. It is difficult, therefore, to compare modern notions of the page directly with theirs. You can open a scroll as wide as you like, exposing one column, two columns, three. This flexible approach to the concept of the page survives to some extent in early codices (bound books). There are early books that are three times taller than wide, others that are close to square, and many shapes between.

Proportions of the Empty Page

In medieval Europe, most books, though certainly not all, settled down to proportions ranging from 1 : 1.5 to 1 : 1.25. Paper – once the mills were built in Europe – was commonly made in sheets whose proportions were 2 : 3 [1 : 1.5] or 3 : 4 [1 : 1.33]. These proportions, which correspond to the acoustically perfect musical intervals of fifth and fourth, also reproduce one another with each fold. If a sheet is 40 × 60 cm [2 : 3] to start with, it folds to 30 × 40 [3 : 4], which folds to 20 × 30, and so on. The 25 × 38 inch [roughly 2 : 3] and 20 × 26 inch [roughly 3 : 4] press sheets used in North America today are survivors of this medieval tradition.

The page proportion 1 : √2, which is now the European standard, was also known to the medieval scribes. And the tall half octagon page, 1 : 1.3 (the shape enshrined now in North American letter paper) has a similar pedigree. The British Museum has a Roman wax-tablet book of precisely this proportion, dated to about 300 CE.

Renaissance typographers continued to produce books in the proportions 1 : 1.5. They also developed an enthusiasm for narrower proportions. The proportions 1 : 1.87 (tall hexagon), 1 : 1.7 (tall pentagon), 1 : 1.67 [3 : 5], and of course 1 : 1.62, the golden section, were used by typographers in Venice before the end of the fifteenth century. The narrower page was preferred especially for works in the arts and sciences. Wider pages, better able to carry a double column, were preferred for legal and ecclesiastical texts. (Even now, a Bible, a volume of court reports or a manual on mortgages or wills is likely to be on a wider page than a book of poems or a novel.)

Renaissance page proportions (generally in the range of 1 : 1.4 to 1 : 2) survived through the Baroque, but books of the Neo-classical age are often wider, returning to the heavier Roman proportion of 1 : 1.3.

8.4.1 *If the text is meant to invite continuous reading, set it in columns that are clearly taller than wide.*

Horizontal motion predominates in alphabetic writing, and for beginners, it predominates in reading. But vertical motion predominates in reading for those who have really acquired the skill. The tall column of type is a symbol of fluency, a sign that the typographer does not expect the reader to have to puzzle out the words.

Shaping the Page

The very long and very narrow columns of newspapers and magazines, however, have come to suggest disposable prose and quick, unthoughtful reading. A little more width not only gives the text more presence; it implies that it might be worth savoring, quoting and reading again.

8.4.2 *Shape the textblock so that it balances and contrasts with the shape of the overall page.*

The proportions that are useful for the shapes of pages are equally useful in shaping the textblock. This is not to say that the proportions of the textblock and the page should be the same. They often were the same in medieval books. In the Renaissance, many typographers preferred a more polyphonic page, in which the proportions of page and textblock differ. But it is pointless for them to differ unless, like intervals in music, they differ to a clear and purposeful degree.

For all the beauty of pure geometry, a perfectly square block of type on a perfectly square page with even margins all around is a form unlikely to encourage reading. Reading, like walking, involves navigation – and the square block of type on a square block of paper is short of basic landmarks and cues. To give the reader a sense of direction, and the page a sense of liveliness and poise, it is necessary to break this inexorable sameness and find a new balance of another kind. Some space must be narrow so that other space may be wide, and some space emptied so that other space may be filled.

In the simple format shown overleaf, a page whose proportions are 1 : 1.62 (the golden section) carries a textblock whose proportions are 1 : 1.8 [5 : 9]. This difference constitutes a primary visual chord which generates both energy and harmony in the

page. It is supplemented by secondary harmonies created by the proportions of the margins and the placement of the textblock – not in the center of the page but high and toward the spine.

The textblock and running head, in this example, is symmetrical, but it is placed asymmetrically on the page. So the lefthand page is an approximate mirror image of the right – its other hand, and not its replica. The two-page spread is symmetrical horizontally – the direction in which the pages turn, either backward or forward, as the reader consults the book – but it is asymmetrical vertically – the direction in which the page stays put while the reader's eye repeatedly works its way in one direction: down.

This interlocking relationship of symmetry and asymmetry, and of balanced and contrasted shape and size, was not new when this example was designed (in Venice in 1501). The first European typographers inherited some two thousand years' worth of research into these principles from their predecessors, the scribes. Yet the principles are flexible enough that countless new typographic pages and page-spreads wait to be designed.

Page spread, probably by Aldus Manutius, Venice, 1501. The text is Virgil's *Aeneid,* set entirely in a crisp, simple italic lower case, 12/12 × 16, with roman small capitals, approximately 5 pt high. The original page size is 10.7 × 17.3 cm.

8.5.1 *Bring the margins into the design.*

In typography, margins must do three things. They must *lock the textblock to the page* and *lock the facing pages to each other* through the force of their proportions. Second, they must *frame the textblock* in a manner that suits its design. Third, they must *protect the textblock*, leaving it easy for the reader to see and convenient to handle. (That is, they must leave room for the reader's thumbs.) The third of these is easy, and the second is not difficult. The first is like choosing type: it is an endless opportunity for typographic play and a serious test of skill.

Perhaps fifty per cent of the character and integrity of a printed page lies in its letterforms. Much of the other fifty per cent resides in its margins.

8.5.2 *Bring the design into the margins.*

The boundaries of the textblock are rarely absolute. They are nibbled and punctured by paragraph indents, blank lines between sections, gutters between columns, and the sinkage of chapter openings. They are overrun by hanging numbers, outdented paragraphs or heads, marginal bullets, folios (page numbers) and often running heads, marginal notes and other typographic satellites. These features – whether recurrent, like folios, or unpredictable, like marginal notes and numbers – should be designed to give vitality to the page and further bind the page and the textblock.

8.5.3 *Mark the reader's way.*

Folios (page numbers) are useful in most documents longer than two pages. They can be anywhere on the page that is graphically pleasing and easy to find, but in practice this reduces to few possibilities: (1) at the head of the page, aligned with the outside edge of the textblock (a common place for folios accompanied by running heads); (2) at the foot of the page, aligned with or slightly indented from the outside edge of the text; (3) in the upper quarter of the outside margin, beyond the outside edge of the text; (4) at the foot of the page, horizontally centered beneath the textblock.

The fourth of these choices offers Neoclassical poise but is not the best for quick navigation. Folios near the upper or lower

Shaping the Page

outside corner are the easiest to find by flipping pages in a small book. In large books and magazines, the bottom outside corner is generally more convenient for joint assaults by eye and thumb. It is rarely a good idea to place the folios on the inner margin. In this location, they will be invisible when genuinely needed (that is, when a reader is flipping through, searching for a certain page) and all too visible to readers who are simply reading.

It is usual to set folios in the text size and to position them near the textblock. Unless they are very black, brightly colored or large, the folios usually drown when they get very far away from the text. Strengthened enough to survive on their own, they are likely to prove a distraction.

8.5.4 *Don't restate the obvious.*

In Bibles and other large works, running heads have been standard equipment for two thousand years. Photocopiers and scanners, which can easily separate a chapter or a page from the rest of a book or journal, have also given running heads (and running feet, or footers) new importance.

Except as insurance against photocopying pirates, running heads are nevertheless pointless in many books and documents with a strong authorial voice or a unified subject. They remain essential in most anthologies and works of reference, large or small.

Like folios, running heads pose an interesting typographic problem. They are useless if the reader has to hunt for them, so they must somehow be distinguished from the text, yet they have no independent value and must not become a distraction. It has been a common typographic practice since 1501 to set them in spaced small caps of the text size, or if the budget permits, to print them in the text face in a second color.

8.6 PAGE GRIDS & MODULAR SCALES

8.6.1 *Use a modular scale if you need one to subdivide the page.*

Grids are often used in magazine design and in other situations where unpredictable graphic elements must be combined in a rapid and orderly way.

Modular scales serve much the same purpose as grids, but they are more flexible. A modular scale, like a musical scale, is a prearranged set of harmonious proportions. In essence, it is

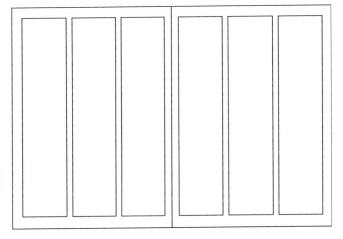

Standard grid for three-column magazine

a measuring stick whose units are *indivisible* (or are treated as such) and are *not of uniform size.* The traditional sequence of type sizes shown on page 45, for example, is a modular scale. The single- and double-stranded Fibonacci series discussed on pages 157–8 are modular scales as well. These scales can, in fact, be put directly to use in page design by altering the units from points to picas. More examples of modular scales are shown on the following page.

It is perfectly feasible to create a new modular scale for any project that requires one, and the scale can be founded on any convenient single or multiple proportion – a given page size, for example, or the dimensions of a set of illustrations, or something implicit in the subject matter. A work on astronomy might use a modular scale based on star charts or Bode's law of interplanetary distances. A book on Greek art might be laid out using intervals from one or more of the Greek musical scales or, of course, the golden section. A work of modernist or postmodern literature might be designed using something more deliberately arcane – perhaps a scale based on the proportions of the author's hand. Generally speaking, a scale based on two ratios (1 : φ and 1 : 2, for example) will give more flexible and interesting results than a scale founded on just one.

The Half Pica Modular scale illustrated overleaf is actually a miniaturized version of the architectural scale of Le Corbusier, which is based in turn on the proportions of the human body.

See Le Corbusier, *The Modulor* (2nd ed., 1954).

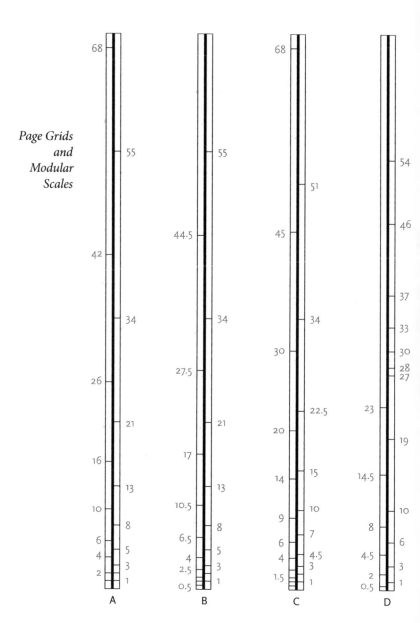

Four examples of modular pica sticks (shown at half actual size). **A** Whole
Pica Modular scale. **B** Half Pica Modular scale. These are both two-stranded
Fibonacci series, based on the ratios 1 : φ and 1 : 2. **C** Medieval Interval scale,
based on the proportions 2 : 3 and 1 : 2. **D** Timaean Scale, a simplified ver-
sion of the Pythagorean scale outlined in Plato's *Timaeus*.

Use of the modular scale. These pages and textblocks have been subdivided using the Half Pica Modular scale. The pages are 52 × 55 picas (8⅝″ × 9⅛″), with margins of 5, 5, 5 & 8 picas. The basic textblock is 42 picas square. Thousands of different subdivisions are possible. (For more complex examples on similar principles, see Le Corbusier, *The Modulor.*)

Examples

The formula for designing a perfect page is the same as the formula for writing one: start at the upper left (or right) hand corner and work your way across and down; then turn the page and try again. The examples on the following pages show only a few of the many typographic structures that might evolve along the way. All but the first are in codex form, in two-page spreads. The exception, a scroll, is the oldest yet also perhaps the most modern.

In fact, the weaving of the text and the tailoring of the page are thoroughly interdependent. We can discuss them one by one, and we can separate each in turn into a series of simple, unintimidating questions. But the answers to these questions must all, in the end, fold back into a single answer. The page, the pamphlet or the book must be seen as a whole if it is to look like one. If it appears to be only a series of individual solutions to separate typographic problems, who will believe that its message coheres?

In analyzing the examples on the following pages, these symbols are used:

Proportions:	P = page proportion: h/w
	T = textblock proportion: d/m
Page size:	w = width of page (trim-size)
	h = height of page (trim-size)
Textblock:	m = measure (width of primary textblock)
	d = depth (height) of primary textblock (excluding running heads, folios, etc)
	λ = line height (type size plus added lead)
	n = secondary measure (width of secondary column)
	c = column width, where there are even multiple columns
Margins:	s = spine margin (back margin)
	t = top margin (head margin)
	e = fore-edge (front margin)
	f = foot margin
	g = internal gutter (on a multiple-column page)

Page and textblock proportions are given here as single values (1.414, for example). To find the same proportions in the table on page 148, look for the corresponding *ratio* (1 : 1.414, for example).

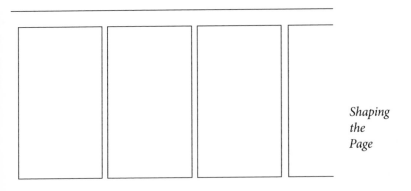

P = variable; T = 1.75. Margins: $t = h/12$; $f = 3t/2$; $g = t/2$ or $t/3$. Text columns from Isaiah Scroll A, from Qumran Cave 1, on the Dead Sea. The column depth is 29 lines and the measure is 28 picas, giving a line length of roughly 40 characters. Elsewhere in the scroll, column widths range from 21.5 to 39 picas. Paragraphs begin on a new line but – in keeping with the crisp, square Hebrew characters – are not indented. (Palestine, perhaps first century BCE.) Original size: 26 × 725 cm.

In diagrammatic form, this scroll looks a lot like an e-book. But the script in the scroll has a liveliness and variety that no e-book can presently match.

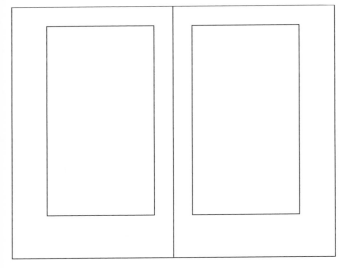

P = 1.5 [2 : 3]; T = 1.7 [tall pentagon]. Margins: $s = t = w/9$; $e = 2s$. The text is a fantasy novel, Francesco Colonna's *Hypnerotomachia Poliphili*, set in a roman font cut by Francesco Griffo. (Aldus Manutius, Venice, 1499.) Original size: 20.5 × 31 cm.

171

Examples

P = 1.62 [golden section]; T = 1.87 [tall hexagon]. Margins: $s = w/9$; $t = s$; $e = 2s$. Secondary column: $g = w/75$; $n = s$. The text is in Claude Garamond's 14 pt roman; the sidenotes are 12 pt italic. The gutter between main text and sidenotes is tiny: 6 or 7 pt against a main text measure of 33½ picas. But the differences in size and lettershape prevent any confusion. The text is a history of the Hundred Years' War. (Jean Froissart, *Histoire et chronique*, Jean de Tournes, Paris, 1559.) Original size: roughly 21 × 34 cm.

This grid is analyzed on the facing page.

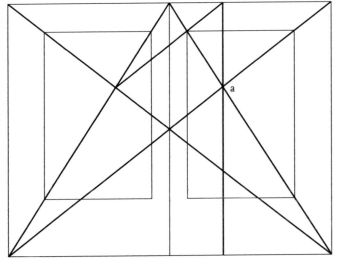

a

P = T = 1.5 [2 : 3]. Margins: $s = w/9$; $t = h/9$; $e = 2s$; $f = 2t$. The margins are thus in the proportion $s : t : e : f = 2 : 3 : 4 : 6$. A sound, elegant and basic medieval structure, which will work for any proportion of page and textblock, so long as the two remain in unison. Spine and head margins may be ninths, tenths, twelfths or any other desired proportion of the page size. Twelfths, of course, give a fuller and more efficient page, with less white space. But if the page proportion is 2 : 3 and the spine and head margins are ninths, as shown here, the consonance of textblock and page is considerably deepened, because $d = w$, which is to say, the depth of the textblock matches the width of the page. Thus $m : w = d : h = w : h = m : d = s : t = e : f = 2 : 3$. Point **a**, where the half and full diagonals intersect, is one third of the way down and across the textblock and the page. (Jan Tschichold, 1955, after Villard de Honnecourt, France, c. 1280. See Tschichold's *The Form of the Book* [1991].)

Scribes employing this format often designed their pages so that the line height was an even factor of the spine margin. So, for example, if $\lambda = s/3$, the depth of the textblock will be 27 lines. If $\lambda = s/4$, the depth of the textblock will be 36 lines.

FACING PAGE: P = 1.5 [2 : 3]; T = 2 [double square]. Margins: $s = e = w/5$; $t = s/2$. The text is a book of poems, set throughout in a chancery italic with roman capitals. The designer and publisher of this book was a master calligrapher, certainly aware of the tradition that the inner margins should be smaller than the outer. He followed that tradition himself with books of prose, but in this book of poems he chose to center the textblock on the page. The text throughout is set in one size. Titles are set in the capitals of the text font, letterspaced about 30%. There are no running heads or other diversions. (Giangiorgio Trissino, *Canzone*, Ludovico degli Arrighi, Rome, c. 1523.) Original size: 12.5 × 18.75 cm.

Examples

P = 1.5 [2 : 3]; T = 1.54 [pentagon textblock]. Margins: $s = w/20$; $t = s = h/30$; $e = w/15 = 4s/3$; $f = 2t$. This is the format used for the index to the fifth edition of the *Times Atlas of the World* (London, 1975). The page is a standard medieval shape. The type is in 5.5 pt Univers leaded 0.1 pt on a 12-pica measure, in a textblock subdivided into five columns per page. Columns are separated by thin vertical rules. Keywords and folios, at the top of the page, are in 16 pt Univers semibold. (Because of their prominence, these running heads are included here in calculating the size and shape of the textblock.) The text is 204 lines deep, yielding an average of 1000 names per page for 217 pages. This index is a masterpiece of its kind: a potent typographic symbol, an efficient work of reference, and a comfortable text to browse. Original size: 30 × 45 cm.

This grid is analyzed on the facing page.

174

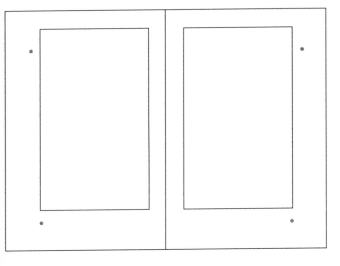

$P = 1.414$ [$\sqrt{2}$]; $T = 1.62$ [φ, the golden section]. Margins: $s = t = w/9$ and $e = f = 2s$. This is a simple format for placing a golden-section textblock on an ISO page, locking the two together with margins in the proportions 1 : 2. Two possible locations for folios are shown: in the upper outside margin and (as an alternative) underneath the lower outside corner of the textblock. There is also ample room for sidenotes in the fore-edge if required. If the spine and top margins on these pages are increased to $w/8$, while the textblock and page are held at their original proportion, the relationship of the margins becomes $e = f = φ s$, another golden section.

FACING PAGE: $P = 1.1$; $T = 0.91$; $c = w/6$. Margins: $s = w/14$; $e = 2s$; $t = 3s$; $f = 3s/2$; $g = m/20$. The proportions of the textblock are the *reciprocal of the proportions of the page*: $0.91 = 1/1.1$, which is to say that the textblock is the same shape as the page, rotated 90°. But if the gutters are removed from the textblock and the four columns closed up solid, the textblock collapses to the same shape *in the same orientation* as the page. In other words, the textblock has been expanded from the same shape to the reciprocal shape of the page *entirely by the addition of white space*. The text is the Greek Bible, lettered in uncials, about 13 characters per line. There are no spaces between the words, but there is some punctuation, and the text has a slight rag, with line breaks carefully chosen. This subtle piece of craftsmanship was produced in Egypt in the fourth century CE. It is the Codex Sinaiticus, Add. Ms. 43725, at the British Library, London. Original size: 34.5 × 38 cm.

Examples

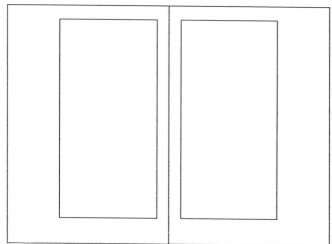

P = 1.414 [√2̄]; T = 2 [double square]. Margins: $s = w/12$; $f = 2t = h/9$; $e = w/3$. The wide fore-edge of this manuscript book had a purpose: it was deliberately left free for sidenotes to be added by the owner. The text is a sequence of short poems by the Roman poet Horace, written in Caroline minuscule: an expensive book indeed, but intended to be used as well as admired. (Ms. Plut. 34.1, Laurentian Library, Florence; tenth century.)

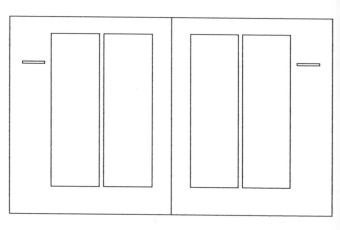

P = 1.176 [truncated pentagon page]; T = 1.46. Margins: $s = h/11$; $t = 5s/6$; $e = 5s/2$; $f = 3s/2$. Columns: $c = 3w/10$; $g = s/4$. The text (set in Friedrich Poppl's Pontifex, 11/13 × 17 RR) is a series of essays on twentieth-century art, published in Canada in 1983, with many full-page illustrations. Original size: 24 × 28 cm.

8.8.1 *Improvise, calculate, and improvise some more.*

Numerical values – used by all typographers in their daily work – give an impression of exactness. Careful measurement and accurate calculation are indeed important in typography, but they are not its final purpose, and moments arise in every project when exactness bumps its head against approximation. On the mechanical side, paper expands and contracts, and printing presses, folding machines and trimming knives – not to speak of typesetting hardware and software – all have their margins of error. The typographer can rarely profit from these variations and cannot entirely prevent them. On the planning side, however, imprecision can often be put to better use.

Shaping the Page

Some typographers prefer to design by arithmetic from the outset, in a space composed of little invisible bricks called points and picas. Others prefer to work in the free two-dimensional space of a sketchpad, converting their layouts afterward to typographic measure. Most work involves a combination of these methods, with occasional collisions between the two. But the margins of inexactness that crop up in the rounding of units, in conflicts between optical and arithmetic spacing and centering, in combining proportions, and in translating from one form of measurement to another should be welcomed as opportunities, not as inconsistencies to be ignored, glossed over or begrudged. The equal temperament of the typesetting machine and the just intonation of the sketchpad should be used to test and refine one another until the final answer sings.

8.8.2 *Adjust the type and the spaces within the textblock using typographic increments, but rely on free proportions to adjust the empty space.*

Proportions are more flexible than picas, and it is usually convenient and appealing to work in even units. A margin of 5.32 picas, for example, begs to be altered to 5 or 5¼ or 5½. But picas per se are less important than proportions, and the system of typographic sizes and units serves the interrelations of letterforms better than it serves the interrelations of empty space. As a general rule, it is better to make incremental jumps in the textblock first and to readjust the margins thereafter – paying more attention

in the latter case to absolute proportion than to convenient units of measurement. When space is measured purely in points, the temptation to rearrange it into even picas is miraculously lessened.

8.8.3 *Keep the page design supple enough to provide a livable home for the text.*

Architects build perfectly proportioned kitchens, living rooms and bedrooms in which their clients will make, among other things, a mess. Typographers likewise build perfectly proportioned pages, then distort them on demand. The text takes precedence over the purity of the design, and the typographic texture of the text takes precedence over the absolute proportions of the pure but silent page.

If, for instance, three lines remain at the end of a chapter, looking forlorn on a page of their own, the design must flex to accommodate them. The obvious choices are: (1) running two of the previous spreads a line long (that is, adding one line to the depth of two pairs of facing pages), which will leave the final page one line short; (2) running half a dozen of the previous spreads a line short, thereby bumping a dozen lines along to the final page; or (3) reproportioning some non-textual element – perhaps an illustration or the sinkage, if any, at the head of the chapter.

Spacious chapter heads stand out in a book, as they are meant to. Reproportioning the sinkage is therefore a poor option unless all chapter heads can be reproportioned to match. And running six spreads short is, on the face of it, clearly a greater evil than running two spreads long.

If there are only a few pages to the document, the whole thing can, and probably should, be redesigned to fit the text. But in a book of many pages, widow lines, orphaned subheads, and the runt ends of chapters or sections are certain to require reproportioning some spreads. A rigid design that demands an invariant page depth is therefore inappropriate for a work of any length. Altering the leading on short pages to preserve a standard depth (vertical justification, it is sometimes called) is not a solution. Neither is stuffing extra space between the paragraphs. These antics destroy the fabric of the text and thus strike at the heart of the book.

9

The state of the art has more by far to do with the knowledge and skill of its practitioners than with the subtleties of their tools, but tools can constrain that skill or set it free. The limitations of the tools are therefore also of some interest. They are of special interest now, because they are subject to rapid change.

9.1 THE HUNDRED-THOUSAND CHARACTER ALPHABET

9.1.1 *Changes in Inventory*

It is often said that the Latin alphabet consists of 26 letters, the Greek of 24 and the Arabic of 28. If you confine yourself to one case only, a narrow historical window and the dialect in power, this assertion can hold true. If you include both caps and lower case, accented letters and a global set of consonants and vowels – á à â å ã ä ą ă ā æ ǽ ç ć č ċ ð đ é ł ñ ń ņ ő š ś ş þ ű ů ū ŵ ý ž ź ż and all the rest – the Latin alphabet is not 26 letters long after all; it is closer to 600 and able to increase at any time. The alphabet that classicists now use for classical Greek, with its long parade of vowels and diacritics – ά ὰ ᾶ ἀ ἁ ἄ ἂ ἆ ἅ ἃ ᾷ ᾳ, and so on – is modest by comparison: fewer than 300 glyphs altogether.

To the 600-character globalized Latin alphabet, mathematicians, grammarians, chemists and even typographers are prone to make additions: arabic numerals, punctuation, technical symbols, letters borrowed from Hebrew, Greek and Cyrillic, and, where the letterforms require or invite them, a few typographic ligatures and alternates as well. There is no hope at this stage of counting the number of sorts or glyphs precisely, but the total is clearly over a thousand.

At the end of the eighteenth century, an English-speaking hand compositor's standard lower case had 54 compartments, holding roman or italic *a* to *z*, arabic numerals, basic ligatures, spaces and punctuation. The upper case had another 98, containing caps and analphabetics. That total, 98 + 54 = 152, is the English-speaking hand compositor's minimum basic allotment. When more sorts are required, as they very often are, supplementary cases are used. Two pair give 304 compartments; three pair give 456; four pair give 608. This has been the ordinary ty-

Printing enthusiasts sometimes speak of the *lay of the case* as if it were universal law – but the lay of the case is as localized as the lay of the land. Hand compositors often set not from paired but from single cases. These have been reduced to as few as 89 compartments but sometimes contain 400 or more.

pographic ballpark for some time. How Gutenberg's cases were arranged we do not know, but we know how big they were. He used not 26 but 290 different glyphs – in one face and one size, in an unaccented script – to set his 42-line Bible. The Monotype machine, built five centuries later, with 255 (later 272) positions in a standard matrix case, had fallen only a little ways behind.

The Hundred-Thousand Character Alphabet

Early computers and e-mail links were, by comparison, living in typographic poverty. The alphabet they used was the basic character set defined by the American Standard Code for Information Interchange, or ASCII. Each character was limited to seven bits of binary information, so the maximum number of characters was $2^7 = 128$. Thirty-three of those were normally subtracted for control codes, and one was the code for an empty space. This leaves 94: not even enough to hold the standard working character set of Spanish, French or German. The fact that such a character set was long considered adequate tells us something about the cultural narrowness of American civilization, or American technocracy, in the midst of the twentieth century.

The extended ASCII character set, which has been in general use since 1980, is made from eight-bit characters. This gives $2^8 = 256$ slots altogether. As a rule, glyphs are assigned to some 228 of these. Editing and composition software often limits the working selection to 216 or less. The upper register of this set – altogether invisible on a normal computer keyboard – is usually filled out with characters selected from the Latin 1 Character Set established by ISO (the International Organization for Standardization, Geneva). These characters – *ä ç é ñ* and so on – are identified and discussed in appendix B, page 315.

The allotment of 216 or 228 characters is meagre but adequate for basic communication in the so-called major languages of Western Europe and North America. This ignores the needs of mathematicians, linguists and other specialists, and of millions of human beings who use the Latin alphabet for Czech, Hausa, Hungarian, Latvian, Navajo, Polish, Romanian, Turkish, Vietnamese, Welsh, Yoruba, and so on. The extended ASCII character set is the alphabet not of the real world nor of the UN General Assembly but of NATO: a technological memento of the them-and-us mentality that thrived in the Cold War.

Good, affordable software that would handle thousands of characters efficiently was for sale (and in fact was widely used) in the early 1980s. Standardization within the industry shrank this palette down, then enormously increased it. Some typographic

NATO was formed in 1948 as a purely Western European organization. When Greece and Turkey joined in 1952, its typographic character grew broader in theory – but changed very little in practice.

tools have not caught up. Typographically sectarian and culturally stunted software is still sold, and still widespread.

Earlier typographers were free to cut another punch at any time and cast another character. The freedom to do likewise exists with the computer. But finding room for all these letters in a shared standard alphabet involves, in the digital world, a shift from eight-bit to sixteen-bit characters. When we make this change, the alphabet increases to 2^{16} = 65,536 characters. The first version of a standard set of characters this size – known as Unicode – was roughed out at the end of the 1980s and published in the early 1990s. By the year 2000, the rudiments of Unicode were embedded in computer operating systems, and major digital founders had adopted it as the new encoding standard.

The State of the Art

It is, like any standard, less than perfect, but it forms a working protocol both for a global Latin alphabet and for the technological coexistence of Arabic, Chinese, Cyrillic, Devanagari, Greek, Hebrew, Khmer, Korean, Latin, Thai, Tibetan and hundreds of other scripts. It was soon clear, however, that 65,000 characters wasn't enough. To extend the set, 2^{10} = 2,048 of the original allotment were assigned to function in pairs. This permits an additional 1024^2 = 1,048,576 characters. In its latest published form (version 7.0, issued in 2014), Unicode defines 112,956 characters, sets 137,468 slots aside for private use, and still has over 800,000 free for future allocation.

See *The Unicode Standard,* Version 7.0 (2014), on line at *www.unicode.org.*

Few of us may need (or want to memorize) 100,000 characters. People who read and write in Chinese have often mastered 20,000; those who work in Korean learn 3,000 or more; those who work in simpler scripts typically learn a thousand or fewer. Yet authors, editors, typographers and ordinary citizens who just want to be able to spell Dvořák, Miłosz, Mą'ii or al-Fārābī, or to quote a line of Sophocles or Pushkin, or the Vedas or the Sutras or the Psalms, or to write $\varphi \neq \pi$, are beneficiaries of a system this inclusive. So is everyone who wants to read their e-mail in an alphabet other than Latin or a language other than English.

There may also never be a font of 100,000 well-made characters designed by one designer. But good fonts with well over ten thousand characters, keyed to the Unicode system, are now readily available. Computer operating systems now support them. More importantly, fonts for particular symbol sets and alphabets can be linked and tuned to one another by adjusting weight, letterfit and scale. This kind of typographic diplomacy is a task of some importance – and when character sets are joined in this way,

sharing typographic space whether or not they are all in one font, Unicode can serve as a coordinating mechanism.

9.1.2 *Glyphs and Characters*

Typographers are frequently surprised to learn that small caps, text figures, swashes and other things they need and use are seldom to be found in the voluminous Unicode catalogue. But Unicode lists *textual* not *typographic* symbols. Its stated aim is to embrace all linguistically meaningful signs, not their typographic forms and permutations. Partly because it has absorbed inconsistent ISO standards, it is not entirely true to its own vision. In theory, however, authors, editors and denizens of Unicode think and transmit elemental signs (f + f + i, for instance, rather than *ffi*), and typographers transform these abstract entities into their endlessly varying outward manifestations.

As the *Unicode Standard* puts it, characters are "the smallest components of written language that have semantic value." Glyphs, which are endlessly varied, are "representations of characters." The plain and swash forms of *z* in Arrighi or Poetica, for example, are different glyphs (or different *sorts*, a hand compositor would say) that correspond to a single character. Assemble all the characters you need and you have a *character set*. Gather all the glyphs you think you'll want and you have a *glyph palette*. Each character will need at least one glyph to represent it. The terminology may be new, but this conceptual distinction between characters and glyphs has been familiar to scribes for millennia. It was equally familiar to Gutenberg and Aldus.

In the early days of letterpress, punchcutters often cut multiple versions of common letters and other characters (the hyphen was a favorite), so that their subtle, often subliminal, variations would invigorate the page. A hand compositor reaching into the typecase for an *e* might then come up with any of several similar but not identical forms. Few readers may consciously notice the differences, yet each of these slyly variant letters contributes its mote of vitality to the printed text. After five hundred years on the library shelf, that vitality remains. It comes in part from the artistry of the cutters, and in part from the use of a system that lets the glyphs outnumber the characters.

Wisely or not, Unicode treats Latin, Greek and Cyrillic caps and lowercase letters as separate characters, while it treats small caps as variant glyphs. The implication is that the difference be-

tween upper and lower case is integral now to the functioning of these three scripts, while small caps and other such refinements belong to a subtler realm of connotation and style. That is a dubious assumption, and no typographer, writer or editor is obliged to accept it, but practically speaking, it is built into the tools we use, just as it was into e.e. cummings's typewriter.

If small caps aren't actually characters, where do we store them, and how to we find them again? In the early days of digital typography, small caps were ignored altogether or badly faked (as they are even now by the reigning word processor). When typographers bridled at such dishonesty, small caps were allotted fonts of their own in a select few typographic families. The prevailing custom now is to place them on the same font as the caps and lower case, encoding them as variants of both. (Small-cap Q, for example, is coded as a variant of both Q and q.) This, however, makes the small caps inaccessible to software that has not been taught the codes (that same word processor for instance).

Taxonomy, like politics, involves a lot of compromise. It is easy to see that in some sections of Unicode, the literalists have had the upper hand, in others the conceptualists. Where the literalists have prevailed (as in, of all places, the dingbat codeblock), even minor variants are classified as characters. Unicode policy has also shifted over time, from literalist to more strictly conceptual sympathies. Arguably, any letter that carries a diacritic can be construed as a composite glyph and not a character. Essential European letters such as *ä é ö ç ñ* have Unicode addresses of their own but can also be identified in Unicode as base-letter plus combining diacritic. After years of readily accepting such composites as elemental characters, Unicode custodians have recently insisted that no further composite characters will be enrolled. Scripts whose lobbyists got there early have their alphabets enshrined as Unicode characters; other scripts, for now at least, have to describe themselves by writing Unicode recipes for assembling the pieces. The letter *ą* (*a-ogonek*) and the other nasal vowels of Polish and Lithuanian are Unicode characters. So are the *ǫ* and *ǭ* of Old Icelandic, the *å̄*, *ē̆* and *ǫ̂* of Vietnamese, and the *ŭ* and *ü̆* employed in romanized Mandarin, but *ą́*, *ę́*, *į́*, *ǫ́*, *ų́* and other widely used Pan-Athapaskan letters, essential for writing Navajo and some forty other Native American languages, have not been made so welcome.

Letterforms can, of course, live rich and fruitful lives without a Unicode address. They have done so for thousands of years. But

The State of the Art

כמנפצ
דסוףץ

Above and below, *reading right to left*: on the upper line are the normal forms of Hebrew *kaf, mem, nun, pe* and *tsadi*. On the lower line are alternate forms of the same letters, used at the ends of words. These final forms could very well be considered alternate glyphs, like word-end swashes, but Unicode treats them as characters. (The typeface above is John Hudson's SBL Hebrew; the face below is Henri Friedlaender's Hadassah.)

כמנפצ
רסוף

183

it is harder now for unrecognized characters to move around the village or the globe in electronic messages and files. The large 'private use' section of Unicode is not a solution – unless shared, dependable, unofficial standards of encoding are constructed, like permanent refugee camps, in that unpoliced domain.

9.1.3 *Manual, Random and Programmed Variation*

The text is a string of characters; the font is a palette of glyphs – along with all the information (width tables, kerning tables and so on) needed for stringing the glyphs to match the characters. If we think about typography in these terms, it is clear that every font could offer the typographer a different range of choices: a different palette of glyphs, in other words, mapped perhaps in many different ways, to the same set of standard characters.

Zuzana Ličko's type family Mrs Eaves (Emigre, 1996) is an example. The family has grown over the years (and since 2009, it has had an unserifed companion face known as Mr Eaves) but the design was unusually rich to begin with. Roman, italic and bold are each equipped with a large battery of typographic ligatures. Some of these are subtle, some distinctly cheeky. Clearly they are interpretations or representations of characters, variations on a theme embodied in characters – or, in other words, they are glyphs. And they are not meant to speed typography up; they encourage us instead to slow down and unwind.

The æ and œ (but not their spaced variants, *ae* and *oe*) are *lexical* ligatures and therefore qualify as characters. The other ligatures shown here are typographic and therefore merely glyphs – though the *st* ligature has also (by accident) been registered in Unicode.

æ æ ćky ee ffy ffr ǵǵ ǵǵy ǵi
ip it ky oe œ ŝp ʃs ʃs Th tt tty ty
ae æ ćky ćt ee fb ff ffy ffr ft ggy ǵi gy ip
it ky oe œ Œ ŝp ʃs st py tt tty ty tw

Some of the ligatures in Zuzana Ličko's typeface Mrs Eaves. There are 30 ligatures for the caps, 40 for the lower case, and one hybrid (Th). The face (though not its complement of ligatures) is based on John Baskerville's roman and italic. It is named for Sarah Ruston Eaves (Mrs Richard Eaves), who for sixteen years was Baskerville's resident housekeeper and lover, and for another eleven years (after the death of her first husband) was his lawful wedded wife.

If every font can have a different set of alternative glyphs, it is pointless to expect the composition software by itself to choose effectively among them. Three other possibilities suggest themselves: (1) the choice of glyphs can be left to the typographer, who picks them and inserts them each by hand; (2) where there are variant forms of single letters, the choice can be left to chance; (3) the rules for choosing glyphs can be tailored to the typeface and embedded in the font itself.

The State of the Art

The first of these options has been the normal practice with foundry type for centuries. The digital faces Poetica, Sophia, Zapf Renaissance and Zapfino, in their original PostScript incarnations, belong to the same tradition. By including extra glyphs for certain characters, these faces offer digital typographers the same degree of freedom (and require in return the same investment of skill and attention) that hand compositors have enjoyed since the days of Gutenberg, Erhard Ratdolt and Nicolas Jenson.

The second option – letting the designer's chosen variants assert themselves at random – is an old and distinguished method too. Francesco Griffo, Claude Garamond and Simon de Colines are three of many early masters who cut multiple forms of letters. Some alternates (with forms like v and t) were used selectively at the beginnings and ends of words, in contexts where their extra width was useful to the line. Others, which differed among themselves scarcely enough to reach the threshold of visibility, could serve – and did serve – to enliven the text at random.

Another kind of random variation involves the interaction of the craftsman's skill and the texture of materials. The letterforms of Griffo and Colines were cut with immense care. But the letters they cut were struck by hand in copper or brass, then cast and dressed and set by hand, inked by hand with handmade ink and printed by hand in a handmade wooden press on handmade paper. Every step along the way introduced small variations planned by no one. In the world of the finely honed machine, those human-scale textures are erased. A sterile sameness supervenes.

The computer is, on the face of it, an ideal device for reviving the old luxury of *random variations at the threshold of perception* (quite a different thing from chaos). But conventional typesetting software and hardware focuses instead on the unsustainable ideal of absolute control – and has been hamstrung in the past by the idea of a single glyph per character. There have been several recent attempts to introduce a layer of random variation, but all have had to work against the grain of technological development.

In the Open-Type version of Hermann Zapf's Zapfino, the sequence $p + p$ can automatically convert to $p_1 + p_2$, but other options can be manually chosen. Four of these are shown below.

An early example was Erik van Blokland and Just van Rossum's typeface Beowolf. In its first experimental version (1990), this face relied on the output device to create truly random perturbations from a single set of letterforms. Though it would not work on all systems, and the evolving hardware and software quickly passed it by, it remains an important landmark in the effort to teach computers what typography really entails.

eeeeeeeee eeeeeeeee eeeeeeeee

Beowolf (FontShop, 1990) is at root a statuesque text roman drawn by Erik van Blokland. The letterforms were sent to the output device through a subroutine, devised by Just van Rossum, that provoked distortions of each letter within predetermined limits in unpredetermined ways. Three degrees of randomization – sampled above – were available. Within the specified limits, every letter was a surprise.

Those are two options: manual and random substitution. There is still the third: building glyph-selection rules into the font itself. This gives *predictable* variation. It is now the reigning method for achieving typographic variation, because this is the method built into the OpenType specification.

For now, therefore, the goal of pleasing randomness – constrained but unplanned variation – goes begging in computerized typography. Is it worth pursuing? Communication requires control, just as life requires control – but it also requires a context beyond its control. Unpremeditated grace is as crucial to the liveliness of the page as it is to the liveliness of the garden.

9.2 THE SUBSTANCE OF THE FONT

Within the tiny confraternity of metal typefounders and letterpress printers there is a subtribe that can argue day and night about recipes for type metal. In such a company, the question of whether to add or subtract five per cent of tin or antimony, or one per cent of copper, can lead to a long and heated exchange. In the community of digital founders and programmers, there is a corresponding subtribe capable of arguing till death about the merits of one digital format versus another.

Between 1980 and 2000, many digital font formats were introduced. Each one's sponsors claimed their product was superior to its predecessors, and sometimes they had grounds to make such claims. In every case, however, it has turned out that

Type metal is typically 60% to 80% lead, 15% to 30% antimony and 5% to 10% tin. Some founders also like to add a trace of copper.

what genuinely matters is not the format used so much as the level of hands-on workmanship, good sense and attention to detail. In metal and digital founding alike, the standard is set by the human who does the work, not by the recipe or the brand name of the tools.

Bitmapped fonts came into use in the 1970s. Fonts of this sort are defined by simple addition and subtraction: *this pixel on, that pixel off, these pixels on, those pixels off.* After 1984, with the introduction of the PostScript language, bitmapped printer fonts rapidly gave way to fonts defined as scalable outlines. A decade later came TrueType, which differs from PostScript in several respects. PostScript and TrueType take quite different approaches to hinting (that is, they have different ways of addressing the problems caused by inadequate resolution), and their descriptive mathematics are different. Both interpret letterforms in terms of Bézier splines (in other words, they rely on algebraic techniques developed by Pierre Bézier and Paul de Casteljau in France in the 1960s and 1970s) – but PostScript splines are cubic, while TrueType's are quadratic.

In mechanics, a spline is a flexible strip that will bend under tension. Boatbuilders and furniture makers use them for laying out curves. In mathematics, a spline is a curve that behaves as if it had fiber: sturdy enough to hold itself up yet limber enough to straighten and bend, stretch and retract.

A simple cubic spline, above, and the same curve (more or less) reconceived below as two quadratic splines.

Think of a curve as a tensile line, bent by means of a lever attached to each end. Such a curve can be mathematically defined in terms of four points. Two of these are the *endpoints* of the curve. The other two, at the far ends of the levers, are known as the curve's *control points*. If the two imaginary levers can be controlled independently, then cubic equations [as for example, $f(t) = (1-t)^3 E_1 + 3t(1-t)^2 C_1 + 3t^2(1-t)C_2 + t^3 E_2$] will be required to describe the curve, and it is called a cubic spline.

The levers themselves *are not part of the curve,* and the control points are usually off the curve. In the simplest case, however, these imaginary levers have a length of zero. Then the control points and the endpoints coincide, and the curve is a straight line.

One way to simplify a cubic spline is to tie the levers together so that both control points coincide (or so that one control point has a fixed relation to the other). If that is done, the mathematical description can be simplified from cubic to quadratic [along the lines, $f(t) = (1-t)^2 E_1 + 2t(1-t)C + t^2 E_2$].

There are some other complications. A cubic spline, for instance, can have additional anchors or points of inflection; a

187

quadratic spline cannot. In brief, cubic splines can be simple or complex; quadratic splines can only be comparatively simple. So translating a cubic spline to quadratic form can mean converting one spline into several (and the translation even then may be imperfect). A TrueType letterform will therefore often have more splines than the equivalent form in PostScript, but these are usually defined by fewer points, and mathematically speaking, the points are usually simpler to describe.

PostScript itself – the computer language central to most digital typography – continues to evolve. Several ways of defining a font in PostScript have also been tried. First out of the gate was a format known as Type 1, and it remains the most ubiquitous. More than fifty thousand fonts are now available in this guise. Most are now also available in TrueType format (TTF) – directly converted, more often than not, from a PostScript original. One outward difference is that Type 1 fonts come in a cumbersome package of two, three, or four digital files (at minimum, one for the glyph shapes and one for the metrics) while a TrueType font is compiled as one file only.

Type 1 and the older or 'closed' style of TrueType have largely been supplanted since the year 2000 by a more versatile font format known as OpenType. The glyphs in an OpenType font can be defined in either cubic or quadratic terms. The kernel of the font, in other words, can be either PostScript or TrueType. Either way, an OpenType font is compiled, like a TrueType font, as a single file. If the kernel is PostScript, the font file will be labeled OTF (for OpenType Format); if the kernel is TrueType, the format is

All quadratic splines can be perfectly expressed as cubic splines, but *not vice versa.* In quadratic equations, the highest power is two (e.g., x squared: x^2); in cubic equations, it is three (e.g., x cubed: x^3).

The *e* on the left, encoded in PostScript, is described by way of 18 cubic splines defined by 60 points. The *e* on the right, encoded in TrueType, is described by way of 23 quadratic splines defined by 52 points. Endpoints are represented by squares, control points by circles.

technically 'TrueType Open,' but the font file will be labeled TTF, like any older TrueType font.

The kernel of an OTF font is not in fact PostScript Type 1 but the more compact PostScript Type 2. This is why OTF font files tend to be smaller than Type 1 files, even when they hold much more information. Type 2 is also known as CFF (Compact Font Format), and OTF fonts are often, for that reason, described as CFF fonts. In effect, CFF has become a nickname for 'PostScript-flavored OpenType.'

Many typographic features can be added to OpenType fonts that cannot be added in Type 1. There may be, for example, contextual alternates and discretionary ligatures, with rules stating where and when these alternates or ligs will be employed. There may be small caps, along with rules that allow automatic substitution of small caps for caps and lower case. There may be four or more sets of figures. The font's default option is still very likely to be an ugly and all but useless set of tabular lining figures, but the 'proportional old-style' figures required for text should be there too – together with a rule allowing you to choose them, through the composition software, as your preferential forms across the board.

Please note that the format alone confers none of these blessings. It merely offers opportunities. A plain vanilla font converted to OpenType is just as plain as before. It will remain so until the font designer or editor takes the time to give it more complexity and depth. OpenType is a 'better' – that is, more capable – format than Type 1, but a well-made font in Type 1 format is still better by far than an OpenType font that is sloppily made.

Please remember, too, that digital fonts, like metal fonts, do nothing by themselves. They are reliant on the knowledge, patience and skill of the individual compositor. They are also at the mercy of the software the compositor happens to use.

Type 1 fonts can include very large glyph palettes. What they cannot include is rules for the interaction or selection of these glyphs. An OpenType font's sophistication lies, for the most part, in such rules. They may be absent altogether. If present, they may be well or badly written. But even the best and most flexible rules will accomplish nothing unless the composition software can interpret them correctly. It is easy, at the moment, to build fonts whose typographic sophistication exceeds the capabilities of all existing composition software. The technological frontier runs, in part, along the boundary between the two.

9.3 SIZE, COLOR AND SCALE

At least two crucial things were lost in the long transition from handcut metal to digital type. One was the sculptural bite of type into paper; another was the rich singularity of detail, weight and proportion inherent in handmade fonts and letterforms. As digital type has matured, it has evolved elaborate substitutes for both. In place of three-dimensionality, high-grade digital type offers increased two-dimensional subtlety, achieved through fastidious shaping and kerning of letters. In place of the lively singularity of handcut metal, it has begun to offer a fine-grained spectrum of weights and proportions stemming from a uniform design.

The infinite scalability of digital type is one of its great attractions. But when multiple sizes of type are mixed on the page, all scaled from one invariant design, the disharmony inherent in uniformity is clear.

A very promising amplification of the Type 1 format, developed by Adobe in the early 1990s, was known as Multiple Master. Fonts in this format are designed in pairs, with each pair embodying two related extremes, such as light and bold, serifed and unserifed, long-limbed and short-limbed or extended and condensed. As many as four such pairs can be combined in a single master font, giving up to four independent axes of variation. The typographer interpolates at will between the two (or four or six or eight) extremes. If, for example, weight (light to bold) is one of the axes in the master font, it is possible to choose any weight between the two extremes and generate an 'instance' of the font at that precise point on the spectrum. If width (condensed to extended) is also an axis, it is possible to choose any point on that spectrum as well.

The greatest use of this technology turned out to have little to do with weight or width. The most valuable Multiple Master fonts proved to be those with an axis of optimal size. (Adobe has always called it 'optical size,' but it is no more optical than visceral.) When a Multiple Master font has an axis of optimal size, one of the reference fonts is weighted and proportioned for printing at a small size, such as 5 or 6 pt. It is paired with another font of the same design, weighted and proportioned for printing at a size such as 96 or 120 pt. By interpolating between these extremes, the typographer can generate a slightly different cut of the same typeface for each size of type (or each narrow range of sizes) in a given publication. In a simple case, there might be a text font, a

footnote font, and a titling font. For a complex text, there might be several more.

These tools proved too subtle for the marketplace, and production of Multiple Master fonts soon ceased. Adobe then began to sell their flagship fonts in 'optical ranges.' In effect, these are prefabricated Multiple Master 'instances.' Adobe Jenson, Arno, Minion, Garamond Premier and other faces are now issued in this form. The sizes have names instead of numbers – caption, small text, regular, subhead, display – each corresponding to an ideal range instead of one specific size. Some other founders have taken a similar approach. For now, this seems the best available method for obtaining balanced color and homogeneous design when setting digital type in multiple sizes.

9.4 METHODS OF JUSTIFICATION

9.4.1 *Use the best available justification engine.*

Most of the type set in the past five hundred years is justified type, and most of it has been justified line by line, by the simple expedient of altering the space between the words. There are, however, better ways. Scribes justify text as they write, by introducing abbreviations and subtly altering the widths of letters. Gutenberg replicated the feat by cutting and casting a host of abbreviations and ligatures along with multiple versions of certain letters, differing modestly in width. In the early 1990s, Peter Karow and Hermann Zapf devised a means of doing much the same in the digital medium – and without relying on scribal abbreviations. When the method they had devised was first offered for sale, it was rejected. Now it is being absorbed. The justification engine used in setting this book is based on the one imagined by Zapf and engineered by Karow two decades ago: an electronic version of what Gutenberg envisioned in the 1440s, as he analyzed the work of master scribes.

Unlike a Monotype or Linotype machine, the computer is perfectly capable of calculating the pros and cons of linebreaks over a whole paragraph. It can break a line in one place, then go back and break it again, and again, and again, if subsequent lines give it reason to do so. Hand compositors have been known to do the same – but rejustification by hand is a tedious business. The computer, once it learns the trick, can do it in a flash.

Another thing computer software can do – because Karow

The characters in the margin on the facing page are Robert Slimbach's Arno (Adobe, 2007). The first group, increasing in size from 7 pt to 102 pt, progresses through the six size ranges of the face (from caption to light display). These glyphs therefore vary not only in size but also in proportion. The second group, decreasing from 102 pt back to 7 pt, is all in the 'regular' font. The proportions of these glyphs are therefore static. (See pp 60, 218.)

191

taught it how – is justify text by making subtle alterations in the spaces *within* letters as well as those between letters and words.

Good justification is calculated paragraph by paragraph instead of line by line. And the best computer justification now relies on microscopic adjustments to all the spaces in the line, including those inside the letters – the counters, that is, in letters such as *b* and *o*. In this book, for example, the justification engine has been permitted to vary the intercharacter spacing by ±3% and to adjust the counters of individual glyphs by the same amount. The bulk of the work is still done by adjusting the spaces between words (±15%), but there are many more letters than spaces in these lines. Tiny adjustments to spaces within and between the glyphs therefore go a long way toward creating even color and texture.

In English, where on average there are five times more letters than spaces on a page, the allowable elasticity in intra- and intercharacter spacing should usually be held to around one fifth of the elasticity permitted in the spaces between words.

9.5 PIXELS, PROOFS & PRINTING

9.5.1 *If the text will be read on the screen, design it for that medium.*

Like a forest or a garden or a field, an honest page of letters can absorb – *and will repay* – all the attention it is given. Much type now, however, is delivered to computer screens. It is a good deal harder to make text truly legible on screen than to render streaming video. The best computer monitors now sold have barely adequate resolution (235 dpi: roughly a third the current norm for laser printers and less than a tenth of the norm for professional offset printing). When texts disintegrate into pixels, the eye goes looking for distraction, which the screen is all too able to provide. Both fine technology *and great restraint* are required to make the screen as restful to the eyes as ordinary paper.

The underlying problem is that the screen mimics the sky instead of the earth. It bombards the eye with light instead of waiting to repay the gift of vision – like the petals of a flower, or the face of a thinking animal, or a well-made typographic page. And we read the screen the way we read the sky: in quick sweeps, guessing at the weather from the changing shapes of clouds, or in magnified small bits, like astronomers studying details. We look to it for clues and revelations more than wisdom. This makes it

Methods of Justification

It has been argued that even a one per cent adjustment of spaces within the glyphs is typographic blasphemy and distortion. I can sympathize with this view. But the fact is, *all* justification involves distortion, suffered in pursuit of a scribal or typographic ideal. And distortion, like poverty, is less painful when spread around.

Nations are not truly great solely because the individuals composing them are numerous, free, and active; [nor corporations because of their market share and profits;] but they are great when these numbers, this freedom, and this activity [or this market share and profit] are employed in the service of an ideal higher than that of an ordinary [hu]man, taken by himself. – MATTHEW ARNOLD [& EVE SMITH]

FL/RR, with invariant word-spacing, letter-spacing and glyph shape.

Nations are not truly great solely because the individuals composing them are numerous, free, and active; [nor corporations because of their market share and profits;] but they are great when these numbers, this freedom, and this activity [or this market share and profit] are employed in the service of an ideal higher than that of an ordinary [hu]man, taken by himself. – MATTHEW ARNOLD [& EVE SMITH]

Justified by wordspacing only.

Nations are not truly great solely because the individuals composing them are numerous, free, and active; [nor corporations because of their market share and profits;] but they are great when these numbers, this freedom, and this activity [or this market share and profit] are employed in the service of an ideal higher than that of an ordinary [hu]man, taken by himself. – MATTHEW ARNOLD [& EVE SMITH]

Justified by letterspacing only.

Nations are not truly great solely because the individuals composing them are numerous, free, and active; [nor corporations because of their market share and profits;] but they are great when these numbers, this freedom, and this activity [or this market share and profit] are employed in the service of an ideal higher than that of an ordinary [hu]man, taken by himself. – MATTHEW ARNOLD [& EVE SMITH]

Justified by glyph reshaping only.

Nations are not truly great solely because the individuals composing them are numerous, free, and active; [nor corporations because of their market share and profits;] but they are great when these numbers, this freedom, and this activity [or this market share and profit] are employed in the service of an ideal higher than that of an ordinary [hu]man, taken by himself. – MATTHEW ARNOLD [& EVE SMITH]

Justified by a combination of wordspacing (±15%) with letterspacing (±3%) and glyph reshaping (±3%).

an attractive place for the open storage of pulverized informa-
tion – names, dates, or library call numbers, for instance – but
not so good a place for thoughtful text.

The screen, in other words, is a reading environment even
more fugitive than the newspaper. Intricate, long sentences full of
unfamiliar words or names stand little chance. At text size, subtle
and delicate letterforms stand little chance as well. Superscripts
and subscripts, footnotes, endnotes, sidenotes, and many other
literate accessories are difficult to see. They also interfere with the
essential illusion (it is an illusion) that reading on-screen increases
one's speed. If the links and jumps of hypertext replace conven-
tional notes, all the subtexts can be the same size, and readers are
at liberty to skip from text to text like children switching chan-
nels on TV. But when reading takes this form, both sentences and
letterforms retreat to greater simplicity. Forms bred on newsprint
and signage are more likely to survive, and subtle Renaissance
romans and italics likely to fail.

In brief, good text faces for the screen are as a rule faces with
low contrast, a large torso, open counters, sturdy terminals, and
slab serifs or no serifs at all. Good on-screen paragraphs are
ragged-right and short. Good on-screen headings are frequent
and simple. Good textblock measures for the screen are fairly
narrow – closer to 36 than to 66 characters per line.

While we wait for screens to improve, there is one other op-
tion, and it is a real one: typographic abdication: deliver the text
but leave the choice of face and measure to the reader.

9.5.2 *Follow the work to the printer.*

All typographic decisions – the choice of type, the choice of size
and leading, the calculation of margins and the shaping of the
page – involve assumptions about the printing. It is well to find
out in advance whether these assumptions stand any chance of
being fulfilled. Good printers have much else to teach their clients,
and the best typographer can always find something to learn. But
the path from the editor's desk to the pressroom floor remains
a journey often fraught with danger and surprise. The reason is
that it is frequently a journey between economic realms. On the
one side, a singular thing, a manuscript, moves slowly through
the hands of individual human beings – author, editor, typogra-
pher – who make judgements and decisions one by one, and who
are free (for a time at least) to change their minds. On the other

side, an immensely expensive commodity (blank paper) passes at great speed and irreversibly through an immensely expensive (and therefore obsessively hungry) machine.

Digital methods have helped to bring editing, typography and type design back, in some respects, to the close relationship they enjoyed in the golden age of letterpress. But everything the writer, type designer, editor and typographer do is still contingent on the skills and methods of the printer – and while typography, for many, has returned to cottage scale, printing has enlarged to the dimensions of heavy industry. The freedom afforded by cheap and standardized typesetting hardware and software also comes at a price. That price is the danger of weary sameness and thinness in all the work the typographer does. The use of standard industrial papers, inks, presses and binding machinery can easily erase whatever remains of the typographer's personal touch. Yet printing is what typography is usually thought to be for.

If only by default, it falls to the typographer more than to anyone else to bridge this gap between a world focused on the perfect final proof and the world of its industrial replication. No one else works as close to that frontier as the typographer, and no one has a greater need to understand what happens on both sides.

The margins of books cannot be calculated correctly until the binding method is chosen, and they cannot be right in the end unless the chosen method is followed. The type cannot be chosen without coming to some decision about the kind of paper it will be printed on, and cannot look right in the end if that decision is later betrayed. A change of one eighth inch in the folding pattern or trim size will ruin a precisely measured page.

Yet another way to undercut the type is to print it with the wrong ink. Color control is important whether or not color is used, for there are many hues of black, some veering toward red, some veering toward blue. Redder blacks are acceptable on ivory paper. If the paper is closer to gray or white, the black of the ink should move closer to blue. But it will be process black by default – and the density of the type will be at the mercy of the press foreman's final color adjustments – if the text and process-color illustrations are printed in one go.

Ink gloss is rarely a problem on uncoated paper. On coated stock, the sheen of the ink is frequently out of control. For the sake of legibility in artificial light, inks that are used for printing text on a coated sheet should have *less* reflectivity than the paper, rather than more.

9.6.1 *Consult the ancestors.*

Typography is an ancient craft and an old profession as well as a constant technological frontier. It is also in some sense a trust. The lexicon of the tribe and the letters of the alphabet – which are the chromosomes and genes of literate culture – are in the typographer's care. Maintaining the system means more than merely buying the newest fonts from digital foundries and the latest updates for typesetting software.

The rate of change in typesetting methods has been steep – perhaps it has approximated the Fibonacci series – for more than a century. Yet, like poetry and painting, storytelling and weaving, typography itself *has not improved.* This is proof, I think, that typography is more art than engineering – though engineering is certainly part of it. Like all the arts, it is basically immune to progress but not immune to change. Typography at its best is sometimes as good, and at its worst is just as bad, as it ever was. The speed of certain processes has certainly increased; some old, hard tricks have come to seem easy, and some new ones have been learned. But the quality of typography and printing, their faithfulness to themselves, and the inherent grace and poise of the finished page, is not greater now than it was in 1465. In several respects, digital typography still lags far behind the methods and resources of Renaissance compositors and medieval scribes.

Maintaining the system means openness to the surprises and gifts of the future; it also means keeping the future in touch with the past. This is done by looking with equal eagerness at the old work and the new. Reproductions, of course, are fine as far as they go, but you will never know what a fifteenth-century manuscript or printed book is like until you touch one, smell one, hold one in your hands.

9.6.2 *Look after the low- as well as the high-technology end.*

A digital typographer is now likely to use two rather flimsy but capable pieces of hardware: a computer, with keyboard and screen, and some kind of proofing device, usually a laser printer. The rest of the system – another computer which imposes the work for the press, and a high-resolution digital plate-maker or other output device – may be miles away.

In the typographer's computer there are likely to be a number of interdependent pieces of software. These will probably include a text editor, composition software, a library of digital fonts, a font manager, and a font editor. There may also be a photo editor and some electronic drawing tools. And the composition software will nowadays include a host of tools for manipulating type, erasing the ancient boundary between text and illustration. All these tools are new, but the craft is old.

Outside the hardware, but no less essential to the system, more primitive tools are still required: a pica stick, a sketch pad, a drawing board and instruments, and a library of reference works and examples of fine typography for discussion and inspiration. It is the latter, low-technology end of most typesetting systems that is usually in the most urgent need of upgrading.

One good typeface is better and more useful than fifty thousand poor ones. Here as always, good means several things. It means that the letterforms themselves are clearly envisioned, lucidly rendered and, beyond all that, convincing. It means they make mute, irrefutable sense to both body and mind. It means that the fabric in which these letterforms are held is well made too. If the type is metal, it means that the metal is well cast – hard, sharp, free of bubbles or sags – and evenly dressed. If the type is digital, it means that the glyphs are correctly aligned and consistently sized, with accurate widths and sensitive kerning instructions. A digital font *can be* an electronic artefact of immense sophistication: not only a masterpiece of design but an intangible piece of craftsmanship enriched by many skilled and often uncredited eyes and minds.

Some observers are dismayed and some excited by the complexity of the equipment most typographers now use. Some are excited and others unnerved by the evident power of that equipment and the ease of its operation. Yet inside that complexity, typography persists as what it is: the making of meaningful, durable, abstract, visible signs. When the system crashes, the craft, its purposes, its values and all its possibilities remain.

GROOMING THE FONT

10

Writing begins with the making of meaningful marks. That is to say, leaving the traces of meaningful gestures. Typography begins with arranging meaningful marks that are already made. In that respect, the practice of typography is like playing the piano – an instrument quite different from the human voice. On the piano, the notes are already fixed, although their order, duration and amplitude are not. The notes are fixed but they can be endlessly rearranged, into meaningful music or meaningless noise.

Pianos, however, need to be tuned. The same is true of fonts. To put this in more literary terms, fonts need to be *edited* just as carefully as texts do – and may need to be re-edited, like texts, when their circumstances change. The editing of fonts, like the editing of texts, begins before their birth and never ends.

You may prefer to entrust the editing of your fonts, like the tuning of your piano, to a professional. If you are the editor of a magazine or the manager of a publishing house, that is probably the best way to proceed. But devoted typographers, like lutenists and guitarists, often feel that they themselves must tune the instruments they play.

10.1 LEGAL CONSIDERATIONS

10.1.1 *Check the license before tuning a digital font.*

Digital fonts are usually licensed to the user, not sold outright, and the license terms vary. Some manufacturers claim to believe that improving a font produced by them is an infringement of their rights. No one believes that tuning a piano or pumping up the tires of a car infringes on the rights of the manufacturer – and this is true no matter whether the car or the piano has been rented, leased or purchased. Printing type was treated the same way from Bì Shēng's time until the 1980s. Generally speaking, metal type and phototype are treated that way still. In the digital realm, where the font is wholly intangible, those older notions of ownership are under pressure to change.

Until Linotype was purchased in 2006 by Monotype Imaging, its standard font license said, "You may modify the Font Software to satisfy your design requirements." FontShop's standard license

still has a similar provision: "You do have the right to modify and alter Font Software for your customary personal and business use, but not for resale or further distribution." Adobe's and Monotype's licenses contain no such provision. Monotype's says instead that "You may not alter Font Software for the purpose of adding any functionality.... You agree not to adapt, modify, alter, translate, convert, or otherwise change the Font Software...."

If your license forbids improving the font itself, the only legal way to tune it is through a software override. For example, you can use an external kerning editor to override the kerning table built into the font. This is the least elegant way to do it, but a multitude of errors in fitting and kerning can be masked, if need be, by this means.

10.2 ETHICAL & AESTHETIC CONSIDERATIONS

10.2.1 *If it ain't broke....*

Any part of the font can be tuned – lettershapes, character set, character encoding, fitting and sidebearings, kerning table, hinting, and, in an OpenType font, the rules governing character substitution. What doesn't need tuning or fixing shouldn't be touched. If you want to revise the font just for the sake of revising it, you might do better to design your own instead. And if you hack up someone else's font for practice, like a biology student cutting up a frog, you might cremate or bury the results.

10.2.2 *If the font is out of tune, fix it once and for all.*

One way to refine the typography of a text is to work your way through it line by line, putting space in here, removing it there, and repositioning errant characters one by one. But if these refinements are made to the font itself, you will never need to make them again. They are done for good.

10.2.3 *Respect the text first of all, the letterforms second, the type designer third, the foundry fourth.*

The needs of the text should take precedence over the layout of the font, the integrity of the letterforms over the ego of the designer, the artistic sensibility of the designer over the foundry's desire for profit, and the founder's craft over a good deal else.

10.2.4 *Keep on fixing.*

Check every text you set to see where improvements can be made. Then return to the font and make them. Little by little, you and the instrument – the font, that is – will fuse, and the type you set will start to sing. Remember, though, this process never ends. There is no such thing as the perfect font.

10.3 HONING THE CHARACTER SET

10.3.1 *If there are defective glyphs, mend them.*

If the basic lettershapes of your font are poorly drawn, it is probably better to abandon it rather than edit it. But many fonts combine superb basic letterforms with alien or sloppy supplementary characters. Where this is the case, you can usually rest assured that the basic letterforms are the work of a real designer, whose craftsmanship merits respect, and that the supplementary characters were added by an inattentive digital mechanic. The latter's errors should be remedied at once.

You may find for example that analphabetic characters such as @ + ± × = · – — © are too big or too small, too light or too dark, too high or too low, or are otherwise out of tune with the basic alphabet. You may also find that diacritics in glyphs such as å ç é ñ ô ü are poorly drawn, poorly positioned, or out of scale with the letterforms.

Monotype Photina as issued

$$1 + 2 = 3 < 9 > 6 \pm 1 \cdot 2 \times 4$$
$$a + b = c \cdot a@b \cdot © 2007$$

Photina repaired

$$1 + 2 = 3 < 9 > 6 \pm 1 \cdot 2 \times 4$$
$$a + b = c \cdot a@b \cdot © 2007$$

José Mendoza y Almeida's Photina is an excellent piece of design, but in every weight and style of Monotype digital Photina, as issued by the foundry, arithmetical signs and other analphabetics are out of scale and out of position, and the copyright symbol and *at* sign are alien to the font. The alien glyphs are shown in grey, good and corrected glyphs in black.

$$é \quad ù \quad ô \quad ã \;\rightarrow\; é \quad ù \quad ô \quad ã$$
$$á \quad è \quad ï \quad û \;\rightarrow\; á \quad è \quad ï \quad û$$

Frederic Goudy's Kennerley is a homely but pleasant face, useful for many purposes, but the early Lanston digital version was burdened with some preposterous diacritics, not designed by Goudy. (These errors were corrected after Lanston was absorbed by P-22, but the older and clunkier fonts are still in circulation.) *Top left*: four accented sorts as issued by Lanston. *Top right*: corrected versions. ¶ All fonts are candidates for similar improvement, and Robert Slimbach's carefully honed Minion has been through a related but more subtle transformation. *Second line, left*: four accented sorts from Minion as first issued by Adobe in 1989. *Second line, right*: the same glyphs, revised by Slimbach ten years later, while preparing the OpenType version of the face, called Minion Pro.

10.3.2 *If text figures, ligatures or other glyphs you need on a regular basis don't reside on the base font, install them there.*

For readable text, you almost always need text figures, but many otherwise promising faces are still sold with titling figures instead. Most Type 1 and TrueType fonts also have a stunted set of ligatures – fi and fl but not ff, ffi, ffl or fj. You may find the missing glyphs on a supplementary 'expert font,' but they all belong together on the base font. For the ligatures to appear, as they must, in the kerning table, the kerning must also be stored in OpenType format.

If, like a good Renaissance typographer, you use only upright parentheses and brackets (see §5.3.2, page 85), copy the upright forms from the roman to the italic font and adjust the fit. Only then can they be kerned and spaced correctly without fuss.

$$\text{ff'}$$
$$\text{ff)}$$
$$[f]$$

10.3.3 *If glyphs you need are missing altogether, make them.*

Standard Latin text fonts (Type 1 or TrueType) have 256 slots and carry a basic set of Western European characters. Eastern European characters such as ą ć đ ė ğ ħ ī ň ő ŗ ş ů are usually missing. So are the Welsh sorts ŵ ẅ ŷ, and a host of characters needed for African, Asian and Native American languages.

The components required to make these characters may be present on the font, and assembling the pieces is not hard, but you

need a place to put whatever characters you make. For rough and ready work, if you need only a few extra glyphs and do not care about spell-checking or system compatibility, you can place the new glyphs in wasted slots – positions such as ∧ < > \ | ` ~, which are accessible directly from the keyboard, or ¢ ÷ ƒ ™ ¤ ‰ ¦, which can be reached indirectly, even from a typical word processor. It is a vastly better practice, however, to make an enlarged OpenType font and place every additional character where it belongs. This is done by assigning it its own PostScript name (and its Unicode number, if it is lucky enough to have one).

10.3.4 *Check and correct the sidebearings.*

The spacing of letters is part of the essence of their design. A well-made font should need little adjustment, except for refining the kerning. Remember, however, that kerning tables exist for the sake of problematical sequences such as *f*, gy, "A, To, Va* and *74.* If you find that simple pairs such as *oo* or *oe* require kerning, this is a sign that the letters are poorly fitted. It is better to correct the sidebearings than to write a bloated kerning table.

The spacing of many analphabetics, however, has as much to do with editorial style as with typographic design. Unless your fonts are custom made, neither the type designer nor the founder can know what you need or prefer. I habitually increase the left sidebearing of semicolon, colon, question and exclamation mark, and the inner bearings of guillemets and parentheses, in search of a kind of Channel Island compromise: neither the tight fitting preferred by most anglophone editors nor the wide-open spacing customary in France.

abc: def; ghx? klm! «non»
abc: def; ghx? klm! «eh?»
abç: déf; ghx ? klm ! « oui »

Three options for the spacing of basic analphabetics in Monotype digital Centaur: foundry issue (*top*); French spacing (*bottom*); and something in between. Making such adjustments one by one by the insertion of fixed spaces can be tedious. It is easier by far, if you know what you want and you want it consistently, to incorporate your preferences into the font.

Digital type can be printed in three dimensions, using zinc or polymer plates, and metal type can be printed flat, from photos or scans of the letterpress proofs. Usually, however, metal type is printed in three dimensions and digital type is printed in two. Two-dimensional type can be printed more cleanly and sharply than three-dimensional type, but the gain in sharpness rarely equals what is lost in depth and texture. A digital page is therefore apt to look anaemic next to a page printed directly from handset metal.

Grooming the Font

This imbalance can be addressed by going deeper into two dimensions. Digital type is capable of refinements of spacing and kerning beyond those attainable in metal, and the primary means of achieving this refinement is the kerning table.

Always check the sidebearings of figures and letters *before* you edit the kerning table. Sidebearings can be checked quickly for errors by disabling kerning and setting characters, at ample size, in pairs: 11223344 … qqwweerrttyy.… If the spacing within the pairs appears to vary, or if it appears consistently cramped or loose, the sidebearings probably need to be changed.

The function of a kerning table is to achieve what perfect sidebearings cannot. A thorough check of the kerning table therefore involves checking all feasible permutations of characters: 1213141516 … qwqeqrqtqyquqiqoqpq … (a(s(d(f(g(h(j(k(l(…)a)s)d)f)g) … –1–2–3–4–5– … TqTwTeTrTtTyTuTiToTp … and so on. This will take several hours for a simple TrueType or Type 1 font. For a full pan-European font, it will take several days.

Class-based kerning (now a standard capability of font editing software) can be used to speed the process. In class-based kerning, similar letters, such as *a á â ä à å ã ă ā ą*, are treated as one and kerned alike. This is an excellent way to begin when you are kerning a large font, but not a way to finish. The combinations Ta and Tä, Ti and Tï, il and íl, i) and ï), are likely to require different treatment.

Kerning sequences such as Tp, Tt and f(may seem to you absurd, but they can and do occur in legitimate text. (Tpig is the name of a town in the mountains of Dagestan; Ttanuu is an important historical site on the British Columbia coast; sequences such as $y = f(x)$ occur routinely in mathematics.) If you know what texts you wish to set with a given font, and know that combinations such as these will never occur, you can certainly omit them

from the table. But if you are preparing a font for general use, even in a single language, remember that it should accommodate the occasional foreign phrase and the names of real and fictional people, places and things. These can involve some unusual combinations. (A few additional examples: McTavish, FitzWilliam, O'Quinn, *dogfish,* jack o'-lantern, Hallowe'en.)

It is also wise to check the font by running a test file – a specially written text designed to hunt out missing or malformed characters and kerning pairs that are either too tight or too loose. On pages 206–7 is a short example of such a test file, showing the difference between an ungroomed font and a groomed one.

It is nothing unusual for a well-groomed Type 1 font (which might contain around two hundred working characters) to have a kerning table listing a thousand pairs. Kerning instructions for large OpenType fonts are usually stored in a different form. Unfurled as a simple list, the kerning data for a pan-European Latin font might easily reach 30,000 pairs. For a well-groomed tri-alphabetic font, decompiling the kerning instructions can generate a table of 100,000 pairs. Remember, though, that the number isn't what counts. What matters is the intelligence and style of the kerning. Remember too that there is no such thing as a font whose kerning cannot be improved.

10.3.6 *Check the kerning of the word space.*

The word space – that invisible blank box – is the most common character in almost every text. It is normally kerned against sloping and undercut glyphs: quotation marks, apostrophe, and upper-case A, T, V, W, Y. It may need mild kerning against some of the figures (especially 1, 3 & 5). It is *not,* however, normally kerned more than a hair either to or away from a preceding lowercase *f* in either roman or italic.

A cautionary example. Most of the Monotype digital revivals I have tested over the years have serious flaws in the kerning tables. One problem in particular recurs in Monotype Baskerville, Centaur & Arrighi, Dante, Fournier, Gill Sans, Poliphilus & Blado, Van Dijck and other masterworks in the Monotype collection. These are well-tried faces of superb design – yet in defiance of tradition, the maker's kerning tables call for a large space (as much as M/4) to be added whenever the *f* is followed by a word space. The result is a large white blotch after every word ending in *f* unless a mark of punctuation intervenes.

Is it east of the sun
and west of the moon — or
is it west of the moon
and east of the sun?

Monotype digital Van Dijck, before and after editing the kerning table. As issued, the font is defective. The kerning table adds 127 units (thousandths of an em) in the roman, and 228 units in the italic, between the letter *f* and the word space. The corrected table adds 6 units in the roman, none in the italic. Other refinements, less drastic but necessary, have also been made to the kerning table used in the second two lines.

This defect – documented in methodical tests of Monotype metal and digital fonts in 1991 – was not corrected even when Monotype reissued its Van Dijck in OpenType 'Pro' format in 2008. It was still present in both OpenType and Type 1 fonts purchased for retesting in the summer of 2012.

Professional typographers may argue about whether the added space should be zero, or ten, or even 25 thousandths of an em. But there is no professional dispute about whether it should be on the order of an eighth or a quarter of an em. An extra space that large is a prefabricated typographic error – one that would bring snorts of disbelief and instantaneous correction from Stanley Morison, Bruce Rogers, Jan van Krimpen, Eric Gill and others on whose expertise the Monotype heritage is built. It is nevertheless an easy error to fix, for anyone equipped with the requisite tool: a digital font editor.

10.4 HINTING

10.4.1 *If the font looks poor at low resolutions, check the hinting.*

Digital hints are important chiefly for the sake of how the type will look on screen. Broadly speaking, hints are of two kinds: generic hints that apply to the font as a whole and specific hints applicable only to individual characters. Many fonts are sold unhinted, and few fonts indeed are sold with hints that cannot be improved.

Manual hinting is tedious in the extreme, but any good font editor of recent vintage will include routines for automated hinting. These routines are usually enough to make a poorly hinted text font more legible on screen. (In the long run, the solution is high-resolution screens, making the hinting of fonts irrelevant except at tiny sizes.)

The font on this page is straight off the shelf: a magnificently complex piece of digital engineering capable of setting bad type in five different scripts and over a hundred different languages.

On the facing page is a well-groomed version of the same font: the same big set of plain vanilla letterforms, tuned to set type well.

Some but not all of the lapses in the original kerning table are circled.

"Ask Jeff" or 'Ask Jeff'. Take the chef d'œuvre! Two of [of] (of) 'of' "of" of? of! of*. *Two of [of] (of) 'of' "of" of? of! of*.* Ydes, Yffignac, Ygrande, Les Woëvres, the Fôret de Wœvres, the Voire and Vauvise are in France, but Ypres is in Belgium. Yves is in heaven; D'Amboise is in jail. Lyford's in Texas & L'Anse-aux-Griffons in Québec; the Łyna in Poland. Yriarte, Yciar and Ysaÿe are at Yale. Kyoto and Ryotsu are both in Japan, Kwikpak on the Yukon delta, Kvæven in Norway, Kyulu in Kenya, not in Rwanda…. Walton's in West Virginia, but «Wren» is in Oregon. Tlalpan is near Xochimilco in México, The Zygos & Xylophagou are in Cyprus, Zwettl in Austria, Fænø in Denmark, the Vøringsfossen and Værøy in Norway. Tchula is in Mississippi, the Tittabawassee in Michigan. Twodot is here in Montana, Ywamun in Burma. Yggdrasil and Ymir, Yngvi and Vóden, Vídrið and Skeggjöld and Týr are all in the Eddas. Tørberget and Våg, of course, are in Norway, Ktipas and Tmolos in Greece, but Vázquez is in Argentina, Vreden in Germany, Von-Vincke-Straße in Münster, Vdovino in Russia, Ytterbium in the periodic table. Are Toussaint L'Ouverture, Wölfflin, Wolfe, Miłosz and Wū Wǔ all in the library? 1510–1620, 11:00 pm, and the 1980s are over.

Part of a text file designed to test for missing or dislocated glyphs and for lapses in the kerning table. Raw font at left; groomed font at right.

The version tested here is Times New Roman PSMT, version 5.08 (2011), a default text font in 2012 versions of the Microsoft Windows operating system. This is a TrueType-flavored OpenType font, includ-

"Ask Jeff" or 'Ask Jeff'. Take the chef d'œuvre! Two of [of] (of) 'of' "of" of? of! of*. *Two of [of] (of) 'of' "of" of? of! of*. Ydes, Yffignac, Ygrande, Les Woëvres, the Fôret de Wœvres, the Voire and Vauvise are in France, but Ypres is in Belgium. Yves is in heaven; D'Amboise is in jail. Lyford's in Texas & L'Anse-aux-Griffons in Québec; the Łyna in Poland. Yriarte, Yciar and Ysaÿe are at Yale. Kyoto and Ryotsu are both in Japan, Kwikpak on the Yukon delta, Kvæven in Norway, Kyulu in Kenya, not in Rwanda.... Walton's in West Virginia, but «Wren» is in Oregon. Tlalpan is near Xochimilco in México. The Zygos & Xylophagou are in Cyprus, Zwettl in Austria, Fænø in Denmark, the Vøringsfossen and Værøy in Norway. Tchula is in Mississippi, the Tittabawassee in Michigan. Twodot is here in Montana, Ywamun in Burma. Yggdrasil and Ymir, Yngvi and Vóden, Vídrið and Skeggjöld and Týr are all in the Eddas. Tørberget and Våg, of course, are in Norway, Ktipas and Tmolos in Greece, but Vázquez is in Argentina, Vreden in Germany, Von-Vincke-Straße in Münster, Vdovino in Russia, Ytterbium in the periodic table. Are Toussaint L'Ouverture, Wölfflin, Wolfe, Miłosz and Wū Wŭ all in the library? 1510–1620, 11:00 PM, and the 1980s are over.

ing pan-European Latin, Greek, Vietnamese, Cyrillic, Hebrew and Arabic character sets. It lacks the text figures, ligatures and small caps typical of full-featured OpenType fonts, and its OT features are actually limited to the Arabic subset. The kerning is quite good as far as it goes – which is about half an inch along a quarter-mile track.

*Grooming
the Font*

The presumption of common law is that inherited designs, like inherited texts, belong in the public domain. New designs (or in the USA, the software in which they are enshrined) are protected for a certain term by copyright; the *names* of the designs are also normally protected by trademark legislation. The names are often better protected, in fact, because infringements on the rights conferred by a trademark are often easier to prove than infringements of copyright. Nevertheless there are times when a typographer must tinker with the names manufacturers give to their digital fonts.

Text fonts are generally sold in families, which may include a smorgasbord of weights and variations. Most editing and typesetting software takes a narrower, more stereotypical view. It recognizes only the nuclear family of roman, italic, bold and bold italic. Keyboard shortcuts make it easy to switch from one to another of these, and the switch codes employed are generic. Instead of saying "Switch to such and such a font at such and such a size," they say, for instance, "Switch to this font's italic counterpart, whatever that may be." This convention makes the instructions transferable. You can change the face and size of a whole paragraph or file and the roman, italic and bold should all convert correctly. The slightest inconsistency in font names can prevent this trick from working – and not all manufacturers name their fonts according to the same conventions. For the fonts to be linked, their family names must be identical and the font names must abide by rules known to the operating system and software in use.

Type is idealized writing – yet there is no end of typefaces, as there is no end to visions of the ideal. The faces discussed in this chapter cover a wide historical range – Renaissance, Baroque, Neoclassical, Romantic, Modern and Postmodern. They also constitute a wide stylistic variety – formal, informal, fluid, crisp, delicate and robust. The emphasis, however, is on types I like to read and to reread. Each face shown seems to me of both historical and practical importance, and each seems to me one of the finest of its kind. Each also has its limitations. I've included some very well-known types, such as Baskerville and Palatino; some others, such as Bembo Condensed Italic and Romulus Sans, that are undeservedly forgotten; and several that are new enough they have not yet had time to establish themselves. Some, like Photina and Vendôme, have long been known in Europe but are rarely seen in North America; others, such as Deepdene, have had just as unbalanced a reception the other way round.

Most readers of this book will have access to digital catalogues, maintained on font vendors' websites. Now that type is principally a digital commodity, printed type specimens are quickly disappearing, but they remain an invaluable resource – because the Web, like the subway, is not a destination. Printing is still what type is for. By giving printed samples here, and pointing out some landmarks as well as hidden features, I hope to make it easier to navigate at will among the disembodied spectres.

Almost all faces listed in this chapter now exist in digital form, though a few are still missing essential components – text figures, for example – in their digital incarnations. Many such shortcomings have been remedied in recent years because typographers have made their wishes known. Yet some digital foundries continue making faces in abbreviated, deformed or pirated form. The presence of a typeface in this list is by no means an endorsement of every or any marketed version. (I have noted some of the instances, but not all, in which a font I wanted to include seemed first to require drastic editing.)

Buyers of type should be aware that they are always buying a copy of someone's original design. Licensed copies are preferable to unlicensed copies for two important reasons. First, if the designer is still alive, the license implies that the fonts are being

Candido, leggiadretto, & caro guanto;
Che copria netto auorio, & fresche rose;
Chi vidi al mondo mai sì dolci spoglie?
Così haues's'io del bel velo altretanto.
O inconstantia de l'humane cose.
Pur questo è furto; & viè, ch'io me ne spoglie.

stro, & domino Iesu Christo. Gratias ago deo meo semper pro
uobis de gratia dei, quæ data est uobis per Christū Iesum, quod
in omnibus ditati estis per ipsum, in omni sermone, & omni co⸗
gnitione (quibus rebus testimonium Iesu Christi confirmatū fuit
in uobis) adeo, ut nō destituamini in ullo dono, expectātes reue

Nuda latus Marti, ac fulg
Thermodoontiaca munita

Le génie étonnant qui lui donna naissance.
Toi qui sus concevoir tant de plans à la fois,
A l'immortalité pourquoi perdre tes droits?

Thousands of fonts, including thousands of copies of earlier foundry types, are currently for sale. Here are four of the thousands of excellent types that are *not* for sale. None of these fonts has survived in original form – and to the best of my knowledge, no reasonably faithful metal, photographic or digital replicas have yet been made. From top to bottom, they are:

1 The Petrarca Italic: a 12 pt Aldine italic designed and cut by Francesco Griffo in 1503 for Gershom Soncino, who printed with it at Fano, on the Adriatic coast, east of Florence. (Note the two forms of *d* throughout.)

2 The Froben Italic: a 12 pt Aldine italic cut for Johann Froben by the unidentified Master of Basel (possibly Peter Schoeffer the Younger). Froben started using this type in 1519.

On Colines, see Kay Amert, *The Scythe and the Rabbit* (2012).

3 The Colines St Augustin Italic [enlarged]: a 13 pt italic designed and cut by Simon de Colines, Paris. Colines had cut several romans by the time he finished this type, in 1528, but it was probably his first italic.

4 Firmin Didot Italic Nº 1: a 12 pt Neoclassical italic cut by the 19-year-old Firmin Didot in his father's shop in Paris, 1783.

sold with the designer's permission and that royalties from the sale are being paid. Second, the license gives some hope – though rarely, alas, a guarantee – that the fonts are not being sold in truncated or mutilated form.

11.1 NOMENCLATURE & SYNONYMY

Only one guiding principle is stated in this chapter:

11.1.1 *Call the type by its honest name if you can.*

The oldest types usually come to us without distinctive names and with only meager clues to who designed them. Setting this record straight, establishing the chronology, and giving credit where credit is due is the basic work of typographic history. People who admire the old types like to talk about them too. For that purpose they need names. These are bestowed for pure convenience, but out of pure affection.

Newer types, and copies of the old ones, need names too. As objects of commerce, they are almost always named by those who sell them, with or without the designer's cooperation. Early in his career, Hermann Zapf designed a type that he called Medici. After some consultation between founder and designer, that name was scrapped. When the first fonts were advertised for sale, they were known as Palatino.

That, however, is not the end of the story. A decade after its release as both a foundry type and Linotype machine face, Palatino became the object of commercial envy among the manufacturers of fonts for phototype machines. Zapf's design – or his two quite different designs, one for the Linotype, one for the foundry – were then copied right and left, and the copies were sold under names like Pontiac, Patina, Paladium and Malibu. A more recently plagiarized version is known as Book Antiqua. Max Miedinger's Helvetica – though not so distinguished a face nor so original a design in the first instance – has also been an object of widespread commercial envy. It is copied to this day under names such as Vega, Swiss and Geneva. Zapf's Optima is plagiarized as Oracle; Friedrich Poppl's Pontifex is plagiarized as Power, and so on.

The problem is not new. Nicolas Jenson's roman and Greek types were copied by other printers in the 1470s. So were Griffo's types, and Caslon's and Baskerville's and Bodoni's in their days. So are they now; though now, with these artists safely dead and

The name *Palatino* alludes to the 16th-century Italian calligrapher Giovanni Battista Palatino, but the type is not based on any of Palatino's hands. The type, like the scribe, is named for the Mons Palatinus – the Palatine hill in Rome, site of a major temple of Apollo and of several imperial palaces.

their work in the public domain, we are free both to make the copies honest and to give them honest names.

Part of the problem is that, in most jurisdictions, type designs themselves are not effectively protected as intellectual property. Courts have not learned to distinguish between typographic artistry and typographic plagiarism. Names, however, can easily be registered as trademarks. Competitors who plagiarize designs can then be forced to give their copies different names. In the literary world, the law works the other way around. It is the substance and the text, not the title, of a story, poem or book that is protected by copyright legislation.

Other complications sometimes spring from this anomaly in the law. The first sizes and weights of Paul Renner's Futura were issued by the Bauer Foundry, Frankfurt, in 1927. The type was a commercial as well as artistic success, and other founders soon copied the design. Sol Hess at Lanston Monotype redrew the face and called it Twentieth Century; ATF sold its own imitation as Spartan. But the Futura that the Bauer Foundry had issued was a timid incarnation of Renner's original design. Renner drew many alternate characters; Bauer issued, for each letter, only the single most conventional of Renner's several forms. In 1993, when David Quay and Freda Sack at The Foundry, London, made a digital translation of Renner's original design, the conventions of the trade prevented them from calling it Futura. Their version – artistically the earliest known version of Futura, though commercially one of the latest to be produced – was issued instead under the trade name Architype Renner. Though it was not Renner's choice, this seemed a serviceable name to most typographers, because it played no invidious tricks and it plainly acknowledged the originating designer.

cordia uale

Type categories such as *roman* and *italic* are not fixed. This is the enlarged trace of a 16 pt serifed type cut in central Italy in 1466–67, probably by Konrad Sweynheym. It is the second type used by Sweynheym and his partner Arnold Pannartz, who printed books with it at Rome from 1467 to 1473. Like Gudrun Zapf-von Hesse's Alcuin type, designed five centuries later, it is really neither roman nor italic. It is rooted in the Carolingian scriptorial tradition, which precedes any such division.

212

The balance of this chapter is a litany of names, with the briefest of histories attached. Part of every font's history is that it was born in a certain medium. At the beginning of each entry, that medium is shown by a simple code:

H = originally a metal type for hand composition
M = originally for machine composition in metal
P = originally designed for photosetting
D = originally designed in digital form

11.2 SERIFED TEXT FACES

abcëfghijõp 123 AQ *abcéfghijôp* 20 pt

Albertina P This graceful, understated text family – embracing Latin, Greek and Cyrillic – was designed in 1965 by the Dutch calligrapher Chris Brand. The Latin portion of the family was issued by Monotype, not in metal but as one of the corporation's first proprietary faces for photocomposition. Technology then moved on, and Albertina was left behind. The Latin component was issued anew in digital form by DTL (the Dutch Type Library) in 1996, complete with its requisite text figures and both roman and italic small caps. The Cyrillic and Greek followed at last in 2004. The forms are quiet and alert, the width economical, and the axis is that of the humanist hand. The crisp italic, with its subtly elliptical dots, slopes at a modest 5°. There is a full range of weights. (See also pp 283, 289.)

AQ 123 ábçdèfghijklmñöpqrstûvwxyz 15 pt book

abcëfghijõp AQ 123 ABCËFGHIJÕP 15 pt regular

Alcuin D A strong and graceful Carolingian face designed in 1991 by Gudrun Zapf-von Hesse and first issued by URW. As a genuine Carolingian, Alcuin is rooted in handwritten scripts that predate by 600 years the separation of roman and italic. It is neither of these itself, though it contains the seeds of both. As such, it does not have and does not need a sloped companion face. There is instead an extensive range of weights with text figures and small caps. This is everything required for setting excellent text. The face should not be used where editorial inflexibility demands the use of roman and italic. (See also pp 120, 212.)

Digital translations of Palatino (on the left) and Aldus (on the right). These are two related faces designed in 1948–53 by Hermann Zapf. To clarify the difference in proportion, selected characters of both are shown here at 72 pt. The basic alphabets (Palatino above, Aldus below) are also shown at 18 pt.

(Note that neither of these cuts was ever intended to be seen at the 72 pt size. Display sizes of foundry Palatino are more delicate than this, and Aldus is a text face for which no display sizes were designed. But the enlargements facilitate comparison.)

aa bb cc
éé ff gg
ññ ôô tt
CC HH

abcdefghijklmnopqrstuvwxyz
abcdefghijklmnopqrstuvwxyz
1 2 3 4 5 6 7 8 9 0 · A B C D É F G
1 2 3 4 5 6 7 8 9 0 · A B C D É F G
A B C D E F G H I J K L M N O
A B C D E F G H I J K L M N O
abcdefghijklmnopqrstuvwxyz
abcdefghijklmnopqrstuvwxyz

abcëfghijõp 123 AQ *abcéfghwxy*

Aldus M Roman and italic, designed in 1953 by Hermann Zapf as a text-size Linotype companion for his new foundry face, Palatino. Aldus is narrower than Palatino and has a lower midline (smaller x-height). It is a crisply sculptured, compact text face, rooted in Renaissance scribal tradition. Small caps and text figures are essential, but the face requires no ligatures. This is one of the most successful faces ever designed for the Linotype machine.

A very close relationship prevailed in the 1950s between the German arm of Linotype and the Stempel foundry in Frankfurt, where Zapf was then resident designer. As a consequence, foundry matrices were also engraved from the Linotype Aldus patterns. Foundry Aldus is in fact still occasionally cast (in five sizes, 6–12 pt Didot) at the Abteilung für Schriftguss in Darmstadt. Digital Aldus, like foundry Aldus, preserves the Linotype equality of set-width in roman and italic. Palatino, Michelangelo and Sistina are the allied titling faces, and Palatino bold will do in a pinch if a bold companion is required. (See also pp 64, 104, 214, 244.)

abcëfghijõp 123 AQ *abcéfghwxy*

Aldus Nova D When Palatino, his best-known typeface, reached its fiftieth birthday, Hermann Zapf began to revise the entire family. The result was Palatino Nova, issued in digital form by Linotype in 2005. As an integral part of the family, Aldus was included – but was not so much revised as supplanted by a new design. In Aldus Nova, as the new face is called, the ascenders have been shortened, the descenders lengthened, and many characters altered in other respects. In the italic, the set-width has been narrowed (freeing the face from restrictions imposed on the original design by the Linotype machine) and the basic form of the midline serifs has changed. Aldus Nova italic may in fact owe more to Zapf Renaissance italic than it does to Aldus. Italic small caps have been added, and a range of optional ligatures (fj, ct, st, tt, etc). Aldus Nova also appears at first glance to have its own bold face, but Aldus Nova bold is really Palatino Nova bold, with the glyph palette reduced to match that of Aldus Nova roman. This substitution works because the vertical proportions of Aldus Nova and Palatino Nova have been rationalized – at some cost to Aldus. The character set is Pan-European Latin. (See also pp 244, 260.)

Digital versions of Adrian Frutiger's Méridien (on the left) and Apollo (on the right). The former, issued in 1954, was initially a foundry face, though matricies were engraved only for the roman. Apollo, designed for filmsetting, was issued in 1962. Selected letters are shown here at 72 pt (Méridien) and 80 pt (Apollo). The basic alphabets (Méridien above, Apollo below) are both shown at 18 pt.

aa bb cc
éé ff *ff*
gg pp tt
CC HH

abcdefghijklmnopqrstuvwxyz
abcdefghijklmnopqrstuvwxyz
1 2 3 4 5 6 7 8 9 0 · A B C D É
1 2 3 4 5 6 7 8 9 0 · A B C D É
A B C D E F G H I J K L M N O
A B C D E F G H I J K L M N O
abcdefghijklmnopqrstuvwxyz
abcdefghijklmnopqrstuvwxyz

216

abcëfghijõp 123 AQ *abcéfghijôp*

Amethyst **D** Canadian printer and punchcutter Jim Rimmer designed the caps for this face in Vancouver in 1994 and initially called the face Maxwellian. He rechristened it Amethyst in 1999, when he drew the lower case. In 2002, after the first printing trials, Rimmer revised the book weight, darkening it by roughly 2%. It became a working typeface at that point. Rimmer's affection for Frederic Goudy is visible in Amethyst and in some of his other faces – Albertan, for example. It is also visible in Kaatskill, a transgenerational collaboration for which Goudy drew the roman and Rimmer the italic. Like Rimmer's other digital fonts, Amethyst has benefited from editing by Richard Kegler. It is distributed now by Kegler's P-22 foundry in Buffalo, New York.

abcëfghijõp 123 AQ *abcéfghijôp* *20 pt*

Apollo **P** Adrian Frutiger's Apollo was commissioned for the Monophoto machine in 1960 and produced in 1962. Frutiger used the opportunity to rethink his first text face, Méridien, drawn eight years earlier. Apollo lacks the sharpness of Méridien, but its smaller eye, blunter serifs and reduced modulation can make it a better choice for text, and it includes the f-ligatures, text figures and small caps that Méridien lacks. (See facing page.)

abcëfghijõp 123 AQ *abcéfghijôp*
áãâå ⓟ *ABČQXYŹ* ❀ *fggghk*
abpcf abpcf abpcf abpcf abpcf

Arno **D** Mixing sizes in scalable type readily leads to discoloration. Robert Slimbach's Arno Pro is one of a small handful of digital type families specifically designed and engineered to solve this problem – and to do it while setting texts of substantial linguistic complexity and typographic sophistication. At the same time, it is one of the handsomest and most elegantly drawn neohumanist faces produced in recent decades – therefore eminently suitable for setting the simplest, purest, most poignant text in a single size. There are 32 fonts in the series, moving in six steps from the six different caption fonts (most useful at 8 pt or smaller) to the two light display fonts (most useful at 48 pt or

✳ "The difficulty of designing a new type of any permanence is great, and [the feat] is rarely accomplished in any country. There has in recent years been an increase in the quality and quantity of typographical history and criticism. *But not until typography knows itself to be responsible to a rightly instructed public has type design of the present a permanent future.*"

— STANLEY MORISON, 1889–1967

On Type Designs Past and Present: A Brief Introduction
(London: Ernest Benn, 1962)

✳ ПОЭТ ЖЕ ЕСТЬ *комбинация*
"*A poet is* A COMBINATION OF AN INSTRUMENT *инструмента с человеком в одном лице,* AND A HUMAN BEING IN ONE PERSON, *with the* с постепенным преобладанием *former coming slowly to predominate over the latter.*" первого над вторым.

— *БРОДСКИЙ ИОСИФ* (JOSEPH BRODSKY), 1940–1996

Поэт и проза (A Poet and Prose), 1979

Five of the six optical ranges of Robert Slimbach's Arno Pro, used to avoid chromatic imbalance in a complex text. The type is set in seven sizes.

larger). Each font is tri-alphabetic (pan-European Latin, Cyrillic and polytonic Greek) and replete with ornaments, ligatures, swashes and quaints. The series was issued by Adobe in 2007. (See also pp 190–91, 218, 284, 290.)

abcëfghijõp 123 AQ *abcéfghijôp* 18 pt

Arrus D This is an elegant and graceful text face designed by calligrapher Richard Lipton for Bitstream in 1991. It is distinguished by the symmetrically notched roman foot serifs and asymmetrically notched head serifs. There is a full range of weights, with text figures and small caps. The same designer's Cataneo, an equally graceful chancery italic (Bitstream, 1994), makes an excellent companion face for Arrus. (See also page 224.)

abcëfghijõp 123 AQ *abcéfghijôp* 20 pt
Monotype 391

Baskerville H John Baskerville designed this roman and italic in the 1750s. The initial versions were cut by John Handy under Baskerville's watchful eye. The result is the epitome of Neoclassicism and eighteenth-century rationalism in type – a face far more popular in Republican France and the American colonies than in eighteenth-century England, where it was made.

Many of the digital faces sold under Baskerville's name are passably faithful to his designs, but small caps and text figures, often omitted, are essential to the spirit of the original, and to an even flow of text. The digital version shown here is Monotype Baskerville 391. At least two Cyrillic versions also exist: one produced by Monotype and one produced by ParaType under license from ITC. (See also pp 13, 56, 77, 84, 97, 129, 290.)

abcëfghijõp 123 AQ *abcéfghijôp* 19 pt

Bell H The original Bell type was cut in London in 1788 by Richard Austin for a publisher named John Bell. It was warmly greeted there and in the USA and was widely used in Boston and Philadelphia in the 1790s. It remains useful for period design work, as an alternative to Baskerville. Monotype cut a facsimile in 1931, and this version has been digitized. Bell has more variation in axis than Baskerville, but it too is an English Neoclassical face. The serifs are very sharp, but the overall spirit is nevertheless closer to brick than to granite, evoking Lincoln's Inn more than St Paul's,

and Harvard Yard more than Pennsylvania Avenue. Bell numerals are three-quarter height, neither hanging nor fully ranging. (See also pp 47, 129.)

20 pt abcëfghijõp 123 AQ *abcéfghijôpy*

Bembo н Bembo was produced by Monotype in 1929, based on a roman cut at Venice by Francesco Griffo in 1495. It is named for the Venetian writer Pietro Bembo (1470–1547) because Griffo's font was first used to print Bembo's little book *De Aetna,* published by Aldus in 1496. The fifteenth-century original had no italic, and Monotype tested two possibilities as a companion face. One was Fairbank italic; the other was the softer Bembo italic shown here. This italic is in essence a revision of Blado (the italic cut for Poliphilus), with sidelong reference to a font designed in Venice in the 1520s by Giovanni Tagliente. Bembo roman and italic are quieter and farther from their sources than Centaur and Arrighi. They are nevertheless serene and versatile faces of genuine Renaissance structure, and they have in some measure survived the transition to digital composition and offset printing. Text figures and small caps are essential. The bold fonts are irrelevant to the spirit of the face. (See also pp 51, 123, 124, 231, 248.)

Note that Monotype's *digital* Bembo does not match Monotype *metal* Bembo in size. (The digital glyphs are larger.)

18 pt abcëfghijõpy! 3 AQ *abcéfghijôpy*

Berling н Designed by the Swedish typographer and calligrapher Karl-Erik Forsberg. This face was issued in 1951 by the foundry from which it takes its name, the Berlingska Stilgjuteriet in Lund, Sweden. It is a neohumanist design, with vigorous modulation of the stroke. Ascenders and descenders are even more frequent in Swedish than in English, and Berling's descenders are unusually short. The ascenders are of normal height but designed to work with or without basic ligatures. The face has a Scandinavian sharpness and clarity, with sharply beaked f, j, y and ! in the roman. Berling Nova, produced in digital form by Örjan Nordling in 2004, includes the requisite text figures. (See also page 84.)

18 pt Berthold Bodoni abcëfghijõp 123 AQ *abcéfghijôp*

18 pt Bauer Bodoni Nº 1 abcëfghijõp 123 AQ *abcéfghijôp*

Bodoni н Giambattista Bodoni of Parma, one of the most prolific of all type designers, is also the nearest typographic counterpart to

Byron and Liszt. That is to say, he is typography's arch-Romantic. His hundreds of faces, cut between about 1765 and his death in 1813, embrace considerable variety, and more than 25,000 of his punches are in the Bodoni Museum in Parma. The revivals issued in his name reflect only a tiny part of this legacy, and many are simply parodies of his ideas. The typical features of Bodoni revivals are abrupt hairline serifs, ball terminals, vertical axis, small aperture, high contrast and exaggerated modulation. The ITC Bodonis, digitized in 1994–95 under the direction of Sumner Stone, are arguably the most suitable versions for text work. (There are three sets of fonts in this series: one for notes, one for titles, and one for text – but the text fonts are not based directly on any Bodoni original. They were produced by interpolating between the large and small designs.) Other favorites are the Bodoni cut by Louis Hoell for the Bauer Foundry, Frankfurt, in 1924, and the Berthold Foundry version, produced in 1930. Both have been issued in digital form. Small caps and text figures are essential to all of these designs. (See also pp 13, 37, 131.)

abcëfghijõp 123 AQ *abcéfghijôp* ẹgr đ wz ABC AQ *abcéfghijôp*

21/26 regular & italic

Brioso **D** Robert Slimbach is a fine calligrapher as well as a master type designer, and Brioso is the most calligraphic of all his text faces to date. It was issued by Adobe in 2003, with a pan-European Latin character set enhanced by a rich glyph palette, rife with ligatures, ornaments, swashes and variant forms. Italic and roman alike are indeed full of brio – full of liveliness or vivacity – yet the forms are highly disciplined as well, and therefore suitable for certain kinds of text as well as display. If there is any superfluity here, it lies not in the letterforms or character sets themselves but in the multiplication of weights. There are 42 fonts in the family, ranging from five weights of caption fonts, for setting at very small sizes, to a pair of poster fonts useful for huge initials and titles. The light weight caption font, and the four sizes of bold fonts, may be misused more than used – but let me not complain that more is on the menu than I myself can eat. The core fonts are superb pieces of work. I have used them with great pleasure. The others are there for any who want or need them.

abcëfghijõp 123 AQ *abcéfghijôp*

Bulmer **H** William Martin of Birmingham was the brother of Robert Martin, Baskerville's chief assistant. He may have learned to cut punches from Baskerville's punchcutter John Handy and may have got his first lessons in type design from Baskerville himself. He moved to London in 1786 and in the early 1790s started cutting types full of Baskervillean shapes yet considerably harsher than Baskerville's. The serifs were abrupt and the contrast much increased. This was the inception of English Romantic typography. Martin's types were sponsored and promoted by the printer William Bulmer, whose name overshadowed that of the designer. They were copied in 1928 by Morris Benton for ATF, and then by Monotype and Intertype. Several digital versions now exist. The most comprehensive of these is the one released by Monotype in 1994. The face is famous among typographers for its left-weighted italic lowercase *o*. (See also page 131.)

abcëfghijõp 123 AQ *abcéfghijôp*

Caecilia **D** This face, first issued by Linotype in 1991, was designed in the Netherlands by Peter Matthias Noordzij, and named for his wife Cécile. It is a neohumanist slab-serif, perhaps the first of its kind, with a slab-serifed true italic to match. The italic is built to Renaissance parameters, sloping at a modest 5°. There is a range of weights, with small caps and text figures. Licensed versions are sold as PMN Caecilia. (See also page 112.)

abcëfghijõp 123 AQ *abcéfghijôp*

Californian **H** The ancestor of this face is Frederic Goudy's University of California Old Style, cut for the university as a proprietary typeface in 1938. Lanston Monotype issued it publicly in 1956 under the name Californian. The digital version shown is issued now by the Lanston subdivision of P-22 and is based on the Lanston Monotype patterns. (As of 2012, the P-22 fonts are much improved over Lanston's first, quite clumsy digital versions, but the kerning and character fit still need extensive repair.) It is useful to compare Californian with ITC Berkeley, a more pasteurized interpretation of the same original, first produced in 1983 by Tony Stan. Out of the box, ITC Berkeley is better fitted, but it has neither the guts nor the flavor of real Californian.

abcëfghijõp 123 AQ *abcéfghijôp* 18 pt light & light italic

Carmina **D** Gudrun Zapf-von Hesse designed this face, released by Bitstream in 1987. While it builds upon her earlier text faces, Diotima and Nofret, Carmina is more versatile and lyrical (hence the name: *carmina* are songs or lyrical poems). There is a good range of weights. Like many early digital fonts, however, it was issued in a Procrustean character set making no provision for text figures. Such figures were a part of the original design but after twenty-five years, they have yet to be released.

abcëfghijõp 123 AQ *abcéfghijôp* 21/27 Cartier Book

ABC ✤❀✲〰❁✿✵❃✿ DEF

Cartier **P** Canadian typographer Carl Dair began working on this face in the Netherlands in 1957. At his death in 1967, the display version of the roman was effectively complete, but the italic was still an overwrought and over-narrow draft. No text weight or small caps had been drawn. The type was nevertheless hurriedly issued for filmsetting, in time for the Canadian centenary in 1967. Cartier roman then became, despite its weaknesses, the *de facto* Canadian national typeface, often used for stamps and other celebratory projects. It was in principle a roman with enough French Gothic flavor to assert a lingering difference between Ottawa and Washington. The letterforms are rooted in Dair's study of fifteenth-century Parisian and Florentine printing, especially the work of Ulrich Gering and Antonio Miscomini.

In the 1970s, British typographer Robert Norton confused things slightly by producing a tamed and sanitized version of Cartier roman and giving it the name of an English colonial partisan: Raleigh. (Raleigh, however, is almost never seen as a book face because Norton gave it no italic.) In the 1990s another Canadian, Rod McDonald, undertook to rescue the design. He gave Dair's roman the editing required to make it useful at text size, performed a brilliant rescue of Dair's original ideas for the italic, supplied the missing small caps, semibold and bold weight, and gave the type its first meticulous fitting. He also enhanced the type with a suite of northern fleurons (maple leaf, spruce limbs, fleur-de-lys, etc) for which Dair made some sketches. The result, called Cartier Book, began to circulate in 1998 and was issued by Agfa Monotype in 2000.

The glyphs in the upper cluster are Monotype Centaur. Those in the lower cluster are Bitstream Arrus. Monotype Centaur retains many features from foundry Centaur, which was drawn and cut one letter at a time. As a consequence, the serifs and other details of each letter belong to that letter alone. There is no mechanical repetition. In Arrus, the serifs are very distinctive, but they are repeated from letter to letter without any change – copied and pasted, where the Centaur serifs are individually carved. In this respect, Arrus is typical of digital type, and Centaur reminiscent of older craft practice. There is no reason why digital letterforms *have* to be mechanically repetitive. But the tools in current use make exact repetition the easiest option. Cutting letters by hand – like writing them by hand – makes exact repetition all but impossible. Such details are of course "invisible" at text size. Yet the effect of microscopic variation or mechanical repetition remains perceptible, in typography just as in woodwork or weaving.

Other faces in which the serifs plainly vary from letter to letter include Amethyst; Quadraat; Linotype Granjon; and Monotype 'Garamond,' Fournier, Poliphilus and Blado.

abcëfghijõp 123 AQ *abcéfghijôp*

abcëfghijõp 123 ſo *ſo abcéfghijôp*

20 pt Adobe
Caslon

Great Primer
Founder's Caslon,
set at 24 pt

Caslon **H** William Caslon designed and cut a large number of romans, italics and non-Latin faces between 1720 and his death in 1766. His work is the typographic epitome of the English Baroque and is remarkably well preserved. He published thorough specimens, and a large collection of his punches is now in the St Bride Printing Library, London. There is not much doubt that Caslon was the first great English typecutter, and in the English-speaking world his type has long possessed the semilegendary, unexciting status of the pipe and slippers, good used car and favorite chair. Typographic opportunists have therefore freely helped themselves to Caslon's reassuring name, and many of the faces sold as Caslons now are merely parodies. Adobe Caslon, drawn by Carol Twombly in 1989, is a respectful, sensitive and well-made digital descendant of the originals, equipped not only with text figures and small caps, but with optional swash caps, ornaments and other antiquarian accessories. It is now made as an OpenType font with a pan-European Latin character set but without Greek and Cyrillic. (No one, alas, has yet made a digital version of Caslon's handsome polytonic Greeks.)

For those in search of more historical veracity, the late Justin Howes produced digital versions directly from printed specimens of several sizes of the original Caslon types. These preserve, in their perfectly static way, a taste of the dynamic, rugged texture of printing in Caslon's time. They were issued as Founder's Caslon, by H.W. Caslon *&* Co. (See also pp 12, 51, 66, 113, 126.)

abcëfghijõp 123 AQ *abcéfghijôp*

22 pt

Centaur & Arrighi **H** Centaur roman was designed by Bruce Rogers in 1912–14, based on the roman type cut at Venice by Nicolas Jenson in 1469. In 1928, the face was mildly sanitized in the course of transposition to the Monotype machine. Frederic Warde drew the Arrighi italic in 1925, based on a chancery font designed by the calligrapher Ludovico degli Arrighi in the 1520s. In 1929, after several revisions, Rogers chose Warde's face as the companion italic for Centaur, provoking more revisions still. The fonts are used both separately and together.

Printed letterpress, Centaur and Arrighi are unrivalled in

their power to re-evoke the typographic spirit of the Venetian Renaissance. In the two-dimensional world of digital composition and offset printing, this power is easily lost. The problem is aggravated by weaknesses in the digitization of Arrighi, destroying the balance achieved when the faces were married in metal.

William Morris's Golden Type (1890), the Doves Roman drawn by Emery Walker and cut by Edward Prince (1900), Morris Benton's Cloister Old Style (ATF, 1913–25), George Jones's Venezia (Shanks, 1916; Linotype, 1928), Ernst Detterer's Eusebius (Ludlow, 1924), Ronald Arnholm's Legacy (ITC, 1992) and Robert Slimbach's Adobe Jenson (Adobe, 1996) are other notable attempts to do some justice to the same Venetian original. (See also pp 12, 16, 37, 67, 79, 84, 105, 123, 124, 202, 224.)

19 pt abcëfghijõp 123 AQ *abcéfghijôp*

Chaparral **D** The evergreen oaks of the California foothills are known in Spanish as *chaparros*. The lean and sunny landscape where they thrive is *chaparral*. Carol Twombly completed this extraordinarily clean and seemingly imperturbable typeface in 1997 – and then retired as staff designer at Adobe. Most good text types owe their power in part to the rhythmic modulation of the line. Here there is very little modulation, and the power comes from the path of the stroke: the subtle out-of-roundness of the bowls and microscopic taper of the stems. There is a range of weights, and the character set is pan-European Latin.

*15 pt Haas
Clarendon light* AQ ábcdèfghijklmñöpqrstûvwxyz

Clarendon **H** Clarendon is the name of a whole genus of Victorian typefaces, spawned by a font that Benjamin Fox cut for Robert Besley at the Fann Street Foundry, London, in 1845. These faces reflect the hearty, stolid, bland, unstoppable aspects of the British Empire. They lack cultivation, but they also lack menace and guile. They squint and stand their ground, but they do not glare. In other words, they consist of thick strokes melding into thick slab serifs, fat ball terminals, vertical axis, large eye, low contrast and tiny aperture. The original had no italic, as nothing of the writing hand or sculpted nib remained in its pedigree. (Stephenson Blake did however issue a sloped roman version of Besley's original Clarendon – known to them as Consort – in foundry metal in 1953.)

Hermann Eidenbenz drew a version of Clarendon for the

Haas Foundry in Münchenstein, Switzerland, in 1951, and in 1962 Haas added the light weight that transformed the series, paring it down from premodern ponderousness to postmodern insubstantiality. In this guise, as a kind of nostalgic steel frame from which all the Victorian murk has been removed, the face has many genuine uses. Monotype Clarendon lacks the presence of Haas Clarendon, which is the version shown.

A related face – a kind of muted Clarendon – is Morris Fuller Benton's Century Schoolbook, issued by ATF in 1924 and in machine form by Monotype in 1928. This too is now available in a light weight and in digital form. (See also pp 106, 132.)

abcëfghijõp 123 AQ *abcéfghijôp* *17 pt*

Comenius P The seventeenth-century Czech theologian Jan Ámos Komenský, or Comenius, is remembered for his efforts to establish universal public education throughout Europe and for his insistence that there is no incongruity between sacred and secular learning. The typeface aptly named for him is distinguished by its lucid blend of humanist and rationalist forms. It was designed by Hermann Zapf and first released by Berthold in 1980. The axis in the roman varies, and the bowls are asymmetrical. The result is a face alive with static energy. The italic is consistent in its axis and full of vibrant motion. There are two bold weights, both graceful and dramatic in their contrast. Zapf drew the text figures, but they have never yet been issued.

abcëfghijõp 123 AQ *abcéfghijôp* *21 pt*

Dante H Roman and italic, designed by Giovanni Mardersteig and cut by hand in steel in 1954 by Charles Malin, in a garden shed in Paris. Monotype adapted the face for machine setting in 1957 and in the early 1990s produced a digitized version. In its foundry form, Dante is one of the great achievements of twentieth-century typography: a finely tooled and stately neohumanist roman coupled with a very lively and lucid italic.

Mardersteig was the greatest modern scholar of Francesco Griffo's work, and his Dante – though not a copy of any of Griffo's types – has more of Griffo's spirit than any other face now commercially available. Used with a reduced size of the upright roman capitals, Dante italic is also the nearest modern counterpart to a true Aldine italic. The Monotype digital version is, alas, somewhat coarser than its metal antecedents. (See also pp 87, 133.)

227

Three types by Gudrun Zapf-von Hesse. The first two letters in each triad are the original and revised forms of Diotima, which began life as a foundry type issued by Stempel in 1953. The final letter in each triad is Nofret, a related design first produced as phototype by Berthold in 1984. The original Diotima was issued in one weight only. The other two faces exist in a range of weights, but only the regular weight is shown. The large glyphs are 68 pt. The basic lowercase alphabets of all three faces are shown below at 16 pt.

á á á b b b

b b b Q Q Q

c c c y y y

2 2 2 k k k

abcdefghijklmnopqrstuvwxyz
abcdefghijklmnopqrstuvwxyz
abcdefghijklmnopqrstuvwxyz
1234567890 · 1234567890 /
1234567890 / 1234567890
abcdefghijklmnopqrstuvwxyz
abcdefghijklmnopqrstuvwxyz
abcdefghijklmnopqrstuvwxyz

228

abcëfghijõp 123 AQ *abcéfghijôp* *21 pt*

Deepdene M This is the gentlest and most lyrical of Frederic Goudy's many book faces. The aperture is larger than usual with Goudy, the x-height modest, and the axis serenely neohumanist. Goudy drew the roman in 1927, naming it after his house in Marlborough, New York (which was named in turn for Deepdene Road on Long Island). The italic – which slopes at only 3° – was finished in 1928, when the face was issued by Lanston Monotype. Light as it is, the italic still has the strength to function as an independent text face. The version shown is issued by the Lanston arm of P-22 and is based on the Lanston Monotype patterns. The swash characters are less an asset than a temptation.

abcëfghijõp 123 AQ *abcéfghijôp* *18 pt original Diotima*

abcëfghijõp 123 AQ *abcéfghijô* *18 pt 'Diotima Classic'*

Diotima H Designed by Gudrun Zapf-von Hesse and cut by the Stempel Foundry, Frankfurt, in 1953, Diotima was later issued by Linotype in digital form. It is named for the earliest woman philosopher on record: Diotima of Mantinea, whose metaphysic of love is expounded in Plato's *Symposium* by her former student, Socrates. The original family has only one weight: a wide, round roman with a markedly narrow italic, and small caps. In metal, 12 pt Diotima prints superbly, but the digital version is too light for printing offset at text size. To address this problem, Akira Kobayashi revised it for Linotype in 2008, widening the italic and adding three additional weights. The regular weight of this revised version – misleadingly labelled 'Diotima Classic' – prints just fine at text size without ink squash – but widening the italic has considerably lessened its aristocratic poise. It is useful to compare this face with the same designer's Nofret – a useful companion to either form of Diotima. (See also page 228.)

abcëfghijõp 123 AQ *abcéfghijôp* *18 pt*

Documenta D Frank Blokland started work on this sturdy, open text face in 1986. It was finally issued by his firm, DTL, in 1993. Small caps and text figures are supplied for the full range of weights. An equally unpretentious and well-made sanserif companion face was released in 1997.

abcëfghijõp 123 AQ *abcéfghijôp*

Electra **M** Several early twentieth-century book faces are creative variations on Neoclassical and Romantic form. This makes them seem, in retrospect, significant precursors of postmodern design. Three were created in the USA for the Linotype machine and became immediate staples of American publishing. One is Rudolph Růžička's Fairfield, issued in 1940. The others are W. A. Dwiggins's Electra, issued in 1935, and his Caledonia, issued in 1938. In metal, Electra was the liveliest of the three, though in digital form this may no longer be the case. It was first issued with a sloped roman in lieu of an italic, but in 1940 Dwiggins supplied the simple, crisp italic now normally used. Small caps and text figures are inherent in the design. (See also page 113.)

abcëfghijõp 123 AQ *abcéfghijôp*
(*Eſpaña Vieja*) ABC **abcéfgbijôp**

Espinosa Nova **D** Antonio de Espinosa (*c.* 1528–1576) was an engraver, a typefounder, and probably the first punchcutter to work in the Americas. The romans, italics and rotundas he cast and used in Mexico City in the 1550s and 1560s have not been traced to any hand except his own. In 2010, Mexican typographer Cristóbal Henestrosa released this digital family, based on Espinosa's fonts. Henestrosa is unusually respectful of his sources. A conventional italic (with sloped caps) and boldface are included in the family, but so is an alternate italic in Renaissance style, with upright caps, and a matching rotunda – the only kind of boldface Espinosa knew. There are also several fonts of initials in Espinosa's style. (See also page 105.)

See Cristóbal Henestrosa, *Espinosa: Rescate de una tipografía novohispana* (2005).

abcëfghijõp 123 AQ *abcéfghijôp*

Esprit **P** Designed by Jovica Veljović in Beograd and issued through ITC, New York, in 1985. This is a sharply serifed roman and italic of variable axis, large x-height and small aperture. The strokes and bowls of the lower case are full of oblique lines and asymmetrical curves which add further energy to the basically rowdy Neobaroque structure. Small caps and text figures are implicit in the design – but the italic text figures, drawn long ago, have still never been released. (See also pp 113, 135.)

AHQ 123 ábçdèfghijklmñöpqrstûvwxyz

AHQ 123 abcdefghijklmnopqrstuvwxyz

22 pt digital
Fairbank –
with 10 pt metal
'Bembo Con-
densed Italic,'
enlarged

Fairbank **M** In 1928, when English calligrapher Alfred Fairbank designed this face and offered it to Monotype, the corporation considered it as a possible companion for their new Bembo roman. It is narrow and has a slope of only 4°, yet it is full of tensile strength, and in the estimation of Monotype's typographical advisor, Stanley Morison, even after it was tamed by Monotype draftsmen, it overpowered the dignified and soft-spoken roman to which it was betrothed. A new and milder italic – the present Bembo italic – was cut to replace it. Fairbank's italic has since remained a typographic loner, officially known (against its designer's explicit wish) as 'Bembo Condensed Italic.'

In fact, a typographic loner is what it needs to be: the role in which it thrives. The humanist italics from which it descends – those of Griffo, the Master of Basel, and Arrighi – were employed on their own for setting extended texts, not as helpmeets to existing roman faces. Fairbank's italic has the same potential.

When Robin Nicholas and Carl Cossgrove at Agfa Monotype finally digitized the face, in 2003, they returned to Fairbank's drawings, restoring the original upright capitals and the long extenders of the lower case but making the face too light for use in text. They also added several needless swash characters and a wholly illegitimate set of lining figures that has no basis whatsoever in chancery tradition or in Fairbank's own aesthetic. To make a working digital version of this highly useful type, Fairbank's own text figures must be restored and the weight increased.

abcëfghijõp 123 AQ *abcéfghijôp*

19 pt light

Fairfield **M** Rudolph Růžička designed this face for the Linotype machine, giving it a rationalist axis, like the Electra of his friend and colleague W. A. Dwiggins. It was issued in 1940 and remained, like Electra, a standard text face in American publishing for roughly forty years. Alex Kazcun digitized the family in 1991, replacing the narrow Linotype italic *f* and *j* with kerning characters and narrowing the set of the italic. He also increased the contrast of the face (thereby tilting it from a pre- to a postmodern design), added additional weights to the range, and included Růžička's alternate italic, oddly rechristened the 'caption font.'

abcëfghijõp 123 AQ *abcéfghijôp*

abcefghijop 123 AQ *abcefghijop*

Figural H The real Figural was designed in Czechoslovakia by Oldřich Menhart in 1940 and finally cut and cast by the Grafo-techna Foundry, Prague, in 1949. A digital version was created by Michael Gills and issued by Letraset in 1992. Except to a few fortunate letterpress printers, this muted digital version seems to be the only form in which the type is presently available.

Menhart was the master of Expressionism in type design, and Figural is among his finest creations: a rugged but graceful roman and italic, deliberately preserving the expressive irregularity of pen-written forms. The same designer's Manuscript (page 242) is similar in character but rougher, and his Monument (page 295) is a congenial titling face. Though digital Figural lacks the stature of the original, it is a good text face at modest size. But like all Menhart's typefaces, Figural deserves a more authentic digital revival. (See also page 109.)

abcëfghijõp 123 AQ *abcéfghijôp*
CFGIT·*CFGIƷOQT*

Fleischmann H This is a digital family based on roman and italic fonts cut by Johann Michael Fleischman [*sic*] in Amsterdam in 1738–39. Fleischman was a prolific and skilled punchcutter and founder whose work, like Bodoni's, covers considerable range. In the late 1730s, he and his competitor Jacques-François Rosart both cut text types that are truly Rococo. The architecture of these fonts is fundamentally Baroque, but exaggerated contrast is found in the roman and italic *o* and *g*, and in all the round up-percase letters. The serifs on the caps are ostentatious and abrupt. Erhard Kaiser's digital interpretation, issued by DTL in 1995, is a little tamer than the metal. It includes text figures, small caps and a range of ornamental ligatures. (See also page 128.)

abcëfghijõp 123 AQ *abcéfghijôp*

Fournier H The typefaces of Pierre-Simon Fournier come from the same historical period – and much the same rationalist spirit – as Baskerville's designs and the Bell type of Richard Austin. Yet

these faces are by no means all alike. The types of Fournier are as French as Bell and Baskerville are English, and Fournier's type is Fournier's, speaking subtly of the man himself.

Fournier is also famous for his use of ornaments. Like Mozart, he moves between pure, and surprisingly powerful, Neoclassicism and airy Rococo. His letters have more variation of axis than Baskerville's, his romans are a little narrower, and his italics are sharper. Late in his life, he cut some of the first condensed roman faces. And like Haydn, he delights in sliding backward from the Neoclassical forms he pioneered to the older forms of the Baroque, which he admired and inherited.

In one important respect, however, Fournier turned his back on the Baroque. He cut his romans and italics as coequal, independent fonts which differ quite deliberately in x-height. In 1925, Monotype cut two separate series based on his work. These were issued in metal as Monotype Fournier and Monotype Barbou. Only the former has been digitized, but both series preserve Fournier's disparate proportioning of roman and italic. Modern editorial convention is still stuck in the Baroque and often demands that roman and italic be mixed on a single line. But Fournier should be used, I think, in Fournier's fashion, or else it should be recut. (See also page 129.)

abcëfghijōp 123 AQ *abcéfghijôp* 19 pt

Galliard ᴘ Galliard was once the name of a type size – 9 pt – as well as a dance and its musical form. The family of type now known by this name was designed by Matthew Carter, issued initially by Mergenthaler in 1978, and later licensed by ɪᴛᴄ. It is a crisp, formal but energetic roman and italic, based on the designs of the sixteenth-century French typecutter Robert Granjon. Enough of Granjon's work survives, both in steel and in print, to prove that he was one of the finest punchcutters who ever lived. Galliard is Carter's homage to the man as well as to his work. It is also the preeminent example of a Mannerist revival typeface.

For period typography, additional sets of Mannerist ligatures and swash capitals are available as well. The best of the several digital versions appears, not surprisingly, to be Carter's own, released in 1992 by Carter & Cone. The obvious titling face is Carter's Mantinia (page 294) – another act of homage to an artist of extraordinary intellect, precision and exemplary technical skill. (See also pp 87, 125.)

Garamond (1) **H** Claude Garamond (or Garamont), who died in 1561, was one of several great typecutters at work in Paris during the early sixteenth century. His teacher, Antoine Augereau, his gifted contemporaries such as Simon de Colines, and even his brilliant patron Robert Estienne are remembered now only by scholars, while Garamond suffers indiscriminate fame. Many of his punches and matrices survive in museum collections, and his style is not hard to learn to recognize. This has not prevented people from crediting him with type he could not possibly have designed and would not, perhaps, have admired.

Garamond's romans are stately High Renaissance forms with a humanist axis, moderate contrast and long extenders. He cut several beautiful italics as well, with some of the first sloped capitals, but he took no apparent interest in the radical new idea of actually *pairing* italics with romans. Revivals of his roman faces are often mated instead with italics based on the work of a younger artist, Robert Granjon. Four Garamond and Garamond/Granjon revivals worthy of serious consideration are:

The large sorts above are from William Ross Mills's '1530 Garamond,' a titling face closer than any other digital version to Garamond's actual punches. It was issued in 1994 by Tiro Typeworks, Vancouver, but later withdrawn.

1 Stempel Garamond, issued by the Stempel Foundry in 1924 and later digitized by Linotype;

2 Granjon, drawn by George William Jones and issued by Linotype in 1928 – now also in the Linotype digital library;

3 Adobe Garamond, drawn by Robert Slimbach, issued in digital form by Adobe in 1989, and re-released in 2000 in the form of pan-European Latin OpenType;

4 Garamond Premier, Slimbach's revision of Adobe Garamond, issued by Adobe in 2005. (This family includes Greek and Cyrillic, but only the roman has any direct connection to Garamond.)

18 pt Stempel Garamond

abcëfghijõp 123 AQ *abcéfghijôp*

18 pt Linotype Granjon

abcëfghijõp 123 AQ *abcéfghijôp*

18 pt Adobe Garamond

abcëfghijõp 123 AQ *abcéfghijôp*

Stempel Garamond is the only one of these in which the italic as well as the roman is based on a genuine Garamond. (The model used, Garamond's *gros romain* italic, is reproduced on page 92.) The rhythm and proportions of the Stempel face are, however, much changed from the original, and the *f*'s are deformed.

An entirely separate strain of designs, based on the work of Jean Jannon, is also sold under the name Garamond. These are discussed on the facing page. (See also pp 60, 101, 123, 236–7.)

234

Garamond (2) **H** Jean Jannon, born in 1580, was the earliest of the great typographic artists of the European Baroque. He was also a French Protestant, printing illegally in a Catholic regime. Under mysterious conditions, he sold several sets of matrices to the Imprimerie Royale in 1641. After two centuries in storage, these were put to use, and type cast from them was misidentified as the work of Claude Garamond. The surviving matrices are now at the Imprimerie Nationale's Atelier du Livre d'Art, near Paris.

Jannon's type is elegant and disorderly: of widely varying axis and slope, sharply serifed and asymmetrical. The best revivals of these lovely, distinctly non-Garamondian letters include:

ATF 'Garamond,' drawn by M.F. Benton and issued in 1918–20;

Lanston 'Garamont,' drawn by Frederic Goudy and issued in 1921;

Monotype 'Garamond,' issued in 1922;

Simoncini 'Garamond,' drawn by Francesco Simoncini and issued in metal by the Simoncini Foundry, Bologna, in 1958;

František Štorm's Jannon, a digital family issued by the Storm foundry, Prague, beginning in 1997.

Monotype has been particularly thorough in Jannon's case, issuing two different cuts of italic, both in metal and in digital form. Monotype 156, in which the slope of the caps varies rambunctiously, is closer to Jannon's originals. Monotype 176 was the corporate revision: an attempt to bring the unrepentant French typecutter, or at least his italic upper case, back into line. But irregularity lies at the heart of the Baroque, and at the heart of Jannon's letters, just as it may lie at the heart of his refusal to conform to the state religion of his day. I prefer Monotype 156 italic (called 'alternate' in digital form) for that reason.

abcëfghijõp 123 AQ *abcéfghijôp*

18 pt Monotype 'Garamond'

abcëfghijõp 123 AQ *abcéfghijôp*

18 pt Simoncini 'Garamond'

Yet another version of Jannon's type is sold as 'Garamond 3.' This is the ATF 'Garamond' of 1918 as adapted in 1936 for the Linotype machine, then re-revised for digital composition. It is perfectly serviceable as a text face, but it lacks both the slightly disheveled grace of Monotype 'Garamond' and the more carefully combed and erect grace of the Simoncini version.

ITC 'Garamond,' designed in the 1970s by Tony Stan, also has nothing to do with Garamond's type. It is a radically distorted form of Jannon's: distant from the spirit of the Baroque and of the Renaissance alike. (See also pp 101, 126, 236, 239.)

In factory form, digital Simoncini 'Garamond' lacks the requisite text figures and small caps which the metal version possessed. They have been added to the fonts shown here.

Stempel Garamond roman (on the left) is indeed based on the work of Claude Garamond (though its *f*, in both roman and italic, is distorted in a misguided attempt to escape the need for ligatures). Monotype 'Garamond' (on the right) is based on the work of Jean Jannon. These two excellent types come from different centuries and spirits as well as different hands. Surely they also merit different names. They are shown here side by side, the Stempel at 70 pt and the Monotype at 78 pt, and one above the other, both at 18 pt.

aa dd éé

ff ôô õ̃õ̃

rr *kk* *xx*

AA HH

abcdefghijklmnopqrstuvwxyz
abcdefghijklmnopqrstuvwxyz
1 2 3 4 5 6 7 8 9 0 · A B C D É F G
1 2 3 4 5 6 7 8 9 0 · A B C D É F G
ABCDEFGHIJKLMT
ABCDEFGHIJKLMNT
abcdefghijklmnopqrstuvwxyz
abcdefghijklmnopqrstuvwxyz

Garamond Premier (Adobe, 2005) is Robert Slimbach's own revision of his earlier Adobe Garamond (1989/2001). The major difference is the character set (the newer face includes Cyrillic and Greek), but the entire Latin glyph set has also been redrawn. Figures have been narrowed while their set-width has increased. Selected characters are shown here at 18, 36 and 120 pt. The large grey sorts are Adobe Garamond; the outlines are Garamond Premier. The diagnostic differences, visible at any size, are the shapes of italic A, Q and W.

* = Adobe
 Garamond

† = Garamond
 Premier

abcëfghijõp 123 AQ *abcéfghijôp*

Haarlemmer M Jan van Krimpen drew this face for Monotype in 1938 to fulfill a private commission. It was issued at last in 1996, in digital form, by DTL. The roman is based on Romulus. The italic however was a new design in 1938. In the 1940s, Van Krimpen revised Haarlemmer into Spectrum. While digitizing the face, Frank Blokland created an unserifed companion, based largely on Van Krimpen's Romulus Sans. This was issued in 1998 as Haarlemmer Sans. (See also page 264.)

abcëfghijõp 123 AQ *abcéfghijôp*

Hollander D Few things are more useful in the typographic world than plain, sturdy, unpretentious and good-natured fonts of type. Hollander is one of several families of such type designed by Gerard Unger in 1983, but not issued until 1986. The same designer's Swift (1985) and Oranda (1992) are similar. Hollander has greater bulk than Swift but also sharper serifs. It therefore suffers more from harsh commercial treatment (low resolution, low-grade presswork, low-grade paper).

abcëfghijõp 123 AQ *abcéfghijôp*
ʔȧčėɜ̌i̡ǰḰl̇ł̇X̌m̊ ʌńŋo̊o͂q̇r̃ʌẏž
ʔȦČĖƎ̌I̡J̌ḰL̇Ł̇ÁM̊ ʌŃŊO̊O͂Q̇R̃ʌẎŽ
∇ᴧ·∩ᑯᒋᒧʔ˓ʃˊˠʅ · ⊲ʊ⋒ᵃᑫᖅ

Huronia D William Ross Mills began designing this bony but gentle face in 2005. It was first issued by Tiro Typeworks five years later and remains in some respects an active project. It is a good working text face for many conventional uses. It is also the nearest thing yet to a truly pan-American font, containing every glyph required for every indigenous language of North or South America. The character set includes pan-Canadian syllabics (Cree, Inuktitut, Dakelh, Chipewyan, Blackfoot, etc); Cherokee syllabics; pan-Athapaskan, Iroquoian, Siouan and Salishan Latin-based alphabets, Americanist and IPA phonetics, as well as Pan-European Latin and polytonic Greek. Small caps are included for the Latin-based glyphs, and for Greek as well.

abcëfghijõp 123 AQ *abcéfghijôp*

Jannon **D** Most typefaces based on the work of Jean Jannon are sold as 'Garamonds', perpetuating an error made by the Imprimerie Nationale, Paris, in 1845. The happy exception to this tradition of misinformation is the Jannon family produced by František Štorm at the Storm Foundry in Prague. Over the years, Štorm has issued several versions, of varying weight and x-height. Some include Greek and Cyrillic. In 2011, he added a companion sanserif, Jannon Sans. (See also page 235.)

Janson **H** See *Kis*, page 241.

abcëfghijõp 123 AQ *abcéfghijôp*

Jenson **H** Many types of many kinds claim to be inspired by the roman cut at Venice in 1469 by Nicolas Jenson. Some of these derivatives are masterpieces; others are travesties. Bruce Rogers's Centaur is deservedly the best known recreation of Jenson's roman, but Monotype's digital Centaur is a two-dimensional ghost of Rogers's three-dimensional homage to the original Jenson type. Adobe Jenson, drawn by Robert Slimbach and issued in 1995, retraces Rogers's steps and also Frederic Warde's. The italic is based on the same model as Warde's Arrighi italic – a separate design later revised to serve as Centaur's italic. When I compare only the digital fonts, it seems to me that Adobe Jenson has better balance between roman and italic and is generally more tolerant of the fundamental flimsiness of offset printing. This is not what I see when Adobe Jenson is printed letterpress from polymer side by side with Monotype Centaur. (Another family of metal type with which this one should be compared is M. F. Benton's Cloister. Adobe Jenson is actually closer, in some interesting respects, to Cloister than to Centaur.) The recent OpenType versions of Adobe Jenson feature a pan-European Latin character set and are available in a range of weights and optical sizes. No one, alas, has yet built a digital revival of Jenson's Greek. (See also pp 16, 112, 186.)

abcëfghijõp 123 AQ abcéfghijôp

Joanna **H** Designed by the English artist Eric Gill and cut by the Caslon Foundry, London, in 1930. The Monotype version was produced in 1937. This is a face of Spartan simplicity, with flat

serifs and very little contrast but considerable variation in stroke axis. The italic has a slope of only 3° and all but six of its lowercase letters (*a b e g p q*) are roman in form, but its narrowness prevents any confusion. Text figures are essential to the face. Gill Sans is an obvious and very satisfying companion.

17pt abcëfghijõp 123 AQ *abcéfghijôp*

Journal **D** A rough and eminently readable face designed by Zuzana Ličko, issued in 1990 by Emigre. Text figures and small caps are part of the design. There is a wide version known as Journal Ultra as well as a range of weights. (See also page 134.)

18pt abcëfghijõp! 123 ABC AQ *abcéfghijôp**

Juliana **M** Sem Hartz, the Dutch typographer who designed this crisp and narrow face for British Linotype in 1958, was famous for his discipline and efficiency, his love of formal dress, and his outrageously colorful language. For copyfitting purposes, this is the most efficient text face ever made for the Linotype machine. It also wears its own formality with ease. As for colorful language, note the exclamation point and the asterisk. Harz designed the italic first, the roman afterward, thereby evading some of the distortions common in Linotype italics (which have to match their romans in set-width). This digital version was produced by David Berlow at the Font Bureau, Boston, in 2007.

21pt abcëfghijõp 123 AQ *abcèfghijôp*

Kennerley **H** This was Frederic Goudy's first successful typeface, designed in 1911. (Goudy was 46 at the time, but his career as a type designer was just beginning.) By his own account, the designer wanted a new type with some of the flavor of Caslon – and Kennerley has Caslon's homey unpretentiousness, though it has returned to Renaissance forms for its underlying architecture and many of its structural details. The italic was drawn seven years after the roman, but Goudy had found his style; the two mate well. The text figures and small caps required by the design are included in Lanston's digital version.

(The spelling 'Kennerly' appears in some type catalogues, but the face was commissioned by and named for the publisher Mitchell Kennerley, 1878–1950.) (See also page 201.)

abcëfghijõp 123 AQ *CG* *abcéfghijlôp* 20 pt

Kinesis D Designed by Mark Jamra and issued by Adobe in 1997. Kinesis breaks several conventions of type design quite handsomely. The descenders have prominent, canted bilateral serifs. The ascenders, however, have no serifs at all: only an asymmetrically flared termination of the stroke, which is lightly cupped in the roman and beveled in the italic. Dots of i and j are tapered; so are the cross strokes of f and t, and all the unilateral serifs (except in the roman lowercase z). All the bilateral serifs, however, are blunt and nearly uniform in stroke-width. The italic includes some sloped roman forms (*i, l*) along with the cursive, triangular bowls of Mannerist calligraphy. The OpenType version of the family, issued in 2002, includes text figures and small caps in a wide range of weights but no East European characters.

abcëfghijõp 123 AQ *abcéfghijnôp* 18 pt Linotype Janson Text

Kis H The Hungarian Miklós Kis is a major figure in Dutch typography, as well as that of his own country. He spent most of the 1680s in Amsterdam, where he learned the craft and cut some wonderfully toothy and compact Baroque type. For many years Kis's work was incorrectly ascribed to the Dutch punchcutter Anton Janson and taken to be the epitome of Dutch Baroque design. Commerce has no conscience, and to this day, Kis's type is sold, even by people who know better, under Janson's name.

Some of Kis's original punches and matrices found their way to the Stempel Foundry in Frankfurt, and Stempel Foundry Janson is in consequence Kis's actual type, with German sorts (ä, ß, ü, etc) rather clumsily added by other hands. Linotype Janson was cut in 1954, based on the Kis originals as redrawn by Hermann Zapf. Monotype Janson and Monotype Erhardt are also adapted – less successfully, I think – from Kis's designs. Linotype Janson Text (1985) seems to me the most successful digital version. It was prepared under the supervision of Adrian Frutiger, based on Kis's originals and on Zapf's excellent Linotype machine version. (See also page 126.)

abcëfghijõp 123 AQ *abcéfghijôp* 20 pt

Legacy D Ronald Arnholm's Legacy (ITC, 1992) is, I think, the blandest of the many twentieth-century attempts to give new,

two-dimensional life to the old three-dimensional type of the master typographer Nicolas Jenson. Blandness, however, is not always a disadvantage in a printing type, and Legacy is of interest on other grounds. It marries a redrawing of Jenson's roman with a redrawing of one of Garamond's italics, rather than one of Arrighi's, and it is the only revival of Jenson's roman that exists in both serifed and unserifed forms.

The model underlying the roman is reproduced on page 16 and the model underlying the italic on page 92. Legacy has a substantially larger eye than either, and in this respect it violates both Jenson's and Garamond's sense of proportion. It is nevertheless a family with many merits and uses. (See also page 264.)

18/21
Lexicon A1, A2,
and A1–F2

abcefghijop 123 AO *abcefghijop*
abcefghijop 123 AO *abcefghijop*
bpbpbpbpbp**bp**bp**bp**bp**bp**bp**bp**

Lexicon **D** Designed by Bram de Does in 1992 and issued in digital form by Enschedé. Lexicon was commissioned, as the name suggests, for a new Dutch dictionary. It was therefore designed to be as compact as a Bible type but to function in a range of sizes and to allow many shades and degrees of emphasis. There are six weights (A to F), with both roman and italic small caps in every weight, and in each weight there are two forms of roman and italic lower case: Nº 1 with short extenders; Nº 2 with extenders of normal length. Lexicon 2A (the light weight with normal extenders) makes an excellent text face for a variety of uses, and Lexicon 1B (the second weight with short extenders) is a good companion face for notes and other compact matter.

18 pt abcëfghijop 123 AQ *abcéfghijôp*

Manuscript **H** This was designed in Czechoslovakia by Oldřich Menhart during World War II and issued by Grafotechna, Prague, in 1951. Manuscript is even rougher than the same designer's Figural, but its rough forms are painstakingly chosen and juxtaposed. The roman and italic are perfectly balanced with each other and within themselves. The numerals are large, but their alignment satisfyingly uneven. There is a matching Cyrillic. Sanitized digital versions, lacking the grit of the original, are a disappointment. The version shown is Alexander White's 'Manuscript Drawn.'

abcëfghijõp 123 AQ *abcéfghijôp*

Mendoza **D** Designed by José Mendoza y Almeida, Paris, and released by ITC in 1991. This is a forceful and resilient neohumanist text face with low contrast and a Spartan finish, closer in some ways to the tough and lovely text romans and italics of sixteenth-century Paris than anything else now to be found in digital form. Mendoza prospers under careful handling but is robust enough to survive printing conditions lethal to other text faces. Small caps and text figures are implicit in the design, but the ligatures are best recut or forgotten. There is also an extensive range of weights. (See also pp 101, 108, 112.)

abcëfghijõp 123 AQ *abcéfghijôp*

Méridien **H** This was Adrian Frutiger's first text face, designed in 1954 for Deberny & Peignot, Paris. Both roman and italic were cut and cast for hand composition, but release of the italic was delayed and its distribution impeded when the foundry issued the type in a phototype version. The roman caps, which have unusual authority and poise, make an excellent titling face in themselves. The same designer's Frutiger makes a useful sanserif companion. But in the absence of small caps and text figures, the related Apollo is often more useful for text. (See also pp 58, 101, 105, 216.)

abcëfghijõp 123 AQ *abcéfghijôp*
abcëfghijõp 123 AQ *abcéfghijôp*

Minion **D** The first version of this family, designed in California by Robert Slimbach, was issued by Adobe in 1989. Multiple Master and OpenType versions have been issued more recently. Minion is a fully developed neohumanist text family which is, in the typographic sense, especially economical to set. That is to say that it gives, size for size, a few more characters per line than most text faces without appearing squished or compressed. Small caps and text figures are essential to the design, and these are available across the range, in several weights of both roman and italic. The OpenType form of the face, called Minion Pro, includes a set of typographic ornaments, swash italics, and upright and cursive Greek and Cyrillic. Slimbach's chancery italic, Poetica, is a useful companion face. (Minion Pro is the face in which this book is set. See also pp 59, 106, 201, 290.)

24 pt foundry Palatino roman (1950)	AEFabcdefghijklmnop qrstuvwxyz 123456 S
36 pt foundry roman, export version (1954): the nine altered characters	EFS pqsvwy
24 pt foundry Palatino italic (1951), with some of the original swash glyphs	abcdefghijklmnopqrstuvwxyz ASMNRTh zke
12 pt Linotype Palatino italic (1951), enlarged	AEF abcdefghijklmnopqrstuvwxyz
18 pt Linofilm Palatino (1963)	AEF abcdefghijklmnopqrstuvwxyz AEF abcdefghijklmnopqrstuvwxyz
18 pt Linofilm Aldus (c.1978)	AEF abcdefghijklmnopqrstuvwxyz AEF abcdefghijklmnopqrstuvwxyz
18 pt Zapf Renaissance (1986)	AEF abcdefghijklmnopqrstuvwxyz AEF abcdefghijklmnopqrstuvwxyz
18 pt Palatino Nova (2005)	AEF abcdefghijklmnopqrstuvwxyz AEF abcdefghijklmnopqrstuvwxyz
18 pt Aldus Nova (2005)	AEF abcdefghijklmnopqrstuvwxyz AEF abcdefghijklmnopqrstuvwxyz

Some of the many forms of Palatino and its close relations. Most digital Palatinos are modelled on the phototype (Linofilm) version of 1963.

244

abcëfghijõp 123 AQ *abcéfghijôp*

Nofret **P** Nofret, which means 'beautiful one,' was a popular woman's name in early Egypt. In 1984 an exhibition prepared by the Cairo Museum opened in Munich under the title *Nofret – die Schöne: Die Frau im Alten Ägypten,* and in that year, Gudrun Zapf-von Hesse's typeface Nofret was released by the Berthold Foundry. It is in many respects a rethinking of the same designer's Diotima, drawn three decades earlier. It is more compact than Diotima in the roman, but of similar width in the italic. There is a wide range of weights, and even the heaviest of these retains its poise. This is not in the typographic sense an egyptian; it is an answer to the question, *What might happen to a typographic egyptian if it acquired feminine grace?* Small caps and text figures are implicit in the design. (See also pp 135, 228.)

abcëfghijõp 123 AQ *abcéfghijôp*

Officina **D** Designed by Eric Spiekermann and colleagues, and issued in 1990 through ITC. This is a narrow and plain yet robust text face, inspired by the typewriter and useful for setting much matter that might, in an earlier age, have stayed in typescript form. It is sturdy enough to withstand rough treatment (low-grade laser printing, for example) yet sufficiently well-built to prosper under better printing conditions. There is a sanserif companion. Cyrillic versions have also been issued. (See also page 136.)

abcëfghijõpt 123 A*EU abcéfghijôp*

abcëfghijõpt 123 A*EU abcéfghijôp*

Palatino **H/M** Almost everyone with an interest in typography can recognize this roman and italic, designed by Hermann Zapf. But in fact there are many Palatinos, and few people know the face so well that they can recognize them all. Trial versions were cut by August Rosenberger at the Stempel foundry, Frankfurt, in 1949. Roman, italic and bold roman were issued both as foundry type and as Linotype matrices, beginning in 1950. Yet the digital versions now in daily use have changed in many ways from the statuesque original foundry versions.

From the outset there were two quite different italics – a narrow one for foundry type, a wider one for the Linotype machine.

There were different forms of the roman as well: one design for sizes up to 12 pt, another for sizes of 14 pt and above. In 1954, Zapf revised the foundry face for export, and for the next thirty years Stempel cast both American and European versions. When he adapted Palatino for photosetting in 1963, Zapf used the less elegant export version as a starting point. Digital Palatino dates from 1987 and is based on the phototype design.

In 1997, Zapf enlarged the character set (without altering the basic Latin letterforms) to include pan-European Latin, Cyrillic and polytonic Greek. The resulting OpenType fonts, produced under license by Microsoft, are known as 'Palatino Linotype' rather than Linotype Palatino. Some incarnations of these fonts include *chữ quốc ngữ,* the Latin character set employed for Vietnamese.

Five decades after the face was first produced, Zapf embarked on another revision, tweaking the shapes of many letters. The result was issued by Linotype in 2005 as Palatino Nova. These fonts too are tri-alphabetic pan-European, but with monotonic rather than polytonic Greek. Into the Palatino Nova family, Zapf also incorporated digital revisions of Michelangelo, Phidias and Sistina, three titling faces that he had designed in the early 1950s as companions to foundry Palatino. (See also pp 15, 59, 77, 97, 104, 118, 133, 211, 214, 244, 287, 291.)

19 pt abcëfghijõp 123 AQ *abcéfghijôp*

Photina **P** A text face with a predominantly rationalist axis, small aperture and narrow set-width but unmistakable calligraphic energy. It was designed by José Mendoza y Almeida and first issued by Monotype in 1972 for photocomposition. There is a range of weights, and the bold versions are gracefully designed. Photina's proportions are deliberately close to those of Univers, which makes an excellent sanserif companion. This is one of the first and one of the finest postmodern text faces. Small caps and text figures are implicit in the design. (See also page 200.)

18/24 abcëfghijõp 123 AQ *abcéfghijôp*
ꦏꦑꦓꦠꦪꦢꦘꦲꦧꦤꦩꦟꦝꦥꦛ

Plantagenet **D** William Ross Mills designed the initial version of Plantagenet in the mid 1990s. It was issued by Tiro Typeworks in 1996. In 2004, he produced a thorough revision, released as

Plantagenet Novus. The newer versions include pan-European Latin and Greek character sets with many additional sorts for Native American languages that are written in Latin letters, as well as Cherokee syllabics, IPA phonetics, and a range of ornaments and swashes. Why should a face with Neoclassical structure and a character set that links classical Greece and Native America bear the nickname of the Anglo-Norman family that gave England all her kings from Henry II in 1154 to Richard III in 1485? I do not know. But *Plantagenet* is an old French name for the broom plant (in modern French, *la plante genêt*). It is said that Geoffrey of Anjou, founder of the family and an avid hunter, wore a sprig of it in his hat and had it planted as cover for birds. Broom was brought, along with the Latin alphabet, from Europe to North America, where both have since run wild.

AQ 123 AQ *ábcdèfghijklmñöpqrstûvwxyz* *eaobabefeghghijklnöp QUA stym* 21/24

Poetica D A chancery italic designed by Robert Slimbach and issued by Adobe in 1992. The basic family consists of four variations on one italic, with differing amounts of swash. There are also five fonts of swash capitals, two of alternate lowercase letters, two fonts of lowercase initials, two of lowercase terminals, two sets of small caps (ornamented and plain), a font of fractions and standard ligatures, another of ornamental ligatures, one font of analphabetic ornaments, and one font entirely of ampersands. The basic face is a plain neohumanist italic, well suited for extended text. The supplementary fonts permit any desired degree of typographic play or ostentation. (See also page 125.)

abcëfghijõp 123 AQ *abcéfghijõp* 22 pt

Poliphilus & Blado H Poliphilus, meaning 'Multiple Love,' is the name of the lead character in Francesco Colonna's fantasy novel *Hypnerotomachia Poliphili,* "The Dream-Fight of Poliphilus," which Aldus Manutius printed in 1499 in a newly revised roman type by Francesco Griffo. In 1923, Monotype tried to replicate this font for use on their machine. The result was Monotype Poliphilus. It was an early experiment in the resuscitation of Renaissance designs, and the Monotype draftsmen copied the actual letterpress impression, including much of the ink squash, instead of paring

Bembo (on the left) and Poliphilus (on the right): two attempts at reproducing a fifteenth-century Venetian type in twentieth-century terms. Both of these types are based on the same original lower case, but on two different sets of original capitals. They are shown here at 80 pt and at 18 pt.

(Poliphilus was, of course, never meant to be seen in public enlarged to this degree. It was created as a text face only. The largest size cut in metal matrix form is 16 pt.)

aa bb cc

éé ff gg

ññ ôô tt

AA CC

abcdefghijklmnopqrstuvwxyz
abcdefghijklmnopqrstuvwxyz
1 2 3 4 5 6 7 8 9 0 · A B C D É F G
1 2 3 4 5 6 7 8 9 0 · A B C D É F G
A B C D E F G H I J K L M N O
A B C D E F G H I J K L M N O
abcdefghijklmnopqrstuvwxyz
abcdefghijklmnopqrstuvwxyz

back the printed forms to restore what the punchcutter had carved. The result is a rough, somewhat rumpled yet charming face, like a Renaissance aristocrat, unshaven and in stockinged feet, caught between the bedroom and the bath. In the squeaky clean world of offset printing, where image tends to outcompete reality, this roughness has finally come into its own.

Six years after producing Poliphilus, Monotype repeated its experiment with a very different result. Monotype Bembo (1929) is based on an earlier state of the same original: the same lower case with an earlier set of capitals. The differences between lowercase Monotype Bembo and Poliphilus, great as they are, are entirely differences of interpretation, not of design.

Blado, the italic companion to Poliphilus, is not based on any of Griffo's own superb italics (one of which is shown on page 210) but on a font designed in a different intellectual milieu, by Ludovico degli Arrighi, about 1526. (Arrighi died soon after finishing that type – his fifth or sixth italic – and it was acquired by the master printer Antonio Blado of Rome. No type called Arrighi existed when the 1923 revival was made. Monotype chose nevertheless to name their revival of the face for the printer who used it, not the calligrapher who designed it.) (See also pp 79, 248.)

abcëfghijõp 123 AQ *abcéfghijôp* 17 pt

Pontifex **P** Designed by Friedrich Poppl in Wiesbaden and issued in 1976 by Berthold in Berlin. Pontifex is one of several eminent twentieth-century faces built on Mannerist lines. Other examples include Adrian Frutiger's Méridien, Georg Trump's Trump Mediäval, and Matthew Carter's Galliard. These are four quite different faces, designed by four quite different artists for three different typographic media, but they share several structural presumptions. All have a humanist axis in the roman but an unusually large x-height, a tendency toward sharpness, angularity and tension in the conformation of individual letters, and a considerable slope – 12° to 14° – in the italic. These are features inherited from French Mannerist typecutters such as Jacques de Sanlècque, Guillaume Le Bé and Robert Granjon. Galliard is in fact a revival of Granjon's letters, while Pontifex, Trump and Méridien are independent modern creations sympathetic in spirit to the earlier Mannerist work. Together, these faces demonstrate the considerable range and depth of what one could call the Neomannerist aspect of the Modernist tradition. (See also pp 78, 133.)

abcëfghijõp 123 AQ *abcéfghijôp*

Pradell **D** Punchcutting, typefounding and printing thrived as never before in Spain during the reign of Carlos III (1759 to 1788). His father, Felipe V (Philip V), had taken a serious interest in printing, and two years after Carlos came to the throne he established a print shop and foundry (the Imprenta Real) in the Royal Library founded by his father. Through the end of his reign, the Imprenta commissioned type from a number of artists, including the Catalan engraver Eudald Pradell. In 2003 another Catalan, Andreu Balius of Barcelona, issued the first version of this type, named for Pradell and modeled on his work. In the recent OpenType version, the character set is pan-European Latin, with small caps, text figures, quaints, abundant ligatures and a good assortment of neoclassical ornaments.

abcëfghijõp 123 AQ *abcéfghijôp*

Quadraat **D** Fred Smeijers's Quadraat, issued by FontShop in 1993, is a study in contrasts: a tensile and large-eyed yet smoothly flowing roman married to an angular, broken but robust italic. The creative ingenuity involved here extends to the matching Cyrillic and the companion sanserif as well. The fonts as issued are expertly kerned and sold with the requisite parts – small caps and text figures – intact. Some fine types were made during the late twentieth century, and this is one. It is not pretty; its beauty is deeper and stranger than that. (See also pp 266–8, 291.)

abcëfghijõp 123 AQ *abcéfghijôp*

Relato **D** This wonderfully unpretentious text face was designed in Barcelona in 2005 by the Argentine typographer Eduardo Manso – and text is what it is unashamedly for. Text figures are the default; small caps are the companion. Quite reasonably, therefore, it is issued in only two weights. It has a sanserif companion, however, which is designed for a wider range of applications and is available in six weights. (Fonts purchased for testing in 2012 have a coding error: *đ* in place of *ð*; that is, *dyet* in place of *eth*.)

abcëfghijõp 123 AQ *abcéfghijôp*

ete ety ffy stfi y ɣ q qz z tz ffff

Requiem ᴅ Requiem is pretty where Quadraat is not, but its beauty runs deeper than prettiness too. In its way, this is the equal of the great neohumanist book types of the early twentieth century: Bembo, Centaur and Dante. It is however the fruit of a later age, more self-conscious and self-involved. Its models are also therefore later: scripts of the High Renaissance, which were likewise acutely self-aware. And Requiem, unlike Bembo, Centaur and Dante, was born in the digital medium, where two dimensions have to do the work of three. It was created by Jonathan Hoefler in New York City, who drew the caps in the early 1990s and completed the family in 1999. It grew out of a commission from a magazine suspiciously entitled *Travel and Leisure,* but like any good type, it savors of self-discipline no less than self-indulgence. The italic, like Robert Slimbach's Poetica, is indebted to the work of Ludovico degli Arrighi and includes a set of artful, playful ligatures to prove it. The roman caps, with which the project started, are grounded in Arrighi's work as well. The roman lower case owes more to another sixteenth-century calligrapher, Ferdinando Ruano. (See also pp 296–7.)

abcëfghijõp 123 AQ *abcéfighijôp*

22 pt Rialto
(*for titling*)

abcëfghijõp 123 AQ *abcéfighijôp*

21 pt Rialto
Piccolo (*for text*)

Rialto ᴅ Requiem is pretty; Rialto is prettier still, but again, its beauty is deeper than that. Named for the best-loved bridge in Venice, it is the product of joint effort by Venetian calligrapher Giovanni de Faccio and Austrian typographer Lui Karner. The result is a face of extraordinary calligraphic loveliness which is nevertheless strong enough (properly used) for the texts of substantial books. Proper use begins with remembering that there are two sets of fonts. Rialto itself is actually a titling face, happiest at 18 pt and above. Rialto Piccolo is the better choice at 16 pt and below – which is to say, the choice for all text sizes. Besides the roman and italic there are small caps and semibold, a full set of ligatures and good italic alternates. The italic slopes at 2°, and the roman and italic share a single set of caps. It was issued in 1999 by *df* Type in Texing, near Vienna. (See also page 297.)

abcefghijop 123 AO *abcefghijop*

Romanée ʜ Designed by Jan van Krimpen and cut in steel by Paul Helmuth Rädisch at the Enschedé Foundry in Haarlem, Netherlands. The roman owes much to the spirit of Garamond. Van Krimpen designed it in 1928 as a companion for an italic cut in the middle of the seventeenth century by another of Garamond's admirers, Christoffel van Dijck. But Van Krimpen remained dissatisfied with the relationship between the two faces, cut in the same land three hundred years apart. In 1948 he designed an italic of his own – his last type – to mate with Romanée roman. The new italic is distinguished by its prominent descenders, serifed on both sides, and it has much less slope than the italic of Van Dijck. Like the italics of the early sixteenth century – and unlike the italics of both Garamond and Van Dijck – it mates a cursive lower case with upright capitals.

"United they fall, apart they stand as fine designs," said Van Krimpen's younger colleague, Sem Hartz. And it is true that Romanée italic stands very well on its own. Perhaps these faces are best used in the Renaissance manner – not the manner of Van Dijck but the manner of Garamond, his predecessors and colleagues – with the italic set in separate passages rather than laced into the midst of roman text. Excellent digital Romanées have been made but never commercially released.

abcëfghijõp 123 AQ *abcéfghijôp*

Romulus ʜ It has been said with some justice that Jan van Krimpen designed three roman types: Lutetia (1925), Romanée (1928), and a third to which at various times in the 1930s and 1940s he gave the names Romulus, Haarlemmer, Sheldon and Spectrum. He did, however, draw five quite different italics: Lutetia (1925), Cancelleresca Bastarda (1934), Haarlemmer (1938), Spectrum (c. 1942) and Romanée (1949). For Romulus, Van Krimpen initially did not design an italic. Instead, on Stanley Morison's advice, he drew a second version of the roman that slopes at 11°. He soon atoned for this by designing the most elaborate and technically challenging italic of his career, the Cancelleresca Bastarda, and incorporating it into the Romulus family.

Regarded solely as a roman and sloped roman, Romulus looks like a well-made but impoverished type. In reality, it is part of a large family issued in part between 1931 and 1936: the forerunner

of other large families such as Legacy, Scala and Quadraat. To date, DTL has digitized only the serifed roman and oblique. These would be of greater use if they were joined by other members of the family: Cancelleresca Bastarda, Romulus Sans and Romulus Open Capitals. (See also pp 58, 254, 299.)

abcëfghijõp 123 AQ *abcéfghijôp* 20 pt

Rongel D The elusive Señor Rongel – I do not know where or when he was born, nor even his full name – was one of several late eighteenth-century Spanish punchcutters favored by the Imprenta Real in Madrid. (His work appears in the Imprenta's magnificent specimen book of 1787, and the Francisco Rongel who was head of the Imprenta Real's foundry in the 1820s was presumably his relative, quite possibly his son.) For more than a decade, the Portuguese typographer Mário Feliciano has been producing digital fonts based on the work of eighteenth-century Iberian punchcutters. His Rongel, issued in 2001, was the first of these revivals, and it remains one of the best.

abcëfghijõp 123 AQ *abcéfghijôp* 18 pt

Sabon H/M Designed by Jan Tschichold. The foundry version was issued by Stempel in 1964, followed by Monotype and Linotype machine versions in 1967. The series consists of a roman, italic, small caps and semibold, based broadly on the work of Claude Garamond and his pupil Jacques Sabon, who was once employed, after Garamond's death, to repair and complete a set of his teacher's punches. The structure of the letterforms is faithful to French Renaissance models, but Tschichold's face has a larger eye than any but the tiniest sizes cut by Garamond. The type was intended as a general-purpose book face, and it serves this purpose extremely well, though it is bland in comparison with Garamond's originals. (See also pp 34, 52, 104.)

abcëfghijõp 123 AQ *abcéfghijôpy* 18 pt

Scala D A crisp, neohumanist text face with sharp serifs and low contrast, designed by Martin Majoor in the 1980s. Though originally made for a concert hall in Utrecht, it is named after an opera house in Milan. It was publicly issued by FontShop International, Berlin, in 1991. This face has many of the merits of

Digital versions of three types by Jan van Krimpen: Romulus (left), Haarlemmer (middle) and Spectrum (right). Selected characters of Romulus are shown here at 78 pt, Haarlemmer at 72 pt, Spectrum at 82 pt. The basic lowercase alphabets of all three are shown at 18 pt.

The italics and the numerals of these three faces are quite distinct, but in the roman, the differences are such as one might expect to find among different sizes of a single handcut type.

ááá bbb

bbb ccc

fff ggg iii

CCC III

abcdefghijklmnopqrstuvwxyz
abcdefghijklmnopqrstuvwxyz
abcdefghijklmnopqrstuvwxyz
1234567890
1234567890/1234567890
abcdefghijklmnopqrstuvwxyz
abcdefghijklmnopqrstuvwxyz
abcdefghijklmnopqrstuvwxyz

the merits of Eric Gill's Joanna – not to mention several merits distinctively its own – without Joanna's eccentricities. Small caps and text figures are implicit in the design. There is also an unserifed branch of the family. (See also pp 268, 270–71.)

abcëfghijõp 123 AQ abcéfghijôp

23 pt

Seria D Like Scala, this is the work of Martin Majoor, issued by FontShop in 2000. The designer has written that after completing Scala he wanted to produce a more "literary" face. Whether Seria is really more literary than Scala, I cannot say. Its small eye and long extenders do make it a less utilitarian face, but I have used it myself – and its matching sanserif – with great satisfaction for both literary and nonliterary texts. The italic slopes at only one degree. Italic and roman alike have upright caps, but not the same upright caps. Those of the italic are slightly but recognizably cursive. (See also pp 268–9.)

ábçdèfghijklmñöpqrstûvwxyz 123
AQAQAQAVEDEEGGMMM

20/24

Silentium D Designed by Jovica Veljović and issued in OpenType form by Adobe in 2000. This is a Carolingian face, like Gudrun Zapf-von Hesse's Alcuin. There is necessarily no italic, but there are four sets of caps (one written, three drawn, including one inline and one reversed set, useful for versals), many scribal alternates and ligatures, and an impressive set of ornaments.

abcëfghijõp 1234689 AQ abcéfghijôp

21 pt

Spectrum H/M This is a refinement of Haarlemmer, designed by Jan van Krimpen in the early 1940s, then delayed by the Second World War and issued by both Enschedé and Monotype in 1952. It was Van Krimpen's last general text face and is now the one most widely used. The roman and italic are reserved, elegant and well matched. The axis is humanist, the aperture large, and the serifs simultaneously sharp and flat (a feature neither unwelcome nor contradictory in typography). Small caps and the distinctive Spectrum text figures, with their very short extenders, are essential to the design. A semibold was added by Sem Hartz and cut by Monotype in 1972. (See also pp 133, 254.)

Q ábbbçdddêfffggg O
(hhhijijijkkklllmñòppp)
A qqqrstüvwxyyyž IJ
+ 1234567890 =

Q ábbbbçddddêffffggg O
{hhhhijijijkkkklllllmñòpppp}
A qqqqrstüvwxyyyž IJ
+ 1234567890 =

Q ábbbçdddêfffggg O
(hhhijijijkkklllmñòppp)
A qqqrstüvwxyyyž IJ
+ 1234567890 =

Trinité roman wide (above), italic (center) and roman narrow (below), set
28/34 ± 2. All three ranges of each roman face are shown together, and
all four ranges of the italic. In each range, only the extending letters vary.

abcëfghijõp 123 AQ *abcéfghijôp*

Swift D This large-eyed face was designed by Gerard Unger and first issued in 1987 by Rudolf Hell in Kiel. It is avowedly a newspaper type but has many additional uses. The widths are modest, and the letters are crisp and open, with chisel-tipped, wedge-shaped terminals and serifs. The axis is humanist and the aperture large. The italic is taut and fluent, with a slope of 6°. The torso of these letterforms is large enough that Swift can function well without text figures and small caps, but these have now been issued. Unger's sanserif family Praxis and his erect sanserif italic Flora (page 262) make useful companion faces for Swift.

abcëfghijõp 123 AQ *abcéfghijôp*

Trajanus H/M Warren Chappell's Trajanus was issued in 1939 as a foundry face by Stempel and in machine form by Linotype. The angular, black forms echo the early humanist scripts of the Renaissance and some of the earliest roman printing types, used in Italy and Germany until they were superseded by the early Venetian whiteletter and then by the Aldine roman and italic. But Trajanus is a remarkably graceful face, and the roman is matched by an equally crisp and fluent italic. The figures, like those of Bell, are three-quarter height lining forms.

There is a companion bold face designed by Chappell and a Trajanus Cyrillic designed by Hermann Zapf. Chappell's own sanserif, Lydian, is another related design, slightly darker than Trajanus but of similar angularity. Linotype issued a digital version in 1997, but the Cyrillic exists only as Linotype metal matrices.

abcëfghijõp 123 AQ *abcéfghijôp*

Trinité P A text family designed in 1978–81 by Bram de Does for the Enschedé Foundry in Haarlem. The commission began with a challenge: to create in the elastic and ephemeral world of phototype something as resonant and reserved as the handcut metal types of Jan van Krimpen. The impressive result was issued in film form in 1982 by Bobst/Autologic in Lausanne but never effectively distributed. Trinité was issued again in digital form by the Enschedé Font Foundry in 1991.

There are three weights of wide roman, two weights of narrow roman, two weights of small caps and two weights of italic.

All weights and widths of roman and italic come in three ranges: with short, normal and long extenders. The capitals remain the same in height; so does the torso of the lower case, but the extenders range to different depths and altitudes. Both weights of italic are also issued in chancery form (with curved extenders). The ordinary roman (Trinité 2, with the normal extenders, either wide or narrow) makes a fine text face for conventional use. The wide version is 9% wider than the narrow and keeps the same internal rhythm. (In wide and narrow versions alike, for example, the set-widths of the roman letters *i, n* and *m* are in exactly the proportion 1:2:3.) The roman letters slope at 1°, the italics at 3°.

Serifed
Text
Faces

There are no separate characters for ligatures in Trinité. They construct themselves from parts. The *f + i* and *f + j*, for instance, combine to form the ligatures *fi* and *fj*. (This is the reason for the dancing dots on *i* and *j* in different versions of the face. In Trinité 1 and 2, the dots meld with the arch of the *f*. In Trinité 3, the tallest version, the dots tuck under the arm of *f* instead.) In its present form, with pi fonts, expert sets and other variants, the full family consists of 81 separate digital fonts. Half a dozen of these would be ample for many normal texts. The technical complexities of the series ought not to obscure the simple beauty of the face, which is rooted in the heritage of Van Krimpen and of Italian Renaissance forms. Even the arithmetical signs in Trinité have a slight scribal asymmetry. This is sufficient to enliven the forms for text use yet not enough to render them dysfunctionally ornate. Small caps and text figures are essential components of the family.

17 pt · abcëfghijõp 123 AQ *abcéfghijôp*

Trump Mediäval H/M This is a very robust text face, designed by Georg Trump. It was first issued in 1954 by the Weber Foundry, Stuttgart, as a foundry type, and in machine form by Linotype. It is a strong, angular roman and italic with humanist axis but Mannerist torque and proportions. The aperture is moderate; the serifs are substantial and abrupt. The numerals, both in text form and in titling form, are notably well designed. The digital version retains the Linotype nonkerning *f*. There is a range of weights but (as often with Linotype faces) only a partial set of ligatures. A number of Trump's excellent script faces – Codex, Delphin, Jaguar, Palomba and Time Script, for example – and his slab-serifed titling face called City, are potentially useful companions. (See also pp 52, 84.)

abcëfghijõp 123 AQ *abcéfghijôp* *20 pt*

Van den Keere **H** This is a family of digital romans, modeled on a 21 pt font that Hendrik van den Keere (Henri de la Tour) of Ghent cut in 1575 for Christophe Plantin of Antwerp. There are several weights, all with the requisite small caps and other components. But in his long, illustrious career as a punchcutter, Van den Keere did not cut a single italic. The italic paired here with his roman is based on the work of his older friend and colleague François Guyot. The digital versions of these types were produced by Frank Blokland in 's-Hertogenbosch and issued by DTL in 1995–97. (See also page 123.)

abcëfghijõp 123 AQ *abcéfghijôp* *21 pt*

Van Dijck **H** The type family now called Van Dijck – first issued by Monotype in 1935 – is based on an italic cut in Amsterdam about 1660 by Christoffel van Dijck and a roman which is probably also his. (Original matrices for the italic still survive; the roman is known only from printed specimens.) These are calm and graceful Dutch Baroque faces, modest in x-height, narrow in the italic and relatively spacious in the roman. A comparison of Van Dijck's work with that of Miklós Kis illuminates the range of Dutch Baroque tradition, but there is plenty of range in Van Dijck's work on its own. His blackletter types are very ornate, while his romans and italics breathe a deep and deliberate serenity, not unlike the works of his great contemporaries, the painters Pieter de Hooch and Jan Vermeer. The digital version of Monotype Van Dijck has unfortunately lost much of the power and resiliency of the Monotype metal version. (See also pp 51, 205.)

abcëfghijõp 123 AQ *abcéfghijôp* *17 pt*

Veljović **P** Designed by Jovica Veljović and issued in 1984 by ITC. Veljović is a lively postmodern face, with much inherent movement wrapped around its rationalist axis, and much prickly energy emerging in the long, sharp, abrupt wedge serifs. There is a wide range of weights. Fonts with text figures are produced by Elsner & Flake. Small caps, though part of the original design, have evidently never been released. Veljović makes an excellent companion for the same designer's Gamma or Esprit and can be mated with his fine script face Ex Ponto. (See also page 15.)

abcëfghijõp 123 AQ *abcéfghijôp*

abcëfghijõp 123 AQ *abcéfghijôp*

g

The letterfit of
Berthold digital
Walbaum has
been edited
extensively to
produce the
fonts used here.

Walbaum **h** Justus Erich Walbaum, who was a contemporary of Beethoven, ranks with Giambattista Bodoni and Firmin Didot as one of the great European Romantic designers of type. He was the latest of the three, but he may well have been the most original. Walbaum cut his fonts at Goslar and Weimar early in the nineteenth century. His matrices were bought by the Berthold Foundry a century later, and Berthold Walbaum, in its metal form, is Walbaum's actual type. Berthold digital Walbaum is a close and, for the most part, careful translation. Monotype Walbaum, different though it is, is also quite authentic. The Berthold version is based on Walbaum's larger fonts, and the Monotype version on his small text sizes.

Each of the major Romantic designers had his own effect on design in the twentieth century. Firmin Didot's ghost is palpable in Adrian Frutiger's Frutiger, Bodoni's ghost in Paul Renner's Futura, and Walbaum's spirit is alive in some of the later work of Hermann Zapf. Yet each of these instances involves a real creative leap, not imitation. (See also page 131.)

abcëfghijõp 123 AQ *abcéfghijôp*

the, qua sbfghj xyz

18/24

Zapf Renaissance **d** When he designed this face, in 1984–85, Hermann Zapf was returning, after almost forty years, to many of the principles that had animated Palatino, his first great success. Zapf Renaissance, however, was meant to thrive in the high-tech, two-dimensional world of digital imaging instead of the slower, more multidimensional world of letterpress. The result is a less printerly and sculptural, more scribal and painterly typeface – and one which is more tolerant than Palatino of digital typography's capricious, even licentious, freedom with size. The family includes a roman, italic, small caps, semibold and swash italic with a rich assortment of pilcrows and fleurons. It is a remarkably handsome face, issued by Scangraphic in 1986 in a technically deficient form. The fonts require some editing prior to use. Palatino Greek (page 287) – which requires similar attention – makes an excellent companion. (See also page 244.)

a

ꓘᴀ⟘ꓩ98 ⟘ꓕꓵ⟘Yꓩ⟘ Ƨꓲꓵꟽ⟘ꓱꓵ ꓷꓕ ꓷꓕ Ƨꓱ

(14 pt unserifed Etruscan specimen — display lettering)

The 14 pt unserifed Etruscan cut by William Caslon for Oxford University Press, about 1745. Unserifed *scripts* are as old as writing itself, but this is one of the earliest unserifed printing types.

11.3 UNSERIFED TEXT FACES

Unserifed letters have a history at least as long, and quite as distinguished, as serifed letters. Unserifed capitals appear in the earliest Greek inscriptions. They reappear at Rome in the third and second centuries BCE, and in Florence in the early Renaissance. Perhaps it is no more than an accident of history that the unserifed letters of fifteenth-century Florentine architects and sculptors were not translated into metal type in the 1470s.

At Athens and again at Rome, the modulated stroke and bilateral serif were the scribal trademarks and symbols of empire. Unserifed letters, with no modulation or, at most, a subtle taper in the stroke, were emblems of the Republic. This link between unserifed, unmodulated letterforms and populist or democratic movements recurs time and again, in Renaissance Italy and in the eighteenth and nineteenth centuries in northern Europe. Populist letters represent themselves as simple, and even simplistic, though they may in fact be extremely sophisticated and subtle.

Unserifed types were first cut in the eighteenth century, but they were cut at first for alphabets other than Latin. A sanserif Latin type was cut for Valentin Haüy, Paris, in 1786 – but Haüy's type was not meant to be seen. It was designed to be embossed, without ink, for the blind to read with their fingers. The first unserifed Latin type for the sighted – cut by William Caslon IV, London, about 1812 – was based on signwriters' letters and consisted of capitals only. Bicameral (upper- and lowercase) unserifed roman fonts were, I think, first cut in Leipzig in the 1820s.

Most, though not all, of the unserifed types of the nineteenth century were dark, coarse and tightly closed. These characteristics are still obvious in faces like Helvetica and Franklin Gothic, despite the weight-reductions and other refinements worked on them over the years. These faces are cultural souvenirs of some of the bleakest days of the Industrial Revolution.

Many rotundas and Greek types cut in the 1460s and 1470s include sanserif forms, but none is consistently unserifed. (A recent example on similar lines is Karlgeorg Hoefer's San Marco, shown on page 276.)

The importance of the Haüy italic was first pointed out by James Mosley. For more on the history of unserifed letters, see Mosley's *The Nymph and the Grot* (London, 1999) and Nicolete Gray, *A History of Lettering* (1986).

During the twentieth century, sanserifs evolved toward much greater subtlety, and in this evolution there seem to be three major factors. One is the study of archaic Greek inscriptions, with their light, limber stroke and large aperture. Another is the pursuit of pure geometry: typographic meditation first on the circle and the line, then on more complex geometric figures. The third is the study of Renaissance calligraphy and humanistic form – vitally important in the recent history of serifed and unserifed letters alike. But in retrospect it seems that both type designers and founders were for many years strangely reluctant to believe that one could simply write a humanist letter and *leave the serifs off.* When this is done, everything happens and nothing happens: if the stroke has width, the stroke-end too has shape and form. It takes the serif's place.

Unserifed Text Faces

18 pt

abcëfghijõp 123 AQ *abcéfghijôp*

Caspari **D** Designed by Gerard Daniëls and issued by the Dutch Type Library in 1993. This is a subtly crafted and simple text face with the essential humanist attributes, including large aperture, a genuine italic with a modest slope of 6°, text figures, small caps and impressive economy of form. It was one of the first unserifed faces issued in fit condition for text work, with text figures and small caps in place. Daniëls added a Cyrillic version in 2003. One thing still missing is a book weight. (See also page 273.)

18 pt

AQ *ábçdèfghijklmñöpqrstûvwxyz*

Flora **P/D** Designed by Gerard Unger, released by Rudolf Hell in 1985 and licensed through ITC in 1989. Flora is a true sanserif italic – and it was, I believe, the first unserifed italic to approximate chancery form. It can be used very happily alone but is designed to function also as a companion to Unger's Praxis (unserifed roman) and Demos (serifed roman and italic). Its slope is only 2.5°, and Flora functions best with Praxis when it is used for setting separate blocks of text.

Unger has written persuasively about the importance of horizontals in his type designs. He associates the strong horizontal thrust of Hollander and Swift with the flat Dutch landscape in the midst of which he lives. But in most of his italics – Swift, Hollander and Flora included – it is verticals that seem to matter most. (See also page 272.)

See Gerard Unger, "Dutch Landscape with Letters," in issue 14 of the Dutch journal *Gravisie* (1989): 29–52.

abcëfghijõp 123 AQ *abcéfghijôp*

18 pt Original Frutiger

abcëfghijõp 123 AQ *abcéfghijôp*

18 pt Frutiger Next

Frutiger **P/D** Adrian Frutiger designed this face in 1975, initially for signage at the Paris-Roissy Airport. It was then issued by Mergenthaler for use on their photosetting machines and immediately prospered as a typeface. What it lacked in the way of humanist structure it made up for in its open, fresh geometry, wide aperture and balance. It also mated well with the same designer's Méridien and Apollo, though such a mixture was not apparently part of the original design plan, and the fonts did not match in weight or body size. In the conversion from signage to typeface, a sloped roman was added, rather than a genuine italic.

In 1999–2000, Frutiger redrew the face, adding a true italic, incorporating subtle curves into the stems of the roman characters, and altering the range to include a book weight. There are other small improvements – repositioning of the diacritics, for example – which make the newer version better for text work, though there are still, as in Méridien, no text figures or small caps. The revised version, issued by Linotype in 2001, is known as Frutiger Next. (See also pp 105, 272–3.)

abcëfghijõp 123 AQ *abcéfghijôp*

17 pt book

Futura **H** This was the first and remains, in all likelihood, the best of the geometric sanserif faces. It was designed by Paul Renner in 1924–26 and issued by the Bauer Foundry, Frankfurt, in 1927. Futura is a subtly crafted face, but many copies have been made, under various names, in metal, film and digital form. By no means all these versions are equally well made – and by no means all the weights that have been added to the family are Renner's own designs.

Geometric though it is, Futura is one of the most rhythmical sanserifs ever made. Its proportions are graceful and humane – very close to those of Centaur in the vertical dimension. This helps to make it suitable – like all the unserifed faces examined here – for setting extended text. (Which is not, of course, to say that it is suitable for texts of every kind.) The best digital versions include text figures and small caps, which were part of Renner's original design but were never issued in metal. (See also pp 14, 106, 133, 212, 272.)

abcëfghijõps 123 AQ *abcéfghijôps*

Gill Sans M Designed by Eric Gill and issued by Monotype in 1927. Gill Sans is a distinctly British but highly readable sanserif, composed of latently humanist and overtly geometric forms. The aperture varies (it is large in *c*, moderate in roman *s*, smaller in roman *e*). The italic, like Fournier's, cut two centuries before, was a revolutionary achievement in its time. Books have been set successfully in Gill Sans, though it requires a sure sense of color and measure. Text figures and small caps – very useful when the face is used for text work – were finally added by the Monotype design staff in 1997. (See also pp 37, 272, 286.)

abcëfghijõp 123 AQ *abcéfghijôp*

Haarlemmer Sans D Frank Blokland at the Dutch Type Library created this face as a digital companion to Jan van Krimpen's Haarlemmer while digitizing the latter in the mid 1990s. Haarlemmer itself, cut by Monotype, began as a private commission. So did Haarlemmer Sans, six decades later. The face has been publicly available since 1998. Small caps and text figures are implicit in the design. (See also page 238 – and compare Van Krimpen's Romulus Sans, page 268.)

abcëfghijõp 123 AQ *abcéfghijôp*

Legacy Sans D Designed by Ronald Arnholm and issued via ITC in 1992. To the best of my knowledge, this is the only published attempt to make an unserifed version of Nicolas Jenson's roman. Arnholm drew the serifed version first, and in the process made some drastic changes to Jenson's proportions, yet resemblances remain. The italic is based not on Arrighi but on Garamond's *gros romain italique.* There is more modulation of the stroke in Legacy Sans than in most unserifed types. Text figures and small caps are part of the design. (See also pp 241–2, 272–3.)

abcëfghijõp 123 AQ *abcéfghijôp*

Lucida Sans D This admirable sans, designed by Kris Holmes and Charles Bigelow in 1985, is far and away the most useful member of one of the largest type families in the world. The Lucida tribe now includes not just serifed and unserifed roman

264

and italic but also Greek, Hebrew, Vietnamese, pan-Asian and pan-European Latin and Cyrillic, a full phonetic character set, a multitude of mathematical symbol sets, swash italic, blackletter, script, a slightly rumpled offshoot known as Lucida Casual, a higher-contrast series called Lucida Bright, a series designed for crude resolutions, called Lucida Fax, a set of fixed-pitch typewriter fonts, and another fixed-pitch font, called Lucida Console. Yet the basic Lucida Sans text figures and small caps, which are essential for civilized text work, are missing from every digital version I have seen. (See also page 272.)

abcëfghijõp 123 AQ *abcéfghijôp*

abcëfghijõp 123 AQ *abcéfghijôp*

BCDEFGHIJKLMNOPRSW

BCDEFGHIJKLMNOPRSW

Optima **H/M/D** Designed by Hermann Zapf in 1952–55 and issued in 1958, both as a foundry face by Stempel and in the form of metal matrices for the Linotype machine. The taper of the stroke in these original metal versions derives from unserifed Greek inscriptions and the unserifed roman inscriptions of Renaissance Florence, but in other respects the architecture of Optima is Neoclassical. The original Optima 'italic' is pure sloped roman. There is a range of weights and a matching text Greek, designed by Zapf and issued by Linotype in 1971 (but the Greek, to the best of my knowledge, has never been digitized).

Optima Nova – a digital revision undertaken by Zapf with the help of Akira Kobayashi – was completed in 2003. It involves many changes to the roman, including the sharpening of the terminals (especially visible in a, c, f, s, C, G) and a return to the original subtle taper of the mainstrokes. (This taper, present in the metal typeface, was abandoned in the first conversion to digital format because of the staircasing it caused at low resolutions.) Roman text figures were also a part of the original foundry design, cut in steel in one trial size but not offered for sale. These are revived in Optima Nova, and italic text figures have been added. The diacritics have been repositioned, and the width of some roman letters (D and W for instance) has noticeably changed. The italic is a new and more cursive but steeper design. Optima Nova italic

Original Optima above, Optima Nova below

Fred Smeijers's Quadraat and Quadraat Sans, compared at 168 pt and 18 pt.

These fonts are obviously sisters, yet they differ in many stark and subtle ways. In lowercase a and e, for instance, the shapes of the counters and slope of the midstroke have changed in the transition from serifed to unserifed form. In the cap A, the slope and thickness of the strokes, and height of the crossbar have changed. In cap H, there is a bevelled intersection at upper right and lower left of the crossbar where it joins the stems. In the unserifed H, these bevels are gone but the crossbar is tapered.

abcdefghijklmnopqrstuvwxyz
abcdefghijklmnopqrstuvwxyz
1 2 3 4 5 6 7 8 9 0 · A B C D É F G
1 2 3 4 5 6 7 8 9 0 · A B C D É F G
A B C D E F G H I J K L M N
A B C D E F G H I J K L M N
O P Q R S T U V W X Y Z
O P Q R S T U V W X Y Z

slopes at 15° (compared with 11° in the original) and includes cursive forms of a, e, f, g and l. (See also page 272.)

abcëfghijõp 123 AQ *abcéfghijôp*

18 pt Sans

abcëfghijõp 123 AQ *abcéfghijôp*

18 pt Sans
Informal

aefgjkqrtuvwxyz 345679 æœß

aefgjkqrtuvwxyz 345679 æœß

acdefgjkquvwxy 345 ß AGJKMN

acdefgjkquvwxy 345 ß AGJKMN

AGJKMNQRVWXY·*AGJKM*

AGJKMNQRVWXY·*AGJKM*

The upper row in each of these three pairs is Palatino Sans, and the lower is Palatino Sans Informal. These sister faces share half their character set, but in these three couplets, only divergent glyphs are shown.

Palatino Sans D Hermann Zapf began to sketch this unpretentious but unorthodox sanserif very early in his career. He made the first detailed drawings in 1973, but the face was not put into production until 2006, after the completion of Palatino Nova. (Zapf turned 88 that year.) The stems of Palatino Sans are slightly flared, as in Optima, but the stroke modulation is very slight, the ends of the strokes are softened, and the axis is more humanist than rationalist. There are two parallel series, which have approximately half the basic alphabet and figure set in common. The basic Sans is the quieter, more reserved of the two, with a comfortably sloped roman in place of an italic. Its sibling, Palatino Sans Informal, consists of a jauntier roman married to a hybrid italic, which is to say a mixture of sloped roman and cursive forms. Both series are issued in a range of weights, from ultra light to bold, but the weights of Palatino Sans do not match those of any form of Palatino or Aldus, so Palatino Sans and its serifed brethren do not comfortably mix on the same line. (See also page 272.)

abcëfghijõp 123 AQ *abcéfghijôp*

20 pt

Quadraat Sans D Fred Smeijers, a Dutch typographer working in Germany and the Netherlands, is one of the few people trained as a type designer first and self-taught as a punchcutter

second. FontShop International released the serifed version of his Quadraat in 1993 and the unserifed version in 1997. The more recent OpenType versions are pan-European Latin and Cyrillic. These fonts, for all their modernity, are strongly rooted in Dutch Baroque tradition. Quirkiness is a hallmark of the Baroque, and these are among the quirkier text faces I have used. They are also among the most rigorously designed. Quadraat Sans, like its serifed partner, is not pretty, nor does it need to be. It is intelligent instead. (See also pp 250, 272, 291.)

12 pt foundry
Romulus enlarged

AQ abcdefghijklmnopqrstuvwxyz

Romulus Sans H Jan van Krimpen's major project in the 1930s was the large Romulus family: serifed and unserifed roman, chancery italic, sloped roman, open titling, and Greek. Many designers have now embarked on similar projects, but in 1930, no one had done so. The most interesting part of the project was Romulus Sans, meant to challenge the new and revolutionary sans of Eric Gill (released in 1927). Four weights of the unserifed roman had been cut in a single size (12 pt) when Van Krimpen's employer, the Enschedé Foundry, halted the project. Romulus Sans is the basis for Frank Blokland's Haarlemmer Sans (page 264).

19 pt

abcëfghijõp 123 AQ *abcéfghijôpy*

Scala Sans D A fine neohumanist sanserif designed by Martin Majoor and issued by FontShop International, Berlin, in 1994. This is as fully humanized as any sanserif I know. It has a sprightly and very legible italic and small caps. Text figures and the full array of standard ligatures are standard issue. In the italic, even the geometric letters at the tail of the Latin alphabet (*v, w, y*) are cursive in their sharp and bony way. (Compare the *y* to that of Bembo italic.) The relationship between the serifed and unserifed forms of Scala is displayed on pp 270–71. (Scala Sans is the unserifed face used throughout this book. See also pp 253, 272.)

23 pt

abcëfghijõp 123 AQ abcéfghijôpy

Seria Sans D Like its serifed counterpart, Martin Majoor's Seria Sans explores the common ground between Italian Renaissance structure and the world of Dutch reserve. The extenders are long and graceful, and the stroke weight subtly varied though opti-

268

cally uniform. Seria Sans goes a long way toward fulfilling the dream of a pure sanserif type that began with Edward Johnston, Eric Gill and Jan van Krimpen. The italic, like its serifed cousin, slopes at only one degree and so shares many of its capitals with the roman. The family was issued by FontShop, Berlin, in 2000. (See also page 255.)

abcëfghijõp 123 AQ *abcéfghijôpy* 17 pt Original Syntax

abcëfghijõp 123 AQ *abcéfghijôpy* 17 pt 'Linotype Syntax'

ΛQ ʌbcdéᵨɢʜɪʝklʍɴõpqrsтüvyz 17 pt Syntax Lapidar

Syntax H/D This was the last and very possibly the best sanserif text face commercially cast in metal. Hans Eduard Meier designed the original version in Switzerland in the late 1960s, and it was cut and cast at the Stempel Foundry, Frankfurt, in 1969. The roman is a true neohumanist sanserif. Renaissance shapes that we are used to seeing in company with serifs and a modulated stroke are simply rendered in unserifed and (almost) unmodulated form. The italic, however, is a hybrid: primarily sloped roman. Close scrutiny reveals that in Syntax the roman is sloped too. The italic slopes at 12° and the roman at something close to half a degree. Half a degree, however, is enough to add perceptible vitality and motion to the forms. The stroke width changes very subtly, and the stroke ends are trimmed at a variety of angles. There are several weights, but as usual in neohumanist faces, the weights above semibold are severely distorted.

For text use, the original Syntax was hampered by the absence of text figures and small caps. Meier redrew the entire family in the late 1990s, adding these two essential components, making very small adjustments to the roman and greater alterations to the italic. The new italic letterforms are narrower than the old, and three of them – *f, j, y* – are more cursive than before. Meier also added serifed and semiserifed versions of the face. As part of this enormous project, he drew serifed and unserifed forms of a playfully minimalist companion face, christened Syntax Lapidar. These revisions add substantially to the range and versatility of the type, but the core of Meier's achievement remains exactly where it was: in the naked structure of the unserifed humanist roman. (See also page 272.)

Martin Majoor's Scala and Scala Sans, shown here at 74 pt and 18 pt.

The serifed and unserifed forms of Scala are closely related and highly compatible, but there are many subtle differences as well. Taking the serifs away from an alphabet changes the relative widths of the characters, which changes the rhythm of the face. In Scala roman, for example, the unserifed caps are uniformly narrower than the serifed caps. The unserifed lower case is slightly narrower too, but most of the difference comes in the straight-legged letters h through n.

aa bb cc
éé ff gg
ññ ôô tt
AA HH

abcdefghijklmnopqrstuvwxyz
abcdefghijklmnopqrstuvwxyz
1 2 3 4 5 6 7 8 9 0 · A B C D É F G
1 2 3 4 5 6 7 8 9 0 · A B C D É F G
A B C D E F G H I J K L M N
A B C D E F G H I J K L M N
O P Q R S T U V W X Y Z
O P Q R S T U V W X Y Z

aa bb cc

éé ff gg

ññ ôô tt

AA HH

abcdefghijklmnopqrstuvwxyz
abcdefghijklmnopqrstuvwxyz
1 2 3 4 5 6 7 8 9 0
1 2 3 4 5 6 7 8 9 0
A B C D E F G H I J K L M N
A B C D E F G H I J K L M N
O P Q R S T U V W X Y Z
O P Q R S T U V W X Y Z

In Scala italic, many lowercase letters are actually wider in the sans than in the serifed form, though the alphabet is narrower overall. And Scala Serif has a clearly modulated stroke, while Scala Sans is optically (not actually) monochrome. Thinned and tapered strokes occur in the sans and serifed forms alike (in the brow of roman a, the bar of roman e, and in the roman and italic g, for example) – but the unserifed stroke is never thinned as much as the stroke with serifs.

abcdefghijklmnopqrstuvwxyz

FUTURA: Cursive characters: none 0

abcdefghijklmnopqrstuvwxyz

ORIGINAL FRUTIGER: Cursive characters: none 0

abcdefghijklmnopqrstuvwxyz

ORIGINAL OPTIMA: Cursive characters: none 0

abcdefghijklmnopqrstuvwxyz

ORIGINAL SYNTAX: Cursive characters: *bcdpq* 5

abcdefghijklmnopqrstuvwxyz

GILL SANS: Cursive characters: *abcdfpq* 7

abcdefghijklmnopqrstuvwxyz

OPTIMA NOVA: Cursive characters: *abdefglpqu* 10

abcdefghijklmnopqrstuvwxyz

PALATINO SANS INFORMAL: Cursive characters: *acdefgklvwxy* 12

Flora is shown
here at 17 pt and
Lucida Sans at
16 pt, all other
specimens
at 18 pt.

abcdefghijklmnopqrstuvwxyz

FLORA: Cursive characters: *abcdefghmnpqru* 14

abcdefghijklmnopqrstuvwxyz

LUCIDA SANS: Cursive characters: *abcdefghmnpqru* 14

abcdefghijklmnopqrstuvwxyz

SCALA SANS: Cursive characters: *abcdefhmnpqtuvwy* 16

Triplex italic –
the most broken
alphabet here –
appears to get
the highest
score. This is
evidence that
brokenness can
coexist with
cursiveness,
though the two
are not the same.

abcdefghijklmnopqrstuvwxyz

LEGACY SANS: Cursive characters: *abcdefghkmnpqrtuy* 17

abcdefghijklmnopqrstuvwxyz

QUADRAAT SANS: Cursive characters: *abcdefghjmnpquvwy* 17

abcdefghijklmnopqrstuvwxyz

TRIPLEX: Cursive characters: *abcdefghiklmnopqrtuvwxyz* 24

SOME ITALICS are not italic at all – that is, they are not cursive. Others are very italic indeed. This is one of the salient differences among sanserif types. We can measure this aspect of a typeface, in a crude way, by counting how many letters in the basic lower case have visibly cursive characteristics. This tells us nothing whatsoever about how *good* or *bad* the typeface is. It tells us, instead, something about the *kind* of goodness it may or may not possess.

The same analysis can be performed on serifed italics too. But it is normal, in a serifed italic of humanist form, for every letter in the lower case to be noticeably cursive. There are no purely sanserif italics for which this seems to be true. (John Downer's Triplex italic lower case is close to 100% cursive in this sense, despite its highly geometric form – but it is not 100% unserifed.)

The features that mark an unserifed letter as cursive are often very subtle. In a letter such as *b, h, m, p* or *r*, for example, it is usually only the shape of the bowl, or the angle and the height at which the curved strokes enter or leave the stem, that reveals its cursive form.

bb pp rr · *bb pp rr*

In Frutiger (on the left, above), the oblique forms of *b, p* and *r* are no more cursive than the upright. In Legacy Sans (on the right, above), the oblique forms are visibly italic. They differ from the corresponding roman forms in structure as well as in slope.

The *g* can be cursive or noncursive, no matter whether it has the binocular form that is usual in serifed roman faces or the monocular form that is typical both of chancery italics such as Trinité and of Realist sanserifs such as Helvetica.

gg gg g · gg gg g

In Syntax (1), the oblique *g* keeps its essentially uncursive roman form. In Legacy Sans (2), the italic *g* differs more from the roman: it develops at least a little bit of swing as well as a slope. The *g* from DTL Elzevir italic (3) – a Baroque serifed face, based on the work of Christoffel van Dijck – provides a comparison. The *g* of Frutiger (4) is monocular but not cursive, even when it slopes. In Gerard Daniëls's Caspari (5), the italic *g* is monocular and cursive, like the *g* in Méridien italic (6).

The first types cut in Europe, including all those used by Johann Gutenberg, were blackletters. Scripts and printing types of this kind were once used throughout Europe – in England, France, Hungary, Poland, Portugal, the Netherlands and Spain, as well as Germany – and some species thrived even in Italy. They are the typographic counterpart of the Gothic style in architecture, and like Gothic architecture, they are a prominent part of the European heritage, though they flourished longer and more vigorously in Germany than anywhere else.

Prowling the Specimen Books

Blackletter scripts, like roman scripts, exist in endless variety. Blackletter types are somewhat simpler, and not all of them need concern us here. But it is worth noting the presence of four major families: *textura, fraktur, bastarda* and *rotunda*. (Another variety of blackletter often listed in type catalogues is Schwabacher. This is bastarda by its domestic German name.)

None of these families is confined to a particular historical period. All four have survived, like roman and italic, through many historical variations. Their differences are many and complex, but they can usually be distinguished by reference to the lowercase *o* alone. Though it is written with only two penstrokes, the *o* in a textura looks essentially hexagonal. In a fraktur, it is normally flat on the left side, curved on the right. In a bastarda, it is normally pointed at top and bottom and belled on both sides. In a rotunda, it is essentially oval or round.

> **de heeft hp ons gheuandet die vten hoghen opgegaen is ꝓ nlichte here den ghenē die in dupſterniſſe ſittē en in die ſcheme des doots. om te lepdē**

Above: A 14-point textura cut by Henric Pieterszoon Lettersnider, probably at Antwerp in 1492. Matrices for this font – likely the oldest set of matrices in existence – are now in the Enschedé Museum in Haarlem. *Below*: Typical lowercase forms in textura, fraktur, bastarda and rotunda. The squashed hexagon shape is fundamental in texturas. Frakturs and bastardas are less angular, but rotunda is the only *unpointed* form of blackletter.

Blackletters can be used in many contexts for emphasis or contrast – even in a world devoted to roman and italic – and need not be confined to the mastheads of newspapers or the titles of religious tracts. Type designers have also not abandoned them. Some excellent blackletters have been drawn in the twentieth century – by German artists such as Rudolf Koch and by the American Frederic Goudy.

A O ábçdèfghijklmñöpqrstûvwxyz ß

18 pt

Clairvaux D The blackletter of the White Monks. The Cistercian abbey of Clairvaux, about half way from Paris to Basel, was founded by St Bernard in 1115 and thrived throughout the twelfth century. The typeface of the same name, designed by Herbert Maring and issued by Linotype in 1990, has much of the simplicity espoused by the old Cistercian order. It is also closer than most bastardas to the forms of the Caroline minuscule, and thus more legible than most to modern eyes.

A O ábçdèfghijklmñöpqrstûvwxyz ß

18 pt

Duc de Berry D A light French bastarda, designed by Gottfried Pott, issued in digital form by Linotype in 1991. Jean de France, the Duke of Berry (1340–1416) would, I think, have found these letterforms familiar, but they do not seem to be based on the script in any of the lavish Books of Hours he once owned.

A O ábçdèfghijklmñöpqrstûvwxyz ß

16 pt

Fette Fraktur H This heavy, Romantic fraktur was designed by Johann Christian Bauer and issued by his foundry at Frankfurt about 1850. It provides strong evidence that the Victorian 'fat face' is inherently more congenial to blackletter than to roman.

A O ábçdèfghijklmñöpqrstûvwxyz ß

21 pt

Goudy Text M Designed by Frederic Goudy and issued by Lanston Monotype in 1928. This is a narrow, smooth, lightly ornamented textura, relatively legible in the upper as well as the lower case. There is a second set of capitals, known as Lombardic caps. In machine form and digital form alike, the type is poorly fitted, but it is worth the work of salvage.

Ā O áabcdèfghíjklmñöpqrssʃtûvwxyz

Goudy Thirty **M** This light bastarda/roman hybrid was one of Frederic Goudy's last typefaces, deliberately conceived as his memorial to himself. ('Thirty' is the old journalists' code for 'end of story' or 'over and out.') It is a light and simple rotunda, designed in 1942, issued by Lanston Monotype in 1948 and now available from P-22 in digital form. There are two different cuts, differing in the forms of *a, s, w* and several of the capitals.

Rhapsodie **H** This is an energetic, legible Schwabacher (German bastarda) designed by Ilse Schüle and issued by Ludwig & Mayer, Frankfurt, in 1951. There is an alternate set of ornamental capitals. I have not seen a good digital version of the face.

San Marco **D** Designed by Karlgeorg Hoefer and issued in digital form by Linotype in 1991. This is the first digital blackletter inspired by the rotundas cut at Venice in the 1470s by Nicolas Jenson. San Marco too is a rotunda – the genus of blackletter most closely connected to Italy and structurally closest to roman forms. It is named for the round-vaulted cathedral of San Marco, at the ceremonial center of Jenson's city. (See also page 105.)

Trump Deutsch **H** Designed by Georg Trump and issued in metal by the Berthold Foundry in 1936. This is a dark, wide, concave, unornamented and energetic textura. Both upper and lower case are open and easily legible forms. The face was digitized in 2002 by Dieter Steffmann.

Wilhelm Klingspor Schrift **H** Rudolf Koch completed this narrow, ornamental textura in 1925, naming it in honor of the recently deceased co-owner of the Klingspor Foundry in Offenbach, where Koch was chief designer. Not all the alternate glyphs in the handsome metal versions appear to have been digitized.

276

Uncial letters were widely used by European scribes from the fourth through the ninth century CE, both for Latin and for Greek, but they had vanished from common use in Gutenberg's time. Uncials were not cut into type until the nineteenth century, and then only for scholarly or antiquarian purposes. In the twentieth century, however, many designers – Sjoerd de Roos, William Addison Dwiggins, Frederic Goudy, Oldřich Menhart, Karlgeorg Hoefer and Günter Gerhard Lange, among others – took an interest in uncial forms, and one artist and printer, Victor Hammer, devoted his typographic life to them.

Historically, uncials are unicameral – they have only one case, as all European alphabets did until the late Middle Ages – but not all recent uncials subscribe to this tradition. Early uncials, like recent ones, are sometimes serifed, sometimes not, and may be modulated or monochrome. They are now used chiefly for display, but some are quiet enough for certain kinds of text.

It is often said that *uncial* (from Latin *uncia*) means 'inch.' The two words are indeed related (both, at root, mean 'twelfth'), but this does not mean uncial letters ought to be, or ever were, one inch high.

AQ ábçdèfghíjklmñôpqʀs
túʋʊwxyz 123 ꝺꞬꞀꝗ 4569 ff

17 pt 'Neue Hammer Unziale'

American Uncial H This is the fourth type Victor Hammer designed, the second for which he cut the punches, and the first he produced after fleeing to the USA from Austria in 1939. All Hammer's types are uncials. Only two – this one and its predecessor Pindar – are bicameral. American Uncial was cast privately in Chicago in 1945, then commercially by Klingspor, and marketed in Europe as Neue Hammer Unziale. Most digital types sold as 'American Uncial' are actually copies of a different face: a unicameral uncial called Samson, which Hammer designed in Italy in the 1920s. Digital versions of the real American Uncial are sold, like their metal forebears, as Neue Hammer Unziale.

ábçdèfGhɪjklɱñôp
qʀstúʋʊwxyz 123 æœþð

20 pt

Omnia D Lightly serifed, round, cursive uncials with a large aperture and humanist axis, designed by Karlgeorg Hoefer. This is a unicameral face, issued by Linotype in 1991.

In ordinary usage, script is what is not type; it is writing: the mode of visual language used in public by calligraphers and in private by other literate humans, including typographers themselves. When script hardens, breaks and starts to look like type, we often call it printing – yet printing is what printers do with type, even type that looks like script, which we are likely to call script type. An innocent observer might conclude that English is an undernourished language – one whose speakers cannot generate a new word even when they need one.

At the root of this confusion is a portion of good sense. Type is writing edited or imitated, translated or paraphrased, honored or mocked – but writing itself is a fluid and linear version of more disconnected epigraphic signs. The difference between 'type' and 'script' reiterates the difference between *glyphic* and *graphic*, or carved and written, characters. That difference was established at least 1500 years before the printing press was born.

The craving to mate roman with italic appears to be an effort to have type and script, or glyphic and graphic, at once. This explains in part why it is difficult to classify a typeface like Poetica. Is it a script, or is it a solitary (romanless) italic?

Scripts have thrived as foundry type, phototype and digital type, and several fine designers – Imre Reiner, for example – have focused as persistently as scripts as others have on romans. But scripts had an importance in the world of commercial letterpress that they lack in the world of two-dimensional printing. Handwritten originals are expensive to photoengrave for reproduction on the letterpress. Specially commissioned calligraphy is easy to include, by way of scanning or photography, in artwork destined for the offset press. The best script to supplement a typographic page is now therefore more likely to be handmade.

Dozens of excellent script types are available. They include Arthur Baker's Marigold and Visigoth, Roger Excoffon's Choc and Mistral, Karlgeorg Hoefer's Salto and Saltino, Günter Gerhard Lange's Derby and El Greco, Michael Neugebauer's Squire, Friedrich Peter's Magnificat and Vivaldi, Imre Reiner's Matura and Pepita, Robert Slimbach's Caflisch, Friedrich Sallwey's Present, Georg Trump's Jaguar and Palomba, Jovica Veljović's Veljović Script, and Hermann Zapf's Noris and Venture. I have restricted the illustrations here to a small subset of the scripts that particularly interest me. Two of these – Eaglefeather and Tekton – are architectural scripts and could have been included just as easily

Prowling the Specimen Books

On the early history of printed scripts, see Stanley Morison, "On Script Types," *The Fleuron* 4 (1921): 1–42 (reprinted in Morison's *Selected Essays*, 1981).

among the text types. I have put them here instead for what they reveal about the process of transition from writing to printing, script to type, and script type to roman and italic.

abcëfghijõp 123 ABDQ abcéfghijôp 20 pt

Eaglefeather **D** This is a family of type created in 1994 by David Siegel and Carol Toriumi-Lawrence, based on some of the architectural lettering of Frank Lloyd Wright (1867–1959). Eaglefeather is issued in two forms, called formal and informal, but only the roman lower case actually differs. The two share one italic, one set of roman caps, small caps, figures and analphabetics. Eaglefeather Informal (the version shown) is actually two italics. The 'roman' is a crisp, unserifed italic with no slope. The 'italic' is the same set of letters with a slope of 10°. The series also includes small caps.

AQ 123 ábçdèfghijklmñõpqrstûvwxyz
AA EEE 4¢ čđį fpgh ik vz 22 pt

Ex Ponto **D** This rough-edged, lyrical script was designed by Jovica Veljović and issued by Adobe in three weights in 1995. The design was completed in exile, and its name, Ex Ponto, alludes to the *Epistulae ex ponto*, 'letters from the Black Sea,' written in exile before 13 CE by the Roman poet Ovid. The newer OpenType version of the face includes three sets of capitals and a wide assortment of variant letters and ligatures. (See also page 37.)

AQ 123 ábçdèfghijklmñõpqrstûvwxyz 20 pt

Legende **H** A wide, dark, disconnected script with a small eye but excellent legibility. It was designed by Ernst Schneidler and issued by the Bauer Foundry, Frankfurt, in 1937. This is one of the best modern exemplars of a class of Mannerist scripts inaugurated by Robert Granjon at Lyon in 1557. Typographers call them *civilités*.

AQ 123 ábçdèfghijkmñõprstûwxyz

Ondine **H** This is a dark but open, lucid, disconnected pen script designed by Adrian Frutiger and originally issued by Deberny & Peignot, Paris, in 1953. It was one of Frutiger's earliest designs and it remains his only script face. (An *ondine* is a sea-nymph, and Frutiger's Ondine is full of waves.)

The term *civilité* stems from the use of Granjon's script in an early French translation of one of Desiderius Erasmus's bestsellers: *De civilitate morum puerilium libellus*: 'A Little Book for Children about Civilized Behavior.'

A Q 123 ábçdèfghijklmñöpqrstûvwxyz

Sanvito D Bartolomeo Sanvito (1433–1511) was one of the greatest Renaissance scribes. The face Robert Slimbach designed in his honor was issued by Adobe in 1993. It now exists in an OpenType version, in several weights and optical ranges.

abcdëfghijõp ABC 123 AQ abcéfghijôp

Tekton D Designed by David Siegel, based on the lettering of architect Frank Ching, and issued by Adobe in 1989. The more recent OpenType version includes a range of weights, with text figures and small caps. In modest sizes, Tekton is functionally a sanserif. At larger sizes, its serifs are visible as tiny beads. The 'italic' is an oblique. The original script can be seen in Ching's book *Architectural Graphics* (New York, 1975; 2nd ed. 1985), printed from handwritten pages. (The third edition of the book, published in 1996, is set in semicondensed digital Tekton.)

AQ 123 ábçàdèfõghijklmñöpqirstûvwxyz

AQ 456 ábçàdèfõgihijklmñöpqirstûvwxyz

AQ 456 ábçàdèfõghijklmñöpqirstûvwxyz

AQ 123 ábçàdèfõghijklmñöpqirstûvwxyz

Zapfino D This calligraphic tour de force designed by Hermann Zapf was issued by Linotype in 1998 as a set of four alphabets with a separate font of supplementary ligatures. In 2004 an enlarged, OpenType version appeared under the name Zapfino Extra. That incarnation of the family includes small caps and extra alternates and ligatures. There is also a darker version of one of the four base character sets, known as Zapfino Forte. It is an exemplary marriage of artistic and technical ability. These fonts can be left to run on autopilot, like ordinary text fonts, but truly effective use of a type as complex as Zapfino requires considerable patience, judgment and skill, much like handsetting in metal. It therefore makes a useful training tool – for typographers and calligraphers alike. (See also page 185.)

μηχόμεμόμ Τε λέαμΔρομ ὁμοῦ καὶ λύχμο

Δράσαντι δ' αἰχρὰ, δεινὰ τάπιτί μια

ωρὸς τὸν θεόν, καὶ θεὸς luῶ ὁ λόγ☉.

Three early Greek types. *Top*: The Complutensian Greek, a 16 pt orthotic font cut by Arnaldo Guillén de Brocar at Alcalá de Henares, near Madrid, in 1510. *Middle*: The 10 pt cursive cut by Francesco Griffo, Venice, in 1502 [here shown at twice actual size]. *Bottom*: An 18 pt chancery Greek cut by Robert Granjon in the 1560s.

11.7 GREEKS

Greek type has a long and complex history peculiarly its own, yet closely entwined with the history of roman. The first full fonts of Greek were cut in Venice and Florence by Nicolas Jenson, Francesco Griffo and others who were simultaneously cutting the first roman and italic faces. Simon de Colines, Claude Garamond, Robert Granjon, Miklós Kis, Johann Fleischman and William Caslon cut good Greeks as well, and their type was widely used. Yet the first Greek book printed in Greece itself was the Mt Athos Psalter of 1759, and the first secular printing press in Greece was established only during the War of Independence, with help from Ambroise Firmin-Didot, in 1821.

Greek adaptations of popular roman faces – Baskerville, Caledonia, Helvetica, Times New Roman, Univers and others – have been issued by Linotype, Monotype and other firms, and are widely used in Greece. But there, as in much of Eastern Europe, the more lyrical forms of modernism have been slower to arrive. Even in the multinational world of classical studies, where Greek types that will harmonize with neohumanist romans are perennially needed, they are in very short supply.

Three important classes of Greek type have been with us since the fifteenth century. These are the *orthotic*, the *cursive*, and the *chancery script*. Orthotic Greek is analogous to roman in the Latin alphabet. It is, in other words, *not cursive*. The letters are relatively self-contained, usually upright, and may or may not have serifs. Cursive Greek type – which exists in both sloped and vertical forms – is analogous to italic. Chancery Greeks are merely elaborate forms of the cursive, but they attained in Greek

Orthotic is from the Greek word ὀρθός (*orthos*), 'upright'; *cursive* from the Latin *currere*, to run or to hurry; and *chancery* from the Latin *cancelli*, 'little crabs.' *Cancelli* came to be the Latin term for a lattice or grate, and then for the ornamental barrier that stood between officials and petitioners at court. It is in other words the bar to which lawyers are still called. Chancery scripts flourished where lawyers worked.

a level of typographic intricacy never yet approached by chancery italic type in the Latin alphabet.

The orthotic Greek types of the Renaissance resemble Renaissance romans yet differ from them in several interesting ways. The stroke is usually quite uniform in thickness, the stroke-ends are sharply rectangular, and the serifs, when present, are usually short, abrupt and unilateral. The geometric figures of triangle, circle and line are prominent in the underlying structure of these faces, though not to the exclusion of more complex curves. This is the oldest form of Greek type, first seen in the partial alphabets cut by Peter Schoeffer the Elder at Mainz and by Konrad Sweynheym at Subiaco, near Rome, in 1465. It is also the style of the first full-fledged and polytonic Greek type, cut by Nicolas Jenson at Venice in 1471.

The finest early example of orthotic Greek, in the opinion of many historians, is the Complutensian Greek of Arnaldo Guillén de Brocar, cut in Spain in 1510. A few years after that, orthotic Greeks completely disappeared. They were not revived until the end of the nineteenth century. The most widely used modern version is the New Hellenic type designed by Victor Scholderer in London in 1927.

The first cursive Greek font was cut by an unidentified craftsman at Vicenza, west of Venice, in 1475. The second, cut at Venice by Francesco Griffo, did not appear for another twenty years – and it was not a simple cursive like the anonymous font from Vicenza but an elaborate chancery script. Griffo cut a simple Greek cursive in 1502, but chancery Greeks remained the fashion throughout Europe for the next two hundred years.

A simple Greek cursive can be turned to a chancery script by the addition of ligatures and alternates, and a chancery script converted to simple cursive by leaving most of these additions out. But the battery of ligatures involved often runs to several hundred, and sometimes to more than a thousand.

= γὰρ

Chancery Greeks were cut by many artists from Garamond to Caslon, but Neoclassical and Romantic designers – including Baskerville, Bodoni, Alexander Wilson and Ambroise Firmin-Didot – all returned to simpler cursive forms. Firmin-Didot's Greek is still in frequent use, in France and Greece alike, but in the English-speaking world the cursive Greek most often seen is the one designed in 1806 by Richard Porson.

γὰρ

Neohumanist Greeks, such as Jan van Krimpen's Antigone, Hermann Zapf's Heraklit and Palatino Greek, and Robert Slim-

bach's Minion and Arno Greeks, have opened a new chapter in the history of the Greek alphabet, bringing the humanist structure of Renaissance roman and italic into the Greek lower case. Ironically, these types evolved just as the custodians of European culture were by and large abandoning the study of the classics.

Greek, like Latin, evolved into bicameral form in the late Middle Ages. The upper case in the two alphabets shares the same heritage, and more than half the uppercase forms remain identical. (The same is true of Greek and Latin uncials.) But the Greek lower case has evolved along a different path. There is a quiet and formal Greek hand, not dissimilar in spirit to the roman lower case, but the usual Greek minuscule is cursive. As a consequence, most Greek faces are like Renaissance italics: upright, formal capitals married to a flowing, often sloping, lower case. No real supporting face has developed in the Greek typographic tradition: no face that augments and contrasts with the primary alphabet as italic does with roman.

That of course is subject to change. Several twentieth-century designers added bold and inclined variants to their Greeks, in imitation of Latin models, and a shift in usage may be underway. But several of the faces shown here are solitary designs. They are meant to be used alone or as supplementary faces themselves, for setting Greek intermixed with roman.

Prowling the Specimen Books

”Aα̦

ἀβγδεζηϑικλμνξοπρστὖφχψως
ἀβγδεζηϑικλμνξοπρστὖφχψως

18 pt

Albertina **D** Chris Brand designed this Greek in the 1960s, together with Albertina Latin and Cyrillic. Initially only the Latin face was produced. The Greek was issued in 2004, by DTL. It exists in both upright and cursive form – but, for now at least, only in a monotonic version. (See also pp 213, 289.)

ἄβγδὲζῆϑικλμνξοπρστὖφχψως

12 pt foundry
Antigone
enlarged

Antigone **H** Designed by Jan van Krimpen and issued by Enschedé in 1927. This is a delicately sculpted neohumanist Greek, intended for the setting of lyric poetry. It was cut specifically to match the same designer's Lutetia roman and italic, but it composes well with his other Latin faces, including Romanée and Spectrum. There is no digital version of Antigone.

ἄβγδεζηθικλμνξοπρστῦφχψὼς

ἄβγδεζηθικλμνξοπρστῦφχψὼς

𝒜𝛥𝛯𝛱 ΑΒΓΔΘΛΞΠ ΣϕΨΩ

Arno **D** Robert Slimbach's Arno family, issued by Adobe in 2007, consists of 32 fonts. There are 16 variants each of roman and italic, scaled from Display size to Caption. Each of the 32 fonts is pan-European, with Latin, Cyrillic and polytonic Greek. For all three alphabets, in every weight, there are upright and sloped small caps and swash initials. This display of technical virtuosity, consistency and sheer determination would be a waste, of course, if the underlying letterforms were not superbly drawn to begin with – but they are. This is the fruit of a lifetime spent studying and drawing humanist letters. (See also pp 107, 217–19, 290.)

ἄβγδεζηθικλμνξοπρστῦφχψὼς

ἄβγδεζηθικλμνξοπρστυφχψὼς

Bodoni **H** The last edition of Giambattista Bodoni's *Manuale tipografico*, published by his widow in 1818, includes samples of 85 Greek fonts, all cut by the same hand. They form several series, embodying at least a dozen different underlying designs. There is in other words no single archetypal Bodoni Greek, any more than there is a single archetypal Bodoni roman or italic. Neither of the two digital fonts shown here coincides with any one font cut by Bodoni, but each is a kind of synthesis of some of his favorite ideas. The upright font was made by Takis Katsoulidis in 1993 and the sloped one by George Matthiopoulos in 2004. Both are issued by the Greek Font Society, Athens (who call the upright font GFS Bodoni and the sloped one GFS Bodoni Classic). Like Bodoni's own upright and cursive Greeks, these two fonts can share the page but are *not* designed for setting together.

ἄβγδεζηθικλμνξοπρστῦφχψὼς

Ἀ Β Γ ϖράγμαῖος Θ Ϊ ω

Complutum **H** Arnaldo Guillén de Brocar cut what we now call the Complutensian Greek at Alcalá de Henares, the old Ro-

man town of Complutum. This orthotic font was commissioned specifically for the six-volume polyglot Bible that Guillén completed in 1517. Guillén printed the New Testament first, mating his new Greek with a Latin rotunda on a handsomely asymmetrical two-column page. (The actual text of the Complutensian New Testament is set in a monotonic version of the font, in which the only diacritic is the acute, but in the front matter and back matter, a full polytonic font is used. This involved the difficult chore of setting by hand on negative leading.) Evidently to save space, Guillén switched to a conventional cursive Greek, much less distinguished, for the massive quadrilingual Old Testament.

In 2007 George Matthiopoulos, head of design at the Greek Font Society, Athens, produced a digital replica of the Complutensian font. It is distributed by the Society as GFS Complutum. Compared with Victor Scholderer's New Hellenic Greek (pp 286–7), this digital Complutensian has a funky shamble – and that is part of its charm. The archaic forms of *mu* and *nu* (ᴧ and ɥ instead of μ and ν) and the two alternates, omegaform *pi* and tall *tau* (ϖ and ⅂ instead of π and τ) may puzzle readers with no exposure to Renaissance Greek, but in every other respect the face is superbly legible – just as it was in 1512.

ἄβγδεζηθικλμνξοπρστῦφχψὼς
ἈΓΔΘΛΞΠΣΦΨΩ

21/24

Didot ʜ More than one typographer has wondered why Didot Greeks look so little like Didot romans. The reason is that the original versions were cut in different eras by father and son, and they embody the two punchcutters' different relationships to two distinct typographic traditions. The original Didot Greeks are the work of Ambroise Firmin-Didot, whose father, Firmin Didot, cut the best-known Didot romans and italics. The romans, cut in the thick of the French Revolution, have a strictly rationalist structure. They have left every vestige of Baroque variety behind.

Didot Greeks have a lefthandedness learned from the Mannerist and Baroque Greeks of Granjon, Jannon, Kis, Caslon and Fleischman. At the same time, the contrast between their thick and thin strokes is stark and Romantic. The caps are tall and narrow. The digital version shown here (called GFS Didot Classic) was made for the Greek Font Society, Athens, by George Matthiopoulos in 1995, revised in 2008. (See also page 113.)

ΑΒΓΔΕϜΙΘ⊕⊙ΘΙΚΛΜϺϺΞΟΟΓΡϹΤΥΦΧͶΩ

Diogenes **D** An alphabet of pure archaic capitals, designed by Christopher Stinehour, Berkeley, in 1996. It is one of two Greek fonts – one digital, one metal – commissioned by the printer Peter Rutledge Koch for use in an edition of the fragments of Parmenides. It is based on inscriptions of the fifth century BCE from the old Greek city of Phokaia and its colony Elea, on the coast of Italy, where Parmenides was born. A slightly darker book weight (shown above) was added in 2003.

ἄβγδεζηθικλμνξοπρστῦφχψὼς
ΑΒΓΔΘΛΞΠΩ ⓚ γγ λλ ϑ φ

Garamond Premier **D** The first Adobe Garamond, issued in 1989, was Latin only. Its designer, Robert Slimbach, revised the family in 2005 into Garamond Premier Pro – a royal family of five weights in four size ranges. At that time, he added polytonic Greek (and pan-Slavic Cyrillic) to each of the 34 fonts. The Greek is like none that Garamond ever cut – and where Garamond's Greeks have hundreds of sumptuous ligatures, these have a grand total of two (double-γ and double-λ). It is a fine Greek all the same, with Greek small caps in every weight and size, meticulously drawn and superbly engineered – and sumptuous as well, in its own much more strict and orderly way.

ἄβγδεζηθικλμνξοπρστῦφχψὼς

Gill Sans **M** This face was designed in the 1950s by Monotype draftsmen, not by Eric Gill himself, as a companion for the Gill Sans roman. Since the roman had been modified already from Gill's original drawings, this Greek is twice removed from the artist for whom it is named. It is however a clean and serviceable design. There are digital versions in several weights, both upright and oblique, but the book weight (shown here) – for which the need is greatest – has never yet been commercially issued.

ἄβγδεζηθικλμνξοπρστῦφχψὼς

New Hellenic **M** Designed by Victor Scholderer and issued by Monotype in 1927. This is an orthotic Greek, reasserting the tradition of Nicolas Jenson, Antonio Miscomini and Arnaldo Guillén

de Brocar, instead of the cursive and chancery Greek tradition of Francesco Griffo, Simon de Colines and Claude Garamond. It is open, erect, gracious and stable, with minimal modulation of the stroke and minimal serifs. A digital version of the face was made in 1993–94 for the Greek Font Society. George Matthiopoulos revised this font in 2000, adding a bold, an oblique and, more importantly, Greek small caps. (The GFS fonts are officially called *Neo,* not *New* Hellenic. See also pp 108, 112.)

ἄβγδεζηθικλμνξοπρστῦφχψὼς

ἄβγδεζηθικλμνξοπρστῦφχψὼς

άβγδεζηθικλμνξοπρστϋφχψως

17 pt Palatino Linotype repaired

17 pt italic with factory diacritics

17 pt Palatino Nova

Palatino D In 1951, Hermann Zapf designed a Greek text face to serve as a companion for his foundry Palatino and Linotype Aldus. This font was christened Heraklit and manufactured in foundry form by Stempel in 1954. Forty years later, as part of the transformation of digital Palatino into the pan-European 'Palatino Linotype,' Zapf revised this Greek, adding an upright bold and two weights of italic. These new versions were incorporated into the pan-European Palatino Linotype issued by Microsoft in 1997. Palatino Linotype Greek is fully polytonic, but the fonts were finished at Microsoft, without Zapf's supervision. Kerning in the Greek is nonexistent, and the diacritics are much too pale. When the diacritics are strengthened (as in the first of the two specimen lines above) and a kerning table is added, this becomes a fine text Greek and mates handsomely with Palatino roman.

An 80 pt *mu* from Palatino Linotype above, and from Palatino Nova below. Other changed letters: ρ, Θ, Ξ, Φ.

In the early 2000s, Zapf revised Palatino Linotype Greek, turning it into the Greek component of Palatino Nova. In certain technical respects, Palatino Nova Greek is an improvement – but it is monotonic only. Palatino Nova Titling, however, includes digital versions of the superb Phidias Greek titling capitals originally issued by Stempel in 1953. (See also pp 244–6, 291.)

ΑΒΓΔΕϜΙΘΘΙΚΛΜΝΞΟΟΓΡϹΤΥΦΧΨϹΩ

12 pt foundry Parmenides

Parmenides H Dan Carr cut this font by hand in steel in Ashuelot, New Hampshire, in 1999–2000, then struck the matrices and cast it for handsetting. Like its digital relative Diogenes, it was commissioned by the printer Peter Rutledge Koch and is based on Greek inscriptions from Parmenides' time and place.

287

ἄβγδεζηθικλμνξοπρστῦφχψὼς

Porson H Designed by the English classicist Richard Porson for Cambridge University and cut by Richard Austin beginning in 1806. The face was soon copied by several other foundries, and in 1912 an edited version was issued by Monotype. This has been the standard Greek face for the Oxford Classical Texts for over a century. It is a calm yet energetic face of Neoclassical design that composes well with many romans. During its long and fruitful career, the Porson lower case has been fitted with several different series of caps, none of which quite matches Porson's original design. The digital version of the face shown here is the one produced in 1995 and revised in 2006 by George Matthiopoulos for the Greek Font Society, Athens. (See also pp 109, 113.)

22/27

ἄβγδεζηθικλμνξοπρστῦφχψὼς
ἄπο γὰ ῗ εἶ μαι ᾧ πὰ οᾧ ᾧ τλ ᾗ χω
ἀνλιληπλικὴ πληγῆς ἀέρῳ δι᾽ ὠτὸς
τὸν θεόν, καὶ θεῷ ἦν ὁ λόγος

Wilson D Greek fonts this well-made have always been rare, though Greeks that aimed at this result were once the norm. At present, this is the only digital Greek with anything approaching the battery of ligatures and alternates familiar to Baroque and Renaissance readers and compositors. It was made by Matthew Carter in 1995, based on the Greek fonts of the eighteenth-century master punchcutter, physician and astronomer Alexander Wilson of Glasgow.

11.8 CYRILLICS

The Cyrillic alphabet was adapted from Greek in the ninth century, and the first Cyrillic type was cut in Kraków by Ludolf Borchtorp in 1490. An improved Cyrillic was cut in Prague in 1517 by the Belarusian Frantsysk Skaryna, but the first Cyrillic cursive was not cut until 1583. The subsequent history of Cyrillic is largely parallel to that of Latin type, with the important exception that there is no humanist or Renaissance phase, and the intimate link-

age between upright and italic which is now taken for granted in Western European typography did not develop in the context of Cyrillic. Only in the eighteenth century were upright and cursive forms paired. Slavic type, like Slavic literature, passed more or less directly from the medieval to the late Baroque. For this and for other, more overtly political reasons, the neohumanist movement in type design also came late to Cyrillic letters.

With minor variations, Cyrillic is now used by close to half a billion people, writing in Russian, Ukrainian, Belarusian, Bulgarian, Macedonian and other Slavic languages. In Serbia and Montenegro it is used for Serbo-Croatian, and in Moldova for Romanian. It is also now the common alphabet for a host of unrelated languages, from Abkhaz to Uzbek, spoken and written across what once was the Soviet Union.

Several excellent type designers have worked in Russia and the neighboring republics in the past century. The list includes Vadim Lazurski from Odessa, Galina Bannikova from Sarapul, Anatoli Shchukin from Moscow, Pavel Kuzanyan and Solomon Telingater from Tbilisi. Few of their designs have been available in the West; many, in fact, have yet to be produced in type at all.

Linotype, Monotype, ParaType and other foundries have issued Cyrillic versions of Baskerville, Bodoni, Caslon, Charter, Frutiger, Futura, Gill Sans, Helvetica, Jannon, Kabel, Plantin, Syntax, Times, Univers and other Latin faces. Nearly all these have their uses, including setting multilingual texts, where matching Latin and Cyrillic fonts may be required. But not all of these derivative Cyrillics can claim to be distinguished designs, and not all are suited to running text.

Cyrillic text fonts are increasingly constructed with the same variations as the better Latin text types: roman, italic and small caps, with text as well as titling figures, often in several weights. Roman type is known in Russian as прямой шрифт (*pryamoi shrift*, 'upright type'). Italic is called курсив (*kursiv*) or курсивный шрифт (*kursivnyi shrift*). Unserifed Cyrillics, like Latin sanserifs, are often made with an oblique (наклонный шрифт = *naklonnyi shrift*, 'sloped type') in place of an italic.

Prowling the Specimen Books

Text figures are available for all Cyrillic faces shown on this and the following pages.

абвгдежофщ АЖО *абвгдежофщ*

18 pt

Albertina D Like Albertina Greek, this was designed by Chris Brand in the 1960s but not produced until 2004. It mates perfectly with its Greek and Latin companions. (See also pp 213, 283.)

абвгдежофщ АЖО *абвгдежофщ*
АБЖТ абвгдеж *ЧЩЯ Ѣ*

Arno D This neohumanist Cyrillic is an integral part of Robert Slimbach's Arno family, issued by Adobe in 2007. It therefore exists in a fine-grained spectrum of weights and styles, with matching Latin and polytonic Greek. There are small caps and swashes for all three alphabets. (See also pp 107, 217–18, 284.)

абвгдежофщ АЖО *абвгдежофщ*

Baskerville M Baskerville himself did not design a Cyrillic, but Cyrillic adaptations of his roman and italic have been made by several foundries. The best of these is Monotype's, designed in 1930 by the young Harry Carter, who would soon grow into a great type historian. For some Russian texts of the eighteenth century and later, a face of Western origin and French Enlightenment spirit is highly appropriate. Baskerville Cyrillic is one obvious choice for this purpose – especially for bilingual publications, if Baskerville happens to suit the translation. (See also page 219.)

абвгдежофщ АЖО *абвгдежофщ*

Lazurski H This is a neohumanist Cyrillic designed by the Russian book designer Vadim Lazurski. It was produced in 1962 in two forms, under two names. In Russia it was issued for machine setting as Garnitura Lazurskogo. The foundry version, edited by Giovanni Mardersteig and cut under his direction by Ruggiero Olivieri, is known as Pushkin. In that form, it has been used only at Mardersteig's press, the Officina Bodoni in Verona. Vladimir Yefimov adapted it for photosetting in 1984, adding a bold weight. Both the Cyrillic and its Latin companion were issued in digital form by ParaGraph, Moscow, in 1991. The requisite text figures were added in 1997. (See also page 110.)

абвгдежофщ АЖО *абвгдежофщ*

Minion D A neohumanist Cyrillic designed by Robert Slimbach as a companion to his Minion Latin and Greek. It was first issued by Adobe in 1992, and re-issued as part of the pan-European Minion in 2000. As a component of this family, it now exists in a range of weights and optical sizes. (See also page 243.)

290

абвгдежофщ АЖО *абвгдежофщ*

17 pt

Palatino Nova **D** Palatino Cyrillic, like Palatino Greek, was designed by Hermann Zapf in the 1990s as part of the transformation of Palatino into 'Palatino Linotype,' then mildly revised a decade later as part of Palatino Nova. (See also pp 244–6.)

абвгдежофщ АЖО *абвгдежофщ*

19 pt

Quadraat **D** Most Cyrillic adaptations of Latin faces have an air of superficiality about them. Fred Smeijers's Quadraat Cyrillic is a wonderful exception to that rule. It exists in a range of weights and is now an integral component of the pan-European version of Quadraat. Quadraat Sans Cyrillic is its natural companion. (See also page 250.)

абвгдежофщ АЖО *абвгдежофщ*

19 pt

Quadraat Sans **D** Like its serifed sister Quadraat, this sanserif has a true cursive italic and has been issued in a range of weights. It is now an integral component of the pan-European OpenType version of Quadraat Sans. (See also pp 266–8.)

абвгдежофщ АЖО *абвгдежофщ*

18 pt regular

Warnock **D** Warnock, like Minion, is a pan-European family of type – Latin, Greek and Cyrillic – designed by Robert Slimbach and issued by Adobe in OpenType format in 2000. It is spikier than Minion, and more artificial (more *drawn* instead of *written*). It is also steeper (the italic slopes at 15° instead of 12°). It exists, like Minion, in a range of weights and optical sizes.

11.9 INSCRIPTIONAL & CALLIGRAPHIC CAPITALS

Every text begins at least once. Most stop and start again repeatedly before they run their course. These beginnings – of sentences, paragraphs, chapters or sections – are the doors and windows of the text. European scribes began to mark the major ones with large, sometimes ornate capital letters – versals – even before the Latin alphabet developed a lower case.

In many early printed books, space is left for such initials to be painted in by hand. Printers also began to print them, in multiple colors, as early as 1459. Many fine alphabets of capitals

291

have sprung from this tradition: fonts of type designed for setting titles or short texts, or to be used one letter at a time. Some of these alphabets – Carol Twombly's Lithos and Gudrun Zapf-von Hesse's Smaragd, for example – are *glyphic* or inscriptional; others are purely calligraphic.

Inscriptional and Calligraphic Capitals
Because they are meant for use with other fonts of text size, many fonts of inscriptional initials are inlines: the interior of the stroke has been carved away to lighten the face. Jan van Krimpen's Lutetia and Romulus Open Capitals, for example, were made by hollowing out the caps of these text faces. But Cristal, designed by Rémy Peignot, and Castellar, designed by John Peters, were created from the start as inline types and exist in no other form.

The capitals from any text font can, of course, be enlarged for use as versals, but the proportions often suffer as a result, and specially proportioned titling capitals exist for only a few text faces (Giovanni Mardersteig's Dante and John Hudson's Manticore are examples). From time to time, however, the capitals from a bicameral text or titling face develop a separate life of their own.

Samples of many of these faces are shown on page 299.
This has occurred, for example, with Berthold Wolpe's Albertus, Carl Dair's Cartier, Herb Lubalin's Avant Garde, and with Georg Trump's Codex and Delphin. The faces listed below were all designed specifically as capitals for titling, not text.

42 pt

A E G Q W

Ariadne **H** Calligraphic initials designed by Gudrun Zapf-von Hesse and issued by the Stempel Foundry, Frankfurt, in 1954. These initials combine especially well at text size with Diotima and at larger sizes with Palatino and Aldus. (See also page 299.)

36 pt foundry Augustea & Augustea Inline

ABCDXYZ

Augustea **H/M** Sharply serifed, formal inscriptional capitals, designed by Aldo Novarese and Alessandro Butti, issued in metal by the Nebiolo Foundry, Torino, in 1951. There is an inline version, originally sold as Augustea Filettata, now digitized as Augustea Open. A lower case was also later added to the capitals. The result is known as Augustea Nova. (See also page 299.)

ABCDEFGHIJKLM
NOPQRSTUVWXYZ
· 1 2 3 4 5 6 7 8 9 0 ·

Castellar M Inline capitals, asymmetrically inscribed, so that the hollowed strokes are light on the left, dark on the right. The face was designed by John Peters and issued by Monotype in 1957. (See also pp 64, 160, 299.)

ABCDEFGHIJKLM
NOPQRSTUVWXYZ
1234567890·ÐÞÆŒ

Charlemagne D These lighthearted Caroline capitals, based on the Carolingian titling scripts and versals of the ninth and tenth centuries, were designed by Carol Twombly and issued in digital form by Adobe in 1989. The newer OpenType version of the face includes a pan-European Latin character set. (See also pp 120, 299.)

ABCDEFGHIJKLM
AKMNRUVXYZ
NOPQRSTUVWXYZ
·1234567890·

Herculanum D Designed by Adrian Frutiger and issued in digital form by Linotype in 1990. There are many variant letters. Herculanum was a Roman city near present-day Naples, buried, like Pompeii, by the eruption of Vesuvius in 79 CE. The face that bears its name is based on written and painted Roman letters of the first and second centuries CE. These unofficial and informal Roman inscriptions were a source of inspiration to Frutiger for more than half a century. The capitals of his Ondine (page 279), designed in the early 1950s, derive from them as well. His Rusticana (page 297) derives from their later relatives.

A B C D E F G H I J K L M
N O P Q R S T U V W X Y Z
Γ Δ Θ Λ Ξ Π Σ Υ Ϋ Φ Ψ Ω

Lithos D Unserifed capitals with a large aperture and cheerful form, based on early Greek inscriptional letters, designed by Carol Twombly and first issued by Adobe in 1989. There are many subtle modulations in the stroke. The new OpenType version of the face includes pan-European Latin and Greek.

ᴬBᴮᴬGGIɪ̵L&Lʟ̵QQŒRR̵TᴛT̵
A B C D E F G H I J K L M N
O P Q R S T U V W X Y Z
Yᵧ̵Yʟ̵A MᴇⒸV̵TT UᴘHᴇMP&ᶜ

Mantinia D This complex face is based on letterforms found in the work of the painter Andrea Mantegna (1431–1506). Andrea del Castagno, Fra Angelico and other fifteenth-century artists lavished as much care on their letterforms as on their human figures, but no Renaissance painter took the alphabet more seriously than Mantegna. The type that honors him was designed by Matthew Carter and issued by Carter & Cone in 1992.

A B C D E F G H I J K L M
N O P Q R S T U V W X Y Z
· K L R U W · NN OO ⑳ ·
∗ Γ Δ Θ Λ Ξ Π Σ Υ Φ Ψ Ω ∗

Michelangelo & Phidias H Michelangelo and its Greek companion Phidias were designed by Hermann Zapf and issued by the Stempel foundry, Frankfurt, in 1951–53, as part of the Palatino family. A new digital version, issued in 2004 as Palatino Nova Titling, combines the Latin and Greek in a single font. (See also pp 118, 299–301.)

294

ABCDEFGHI JKLMNOPQRS TUVWXYZ

Monument H These open inline capitals were designed by Oldřich Menhart and first cast in 1950 by the Grafotechna Foundry, Prague. This digital version was issued by ProFonts, Hamburg, in 2010. Here the imperial stillness typical of Roman inscriptional letters is transformed to a kind of stately folk dance under Menhart's hand. (See also page 299.)

ABCDEFGHIJKLMN OPQRSTUVWXYZ

Neuland H These dark, rugged, unserifed roman capitals were designed and cut by Rudolf Koch, then cast in metal by the Klingspor Foundry, Offenbach, in 1923. Koch cut the original punches freehand, without pattern drawings. Each size in the foundry version therefore has many idiosyncracies of its own. These splendid subtleties are lost in all the existing digital versions. (See also page 299.)

ΛBCDEFGH‡JKLM
ΛBCDEFÇH‡JKLMN
NOPQRSTVVWXYZ
OPQRSTVVWXYZ

Numa D This double set of immensely cheerful lightweight capitals is based on very early Italian inscriptions – which is to say, it is based on some of the oldest surviving examples of Latin script. The face was designed by Sumner Stone and issued by his foundry in 2007. It is named for Numa Pompilius, king of Rome in the late eighth and early seventh centuries BCE.

Pericles H Designed by Robert Foster and issued by ATF in 1934. A digital version, with the original variant letters and several new additions, was produced in 2005 by Steve Matteson at Ascender Corp. in Chicago. The foundry face has one weight only. Matteson added a second, lighter version. (See also page 299.)

42 pt

Raffia H One or two of these initials go a very long way, but a great deal can be learned from them. Henk Krijger, who designed them, was a Dutch typographer and artist born and raised in Indonesia, where he learned about tropical plants even before he learned his letters. Raffia fiber, peeled from the fronds of certain palms, is the common form of twine in many tropical regions – but raffia twine is flat, twisty and springy, like the stroke of a broadnib pen, not obedient, limp and round, like cotton string or the stroke of a ballpoint. Krijger understood that the goodness of good penstrokes rests in their organic form. His Raffia initials were issued by the Amsterdam foundry in 1952. The only digital version that captures the spirit of the original is the one made recently at CanadaType in Toronto by Patrick Griffin.

21/33
Requiem
Banner

296

Requiem Banner D Requiem, the distinguished text face designed by Jonathan Hoefler in 1999, is supplemented not only by two display weights of roman and italic but also by two weights of innovative banner letters, augmented by floriated terminals, spacers and connectors. (See also page 251.)

⸺ A B C D E F F G H I J K L M ⸺
◖ I J J L I L Y T I Y I P F I E T L Y J R ✇ *24/28*
· N O P Q R S T U V W X Y Z ·

Rialto Titling D These elegant, light calligraphic capitals are part of the Rialto family, designed by Giovanni de Faccio and Lui Karner, issued by *df*Type in 1999. There is a full set of letters at standard height and a partial set of ascending and descending forms. (See also page 251.)

A B C D E F G H I J K L M
N O P Q R S T U V W X Y Z *18/24*

Rusticana D This is one of a group of three faces designed by Adrian Frutiger based on the more populist, less imperial varieties of Roman inscriptions. The other members of the family are Herculanum and Pompeijana. Rusticana owes its form to Roman inscriptional lettering of the fourth and fifth centuries CE.

A B C D E F G H I J K L M
N O P Q R S T U V W X Y Z
Q R T U W · Ö Ö Ü Ü *24/30*
Palatino Nova Imperial

Sistina H Sistina, like Michelangelo, was an early part of the Palatino family and one of the great twentieth-century metal titling faces. It was designed by Hermann Zapf and issued by the Stempel foundry, Frankfurt, in 1951. Zapf revised it slightly in 2004 when a new digital version was made to accompany Palatino Nova. The new version is known as Palatino Nova Imperial.

ABCDEFGHIJKLM
NOPQRSTUVWXYZ

Smaragd D A set of light but powerful inline capitals designed by Gudrun Zapf-von Hesse and issued by the Stempel Foundry in 1952. *Smaragd* means emerald: the substance on which the secrets of Hermes Trismegistos – the Greek incarnation of Thoth, the inventor of writing – were reputedly engraved.

AABCDEEFFGHIJKLM
MNOPQRSTTUVWXXYZ
12344567890·ŒÆ

Sophia D Designed by Matthew Carter and issued by Carter & Cone in 1993. This complex face with its many variant glyphs is based primarily on the alphabet found on an inscribed cross, made in Constantinople in the mid sixth century. The cross was a gift to the Bishop of Rome from the Byzantine Emperor Justin II and his wife (later also his regent) the Empress Sophia. It intrigued the type historian Stanley Morison, who wrote about these letters in his last book, *Politics and Script.*

ABCDEFGHIJKLM
NOPQRSTUVWXYZ

Trajan D Serifed capitals, based on the inscription at the base of Trajan's Column, Rome, carved at the beginning of the second century CE. The face was drawn by Carol Twombly and issued in digital form by Adobe, in two weights only (normal and semibold). In its OpenType version, it includes the pan-European Latin character set. A further revision, known as 'Trajan 3,' issued in 2012, includes handsome Greek and Cyrillic capitals added by Robert Slimbach. But in 'Trajan 3' the range of weights has also been extended to ludicrous extremes, from extra light to extra bold – distortions far removed from the spirit of classical Roman inscriptions. (See also page 120.)

299

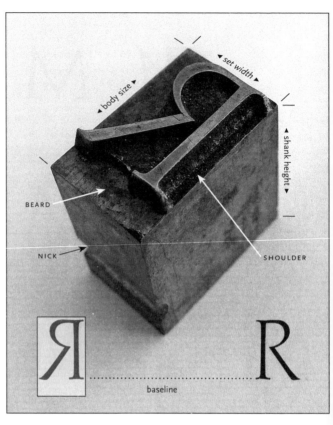

The Physical Reality of Type

To THINK ABOUT TYPE, you have to think backwards and forwards at once. This SORT, or piece of type, is resting on its FOOT. The FACE (which prints) and SHOULDERS (which are just beneath the face) are facing up. It has two SIDES, and the one that we can see here is the *left* side, facing lower right. The surface facing lower left is called the FRONT. The opposite surface, facing upper right and so invisible from here, is called the BACK. When the face of the type is viewed straight on and right side up (like the image in the lower left corner of this photo), the back is at the top, the front is at the bottom, the left side is on the right, and the foot is around the back. The feet of the letter itself point toward the *front*, not the foot, of the type. Across the lower front is the NICK, which allows the compositor to distinguish front from back by touch alone.

The distance from front to back of the sort is the BODY SIZE. The distance side to side is the SET WIDTH. The distance foot to shoulder is the SHANK HEIGHT. The small remaining vertical distance, from shoulder to face, is the DEPTH OF STRIKE. The total height from foot to face (the

shank height *plus* the depth of strike) is called the HEIGHT-TO-PAPER. All of these dimensions are physically incarnate in the type and fundamental to typography, yet none of them can be seen or measured directly in the letter that is printed from the type.

In a sense, the most basic dimension of all in typography is the TYPE SIZE – but that dimension also cannot be directly measured from the printed letter. Strangely enough, it can't always be found in the type metal either. Type size is confined by practicality, but it is a statement of an ideal in relation to a scale. It is the size of the body on which the type is theoretically meant to be cast, though the body on which it is actually cast may be larger or smaller than that.

The magnified sort on the facing page is a 60 pt Michelangelo R – fifty grams of recyclable metal, rich with art and information. It was cast at the Stempel foundry, Frankfurt. In the lower right corner of the photo is a letter printed from this sort, shown actual size. Michelangelo is a titling face – capitals only – designed in 1950 by Hermann Zapf.

This particular sort is part of a font cast for export to North America. The type size is 60 pt Didot – a little over 64 pt in Anglo-American measure – but it is cast on a 60 pt Anglo-American body (about 56 pt Didot). When Michelangelo in the 60 pt Didot size is cast for a European printer, only J and Q (the two descending letters) are normally cast on a 60 pt Didot body. The rest of the font is normally cast on 48 pt Didot (about 51½ pt Anglo-American). This leaves the type without a BEARD, but in titling faces, that can be an advantage. Domestic and export sorts are shown together below.

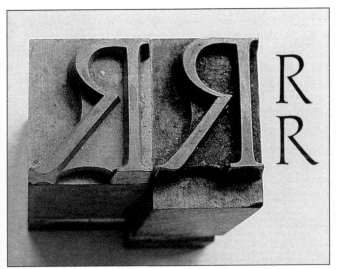

Height-to-paper is a standard that varies from country to country – but in any given region it is the same for all sizes of type. Depth of strike is typically less than 10% of height-to-paper.

Michelangelo has two forms of the letter R. Both are shown on this page – the narrower cast on an Anglo-American body, the wider on a continental body. Height-to-paper is also different in Western Europe than in the Anglo-American world. So these two sorts – same character, same type size, and same typeface – are physically different in every dimension: height, width and depth (which are, in typographic terms, *height-to-paper, set-width* and *body size*). Nowhere in either piece of type is there anything that corresponds exactly to the *type size*. (See pp 342–3 for details of Didot and Anglo-American measurement systems.)

APPENDIX A: THE WORKING ALPHABET

A census taken today will be inaccurate tomorrow, but in its travels through the world, the Latin alphabet has evolved to a working set of over 600 characters (counting caps and lower case), reinforced by about 500 more of its closest allies, Greek and Cyrillic. A few of the characters listed below are tied to a single language. Most are used by dozens or hundreds of languages. Three examples at most are given for each.

All italicized terms in this list also appear in appendix B, page 315.

Additional Latin Letters		Examples of usage
æ Æ	*aesc*	Faroese; Icelandic
ɓ ʙ	hooktop B	Fulfulde; Hausa; Kpelle
ð Ð	*eth; edh*	Faroese; Icelandic
đ Ð	*dyet*	Serbo-Croatian; Vietnamese
ɗ ᴅ	hooktop D	Fulfulde; Hausa
ɖ Ɖ	hooktail D	Ewe
ə Ǝ/ə	*schwa*	Azeri; Kanuri; Lushootseed
ɛ ɛ	African epsilon	Dinka; Ewe; Twi
ʄ ꜰ	hooktail F	Ewe
ɣ ɣ	African gamma	Ewe; Kpelle
ħ Ħ	*barred H*	Maltese
ı	*dotless i*	Azeri; Turkish
ɨ Ɨ	barred i	Micmac; Mixtec; Sahaptin
ƙ ᴋ	hooktop ᴋ́	Hausa
ĸ Kʻ	kra	Old Greenlandic
ł ł	*barred L*	Heiltsuk; Navajo; Polish
ɫ ɫ	double-barred L	Kutenai
λ	blam (barred lambda)	Lillooet; Nuxalk; Okanagan
ŋ Ŋ	*eng*	Ewe; Northern Saami; Wolof
ø Ø	*slashed o*	Danish; Faroese; Norwegian
ơ Ơ	*horned o*	Vietnamese
ɔ ɔ	open o	Atsina; Ewe; Twi
œ Œ	*ethel*	French; archaic English
ſ	*long s*	Irish; archaic pan-European
ß	*eszett*	German; recent English
þ Þ	*thorn*	Anglo-Saxon; Icelandic
ŧ Ŧ	*barred T; tedh*	Havasupai; Northern Saami
ư Ư	*horned U*	Vietnamese

v V	curly v	Ewe	
þ	*wynn*	early English	
ɣ Y	hooktop ɣ	Fulfulde	
ȝ	*yogh*	Anglo-Saxon; early English	
ȝ Ʒ	*ezh*	Skolt	

Inflected Latin Letters	Examples of usage	*The Working Alphabet*
á Á a-*acute*	Czech; Icelandic; Spanish	
à À a-*grave*	Dogrib; French; Italian	
ȁ Ȁ a-*double grave*	Serbo-Croatian poetics	
â Â a-*circumflex*	Cree; French; Welsh	
ǎ Ǎ a-*caron* / a-wedge	romanized Mandarin	
ä Ä a-*umlaut*	Estonian; Finnish; German	
å Å a-*ring* / round a	Arikara; Cheyenne; Swedish	
ā Ā a-*macron* / long a	Cornish; Latvian; Maori	
ă Ă a-*breve* / short a	Latin; Romanian; Vietnamese	
ȃ Ȃ a-*arch*	Serbo-Croatian poetics	
ã Ã a-*tilde*	Portuguese; Vietnamese	
ả Ả a-*hoi*	Vietnamese	
ấ Ấ a-*circumflex-acute*	Vietnamese	
ầ Ầ a-*circumflex-grave*	Vietnamese	
ẫ Ẫ a-*circumflex-tilde*	Vietnamese	
ẩ Ẩ a-*circumflex-hoi*	Vietnamese	
ậ Ậ a-*circumflex-underdot*	Vietnamese	
ắ Ắ a-*breve-acute*	Vietnamese	
ằ Ằ a-*breve-grave*	Vietnamese	
ẵ Ẵ a-*breve-tilde*	Vietnamese	
ẳ Ẳ a-*breve-hoi*	Vietnamese	
ặ Ặ a-*breve-underdot*	Vietnamese	
ǟ Ǟ a-*umlaut-acute*	Tutchone	
ä̀ Ä̀ a-*umlaut-grave*	Tutchone	
ǟ Ǟ a-*umlaut-macron*	Tutchone	
ạ Ạ a-*underdot* / a-*nang*	Twi; Vietnamese	
a̱ A̱ a-*underscore*	Kwakwala; Tsimshian	
á̱ Á̱ a-*acute-underscore*	Kwakwala	
ą Ą a-*ogonek* / tailed a	Polish; Lithuanian; Navajo	
ą́ Ą́ a-*acute-ogonek*	Navajo; Western Apache	
ą̀ Ą̀ a-*grave-ogonek*	Dogrib; Gwichin; Sekani	
ǽ Ǽ *aesc-acute*	Old Icelandic; linguistics	
ǣ Ǣ *aesc-macron* / long aesc	Anglo-Saxon; Old Norse	

ḃ	Ḃ	b-*overdot* / dotted b	Old Gaelic
ć	Ć	c-*acute*	Polish; Serbo-Croatian
ĉ	Ĉ	c-*circumflex*	Esperanto
č	Č	c-*caron* / c-wedge / cha	Czech; Latvian; Lithuanian
ċ	Ċ	c-*overdot* / dotted c	Maltese; Old Gaelic
c̓	C̓	*glottal* c	Kalispel; Kiowa; Nuxalk
č̓	Č̓	*glottal* cha	Comox; Kalispel; Lillooet
ç	Ç	c-*cedilla* / soft c	Albanian; French; Turkish
ḋ	Ḋ	d-*overdot* / dotted d	Old Gaelic
ď	Ď	d-*palatal hook* / d-háček	Czech; Slovak
ā	Ā	d-*macron*	Old Basque
ḍ	Ḍ	d-*underdot*	Twi; romanized Arabic
ḓ	Ḓ	d-*undercomma*	Livonian
é	É	e-*acute*	Czech; French; Hungarian
è	È	e-*grave*	Catalan; French; Italian
ȅ	Ȅ	e-*double grave*	Serbo-Croatian poetics
ê	Ê	e-*circumflex*	French; Portuguese; Welsh
ě	Ě	e-*caron* / e-wedge	Czech; romanized Mandarin
ė	Ė	e-*overdot* / dotted e	Lithuanian
ë	Ë	e-*diaeresis* / e-trema	Albanian; Dutch; French
e̊	E̊	e-*ring*	Arikara; Cheyenne
ē	Ē	e-*macron* / long e	Cornish; Maori
ĕ	Ĕ	e-*breve* / short e	Latin
ê	Ê	e-*arch*	Serbo-Croatian poetics
ẽ	Ẽ	e-*tilde*	Vietnamese
ẻ	Ẻ	e-*hoi*	Vietnamese
ế	Ế	e-*circumflex-acute*	Vietnamese
ề	Ề	e-*circumflex-grave*	Vietnamese
ễ	Ễ	e-*circumflex-tilde*	romanized Mandarin
ě̂	Ě̂	e-*circumflex-caron*	romanized Mandarin
ê̄	Ê̄	e-*circumflex-macron*	Vietnamese
ể	Ể	e-*circumflex-hoi*	Vietnamese
ệ	Ệ	e-*circumflex-underdot*	Vietnamese
ẹ	Ẹ	e-*underdot* / e-*nang*	Twi; Vietnamese
ę	Ę	e-*ogonek* / tailed e	Polish; Lithuanian; Navajo
ę́	Ę́	e-*acute-ogonek*	Navajo; Western Apache
ę̀	Ę̀	e-*grave-ogonek*	Dogrib; Gwichin; Sekani
ə́		*schwa-acute*	Comox; Lushootseed; Sechelt

Inflected
Latin
Letters

ɛ̈ Ɛ̈	African epsilon *umlaut*	Dinka
ɛ̃ Ɛ̃	African epsilon *tilde*	Kpelle; Twi
ḟ Ḟ	f-*overdot* / dotted f	Old Gaelic
ǵ Ǵ	g-*acute*	romanized Macedonian
ĝ Ĝ	g-*circumflex*	Aleut; Esperanto
ǧ Ǧ	g-*caron*	Heiltsuk; Kwakwala; Skolt
ġ Ġ	g-*overdot* / dotted g	Iñupiaq; Kiksht; Maltese
ğ Ğ	g-*breve*	Azeri; Tatar; Turkish
g̓ G̓	*glottal* g	American linguistics
g̲ G̲	g-*underscore*	Tlingit
ģ Ģ	g-*(turned) undercomma*	Latvian; Livonian
ĥ Ĥ	h-*circumflex*	Esperanto
ḣ Ḣ	h-*overdot*	Lakhota (archaic)
ḥ Ḥ	h-*underdot*	romanized Arabic & Hebrew
í Í	i-*acute*	Icelandic; Gaelic; Spanish
ì Ì	i-*grave*	Dogrib; Italian; Sekani
ȉ Ȉ	i-*double grave*	Serbo-Croatian poetics
î Î	i-*circumflex*	French; Romanian; Welsh
ǐ Ǐ	i-*caron* / i-wedge	romanized Mandarin
İ	*dotted I*	Azeri; Tatar; Turkish
ï Ï	i-*diaeresis*	French
i̊ I̊	i-*ring*	Arikara; Cheyenne
ī Ī	i-*macron* / long i	Cornish; Latvian; Maori
ĭ Ĭ	i-*breve* / short i	Latin; Vietnamese
î Î	i-*arch*	Serbo-Croatian poetics
ĩ Ĩ	i-*tilde*	Guaraní; Kikuyu; Vietnamese
ỉ Ỉ	i-*hoi*	Vietnamese
ị Ị	i-*underdot* / i-*nang*	Igbo; Vietnamese
į Į	i-*ogonek* / tailed i	Chiricahua; Lithanian; Navajo
į́ Į́	i-*acute-ogonek*	Chiricahua; Mescalero; Navajo
į̀ Į̀	i-*grave-ogonek*	Dogrib; Gwichin; Sekani
ĵ Ĵ	j-*circumflex*	Esperanto
ǰ J̌	j-*caron* / j-wedge	American linguistics
ḱ Ḱ	k-*acute*	romanized Macedonian
k̓ K̓	*glottal* k	Comox; Kiowa; Osage
ǩ Ǩ	k-*caron*	Skolt

| ķ Ķ | k-*undercomma* | Latvian; Livonian |
| ḵ Ḵ | k-*underscore* | Sahaptin; Tlingit |

í Ĺ	l-*acute*	Slovak
ľ Ľ/Ľ	l-*palatal hook*	Slovak
ḷ Ľ	*glottal* l	Heiltsuk; Nisgha; Tsimshian
ḷ Ḷ	l-*underdot* / syllabic l	romanized Sanskrit
ļ Ļ	l-*cedilla* / soft l	Latvian; Livonian
ļ Ļ	l-*undercomma*	[alternative to l-cedilla]
ḻ Ḻ	l-*underscore*	romanized Malayalam
ḹ Ḹ	l-*underdot-macron*	romanized Sanskrit

<table>
<tr><td>ɫ Ɫ</td><td>*barred l-underdot*</td><td>Iñupiaq</td></tr>
<tr><td>ƛ Ƛ</td><td>*glottal* blam</td><td>Kalispel; Lillooet; Nuxalk</td></tr>
</table>

m̓ M̓	*glottal* m	Kwakwala; Nisgha; Tsimshian
ṁ Ṁ	m-*overdot* / dotted m	Gaelic; romanized Sanskrit
ṃ Ṃ	m-*underdot*	romanized Sanskrit

ń Ń	n-*acute*	Chiricahua; Navajo; Polish
ǹ Ǹ	n-*grave*	romanized Mandarin
n̓ N̓	*glottal* n	Kwakwala; Nisgha; Tsimshian
ṅ Ṅ	n-*overdot* / dotted n	romanized Sanskrit
n̊ N̊	n-*ring*	Arikara
ň Ň	n-*caron* / n-wedge	Czech; romanized Mandarin
ñ Ñ	n-*tilde*	Basque; Catalan; Spanish
ņ Ņ	n-*cedilla* / soft n	Latvian
ņ Ņ	n-*undercomma*	Latvian
ṇ Ṇ	n-*underdot*	Twi; romanized Sanskrit
ṉ Ṉ	n-*underscore*	romanized Malayalam

ó Ó	o-*acute*	Gaelic; Navajo; Spanish
ő Ő	o-*double-acute*	Hungarian
ò Ò	o-*grave*	Catalan; Dogrib; Italian
ȍ Ȍ	o-*double grave*	Serbo-Croatian poetics
ô Ô	o-*circumflex*	French; Portuguese; Welsh
ǒ Ǒ	o-*caron* / o-wedge	romanized Mandarin
ȯ Ȯ	o-*overdot* / dotted o	Livonian
ö Ö	o-*umlaut*	Hopi; German; Turkish
o̊ O̊	o-*ring*	Arikara; Cheyenne
ō Ō	o-*macron* / long o	Cornish; Maori
ŏ Ŏ	o-*breve* / short o	Latin; romanized Korean

Inflected Latin Letters

ȏ Ȏ	o-*arch*	Serbo-Croatian poetics
õ Õ	o-*tilde*	Estonian; Portuguese
ỏ Ỏ	o-*hoi*	Vietnamese
ȱ Ȱ	o-*overdot-macron*	Livonian
ȫ Ȫ	o-*umlaut-macron*	Livonian
ȭ Ȭ	o-*tilde-macron*	Livonian
ố Ố	o-*circumflex-acute*	Vietnamese
ồ Ồ	o-*circumflex-grave*	Vietnamese
ỗ Ỗ	o-*circumflex-tilde*	Vietnamese
ổ Ổ	o-*circumflex-hoi*	Vietnamese
ộ Ộ	o-*circumflex-underdot*	Vietnamese
ọ Ọ	o-*underdot* / o-nang	Igbo; Vietnamese; Yoruba
ǫ Ǫ	o-*ogonek* / tailed o	Navajo; Seneca; Old Icelandic
ǫ́ Ǫ́	o-*acute-ogonek*	Navajo; Slavey; Old Icelandic
ǫ̀ Ǫ̀	o-*grave-ogonek*	Dogrib; Gwichin; Sekani
ǿ Ǿ	*slashed o-acute*	Old Icelandic; linguistics
ớ Ớ	*horned o acute*	Vietnamese
ờ Ờ	*horned o grave*	Vietnamese
ỡ Ỡ	*horned o tilde*	Vietnamese
ở Ở	*horned o hoi*	Vietnamese
ợ Ợ	*horned o underdot*	Vietnamese
ɔ́ Ɔ́	open o *acute*	Adangme
ɔ̈ Ɔ̈	open o *umlaut*	Dinka
ɔ̃ Ɔ̃	open o *tilde*	Kpelle; Twi
ɔ̨ Ɔ̨	open o *ogonek*	Kiowa; American linguistics
p̓ P̓	*glottal* p	Kiowa; Kwakwala; Osage
ṗ Ṗ	p-*overdot* / dotted p	Old Gaelic
q̓ Q̓	*glottal* q	Kwakwala; Nuxalk; Tsimshian
ŕ Ŕ	r-*acute*	Slovak; Sorbian; Old Basque
r̊ R̊	r-*ring*	Arikara
ř Ř	r-*caron* / r-wedge	Alutiiq; Czech; Sorbian
ṛ Ṛ	r-*underdot* / syllabic r	romanized Sanskrit
ŗ Ŗ	r-*cedilla* / soft r	Latvian
r̦ R̦	r-*undercomma*	Livonian; Old Latvian
r̲ R̲	r-*underscore*	romanized Malayalam
ṝ Ṝ	r-*underdot-macron*	romanized Sanskrit

	ś Ś	s-*acute* / sharp s	Polish; romanized Sanskrit
	s̓ S̓	*glottal* s	American linguistics
	š Š	s-*caron* / s-wedge	Czech; Omaha; Latvian
	ṡ Ṡ	s-*overdot* / dotted s	Old Gaelic
	ẛ	dotted *long s*	Old Gaelic
	š̓ Š̓	*glottal* s-*caron*	Lakhota; Omaha
Inflected	ṣ Ṣ	s-*underdot*	Yoruba; romanized Arabic
Latin	s̲ S̲	s-*underscore*	Tlingit
Letters	ş Ş	s-*cedilla*	Turkish
	ș Ș	s-*undercomma*	Romanian
	ṫ Ṫ	t-*overdot* / dotted t	Old Gaelic
	ť Ť	t-*palatal hook* / t-háček	Czech; Slovak
	t̓ T̓	*glottal* t	Kiowa; Tsimshian
	t̄ T̄	t-*macron*	Lakhota; Old Basque
	ṭ Ṭ	t-*underdot*	romanized Arabic & Hebrew
	ț Ț	t-*undercomma*	Livonian; Romanian
	ú Ú	u-*acute*	Icelandic; Navajo; Spanish
	ű Ű	u-*double-acute*	Hungarian
	ù Ù	u-*grave*	Dogrib; Italian; Sekani
	ȕ Ȕ	u-*double grave*	Serbo-Croatian poetics
	û Û	u-*circumflex*	French; Welsh
	ǔ Ǔ	u-*caron* / u-wedge	romanized Mandarin
	ü Ü	u-*umlaut*	Estonian; German; Turkish
	ů Ů	u-*ring* / u-kroužek	Arikara; Cheyenne; Czech
	ū Ū	u-*macron* / long u	Cornish; Lithuanian; Maori
	ŭ Ŭ	u-*breve* / short u	Latin; romanized Korean
	ȗ Ȗ	u-*arch*	Serbo-Croatian poetics
	ũ Ũ	u-*tilde*	Kikuyu; Vietnamese
	ủ Ủ	u-*hoi*	Vietnamese
	ǘ Ǘ	u-*umlaut-acute*	romanized Mandarin
	ǜ Ǜ	u-*umlaut-grave*	romanized Mandarin
	ǖ Ǖ	u-*umlaut-macron*	romanized Mandarin
	ǚ Ǚ	u-*umlaut-caron*	romanized Mandarin
	ụ Ụ	u-*underdot* / u-nang	Igbo; Vietnamese
	ų Ų	u-*ogonek* / tailed u	Lithuanian; Mescalero; Navajo
	ų́ Ų́	u-*acute-ogonek*	Mescalero; Navajo
	ų̀ Ų̀	u-*grave-ogonek*	Gwichin; Sekani; Tagish
	ứ Ứ	*horned u acute*	Vietnamese
	ừ Ừ	*horned u grave*	Vietnamese

ư Ữ *horned u tilde* Vietnamese
ử Ử *horned u hoi* Vietnamese
ự Ự *horned u underdot* Vietnamese

ẃ Ẃ w-*acute* Welsh
ẁ Ẁ w-*grave* Welsh
ẉ Ẉ *glottal* w Heiltsuk; Klamath; Tsimshian *The*
ŵ Ŵ w-*circumflex* Chichewa; Welsh *Working*
ẅ Ẅ w-*diaeresis* Tsimshian; Welsh *Alphabet*
ẘ W̊ w-*ring* Arikara
w̆ W̆ w-*breve* Gã; Twi

x̂ X̂ x-*circumflex* Aleut
x̓ X̓ *glottal* x Chiwere; Tsimshian
x̣̓ X̣̓ *glottal* x *underdot* Tsimshian
x̌ X̌ x-*caron* / x-wedge Heiltsuk; Kwakwala
x̣ X̣ x-*underdot* Nuxalk; Okanagan
x̱ X̱ x-*underscore* Sahaptin; Tlingit

ý Ý y-*acute* Faroese; Icelandic; Slovak
ỳ Ỳ y-*grave* Welsh
y̓ Y̓ *glottal* y Heiltsuk; Klamath; Tsimshian
ŷ Ŷ y-*circumflex* Welsh
ÿ Ÿ y-*diaeresis* / y-umlaut French
ȳ Ȳ y-*macron* Cornish; Livonian
ÿ̓ Ÿ̓ *glottal* y-*umlaut* Tsimshian
ỹ Ỹ y-*tilde* Guaraní; Twi; Vietnamese
ỷ Ỷ y-*hoi* Vietnamese
ỵ Ỵ y-*underdot* / y-nang Vietnamese

ź Ź z-*acute* / sharp z Polish; Sorbian
z̓ Z̓ *glottal* z Lillooet
ž Ž z-*caron* / z-wedge / zhet Czech; Latvian; Lithuanian
ż Ż z-*overdot* / dotted z Maltese; Polish
ẓ Ẓ z-*underdot* romanized Arabic

ǯ Ǯ *ezh-caron* / edzh Klamath; Skolt

Basic Greek

Basic and Inflected Greek Letters

α	A	alpha / 1
β	B	beta / 2
γ	Γ	gamma / 3
δ	Δ	delta / 4
ε	E	epsilon / 5
ζ	Z	zeta / 7
η	H	eta / 8
θ	Θ	theta / 9
ι	I	iota / 10
κ	K	kappa / 20
λ	Λ	lambda / 30
μ	M	mu / 40
ν	N	nu / 50
ξ	Ξ	xi / 60
ο	O	omicron / 70
π	Π	pi / 80
ρ	P	rho / 100
σ	Σ	sigma / 200
ς		terminal sigma
τ	T	tau / 300
υ	Υ	upsilon / 400
φ	Φ	phi / 500
χ	X	khi / 600
ψ	Ψ	psi / 700
ω	Ω	omega / 800

Numerals have long been written with letters in Greek, and every basic letter has its own numeric value. For the numerals 6, 90 and 900, archaic letters (shown on the facing page) are used. A letter or sequence of letters representing a number is marked with a horn. λς′ = 36; ͵γρδ = 3,104.

Ideally, Unicode recognizes only *characters*, not *glyphs*. With Greek, this rule is often broken. The reason given is the wide use of certain Greek glyphs as scientific symbols. The glyph called *omega pi* (ϖ or ϖ) is an alternate form of *pi* (π), not of *omega* (ω).

Alternate and Symbolic Greek

β	curly beta
ϵ	lunate epsilon
ϑ	script theta
Θ	symbol Theta
ϰ	script kappa
ϖ	omega pi
ϱ	curly rho
ϲ	lunate sigma
ϒ	hooked Upsilon
ϕ	alternate phi

Monotonic Greek

ά	alpha tonos
έ	epsilon tonos
ή	eta tonos
ί	iota tonos
ϊ Ϊ	iota dialytika
ΐ	iota dialytika tonos
ό	omicron tonos
ύ	upsilon tonos
ϋ Ϋ	upsilon dialytika
ΰ	upsilon dialytika tonos
ώ	omega tonos

Polytonic Greek

ά		alpha oxia
ὰ		alpha varia
ᾶ		alpha perispomeni
ἀ	Ἀ	α psili
ἄ	Ἄ	α psili oxia
ἂ	Ἂ	α psili varia
ἆ	Ἆ	α psili perispomeni
ἁ	Ἁ	α dasia
ἅ	Ἅ	α dasia oxia
ἃ	Ἃ	α dasia varia
ἇ	Ἇ	α dasia perispomeni
ᾳ	ᾼ	α ypogegrammeni
ᾴ		α oxia
ᾲ		α varia
ᾷ		α perispomeni
ᾀ	ᾈ	α psili
ᾄ	ᾌ	α psili oxia
ᾂ	ᾊ	α psili varia
ᾆ	ᾎ	α psili perispomeni
ᾁ	ᾉ	α dasia
ᾅ	ᾍ	α dasia oxia
ᾃ	ᾋ	α dasia varia
ᾇ	ᾏ	α dasia perispomeni
έ		epsilon oxia
ὲ		epsilon varia
ἐ	Ἐ	ε psili
ἔ	Ἔ	ε psili oxia
ἒ	Ἒ	ε psili varia
ἑ	Ἑ	ε dasia
ἕ	Ἕ	ε dasia oxia
ἓ	Ἓ	ε dasia varia
ή		eta oxia
ὴ		eta varia
ῆ		eta perispomeni
ἠ	Ἠ	η psili
ἤ	Ἤ	η psili oxia
ἢ	Ἢ	η psili varia
ἦ	Ἦ	η psili perispomeni
ἡ	Ἡ	η dasia
ἥ	Ἥ	η dasia oxia
ἣ	Ἣ	η dasia varia
ἧ	Ἧ	η dasia perispomeni
ῃ	ῌ	η ypogegrammeni
ᾔ		η oxia
ᾒ		η varia
ᾖ		η perispomeni
ᾐ	ᾘ	η psili
ᾔ	ᾜ	η psili oxia
ᾒ	ᾚ	η psili varia
ᾖ	ᾞ	η psili perispomeni
ᾑ	ᾙ	η dasia
ᾕ	ᾝ	η dasia oxia

ἦ ῍Η η dasia varia
ἧ ῏Η η dasia perispomeni

ί iota oxia
ὶ iota varia
ῑ iota perispomeni
ἰ Ἰ ι psili
ἴ Ἴ ι psili oxia
ἲ Ἲ ι psili varia
ἶ Ἶ ι psili perispomeni
ἱ Ἱ ι dasia
ἵ Ἵ ι dasia oxia
ἳ Ἳ ι dasia varia
ἷ Ἷ ι dasia perispomeni
ϊ Ϊ ι dialytika
ΐ ï oxia
ῒ ï varia
ῗ ï perispomeni

ό omicron oxia
ὸ omicron varia
ὀ Ὀ o psili
ὄ Ὄ o psili oxia
ὂ Ὂ o psili varia
ὁ Ὁ o dasia
ὅ Ὅ o dasia oxia
ὃ Ὃ o dasia varia

ῥ rho psili
ῥ rho dasia

ύ upsilon oxia
ὺ upsilon varia
ῦ upsilon perispomeni
ὐ Ὑ υ psili
ὔ Ὕ υ psili oxia
ὒ Ὓ υ psili varia

ὖ ῟Υ υ psili perispomeni
ὑ Ὑ υ dasia
ὕ Ὕ υ dasia oxia
ὓ Ὓ υ dasia varia
ὗ ῟Υ υ dasia perispomeni
ϋ Ϋ υ dialytika
ῧ ü oxia
ῢ ü varia
ῧ ü perispomeni

ώ omega oxia
ὼ omega varia
ῶ omega perispomeni
ὠ Ὠ ω psili
ὤ Ὤ ω psili oxia
ὢ Ὢ ω psili varia
ὦ Ὦ ω psili perispomeni
ὡ Ὡ ω dasia
ὥ Ὥ ω dasia oxia
ὣ Ὣ ω dasia varia
ὧ Ὧ ω dasia perispomeni

ῳ Ὠ omega ypogegrammeni
ῴ ῳ oxia
ῲ ῳ varia
ῷ ῳ perispomeni
ᾠ ῼ ῳ psili
ᾤ ῼ ῳ psili oxia
ᾢ ῼ ῳ psili varia
ᾦ ῼ ῳ psili perispomeni
ᾡ ῼ ῳ dasia
ᾥ ῼ ῳ dasia oxia
ᾣ ῼ ῳ dasia varia
ᾧ ῼ ῳ dasia perispomeni

Archaic and Numeric Greek

ϝ digamma / old 6
ς stigma / new 6
ϟ qoppa / 90
ϙ old qoppa
ϡ sampi / 900
α′ right horn (for numerals 1–999)
‚α left horn (for numerals 1000 and up)
Ϻ san

Prosodic Greek

ᾱ Ᾱ alpha macron
ᾰ Ᾰ alpha vrachy
ῑ Ῑ iota macron
ῐ Ῐ iota vrachy
ῡ Ῡ upsilon macron
ῠ Ῠ upsilon vrachy

Analphabetic Greek

· anoteleia (Greek semicolon)
; erotematikon (Greek question mark)
ϗ kai (Greek ampersand)

Eight diacritics are customarily used in classical Greek:

ὀξεῖα (*oxeia*) = acute

βαρεῖα (*bareia*) = grave

περισπωμένη (*perispōmenē*) = the Greek circumflex (usually shaped like an arch or a tilde)

ψιλή (*psilē*) = smooth

δασεῖα (*daseia*) = rough

ὑπογεγραμμένη (*hypogegrammenē*) = iota subscript

διαλυτικά (*dialytika*) = diaeresis

κορωνίς (*korōnis*) = crasis

To Unicode, these diacritics are known by modernized forms of their old Greek names: *oxia, varia, perispomeni, psili, dasia, ypogegrammeni, dialytika.* The Greek *breve* (for marking short vowels) is known to Unicode as *vrachy* (from Greek βραχύ).

Basic and
Inflected
Cyrillic
Letters

To people raised on the Latin alphabet, it can come as a surprise that the cursive form of Cyrillic т is *m*, the cursive form of д is *∂* or *g*, and the cursive form of ѣ is *ҍ*. Typical lowercase cursive forms are therefore shown for all Cyrillic letters in this list.

The invariant Cyrillic letter I, often romanized as *h*, is an independent letter of the alphabet in some Caucasian languages. More often, it is used in digraphs and trigraphs, e.g., Abaza ЧІ and ЧІв (which are чІ and чІв in lower case).

Russian Cyrillic	
а А *а*	= a
б Б *б/δ*	= b
в В *в*	= v
г Г *г/ī*	= g
д Д *∂/g*	= d
е Е *е*	= e/ie
ж Ж *ж*	= ž
з З *з*	= z
и И *и*	= i
й Й *й*	= j/ĭ
к К *к*	= k
л Л *л*	= l
м М *м*	= m
н Н *н*	= n
о О *о*	= o
п П *п/ū*	= p
р Р *р*	= r
с С *с*	= s
т Т *m/ū*	= t
у У *у*	= u
ф Ф *ф*	= f
х Х *х*	= x/kh
ц Ц *ц*	= c/ts
ч Ч *ч*	= č/ch
ш Ш *ш*	= š/sh
щ Щ *щ*	= shch
ъ Ъ *ъ*	= 'hard'
ы Ы *ы*	= y
ь Ь *ь*	= 'soft'
э Э *э*	= è
ю Ю *ю*	= yu/iu
я Я *я*	= ya/ia

Other Cyrillic		
ă Ă *ă*	= ă	Chuvash
ä Ä *ä*	= ä	Mari, &c
æ Æ *æ*	= æ	Ossetian
å Å *å*	= å	Serbo-Croatian
ғ Ґ *ғ*	= g	Ukrainian
ѓ Ѓ *ѓ*	= ǵ/gj	Macedonian, &c
ғ Ғ *ғ*	= ğ/gh	Bashkir; Kazakh, &c
Ҕ Ҕ *ҕ*	= ğ/gh	Abkhaz; Yakut, &c
ё Ё *ё*	= yo	Bashkir; Tajik, &c
ĕ Ĕ *ĕ*	= ĕ	Chuvash
ә Ә *ә*	= ə/ä	Bashkir; Tatar, &c
ӛ Ӛ *ӛ*	= ë	Khanty
ђ Ђ *ђ*	= đ/džy	Serbo-Croatian
ѕ Ѕ *ѕ*	= ż/dz	Macedonian
ћ Ћ *ћ*	= ć/chy	Serbo-Croatian
ё Ё *ё*	= ё	Serbo-Croatian
ѐ Ѐ *ѐ*	= è	Macedonian
є Є *є*	= ye/ě	Ukrainian
җ Җ *җ*	= dž	Moldovan
ӝ Ӝ *ӝ*	= dž	Udmurt
ж Җ *җ*	= ż/ǰ	Kalmyk; Tatar, &c
ӟ Ӟ *ӟ*	= dź	Udmurt
ҙ Ҙ *ҙ*	= ð/ź	Bashkir
ӡ Ӡ *ӡ*	= ǰ/dz	Abkhaz
ѝ Ѝ *ѝ*	= ì	Macedonian
ӣ Ӣ *ӣ*	= ī	Tajik
ӥ Ӥ *ӥ*	= ï	Udmurt
й Й *й*	= ï	Serbo-Croatian
і І *і*	= î	Khakass
і І *і*	= i	Belarusian, &c
І І *І*	= h	Abaza; Ingush, &c
ї Ї *ї*	= ï/yi	Ukrainian
ј Ј *ј*	= j/y	Macedonian, &c
ќ Ќ *ќ*	= kj	Macedonian, &c
қ Қ *қ*	= k	Kazakh; Tajik, &c
k̄ K̄ *k̄*	= q'	Abhkaz
к К *к*	= g	Azeri
ҡ Ҡ *ҡ*	= q	Chukchi, &c
ҡ Ҡ *ҡ*	= q	Bashkir
љ Љ *љ*	= lj	Macedonian, &c

312

њ Њ *њ* = nj	Macedonian, &c	
ҥ Ҥ *ҥ* = ŋ/ng	Bashkir; Tuvan, &c	
њ Њ *њ* = nj/ñ	Khanty; Koryak, &c	
ҥ Ҥ *ҥ* = ngh	Altay; Yakut, &c	
ӧ Ӧ *ӧ* = ö	Altay; Shor, &c	
ȍ Ȍ *ȍ* = ȍ	Serbo-Croatian	
ҩ Ҩ *ҩ* = ò	Abhkaz	
ҧ Ҧ *ҧ* = p'	Abkhaz	
p̏ P̏ *p̏* = ȑ	Serbo-Croatian	
ҫ Ҫ *ҫ* = ş	Bashkir; Chuvash	
т̡ Т̡ *т̡* = ţ/t	Abkhaz	
ҵ Ҵ *ҵ* = ts'	Abkhaz	
ў Ў *ў* = ŭ/w	Belarusian; Uzbek	
ӯ Ӯ *ӯ* = ū	Tajik	
ӱ Ӱ *ӱ* = ü	Altay; Khanty, &c	
ӳ Ӳ *ӳ* = ű	Chuvash, &c	
ӱ̏ Ӱ̏ *ӱ̏* = ü̏	Serbo-Croatian	
ү Ү *ү* = ü/ū	Bashkir; Kazakh, &c	
ұ Ұ *ұ* = ʉ	Kazakh	
ө Ө *ө* = ō/ö	Tuvan; Yukaghir, &c	
ӫ Ӫ *ӫ* = ő	Khanty	
х̣ Х̣ *х̣* = h/ħ	Tajik; Uzbek, &c	
ҷ Ҷ *ҷ* = č̣	Abkhaz; Tajik	
ҷ Ҷ *ҷ* = č/ǰ	Shor	
ҷ Ҷ *ҷ* = dž/c	Azeri	
ӵ Ӵ *ӵ* = ċ	Udmurt	
ӹ Ӹ *ӹ* = ÿ	Mari	
ҽ Ҽ *ҽ* = tç	Abkhaz	
ҿ Ҿ *ҿ* = tç'	Abkhaz	
һ Һ *һ* = h	Bashkir; Buryat, &c	
џ Џ *џ* = dž	Macedonian, &c	
ԝ Ԝ *ԝ* = w	Yukaghir	

Old Cyrillic

ё Ë *ё*	yo	ѣ Ѣ *ѣ*	yat		
є Є *є*	yest	ѥ Ѥ *ѥ*	ye		
ѕ Ѕ *ѕ*	zelo	ѯ Ѯ *ѯ*	ksi		
і І *ï*	izhe	ѱ Ѱ *ѱ*	psi		
ћ Ђ *ћ*	derv	ѳ Ѳ *ѳ*	fita		
ѡ Ѡ *ѡ*	ot	ѵ Ѵ *ѵ*	izhitsa		

International Phonetics

VOWELS

a	ɐ	ɑ	ɒ	æ	ʌ
e	ə	ɘ	ɛ	ɜ	ɞ
i	ɨ	ɪ	ʏ		
o	ɵ	ø	œ	ɶ	ɔ
u	ʉ	ʊ	ɯ	y	ʏ

The Working Alphabet

CONSONANTS

b	ɓ	ʙ	β		
c	ç	ɕ			
d	ɗ	ɖ	ð		
f	ɸ				
g	ɠ	ɢ	ʛ	ɣ	
h	ħ	ɦ	ʜ		
j	ʝ	ɟ	ʄ		
k					
l	ɭ	ʎ	ʟ	ɬ	ɮ
m	ɱ				
n	ɲ	ŋ	ɳ	ɴ	
p					
q					
r	ɾ	ɽ	ɹ	ɻ	ɺ
	ʀ	ʁ			
s	ʂ	ʃ			
t	ʈ	θ			
v	ʋ				
w	ʍ	ɥ	ɰ		
x	χ	ɧ			
z	ʑ	ʐ	ʒ		
ʔ	ʡ	ʕ	ʢ		
ǃ	ʘ	ǀ	ǂ	ǁ	
[ɱ	ʛ̥	ɞ̫	ʍ̫	ʔ̃]	

This is only the skeleton of the IPA, which also admits the use of over fifty diacritics. For the names and functions of the symbols, see the *Handbook of the International Phonetic Association* (1999).

INFLECTIONS

↑	↓	↗	↘	
˥	˦	˧	˨	˩
ꜛ	ꜜ	˥	˧	˥
꞉	ˑ	ˈ	ˌ	.

313

*Visual
Index of
Analphabetic
Characters*

All glyphs
whose names
are italicized
in this list
are treated
individually
in appendix B.
The remainder
are treated in
three groups:
(1) arithmetical
signs; (2) cur-
rency signs;
(3) musical
signs.

Single Stroke

˙	*overdot*
·	*midpoint*
.	*period*
.	*underdot*
•	*bullet*
'	*apostrophe*
'	*inverted comma;*
	turned comma
,	*comma*
,	*undercomma*
´	*acute*
`	*grave*
'	*prime*
'	*dumb quote*
¯	*macron*
-	*hyphen*
-	subtraction
_	*lowline*
–	en *dash*
—	em *dash*
‾	*vinculum*
\|	*bar*
/	*solidus*
/	*virgule*
\	*backslash*
¬	*negation*
[]	*square brackets*
⟨ ⟩	*angle brackets*
√	*radical*
‹ ›	*guillemets*
>	greater than
<	less than
ˇ	*caron*
ˆ	*circumflex*
⌢	*arch*
˘	*breve*
∧	*dumb caret*
˛	*ogonek*
¸	*cedilla*
'	*hoi*

Single Stroke (continued)

ʔ	*glottal stop*
˜	*tilde*
~	*swung dash*
()	*parentheses*
{ }	*braces*
˚	*ring*
°	*degree*

Double Stroke

¨	*diaeresis/umlaut*
:	*colon*
;	*semicolon*
" "	*quotation*
„ "	*quotation*
¡ !	*exclamation*
¿ ?	*question*
"	*double prime*
˝	*double acute*
‶	*double grave*
"	*dumb quote*
=	equal
¦	*pipe*
‖	*double bar*
+	addition
×	*dimension*
« »	*guillemets*
⟦ ⟧	*square brackets*
♮	natural
♭	flat

Multiple Stroke

…	*ellipsis*
÷	division
≠	*unequal*
±	plus-or-minus
#	*octothorp*
♯	sharp
¤	louse

Pictograms

*	*asterisk*
†	*dagger*
‡	*double dagger*
☞	*fist*
❧	*hedera*

Modified Letters

@	*at*
©	*copyright*
¢	cent
€	*euro*
& *&*	*ampersand*
ƒ	guilder
£	sterling
℗	*phonomark*
¶	*pilcrow*
®	*registered*
§	section
$	dollar
™	trademark
¥	yen
0	*null*
%	*per cent*
‰	*per mille*

There is, of course, no limit to the number of typographic characters. Still less is there a limit to the number of variant glyphs by which these characters are realized. This appendix lists characters included on standard ISO (Type 1, TrueType or OpenType) and pan-European (TrueType or OpenType) Latin text fonts. It also lists a few additional characters of long-standing typographic importance. Unicode numbers are given in square brackets at the end of each entry. Some characters (especially diacritics) have more than one address in Unicode. As a rule, only one of these addresses is given here. Two addresses are given for characters (such as *aesc*) that occur in both the upper and lower case.

acute An accent used on vowels – á é í ó ú ý ǽ – in Czech, French, Gaelic, Hungarian, Icelandic, Italian, Navajo, Spanish and other languages, and on consonants – ć ĺ ń ŕ ś ź – in Croatian, Polish, Slovak and romanized Sanskrit. In romanized Mandarin it is used with vowels – á é í ń ó ú ǘ – to mark the rising tone. It is also used with Cyrillic consonants – ŕ and ḱ – in Macedonian, and with all the vowels in Greek. Upper- and lowercase versions of the basic six acute vowels appear on standard ISO Latin text fonts. Pan-European fonts usually include both upper- and lowercase forms of the basic five acute consonants and the old Icelandic vowel *ǽ*. The acute schwa (ə́) and open o (ɔ́) and the Athapaskan high nasal vowels – ą́ ę́ į́ ǫ́ ų́ – are present only on specialized fonts. [U+0301]

aesc This ligature is a letter of the alphabet in Danish, Norwegian, Anglo-Saxon and Old Norse, corresponding in part to the Swedish *ä*. It is also sometimes used (unnecessarily) in Latin. In English, words of Greek origin were formerly spelled with æ corresponding to Greek αι (alpha iota). Thus *aesthetics* in older texts is *æsthetics*. Deliberate archaism and pedantically correct quotation still, therefore, require the ligature even in English. *Aesc* (*æsc* in the older spelling) is pronounced *ash*. [U+00C6, +00E6]

ampersand A scribal abbreviation for *and*, dating back to Roman times. It takes many forms – ℮ ⅋ & & &c – all derived from the Latin word *et*. [U+0026]

angle brackets These useful characters are missing from most text fonts, but they are found in many pi or symbol fonts and in some fonts of blackletter and Greek. They serve many functions in mathematical and scientific writing. In the editing of classical texts, angle brackets are used to mark editorial *additions* while *braces* mark the editor's *deletions*. See also *square brackets*. [U+2329, +232A]

apostrophe Also called *raised comma* or *single close-quote*. A mark of elision in English, French, Greek, Italian and many other languages. It grew from that use in English to become also a sign of the possessive. (*It's* = *it is*, but *John's* = *Johnes* = belonging to John.) A superimposed apostrophe (not to be confused with the *acute*) is the standard symbol in linguistics for a glottalized consonant: ṁ ṗ q̇ ẇ, etc. As a matter of convenience, these symbols are often converted to consonants *followed* by normal apostrophes: m' p' q', etc. Apostrophized consonants of this sort are frequent in typography. The apostrophized *d* and *t* (ď and ť, whose capital forms are Ď and Ť) are letters of the alphabet in Czech; so are ľ and Ľ in Slovak, while ch', k', ḵ', l', s', t', tl', ts', x', x̱' and their corresponding capitals (written with apostrophes, not carons) are letters of the alphabet in Tlingit and other Native American languages. Used alone, the apostrophe often serves as a sign for the glottal stop. In Unicode, these functions are carefully distinguished. See also *dumb quotes, glottal stop, palatal hook* and *quotation marks*. [U+02BC, +0313, +0315, +2019]

arch A diacritic used with vowels and one syllabic consonant – â ê î ô û r̂ (and the corresponding Cyrillic letters, а̂ е̂ ӥ о̂ ŷ р̂) – to mark the long falling tone in Serbo-Croatian. Though not employed in ordinary writing, these forms are used in teaching, in linguistics, and in some editions of metrical poetry. Few text fonts include either the arch or the composite glyphs in which it is used. Not to be confused with the circumflex, which is pointed. Also known as a *dome* or *inverted breve*. It has also been called a *cap*, which leads to confusion. [U+0311]

arithmetical signs Only eight basic signs, + − ± × ÷ < = >, are included in most text fonts. When other mathematical symbols, such as ≠ ≈ ∇ ≡ √ ≤ ≥, are required, it is generally best to take all signs, including the basic ones, from the same technical font so that all forms match in color and size. [U+002B, +2212, +00B1, +00D7, 00F7, 003C, 003D, 003E, &c.]

asterisk This is usually a superscript, used primarily for marking referents and keywords. In European typography, it is widely used to mark a person's year of birth (as the dagger, substituting for a cross, is used to mark the year of death). In philology, it marks hypothetically reconstructed or fetal forms. The asterisk takes many forms (* * * * * *, for example). It appears in the earliest Sumerian pictographic writing and has been in continuous use as a graphic symbol for at least 5,000 years. [U+002A]

at sign A commercial symbol meaning *at* or *at the rate of*. Electronic mail has given it new life, and it is now therefore occasionally well designed. Still, it has no role in normal text. [U+0340]

backslash This is an unsolicited gift of the computer keyboard. Basic though it may be to elementary computer operations, it has no accepted function in typography. [U+005C]

bar The vertical bar is used in mathematics as a sign of absolute value, in prosodical studies to mark a caesura, and in propositional calculus (where it is called the *Sheffer stroke*) as a sign of nonconjunction. In bibliographical work, both single and double bars are used. Also called *caesura*. [U+007C]

barred H A letter of the Maltese alphabet (and of the IPA), corresponding to Arabic ح (*ḥ*). Its Maltese name is *h maqtugha*, "cut h." It is found on most pan-European fonts. [U+0126, +0127]

barred L A basic letter of the alphabet in Chipewyan, Navajo, Polish, and many other languages, and essential for setting names such as Czesław Miłosz. Ł and ł are present on most Latin text fonts, but the glyphs almost always need editing: they need different sidebearings than plain *L* and *l*, and need to be written into the kerning table. Also known as *ew*. [U+0141, +0142]

barred T In Northern Saami, barred T signifies a sound like *th* in English *thing* [IPA θ]. In Havasupai, it signifies a dental *t* [IPA ṯ]. Ŧ and ŧ are present on most pan-European Latin text fonts, but with the wrong sidebearings, borrowed from plain *T* and *t*. Also known as *tedh*, by analogy with *edh* (ð). [U+0166, +0167]

braces Braces are rarely required in text work, but they can function perfectly well as an extra and outer (or inner) set of parentheses: { ([–]) }. In mathematics they are used to mark phrases

and sets. In editing classical papyri, braces are often used to mark editorial deletions. [U+007B, +007D]

brackets See *angle brackets* and *square brackets*.

breve An accent used on vowels and consonants – ă ĕ ĭ ğ ŏ ŭ – in Malay, Romanian, Turkish, Vietnamese, and in some forms of romanized Korean. In English, it is used in informal phonetic transcriptions to mark lax (or so-called 'short') vowels. In writings on metrics and prosody, it is the sign of a quantitatively short vowel or syllable. It is also used on the Russian *i* (й, whose cursive form is ŭ) and on a second vowel, ў, in Belarusian and Uzbek. The breve is always rounded, the *caron* always angular. (*Breve* is two syllables, with the stress on the first, as in *brave, eh?*) Also called *short* and (in Greek) *vrachy*. [U+0306]

bullet A fat midpoint, not always round, used as a typographic flag. Bullets are commonly hung in the margin to mark items in a list, or centered on the measure to separate larger blocks of text. See also *midpoint*. [U+2022, +25C9, +25E6, &c.]

caron An inverted circumflex. It is used on consonants and vowels – č ě ň ř š ž – in Croatian, Czech, Lithuanian, Northern Saami, Slovak, Slovene, Sorbian and other scripts. In romanized Thai, the caron indicates a rising tone. In romanized Chinese, it marks the retroflexive third tone (falling/rising tone) of standard Mandarin: ǎ ě ̌ ǐ ̌ ŏ ̌ ǔ ̌ . It is also used in new scripts for several Native American languages. For no good reason, most ISO fonts include a prefabricated upper- and lowercase š and ž, while other combinations must be built with the floating accent. Pan-European fonts contain a larger but still incomplete set of caroned letters, usually č ě ň ř š ž and Č Ď Ě Ň Ř Š Ť Ž. Also called a *wedge* or a *háček* (*hah-check*), which is its Czech name. In Czech, however, this character is actually a variant of the *palatal hook,* which can take the form of either caron or apostrophe. [U+030C]

cedilla A diacritic used with consonants, such as the ç in Catalan, French, Nahuatl and Portuguese, and ç and ş in Turkish. In Latvian and Romanian, the *undercomma* is widely preferred. Not to be confused with the *ogonek* or nasal hook, which curves the other way and is used with vowels. The name means *little z*. Turkish ş and Ş are missing from standard Type 1 fonts. [U+0327]

circumflex A diacritic used on vowels – â ê î ô û ŵ ŷ – in Cree, French, Portuguese, Romanian, Vietnamese, Welsh and many other languages. In transliterated texts (e.g., from Arabic and Hebrew), it is sometimes used as a poor substitute for the macron, to mark long vowels. In romanized Thai, a circumflex signifies a falling tone. Most Latin text fonts lack the circumflected Welsh vowels ŵ and ŷ. Widely nicknamed *hat*. [U+0302]

colon A grammatical marker inherited from the medieval European scribes. It is also used in mathematics to indicate ratios and in linguistics as a mark of prolongation. In classical rhetoric and prosody, a *colon* (plural, *cola*) is a long clause, and a *comma* is a short one. [U+003A]

comma A grammatical marker, descended from early scribal practice. In German, and often in East European languages, the comma is used as an open quote. Throughout Europe, it is also used as a decimal point, where most North Americans expect a period. In North American usage, the comma separates thousands, while a space is preferred in Europe. Thus 10,000,000 = 10 000 000, but a number such as 10,001 is typographically ambiguous. It could mean either ten and one one-thousandth or ten thousand and one. See also *quotation marks*. [U+002C]

copyright symbol On poorly designed fonts, the copyright symbol often appears as a superscript. Its rightful place in typography is always on the baseline: ©. [U+00A9]

curl Synonym for *hoi*.

currency symbols Most ISO fonts of recent vintage include six genuine currency signs – $ £ € ƒ ¥ ¢ – and one imaginary sign, ¤. The latter is the louse or sputnik, a ghost whose only function is to hold a place on the font to which a real currency symbol (afghani, baht, colón, rial, rupee, sheqel, etc) can be assigned.

 The dollar sign, a slashed S, is descended from a symbol for the shilling. The same sign has come to be used for currencies with many other names: sol, peso, etc. The sign of the pound sterling, a crossed cursive L, actually stands for the Latin *libra* (also the source of the abbreviation *lb*, used for the pound avoirdupois). This £ sign is now used not only for British currency but for the pound, lira or livre of many African and Middle Eastern states.

The success of the euro has made some older currency signs redundant, and several are still lurking on type fonts. One such is the sign for Dutch guilders: a squat *f* (*ƒ*) standing for *florin,* an old name for the currency. (That *ƒ* is now used only in Aruba and the Netherlands Antilles.) The cent sign (¢), another typographic heirloom, is irrelevant for most work. It remains in the character set chiefly out of nostalgia. [U+0024, +00A2, +00A3, +00A5, +0192, +20AA, +20AC, &c.]

dagger A reference mark, used primarily with footnotes. In European typography, it is also a sign of mortality, used to mark the year of death or the names of deceased persons, and in lexicography to mark obsolete forms. In editing classical texts, daggers are used to flag passages judged to be corrupt. Also called *obelisk, obelus* or *long cross.* [U+2020]

dashes Latin text fonts include, at minimum, an em dash, en dash and hyphen. A figure dash and three-quarter em dash are sometimes included as well, and a three-to-em dash more rarely. [U+2013, +2014, &c.]

degree sign Used in text to give temperatures, inclinations, latitudes, longitudes and compass bearings. Not to be confused with the *superior o* or *ordinal o* used in abbreviations, nor with the *ring,* a diacritic. [U+00B0]

diaeresis / umlaut A diacritic used with vowels – ä ë ï ö ü ẅ ÿ – in many languages, including Albanian, Dinka, Estonian, Finnish, German, Swedish, Turkish, Welsh, and less frequently also in English, Greek, Spanish, Portuguese and French. Linguists distinguish between the *umlaut,* which marks a *change* in pronunciation of a single vowel (as in the German *schön*) and the *diaeresis,* which marks the *separation* of adjacent vowel sounds (as in naïve and Noël). The typographic symbol is the same, but in English, Greek and the Romance languages, it usually represents a diaeresis, while in Germanic and Scandinavian languages, it usually represents an umlaut. Except for the Welsh ẅ and African ë and ɔ̈, the umlauted or diaeretic vowels are present on most Latin text fonts.

In French the diaeresis is called *tréma,* in Greek *dialytika.* In Hungarian there are two forms of umlaut: the familiar double dot, used for short vowels, and the *double acute* or *long umlaut,* used for long vowels (ű is the long form of ü).

The letter *ÿ* is a vowel sometimes used in archaic French and still required in the modern form of a few personal names and place names. Rightly or wrongly, it is also sometimes used as an alternate form of the *ij* ligature in Dutch. [U+0308]

diesis Synonym for (1) *double dagger,* (2) musical sharp.

dimension sign An unserifed x, usually square, also known as a multiplication sign. See *arithmetical signs*. [U+00D7]

2 × 2

dotless i and **dotted I** These are both letters of the alphabet in Turkish, where the lowercase form of I is ı and the uppercase form of i is İ. The dotless form signifies a back vowel (IPA ɯ), the dotted one a front vowel (IPA i, as in English *liter.* [U+0130, +0131]

ıIİi

dome Synonym for *arch.*

double acute A diacritic used on two Hungarian vowels: ő and ű. Also called *long umlaut*. The name 'Hungarian umlaut' should be avoided, since the short umlauted vowels ö and ü also appear in Hungarian (as in the place name Kiskőrös). Not to be confused with the double prime nor with the close quote. [U+030B]

Ő

double bar This is a standard symbol in bibliographical work and an old standard reference mark in European typography. It is missing from most text fonts but is easily made by kerning two single bars together. [U+2016]

‖

double dagger A reference mark for footnoting. Also called *diesis* or *double obelisk*. [U+2021]

‡

double grave A Serbo-Croatian diacritic used, like the arch, with five vowels and one syllabic consonant: ȁ ȅ ȉ ȍ ȕ ȑ (and in Cyrillic, ȁ ȅ ѝ ȍ ӳ р̏). This is a prosodic sign, to indicate the short falling tone. Though not employed in ordinary writing, the double grave is used in teaching, in linguistics, and in some editions of metrical poetry. It is rarely found on text fonts. [U+030F]

Ȍ

double prime An abbreviation for inches (1″ = 2.54 cm) and for seconds of arc (360″ = 1°). Not to be confused with quotation marks, the double acute, nor with dumb quotes. Prime and double prime are rarely found on text fonts. See also *prime*. [U+2033]

60″

dumb caret Also known, in vain, as the *ascii circumflex*. This is a stray, like the backslash and dumb quotes, ossified into the standard ASCII keyboard. The true circumflex (ˆ) is a different and genuine character. So is the *logical and* (∧, the sign of logical conjunction). Since it has no typographic function, the dumb caret also has no typographic form. It is a wasted slot on the keyboard, waiting for something else to take up residence. [U+005E]

dumb quotes These are refugees from the typewriter keyboard. Typesetting software interprets quotation-mark keystrokes in context, converting the dumb quotes to smart quotes (never infallibly). Yet the dumb quotes are still there, taking space on the font. They have no typographic function. See also *double prime, quotation marks* and *prime*. [U+0022, +0027]

dyet A basic letter in Vietnamese (where its sound is IPA d or ɗ) and in Serbo-Croatian (where it is a voiced palatal affricate, IPA d͡ʑ). The uppercase form of the letter is, as a rule, graphically the same as the uppercase *eth,* but it is notionally different. It therefore has a different Unicode address. [U+0110, +0111]

ellipsis The sign of elision and of rhetorical pause: three dots. [U+2026]

eng A letter of the alphabet in Northern Saami and in many African languages. Lowercase eng is also used in linguistics and lexicography to represent the *ng* sound in the word *wing*. (Note the different sounds represented by the same letters in the words *wing, Wingate, singlet* and *singe*: ŋ, n-g, ŋg, ndʒ.) The eng is found on pan-European and pan-African fonts. [U+014A, +014B]

eszett The *ss* ligature, *long s + short s* (ſ + s). It was once essential for setting English and is still essential for German. Not to be confused with the Greek beta, β. Also known as *sharp s*. Note that *not all instances* of *ss* in German turn to *ß,* and some instances of *ß* originate as *sz* instead of *ss.* [U+00DF]

eth A letter of the alphabet in Anglo-Saxon, Faroese, Icelandic, and in IPA. The uppercase eth is the same as the uppercase *dyet,* but the lowercase forms are not interchangeable, and the letters represent quite different sounds. (The name *eth,* also spelled *edh,* is pronounced like the *eth* in *whether.*) [U+00D0, +00F0]

ethel A ligature formerly used in English and still essential for setting French. English words and names derived from Greek were formerly spelled with the ethel (or *œthel*) corresponding to the Greek οι (omicron iota). Thus the old form of *ecumenical* is *œcumenical* (from οῖκος, Greek for 'house') and the Greek name Οἰδίπους (Oidípous), Latinized as Oedipus, was formerly written Œdipus. The ligature is required, therefore, for deliberate archaism and for academically correct quotation from older English sources, as well as for spelling French terms such as *hors d'œuvre*. In IPA, œ , Œ and ɜ are three different sounds. [U+0152, +0153]

ew Synonym for *barred* L (ł/Ł).

exclamation In Spanish, the inverted exclamation mark is used at the beginning of the phrase and the upright mark at the end. In mathematics, the upright exclamation mark is the symbol for factorials ($4! = 4 \times 3 \times 2 \times 1$). It is also often used to represent the palatal clicks of the Khoisan languages of Africa (thus, for example, the name !Kung or !Xun for one of the Khoisan languages and its speakers). Also called *screamer*. [U+0021, +00A1]

ezh This is an altered form of z, generally representing a sound like that of *z* in English *azure* or *j* in French *justice,* which is the sound of Czech ž or Polish ż. Ezh is a letter of the alphabet in Skolt, a language of the Saami family, spoken in northern Russia and Finland. The lowercase form is also part of the IPA and therefore present on any font of phonetic characters. Not to be confused with *yogh.* [U+01B7, +0292]

figures A text font normally includes at least one set of figures, which usually ought to be (and usually are not) text figures (OSF). Supporting fonts and OpenType fonts often include three further sets: titling (i.e., lining) figures, superiors and inferiors. The superiors are used for exponents, superscripts and the numerators of fractions, the inferiors for the denominators of fractions. For chemical formulae (H_2O etc) and mathematical subscripts, lowered inferior figures are needed. [U+0030−0039; +00B2, +00B3, +00B9, +2070, +2074−2079; +2080−2089]

fist The typographer's fist is neither a blunt instrument nor a closed purse. It is a silent, pointing hand. All too often, however, it is overdressed, with ruffles at the cuff. A Baroque invention,

the fist is missing from the standard ISO Latin character set and must be found on a supplementary font. [U+261A−261F]

fractions Three fractions – ¼ ½ ¾ – appear on most ISO text fonts, and six more – ⅛ ⅓ ⅜ ⅝ ⅔ ⅞ – on some pan-European fonts. [U+00BC−00BE; +2153−215E]

glottal stop The glottal stop is a sound in search of a character: a basic sound in many languages now written in Latin letters, but one for which the Latin, Greek and Cyrillic alphabets have no traditional symbol. Linguists use the character ʔ or ˀ – a gelded question mark – to represent this sound, but the symbol most commonly used in normal text is the apostrophe. In romanized Arabic the inverted comma or open quote (ʻ) is typically used to represent the letter ʻain (ع), whose phonetic symbol is ʕ or ˤ, and the apostrophe (ʼ) is used to represent hamza (ء, أ, إ, etc), the Arabic glottal stop. Thus, the Koran in romanized Arabic is al-Qurʼān; Arab is ʻarab; the family is al-ʻāʼila. Also known by its Spanish name, saltillo, "little leap." See also apostrophe, inverted comma and quotation marks. [U+0294, +02BC, +02C0]

grave An accent used with vowels – à è ì ò ù ỳ – in French, Italian, Portuguese, Catalan, Vietnamese and many other languages. In romanized Mandarin it is used with vowels – à è ì ò ù ǜ – to mark the falling tone. In Gaelic the grave is normally used instead of the macron to mark elongated vowels. The basic five grave vowels are present on most Latin text fonts. [U+0300]

guillemets Single and double guillemets are widely used as quotation marks with the Latin, Cyrillic and Greek alphabets in Europe, Asia and Africa. Attempts to introduce them into North America have met with only slight success. In French and Italian, the guillemets almost always point out, «thus» and ‹thus›, but in German they more frequently point in, »so« and ›so‹. Single guillemets should not be confused with angle brackets nor with the arithmetical operators meaning greater-than and less-than.

Guillemet means Little Willy, in honor of the sixteenth-century French typecutter Guillaume [William] Le Bé, who may have invented them. Also called chevrons, duck feet and angle quotes. [U+00AB, +00BB, +2039, +203A]

háček See caron and palatal hook. • **hat** See circumflex.

hedera An ivy leaf: a type of fleuron. (*Hedera* is the Latin name for ivy.) This is one of the oldest of all typographic ornaments, present in early Greek inscriptions. [U+2619, +2766, +2767]

hoi This is one of the five tonemarks used with vowels in the Vietnamese alphabet. It resembles a small dotless question mark and signifies the dipping-rising tone. The spelling in Vietnamese is, naturally, *hỏi* – and the name in Vietnamese does mean "question." In English it is also called a *curl*. [U+0309]

horned o A letter of the Vietnamese alphabet, representing a close mid-back unrounded vowel (IPA ɤ). [U+01A0, +01A1]

horned u Another basic Vietnamese letter, representing a close back unrounded vowel (IPA ɯ). [U+01AF, +01B0]

hyphen The shortest of the dashes. [U+002D]

interpunct See *midpoint*. • **inverted breve** See *arch*.

inverted comma Also called a single open-quote, and used for that purpose in English, Spanish and many other languages. In Hawaiian, oddly enough, it is the preferred way of writing the glottal stop (IPA ʔ), which is otherwise represented in Latin script by an apostrophe. Thus, in Hawaii, we are urged to write Hawaiʻi and Molokaʻi, not Hawaiʼi and Molokaʼi. In transliterated Arabic and Hebrew, however, the inverted comma represents the letter *ʿain* (ع) or *ayin* (ע), a pharyngeal continuant (IPA ʕ). Thus: Sunni and Shīʿa; King Ibn Saʿūd. Only the well-curved form of the character (ʻ instead of ʼ) is useful in transliteration. See also *glottal stop, quotation marks, reversed apostrophe*. [U+2018]

kropka See *overdot*. • **kroužek** See *ring*.

Polytonic Greek employs a diacritic that closely resembles the inverted comma. This is the *dasia*, "hairy," the sign of aspiration. Its opposite is *psili* (see pp 311, 316).

letters At least three varieties of letters appear in an ordinary font of Latin type. There is normally a full basic alphabet of upper and lower case and a partial alphabet of superior letters. The superiors are used to abbreviate ordinal numbers: English 1st, 2nd, 3rd; French 1re, 2e (*première, deuxième*); Spanish 2a, 2o (*segunda, segundo*), etc. They are also used in a few verbal abbreviations, such as 4o = quarto; 8o = octavo; Mr = mister; No = number, but in English most such forms are now archaic. A basic Latin font

includes only two superior letters, *ordinal a* and *ordinal o*, which are essential for setting text in Romance languages. (They are used with figures to represent ordinal numbers: first, second, third….) More superiors (at least abdeilmnorst) are often to be found on good OpenType fonts. Good OpenType fonts also routinely include small caps in addition to u&lc and superior letters. Full pan-European fonts should also include a complete set of Cyrillic and Greek characters, with or without their own small caps.

Note that the identity of letters can vary from language to language. The digraph *qu*, for example, is perceived as a single entity by many speakers of English; so are *ch* and *ll* by most speakers of Spanish. The digraphs *dd, ff, ng, ll, ph, rh, th* are single entities in Welsh. So are *dz, lj, nj* in Serbo-Croatian (where they correspond to Cyrillic џ, љ and њ). [U+0041—005A; +0061—007A; +00C0—00D6; +00D8—00F6; +00F8—00FF, &c.]

ligatures Basic Latin fonts are limited to two typographic ligatures, *fi* and *fl*. Rigid definitions of the glyph set, leaving no provision for additional ligatures (such as *ff, ffi, ffl, fj, ffj*), are a hazard to typography. All ligatures belonging to the typeface should reside on the basic font. This may include nonstandard modern ligatures such as *ffb, ffk, fft*, archaic ones such as *ſb, ſh, ſſi*, formed with *long s*, or Germanic ligatures such as *ch, ck, tz*.

The *lexical* ligatures æ, Æ, œ, Œ and ß are bonafide Unicode characters, separately listed in this appendix. *Typographic* ligatures such as *fi* and *st* are or ought to be mere glyphs. Writers, grammarians and lexicographers, not typographers, determine where lexical ligatures ought to be used. Typographic ligatures are creatures of the script, not the dictionary. (Nevertheless, several hundred Arabic ligatures and a haphazard handful for Armenian, Hebrew and Latin have found their way into Unicode as 'presentation forms.') [U+FB00—FB06]

logical not See *negation*.

long s This taller form of *s* looks like *f* without its crossbar. (Note however that the glyph often *does* have a spur on the left.) Long s was commonly used in English (uſed in Engliſh, *uſed in Engliſh*, USED IN ENGLISH) through the end of the eighteenth century. It was then the normal form of *s* in initial and medial positions. Short *s* was used at the ends of words and (usually) as the second *s* in a pair. Long s + short s forms the ligature ß, still used in

German. Long s itself is still routinely used in blackletter, though archaic in whiteletter. It often entails a substantial further set of ligatures – e.g., ſb ſh ſi ſk ſl ſſ ſſi ſſl. [U+017F]

long umlaut See *double acute.* • **louse** See *currency symbols.*

lowline This is a standard ISO character, positioned as a baseline rule. Not to be confused with the *underscore.* [U+005F]

macron A diacritic used to mark long vowels – ā ē ī ō ū – in many languages: Fijian, Hausa, Latvian, Lithuanian and Maori, among others. It is used for the same purpose in romanized Arabic, Greek, Hebrew, Japanese and Sanskrit, but in romanized Mandarin it marks the level tones. Some writers of Lakhota (Sioux) also use it to write disaspirated consonants (c̄ k̄ p̄ t̄). [U+0304]

midpoint An ancient European mark of punctuation, widely used in typography to flag items in a vertical list and to separate items in a horizontal line. A closely spaced midpoint is also often used to separate syllables or letters, especially in Catalan when one *l* adjoins another. (In Catalan as in Spanish, *ll* is treated as a single letter. When one *l* is adjacent to but separate from another, they are written *l·l.* Examples: the Catalan words *cel·les* [cells], *col·lecció* [collection] and *paral·lel.*) The same sign is used in mathematics for scalar multiplication and in symbolic logic for logical conjunction. Also called *interpunct* or *interpoint.* [U+00B7]

The Greek *anoteleia,* "raised period" [U+0387], used like a semicolon, looks like a midpoint, but it is a different character.

(Upper- and lowercase *L* + *midpoint* [Ŀ, ŀ] are needlessly treated by ISO, and therefore by Unicode, as single characters: U+013F & +0140.)

mu The Greek lowercase *m* represents the prefix *micro-* = 10^{-6}. Thus milligrams is written *mg* and micrograms *µg.* (A millionth of a meter or *micron,* formerly written *µ,* is now ordinarily written *µm.*) [U+03BC]

musical signs Three elementary musical symbols – ♭ ♯ ♮, the flat, sharp and natural – are needed for setting normal texts that make reference to standard European musical pitches and keys (Beethoven's Sonata Op. 110 in A♭, Ennemond Gaultier's Suite for Lute in F♯m, the drop from C♯ to C♮, etc). These characters are,

however, missing from most text fonts. (The octothorp is *not* an adequate substitute for the sharp.) [U+266D–266F]

nang See *underdot.* • **nasal hook** Synonym for *ogonek.*

negation The negation sign used in the propositional calculus (symbolic logic) was formerly the swung dash (~). Since the swung dash is also used as a sign of similarity, this created confusion. The usual form of the negation sign now is the angled dash (¬). This is part of the standard ISO Latin character set and is included on most digital text fonts, though it is useless without the other logical operators, such as ∪ ∩ ∧ ∨ ≡, which are almost never found on text fonts. Also called *logical not.* [U+00AC]

null Also known as a slashed or crossed zero. This glyph is used to distinguish zero from the letters *O* and *o*. But the null in its usual form is easily confused with *slashed o* (ø, ǿ), a letter of the alphabet in Danish and Norwegian, and even with the Greek letter phi (φ). The crossed form of the null, ө, is also confusible with theta (θ). A null glyph is present on some text fonts and on many phonetic and technical fonts. (As an alternate form of zero, this glyph has no address of its own in Unicode.)

number sign, numeral sign Synonym for *octothorp.*

obelisk, obelus (plural, *obeli*) Synonym for *dagger.*

octothorp Otherwise known as the numeral sign. It has also been used as a symbol for the pound avoirdupois, but this usage is now archaic. In cartography, it is a traditional symbol for *village*: eight fields around a central square. That is the source of its name. *Octothorp* means eight fields. [U+0023]

ogonek A diacritic used with vowels – ą ę į ǫ ų – in Lithuanian, Navajo, Polish and other languages. Also called a *nasal hook.* Not to be confused with the cedilla, which is used with consonants and curves the other way. *Ogonek* is a Polish diminutive, meaning 'little tail,' and the usual Polish name for the stem of an apple. Vowels with ogonek are known as *tailed vowels.* A *reversed ogonek* is used in the Bashkir consonant ҙ. [U+0328]

ordinal a, ordinal o See *letters.*

overdot A diacritic used with consonants – ċ ġ ṁ ṅ ż – in Maltese, Polish, old Gaelic and romanized Sanskrit, and with vowels – ė and İ – in Lithuanian and Turkish. In phonetics, it is widely employed as a sign of palatalization. Often known by its Polish name, *kropka*. See also *dotless i and dotted I*. [U+0307]

palatal hook A diacritic used in the Czech and Slovak alphabets to mark the so-called soft or palatal consonants. It usually looks like an apostrophe or single close quote but is differently fitted (cut closer on the left). In some fonts it also differs slightly from the apostrophe in shape and size. It combines with ascending lowercase consonants (ď, ľ, ť) and one capital (Ľ). The uppercase forms of ď and ť are Ď and Ť (and Ľ is an alternate form of Ľ). The caron form is used for both the caps and lower case of non-ascending letters (Č, č, Ř, ř). In Czech, both these forms of the diacritic are known as *háček,* "hook." Sometimes, unhelpfully, called the *apostrophe accent.* See also *undercomma.* [U+030C]

paragraph sign See *pilcrow.*

parentheses These are used as phrase markers in grammar and in mathematics, and sometimes to isolate figures or letters in a numerical or alphabetical list. [U+0028, +0029]

per cent Parts per hundred. Not to be confused with the symbol c/o, 'in care of,' which is also sometimes cut as a single glyph. [U+0025]

per mille Parts per thousand (61‰ = 6.1%). Though it is very rarely needed in text typography, this sign has been given a place in the standard ISO Latin character set. [U+2030]

period The normal sign for the end of a sentence in all the languages of Europe. But it is also a letter of the alphabet in Tlingit, pronounced as a glottal stop, and in phonetics it is the sign of a syllable boundary. Also called *full point* or *full stop.* [U+002E]

phonomark The copyright symbol used for sound recordings. Also sometimes called, unhelpfully, the *publish* symbol. [U+2117]

pilcrow An old scribal mark used at the beginning of a paragraph or main text section. It is still used by typographers for that very

¶ purpose, and occasionally as a reference mark. Well-designed faces offer pilcrows with some character – ¶ ¶ ¶ ¶ ⊄ ¶ ¶' – in preference to the overused, bland standard, ¶. [U+00B6]

pipe Despite its importance to computer programmers and its presence on the standard ASCII keyboard, the pipe has no function in typography. This is another key, and another slot in the font, that begs to be reassigned to something typographically useful. Also called a *broken bar* or *parted rule*. [U+00A6]

prime An abbreviation for feet ($1' = 12''$) and for minutes of arc ($60' = 1°$). Single and double primes should not be confused with apostrophes, dumb quotes or genuine quotation marks, though in some faces (frakturs especially) these glyphs may all have a similar shape and a pleasant slope. See also *apostrophe, double prime, dumb quotes* and *quotation marks*. [U+2032]

question mark In Spanish, the inverted question mark is used at the beginning of the phrase, in addition to the upright question mark at the end. [U+003F, +00BF]

quotation marks A standard ISO font includes four forms of *guillemet* and six forms of Anglo-Germanic quotation mark: ' ' , „ " ". One of these is also the apostrophe. Another is graphically identical to the comma but separately encoded. In English and Spanish, common usage is 'thus' and "thus"; in German, it is ‚thus' and „thus". This echoes national habits in the usage of guillemets. Both forms of quotation mark point inward in German, outward in Romance languages: „auf diese Weise" *und* »diese Weise« in German; "comme ça" *et* «comme ça» in French. See also *double prime, dumb quotes* and *prime*. [U+2018–201F]

radical sign The sign of the square root, normally used in conjunction with the *vinculum*: $\sqrt{10} = 3.16227766....$ [U+221A]

registered trademark This is properly a superscript, though the otherwise similar copyright symbol is not. [U+00AE]

reversed apostrophe(s) Mutant forms of the single and double open quote. They appear in several American advertising and text faces cut in the first years of the twentieth century and in some made at the end of that century as well. [U+201B, +201F]

ring Also called *kroužek*. A diacritic used in Arikara, Cheyenne, Czech, Danish, Norwegian, Swedish and other languages. The Scandinavian *round A* (å, Å = IPA ɯ) is present on ISO text fonts, but ů and Ů (*u* with *kroužek*), just as common in Czech, must be found on an East European or pan-European font, or built from component parts. In Arikara and Cheyenne, the ring marks devoiced letters. Uppercase or small cap round A or *A-ring* is the symbol for ångström units (10^4 Å = 1 μm). [U+030A]

schwa A rotated *e*, representing a short, bland vowel (in the jargon of phonetics, a mid central unrounded vowel). It occurs in many African and Native American alphabets. Two uppercase forms are current in Africa: Ǝ and Ə. Note that the Ǝ is horizontally *mirrored* instead of rotated. [U+018E, +01DD, +0259]

section A scribal form of double *s*, now used chiefly with reference to legal codes and statutes, when citing particular sections for reference. (The plural abbreviation, meaning sections, is written by doubling the symbol: §§.) [U+00A7]

semicolon A grammatical marker, hybrid between colon and comma, derived from European scribal practice. The Greek question mark (*erotematikon*) looks the same but isn't. [U+003B]

slashed o This is a basic letter of the alphabet in Norwegian and Danish, generally corresponding to the Swedish ö. The lowercase form is also part of the IPA. Henrik Ibsen's last play, for example, was *Når vi døde vågner*, and one of his first was *Fru Inger til Østråt*. The letter is sometimes needed in English too, for setting names such as Jørgen Moe and Søren Kierkegaard. [U+00D8, +00F8]

solidus The fraction bar. Used with superior and inferior numbers to construct piece fractions. The *solidus* was a Roman imperial coin introduced by Constantine in 309 CE. There were 72 *solidi* to the *libra,* the Roman pound, and 25 *denarii* to the *solidus.* The British based their own imperial coinage and its symbols – £/s/d, for pounds, shillings and pence – on the Roman model, and *solidus* became in due course not only a byword for shilling but also the name of the slash mark with which shillings and pence were written. (Given the design and fitting of the characters on most modern type fonts, the solidus is now best used for fractions alone. An italic virgule is usually the best character for setting

references to British imperial money.) See also *virgule*, which is a separate character. [U+2044]

sputnik Synonym for *louse*. See *currency symbols.*

square brackets These essentials of text typography are used for interpolations into quoted matter and as a secondary and inner set of parentheses. In the editing of classical texts, square brackets normally mark editorial *restorations* while angle brackets mark editorial and conjectural insertions, and braces mark deletions. Double square brackets are used by textual scholars to mark deletions made not by the editor but by the original author or scribe. In editing manuscripts and papyri, square brackets also mark hiatuses caused by physical damage. [U+005B, +005D]

swung dash A rare character in text but important in logic and mathematics as the sign of similarity ($a \sim b$) and in lexicography as a sign of repetition. The same sign has been used in symbolic logic to indicate negation, but to avoid confusion, the angular negation sign or *logical not* (¬) is now preferred. In the eyes of ISO and Unicode, the swung dash found on computer keyboards is an *ascii tilde* – a character of use to programmers but meaningless to typographers. Most fonts actually carry a swung dash, not a tilde, in this position. To Unicode, the true swung dash has a different address. Not to be confused with *tilde,* a smaller character used as a diacritic. [U+007E; +2053, +223C]

tedh Synonym for *barred T* (ŧ/Ŧ).

thorn A basic letter of the alphabet in Anglo-Saxon and Middle English, as well as in Icelandic: *Þótt þu langförull legðir....* Its sound is that of IPA θ: voiceless *th,* as in English *thorn.* Not to be confused with *wynn.* [U+00DE, +00FE]

tilde A diacritic used on vowels – ã ẽ ɛ̃ ĩ õ ɔ̃ ũ ỹ – in many languages (Estonian, Kikuyu, Portuguese, Twi, Vietnamese...) and on at least one consonant (ñ) in many more. Ã, ã, Ñ, ñ, Õ, õ are found on standard ISO Latin text fonts. Pan-European fonts include the old Greenlandic vowels Ĩ, ĩ, Ũ, ũ as well. [U+0303]

trademark This is a superscript, found on most text fonts but useless except for commercial work. [U+2122]

turned undercomma This diacritic is a variant of the under-comma, used in the lowercase sign of the Latvian voiced palatal stop (ģ). The uppercase form of this letter is Ģ. (The *g* is the only descending letter in the Latvian alphabet that carries a palatal diacritic.) See also *undercomma*. [U+0326, used in U+0123]

umlaut See *diaeresis/umlaut*.

undercomma This is a variant form of the cedilla, popularized in the early twentieth century through the use of typewriters which lacked a real cedilla subscript. Through long habituation, it is now preferred to the cedilla by many writers and some typographers working in Latvian and Romanian. In these languages it is used to mark the soft (palatal) consonants: ļ ņ ŗ ş ţ and their uppercase counterparts. It has become, in other words, a variant form of the *palatal hook*. Also called *comma below*.

 Because of its descender, Latvian lowercase palatal *g* (ģ) is marked with a raised and inverted form of this diacritic, the *turned undercomma*. [U+0326]

underdot A diacritic used with consonants – ḍ ḥ ḷ Ị ṛ ṝ ṣ ṭ ẓ – in romanized Arabic, Hebrew and Sanskrit, and primarily with vowels in Igbo, Yoruba, Twi, and many other African alphabets. In Vietnamese, it is a tonemark used with low glottalized vowels (ạ ặ ậ ệ ị ợ ự &c). Palaeographers routinely use the underdot to mark letters whose reading is uncertain. Its typographic nick-name, *nang*, is a simplified form of its Vietnamese name, *nặng*. Its Unicode name is *dot below*. Like the period, it can take many shapes, but in African scripts, a squarish or elongated dot is often preferred. It is absent from most Latin text fonts. [U+0323]

underscore A diacritic required for many African and Native American languages, and useful for some purposes in English. It is also used as an alternative to the underdot in setting romanized Arabic and Hebrew. To clear descenders, a repositioned version of the character is required. See also *lowline*. [U+0332]

unequal A useful symbol missing from most ISO text fonts. It is essential for setting mathematics and occasionally useful even in general text. [U+2260]

vertical rule See *bar*.

vinculum An overbar or overline, used in mathematics ($\sqrt{10}$) and in the sciences (\overline{AB}) to signify the unity of a group. The name is Latin for *bond* or *chain*. [U+203E]

virgule An oblique stroke, used by medieval scribes and many later writers as a form of comma. It is also used to build *level* fractions (e.g., $\pi/3$), to represent a linebreak when verse is set as prose, and in dates, addresses and elsewhere as a sign of separation. In writing the Khoisan languages of western Africa, it is sometimes used to represent dental or lateral clicks. Also called *slash* or *front slash* (to distinguish it from the *backslash*). It is poorly positioned on many fonts and consequently needs some subtle editing. Compare *solidus*. [U+002F]

wedge Synonym for *caron*.

wynn This is an archaic English predecessor of the modern letter *w*. It appears only in specialized fonts designed for medievalists, and it is all too easy to confuse with *thorn,* but out of faithfulness to the manuscript tradition, it is occasionally used in printing Middle English texts. [U+01BF, +01F7]

yogh This is an archaic Western European form of *y*, sometimes still used in Old and Middle English texts. The twelfth-century English poet Layamon, for example, wrote at a time when the English alphabet included aesc, eth, thorn and yogh, and the letter yogh appeared where we now put a *y* in Layamon's name: Laȝamon. The pronunciation varies with context between the sound of *y* in English *layer* and that of *g* in German *sagen*. Yogh is very rarely found on text fonts – and the numeral 3 is not an adequate substitute. [U+021C, +021D]

NOTE: A number of reference works (including the first three editions of *The Unicode Standard,* both editions of Pullum & Ladusaw's *Phonetic Symbol Guide,* and the first two editions of *The Elements of Typographic Style*) fail to distinguish *yogh* from *ezh*. The two characters *can* be graphically identical and therefore can be realized by one and the same glyph, but they are different in origin and sound – and also different now in Unicode.

APPENDIX C: GLOSSARY OF TERMS

Names of individual characters and diacritics (circumflex, dyet, midpoint, virgule, etc) are not in this glossary. Look for them in appendix B. For the basic terminology of metal type, see page 300. For historical terms (Renaissance, Baroque, etc), see chapter 7.

/ and × On and by. For instance: 10/12 × 21 (ten on twelve by twenty-one) means 10 pt type set with 12 pt leading (2 pt extra lead added to the 10 pt body size, for a total of 12 pt, baseline to baseline) on a measure of 21 picas.

Abrupt and *Adnate* Serifs are either *abrupt* – meaning they break from the stem suddenly at an angle – or they are *adnate*, meaning that they flow smoothly into or out of the stem. In the older typographic literature, adnate serifs are generally described as bracketed.

Aldine Relating to the publishing house operated in Venice by Aldus Manutius between 1494 and 1515. Most or all of Aldus's type – which included roman, italic and Greek – was cut by Francesco Griffo of Bologna. Type that resembles Griffo's, like typography that resembles Aldus's, is called Aldine. Monotype Poliphilus and Bembo roman are Aldine revivals, though their companion italics are not. No Aldine italics or Aldine Greeks are in circulation at the present time.

Two Aldine italics are reproduced on p 210.

Analphabetic A typographic symbol used with the alphabet but lacking a place in the alphabetical order. Diacritics such as the acute, umlaut, circumflex and caron are analphabetics. So are the asterisk, dagger, pilcrow, comma and parentheses.

Aperture The opening from *counter* to exterior in a glyph such as C G S a c e s. Humanist faces such as Bembo and Centaur have large apertures. Romantic faces such as Bodoni and Realist faces such as Helvetica have small ones. Very large apertures occur in archaic Greek inscriptions and in typefaces such as Lithos, which are derived from them.

Axis Short for *stroke axis,* which is the axis of the pen or other tool used to make the letter. It needn't – and often doesn't – coincide with the *slope* of the letter. If a glyph has thick strokes and thin ones, find the thickest and extend them into lines. These should reveal the axis (or *axes*; there may be several) of the pen that made the stroke. (See pp 12–15 and page 131.)

Ball Terminal A circular form at the end of the arm, leg or brow in letters such as a, c, f, j, r and y. Ball terminals are found in many romans and italics of the Romantic period, some Realist faces, and in many recent faces built on Romantic lines. Examples: Bodoni, Scotch Roman and Haas Clarendon. See also *beak terminal* and *teardrop terminal*.

Baseline Whether written by hand or set in type, the Latin lowercase alphabet implies an invisible staff of four lines: topline, midline, baseline and beardline. The topline is the line reached by ascenders in letters like b, d, h, k, l. The midline marks the top of letters like a, c, e, m, x, and the top of the torso of letters like b, d, h. The baseline is the line on which all these letters rest. The beardline is the line reached by descenders in letters such as p and q. The cap line, marking the top of the uppercase letters, does not necessarily coincide with the topline of the lower case. (See *cap height* and *x-height*.)

 Round letters like e and o normally dent the baseline. Pointed letters like v and w normally pierce it, while the foot serifs of letters like h and m usually rest precisely upon it.

Bastarda A class of *blackletter* types. See page 274.

Beak Terminal A sharp spur, found particularly on the f, and also often on a, c, j, r and y, in many romans and some italics of the past hundred years. Examples: Apollo, Berling, Méridien, Perpetua, Pontifex, Veljović.

Bicameral A bicameral alphabet is two alphabets joined. The modern Latin alphabet, which you are reading, is an example. It has an upper and a lower case, as closely linked and yet as easy to distinguish as the Senate and the House of Representatives. Unicameral scripts (Arabic, Hebrew and Devanagari, for example) have only one case. Tricameral alphabets have three – and a normal font of roman type is tricameral if it includes an upper case, a lower case and small caps.

Bilateral Extending to both sides. Bilateral serifs, which are always *reflexive*, are typical only of roman faces. Unilateral serifs are typical of both romans and italics.

Bitmap A digital image in unintelligent form. A letterform can be described embryologically and intelligently, as the series of penstrokes that produce the form, or morphologically, as a series of reference points and splines describing its perimeter. Such descriptions are partially independent of size and position. The same image can also be described quite accurately but superficially as the addresses of all the dots (or *bits*) in

its digital representation. This sort of description, a bitmap, ties the image to one orientation and size.

Blackletter Blackletter is to typography what Gothic is to architecture: a general name for a wide variety of forms that arose predominantly in the north of Europe, spread southward and lasted far into the Renaissance. Like Gothic buildings, blackletter types can be massive or light. They are often tall and pointed, but can be round instead. Compare *whiteletter*. The categories of blackletter include bastarda, fraktur, quadrata, rotunda and textura. See page 274.

Bleed As a verb, to bleed means to reach to the edge of the printed page. As a noun, it means printed matter with no margin. If an image is printed so that it reaches beyond the trim line, it will bleed when the page is trimmed. Photographs, rules, solids and background screens or patterns are often allowed to bleed. Type can very rarely afford to do so.

Blind In letterpress work, printing blind means printing without ink, producing a colorless impression.

Blind Folio A page which is counted in the numbering sequence but carries no visible number.

Block Quotation A quotation set off from the main text, forming a paragraph of its own, often indented or set in a different face or smaller size than the main text. A *run-in quotation*, on the other hand, is run in with the main text and usually enclosed in quotation marks.

Body (1) In reference to foundry type: the actual block of typemetal from which the sculpted mirror-image of the printed letter protrudes. (2) In reference to phototype or digital type: the rectangular face of the metal block that the letter would be mounted on *if it were* three-dimensional metal instead of a two-dimensional image or bitmap. Retained as a fiction for use in sizing and spacing the type. Compare *sidebearing*.

Body Size In graphic terms, the *height* of the *face* of the type, which in letterpress terms is the *depth* of the *body* of the type. More precisely, this is the height of the face of the metal block on which a font is *designed to be* cast. In digital type, it is the height of its imaginary equivalent, the rectangle defining the space owned by a given letter, and not the dimension of the letter itself. Body sizes are usually given in points – but European metal sizes are usually given in Didot points, which are roughly 7% larger than Anglo-American metal or PostScript (digital) points. For further details, see pp 300–301.

Bowl The generally round or elliptical forms which are the basic bodyshape of letters such as C, G, O, b, c, d, e, o, p. A bowl always includes a *counter* but never a *stem*. See also *eye*.

Cap Height The distance from baseline to cap line of an alphabet, which is the approximate height of the uppercase letters. It is often less, but sometimes greater, than the height of the ascending lowercase letters. See also *baseline* and *x-height*.

Chancery A class of cursive letterforms, generally featuring extra ligatures and lengthened and curved extenders. Many, but not all, chancery letterforms are also *swash* forms.

Cicero A unit of measure equal to 12 Didot points. This is the continental European counterpart to the British and American *pica*, but the cicero is slightly larger than the pica. It is equivalent to 4.52 mm or 0.178 inch. See *point*.

Color The darkness or blackness and relative evenness of a typeset page, which is *not* the same as the weight of the face. The spacing of words and letters, leading of lines, and frequency of caps and diacritics, not to mention properties of ink and paper, all affect the color, in this sense, of the page.

Contrast The difference between the thick strokes and the thin strokes of a given letter, or of all the letters in a given font. In Romantic faces such as Bulmer and Bodoni, the contrast is high. In unmodulated faces such as Gill Sans and Futura, contrast is low or nonexistent.

Counter White space contained by a letterform – either fully enclosed, as in *d* or *o*, or partially so, as in *c* or *n*.

Crosshead A heading or subhead centered over the text. Compare *sidehead*.

Cursive Flowing. Often used as a synonym for *italic*.

Cut (1) To make a font or glyph. (2) One incarnation or version of a face. ("These two Helveticas are different cuts.")

Dingbat A glyph that is not a letter, number or punctuation mark but a typographic widget. It may be an abstract marker or decorative bullet, a graphic symbol (spade, club, pawn, bishop, etc); or a pictogram (e.g., a tiny picture of a mosque, church or telephone). Emoticons are dingbats. Compare *fleuron*.

Dot Leader A row of evenly spaced periods or midpoints, occasionally used to link flush-left text with flush-right numerals in a table of contents or similar context. (The only instance in this book is on page 300.)

DPI Dots per inch. The usual measure of output *resolution* in digital typography and in laser printing.

Drop Cap A large initial capital or *versal* mortised into the text. (See page 64 for examples.) Compare *elevated cap.*

Drop Folio A folio (page number) dropped to the foot of the page when the folios on other pages are carried near the top. Drop folios are often used on chapter openings.

Dropline Paragraph A paragraph marked by dropping directly down one line space from the end of the previous paragraph, without going back to the left margin. (See page 40 for an example.)

Elevated Cap A large initial capital or versal rising up from the beginning of the text instead of nested down into it.

Em In linear measure, a distance equal to the type size, or a space the square of the type size. Thus an em is 12 pt (or a 12 pt square) in 12 pt type, and 11 pt (or an 11 pt square) in 11 pt type. Also called *mutton.*

En Half an em in linear measure, or a space one em deep and half an em wide. To avoid confusion, typographers speak of ems as *muttons* and ens as *nuts.*

Extenders Descenders and ascenders; i.e., any parts of the letter-form that extend below the baseline, as in p and q, or above the midline, as in b, d and f.

Eye Synonym for *bowl* in the lower case. *Large eye* means, in effect, large *x-height,* while *open eye* means large *aperture.*

FL Flush left, which means set with an even left margin. By implication, the right margin is ragged. To be more precise, one could say FL/RR: flush left, ragged right.

FL&R Flush left and right, which is to say *justified.*

Fleuron A horticultural dingbat. That is to say, a typographic ornament ordinarily in the shape of a flower or leaf. Some fleurons are designed to be set in bulk and in combinations, to produce what amounts to typographic wallpaper.

Flush and Hung Set with the first line FL and subsequent lines indented, like the entries in this glossary.

Folio In bibliography, a leaf and the name of a size; but in typography, a folio is a typeset page *number,* not the page itself.

Font A full set of glyphs, regarded purely as designs, or the physical embodiment of that set. In relation to metal, this means the set of sorts *sufficient for a given text or language* and *in a given size,* in the quantity required to do the job. In relation to digital type, it means the glyph palette itself or the digital file encoding it. (The older British spelling, *fount,* has not only the same meaning but also the same pronunciation.)

Fore-edge The outside edge or margin of a book page; i.e., the edge or margin opposite the spine.

FR Flush right. With an even right margin. By implication, the left margin is ragged. The sidehead on this page is an example.

Fraktur A class of *blackletter* types. See page 274.

Glyph An incarnation of a character. See *sort*.

Gutter The blank column between two columns of type or the margins at the spine between two facing textblocks.

Hanging Figures Text figures.

Hair Space Normally M/24 or the width of a slip of paper.

Hard Space A word space that will not translate into a line-break. Also called *no-break space*.

Hint The letterforms that make up a digital font are usually defined mathematically in terms of outlines or templates, which can be freely scaled, rotated and moved about. When pages are composed, these outlines are given specific locations and sizes. They must then be *rasterized*: converted into solid forms made up of dots at the resolution of the output device. If the size is very small or the resolution low, the raster or grid will be coarse, and the dots will fill the mathematical template very imperfectly. Hints are *the rules of compromise* applied in this process of rasterization. At large sizes and high resolutions, they are irrelevant. At smaller sizes and lower resolutions, where distortion is inevitable, they are crucial. *Hinted* fonts include hints as integral parts of the font definition. See also *bitmap*.

Humanist Humanist letterforms originated among the humanists of the Italian Renaissance and persist to the present day. They are of two primary kinds: roman and italic, both of which derive from Roman capitals and Carolingian minuscules. Humanist letterforms show the clear trace of a broadnib pen held by a right-handed scribe. They have a *modulated* stroke and a *humanist axis*.

Humanist Axis An oblique stroke axis reflecting the natural inclination of the writing hand. See pp 12 & 15.

Inline A glyph in which the inner portions of the main strokes have been carved away, leaving the edges more or less intact. Inline faces lighten the color while preserving the shapes and proportions of the original face. Castellar, Smaragd and Romulus Open Kapitalen (see pp 298–9) are examples of inline faces. Not to be confused with *outline*.

IPA International Phonetic Association and its alphabet. The organization was founded in 1886. The alphabet is a set of

phonetic letters, diacritics and tonemarks, widely used but – like any scientific system – subject to constant refinement and modification. See page 313.

ISO International Organization for Standardization, headquartered in Geneva. An agency for international cooperation on industrial and scientific standards. Its membership consists of the national standards organizations of more than one hundred countries.

Yannis Haralambous's *Fonts & Encodings* (2007) includes a fine account of the imperfections in successive ISO font standards.

Italic A class of letterforms more cursive than roman but less cursive than script, developed from the Carolingian hand in fifteenth-century Italy. In most italics, the separate letters are implicitly connected by their *transitive* serifs.

Justify To adjust the length of the line so that it is flush left and right on the measure. Type in the Latin alphabet is commonly set either justified or FL/RR (flush left, ragged right).

Kern (1) Part of a letter that reaches into the space of another. In many faces, roman f has a kern to the right, italic *j* a kern to the left, and italic *f* one of each. (2) To alter the fit of a pair of glyphs – such as *To* or *f*) – so that one closes up to *or backs away from* the other. (3) Of a glyph: to have a kern, *or* to be part of an adjusted pair (which is called a 'kerning pair').

Lachrymal Terminal Synonym for *teardrop terminal.*

Lead [rhymes with *red*] (1) A strip of soft metal used for vertical spacing between lines of type, or its digital equivalent. (2) To space type vertically by inserting leads or their digital equivalent. (See page 118 for a photo.)

Leading [rhymes with *sledding*] In digital typography, this usually means the total vertical increment, baseline to baseline, in a block of text. Ten-point type leaded 2 pt is set 10/12. We now usually say the leading is 12 pt, not 2 pt.

Ligature Two or more letters tied into a single character. The sequence *ffi*, for example, forms a ligature in most Latin text faces.

Lining Figures Figures of even height. Usually synonymous with *titling figures*, but some lining figures are smaller and lighter than the uppercase letters.

Logogram A specific typographic form tied to a certain word. Example: the nonstandard capitalizations in the names e.e. cummings, Параграф, TrueType and WordPerfect.

M/3 A third of an em: e.g., 4 pt in 12 pt type; 8 pt in 24 pt type.

Measure The standard length of the line; i.e., column width or width of the overall textblock, usually measured in picas.

Mid Space A space measuring M/4, a fourth of an em.

341

Modulation In relation to typography, modulation means a varia-
tion – usually cyclical and predictable – in the width of the
stroke. In monochrome (unmodulated) letterforms such as
Frutiger, the stroke is always fundamentally the same width.
In a face such as Bembo or Centaur, the stroke is based on
the trace of a broadnib pen, which makes thin cross strokes
and thicker pull strokes. When letters are written with such
an instrument, consistent modulation automatically occurs.

Monotonic Modern Greek retains only one of the old tonic ac-
cents, the *oxia* or acute, renaming it the *tonos*. (Greek has
often, in fact, been written and sometimes set in this fashion,
but the practice became official in 1982.) Fonts for setting
Greek in this simplified form are called monotonic. Their
tonos is often vertical, like a dumb quote. Compare *polytonic*.

Mutton An *em*. Also called mutton quad.

Negative Leading Leading smaller than the body size. Type set
16/14, for example, is set with negative leading.

Neohumanist Recent letterforms that revive and reassert *human-
ist* principles are called neohumanist.

Nut An *en*.

Old-Style Figures (OSF) A common synonym for *text figures*.

Orthotic A class of Greek scripts and types that flourished in
Western Europe between 1200 and 1520, revived in the early
twentieth century. Orthotic Greeks are noncursive and usually
bicameral. In other words, they are analogous to the roman
form of Latin script. Both caps and lower case are usually
upright. Serifs, when present, are usually short, abrupt and
unilateral. The geometric figures of circle, line and triangle
are usually prominent in their underlying structure. Gill Sans
Greek and New Hellenic (page 286) are examples.

Outline A hollow but slightly fattened letterform made by draw-
ing around the perimeter of a glyph. Outline letters are easy
to make with digital tools, but they lack the leanness and
poignancy of well-made *inline* letters. In metal, outline faces
are rare and mostly undistinguished. (R. Hunter Middleton's
Condensed Gothic Outline is an example.)

Pi Font A font of assorted mathematical and other symbols,
designed to be used as an adjunct to one or more text fonts.

Pica A unit of measure equal to 12 *points*. Two different picas
are in common use. (1) In traditional printers' measure, the
pica is 4.22 mm or 0.166 inch: close to, but not exactly, one
sixth of an inch. This is the customary British and American

unit for measuring the length of the line and the depth of the textblock. (2) The PostScript pica is precisely one sixth of an inch: 0.166666…". The difference between these units is roughly 0.03%. (Note: the continental European counterpart to the pica is the *cicero*, which is 7% larger.)

Piece Fraction A fraction (such as ⁵⁄₆₄ or ¹⁷⁄₁₂₈) that is not itself a glyph and must be constructed from separate components.

Point (1) In traditional British and American measure, a point is a twelfth of a *pica*, which makes it 0.3515 mm, or 0.01383 inch. In round numbers, there are 72 points per inch, or 28.5 points per centimeter. (2) In continental Europe a larger point, the Didot point, is used. The Didot point (a twelfth of a *cicero*) is 0.38 mm or 0.01483 inch. In round numbers, there are 26.5 Didot points per centimeter, or 67.5 per inch. (3) Nearly all digital typesetting devices, like the PostScript and TrueType languages they employ, make the point precisely ¹⁄₇₂ inch and the pica precisely one sixth of an inch.

Polytonic Classical Greek has been set since the fifteenth century with an array of tonic accents and other diacritics inherited from the Alexandrian scribes. These diacritics – now known as *oxia* (acute), *varia* (grave), *perispomeni, psili, dasia, dialytika* (diaeresis), *ypogegrammeni* (iota subscript) and *koronis* – are used singly and in many combinations. (See pp 310–11 & 316 for the details.) Modern Greek retains only the *oxia* (reinterpreted as the *tonos*) and an occasional *dialytika*. Greek fonts equipped with the full set of accents are accordingly known as polytonic Greeks, and modern Greek fonts as *monotonic*.

Quad (1) An *em* space. Also called *mutton quad*. (2) To fill or be filled with blank ems. ("This line is quadded out.")

Quaint An antiquated sort or glyph, used to recreate the typographic flavor of a bygone age. The *ct, sp* and *st* ligatures, and the long s (ſ, ſ) and its ligatures, are quaints.

Ranging Figures Synonymous with *lining figures*.

Raster Digital grid. See *hint*.

Rationalist Axis Vertical axis, typical of Neoclassical and Romantic letterforms. See page 13. Compare *humanist axis*.

Reflexive A type of *serif* that concludes the stroke of the pen by drawing back upon itself. Reflexive serifs are typical of roman faces, including the face in which these words are set. They always involve a sudden, small stoppage and reversal of the pen's direction, and more often than not they are *bilateral*. See also *transitive*.

343

Resolution In digital typography, resolution is the fineness of the grain of the typeset image. It is usually measured in dots per inch (dpi). Laser printers, for example, generally have a resolution between 300 and 1200 dpi, and platemakers or typesetting machines a resolution significantly greater than 1200 dpi. The resolution of the conventional television screen is only about 50 dpi, and the resolution of most computer screens is also very low: between 72 and 140 dpi. But other factors besides resolution affect the apparent roughness or fineness of the typeset image. These factors include the inherent design of the characters, the skill with which they are digitized, the *hinting* technology used to compensate for coarse *rasterization*, and the nature of the surface on which they are reproduced.

Rotunda A class of *blackletter* types. See page 274.

RR Ragged right, which is to say unjustified.

Sanserif From the earlier English forms *sans serif* and *sans surryphs*, without serifs: synonymous with *unserifed*.

Serif A stroke added to the beginning or end of one of the main strokes of a letter. In the roman alphabet, serifs are usually *reflexive* finishing strokes, forming unilateral or bilateral stops. (They are unilateral if they project only to one side of the main stroke, like the serifs at the head of T and the foot of L, and bilateral if they project to both sides, like the serifs at the foot of T and the head of L.) *Transitive* serifs – smooth entry or exit strokes – are usual in italic.

There are many descriptive terms for serifs, especially as they have developed in roman faces. They may be not only unilateral or bilateral, but also long or short, thick or thin, pointed or blunt, abrupt or adnate, horizontal or vertical or oblique, tapered, triangular, and so on. In texturas and some frakturs, they are usually diamond-shaped (scutulate), and in some architectural scripts, such as Eaglefeather and Tekton, the serifs are virtually round.

Sidebearing The space – essential to legibility and to evenness of *color* – that a glyph carries with it on the left and right. Sidebearings, then, are what distinguishes set-width from glyph width. Where a sidebearing is negative, there is a *kern*.

Sidehead A heading or subhead set flush left (more rarely, flush right) or slightly indented. Compare *crosshead*.

Slab Serif An abrupt or adnate serif of the same thickness as the main stroke. Slab serifs are a hallmark of the so-called egyptian and clarendon types: two groups of Realist faces

produced in substantial numbers since the early nineteenth century. Memphis, Rockwell, Serifa and Caecilia are examples.

Slope The angle of inclination of the stems and extenders of letters. Most (but not all!) italics slope to the right at something between 2° and 20°. Not to be confused with *axis*.

Solid Set without additional *lead*, or with the line space equivalent to the type size. Type set 11/11 or 12/12, for example, is set solid.

Sort A single piece of metal type; thus a character in one particular face and size. In the world of digital type, where letters have no physical existence until printed, the word *sort* has been largely displaced by the word *glyph*. A glyph is a version – a conceptual, not material, incarnation – of the abstract symbol called a character. Thus, *z* and *ʒ* are alternate glyphs (in the same face) for the same character.

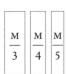

Stem The more or less straight and vertical part of a letter. *C* and *e* have no stem; *E* has a stem and crossbars; *l* consists of stem and serifs alone; *n* has a short stem, *h* a long one.

Swash A letterform reveling in luxury. Some swash letters carry extra flourishes; others simply occupy an extra helping of space. Swash letters are cursive and swash typefaces therefore usually italic. True italic capitals (as distinct from sloped roman capitals) are usually swash. (*The Caps in this Sentence are Examples.*) Lowercase swash glyphs are found in many humanist (and some Baroque and Neoclassical) italics.

Teardrop Terminal A swelling, like a teardrop, at the end of the arm in letters such as a, c, f, g, j, r and y. This feature is typical of typefaces from the Late Renaissance, Baroque and Neoclassical periods, and is present in many recent faces built on Baroque or Neoclassical lines. Examples: the Jannon 'Garamonds,' Van Dijck, Kis, Caslon, Fournier, Baskerville, Bell, Walbaum, Zapf International, Galliard. Also called *lachrymal terminal*. See also *ball terminal* and *beak terminal*.

Textblock The part of the page normally occupied by text.

Text Figures Figures – 1 2 3 4 5 6 – designed to match the lowercase letters in size and color. Most text figures are ascending and descending forms. Also called *old-style figures*. Compare *lining figures, ranging figures* and *titling figures*.

Textura A class of *blackletter* types. See page 274.

Thick Space A space usually measuring M/3, a third of an em.

Thin Space In letterpress work, a space measuring M/5, a fifth of an em. In computer typesetting, sometimes understood as M/6 or M/8. Compare *hair space, mid space* and *thick space*.

Three-to-em One-third em. Also written M/3. See also *thick*.

M/3	M/4	M/5

Titling Figures Figures – 1 2 3 4 5 6 – designed to match the upper-case letters in size and color. Compare *text figures*.

Transitive A type of serif which flows directly into or out of the main stroke without stopping to reverse direction, typical of many italics. Transitive serifs are usually unilateral: they extend only to one side of the stem. See also *reflexive*.

Type Size Synonym for *body size*.

U&lc Upper and lower case: the normal form for setting text in the Latin, Greek and Cyrillic alphabets, all of which are now *bicameral*.

Unicameral Having only one case – like the Arabic, Hebrew, Thai and Tibetan scripts, and many roman titling faces. Compare *bicameral*.

Unicode A scheme, begun in 1988, for standardized encoding of all the characters in all the world's scripts. See page 181.

Versal A large initial capital, either elevated or dropped. Also called *lettrine*.

Weight The darkness (blackness) of a typeface, independent of its size. See also *color*.

Whiteletter The generally light roman letterforms favored by humanist scribes and typographers in Italy in the fifteenth and sixteenth centuries, as distinct from the generally darker *blackletter* script and type used for ecclesiastical and legal texts. Whiteletter is the typographic counterpart to Romanesque in architecture, as blackletter is the counterpart to Gothic.

White Line A line space (interval of standard *leading* that contains no text).

Word Space The space between words. When type is set FL/RR, the word space may be of fixed size. When the type is *justified*, the word space is usually elastic.

x-height The distance between the baseline and the midline of an alphabet. Thus, the approximate height of the unextended lowercase letters (a, c, e, m, n, o, r, s, u, v, w, x, z) and of the torso of letters with extenders (b, d, h, k, p, q, y). The relation of x-height to *cap height* is an important characteristic of any *bicameral* Latin typeface, and the relation of x-height to *extender* length is a crucial property of any Latin or Greek lower case. See also *baseline* and *eye*.

A biographical index of designers important to typographic history, and of all those doing important work in the present day, would be a hefty volume in itself. (At least two book-length catalogues of type designers have indeed been published, and I regret that I have not yet seen one I can recommend.) The following list is little more than a cross-reference to important designers whose work is mentioned elsewhere in this book.

LUDOVICO DEGLI ARRIGHI (*c.*1480–1527) Italian calligrapher and designer of several chancery italic fonts. Frederic Warde's Vicenza and Arrighi (the italic companion to Centaur) are based on one of his faces. Monotype Blado (the italic companion to Poliphilus) is a rough approximation of another.

ANTOINE AUGEREAU (*c.*1490–1534) Parisian punchcutter and printer. Author of several text romans and at least one Greek. Along with his contemporary Simon de Colines, Augereau defined the style of French typography later identified with the name of his most famous apprentice, Claude Garamond. This activity came to an end when he was hanged and his corpse publicly burnt, on Christmas Eve of 1534, after being wrongfully convicted of printing anti-Catholic posters.

RICHARD AUSTIN (*c.*1765–1830) English punchcutter producing Neoclassical and Romantic faces. He cut the original Bell type, the first Scotch Roman, and the original version of Porson Greek. W. A. Dwiggins's Caledonia is based substantially on Austin's work.

ANDREU BALIUS (1962–) Catalan typographer and designer based in Barcelona. Designer of Carmen, Pradell, Taüll and other faces.

JOHN BASKERVILLE (1706–1775) English calligrapher, printer, type designer and businessman. He designed a uniform series of Neoclassical roman and, italics, and one Greek. Most of the romans and italics sold in his name are based on his work and some resemble it closely – but there is no such thing as an authentic Baskerville bold. George Matthiopoulos has also made a digital version of his Greek type, issued by GFS. His surviving punches, cut for him in the 1750s by John Handy, are now at the University Library, Cambridge,

The principle problem with the existing works is lack of historical accuracy. One of them (published by a respected university press) informs us that Jean Jannon (who was born in 1580) studied with Robert Estienne (who died in 1559). Another, published by a trade press, is so rife with misspelled names and erroneous dates that it cannot be safely consulted on any topic. All of us make mistakes, but we must do so, as Dostoevsky says, "within decent limits."

and a set of original matrices is held by the Walter Fruttiger Foundry, Münchenstein.

LUCIAN BERNHARD (1885–1972) German immigrant to the USA. Painter, poet, industrial designer and typographer. Author of a large number of roman faces, distinguished by their long extenders. These were cut and cast primarily by ATF and Bauer.

CHARLES BIGELOW (1945–) American typographer and scholar. Codesigner, with Kris Holmes, of the Lucida family.

ARCHIBALD BINNEY (1762–1838) Scottish immigrant to the USA. He was trained as a punchcutter in Edinburgh. With James Ronaldson, another Scottish immigrant, he established the Binney & Ronaldson Foundry in Philadelphia, where he cut Baroque, Neoclassical and Romantic type.

FRANK BLOKLAND (1959–) Dutch type designer and founder of the Dutch Type Library in 's-Hertogenbosch. His faces include Berenice and Documenta. His historical revivals include DTL Van den Keere and its companion, Guyot italic.

GIAMBATTISTA BODONI (1740–1813) Italian punchcutter, printer and prolific designer of type, working at Rome and Parma. Bodoni is best known for his dark and razor-sharp Romantic romans, italics and sometimes wildly ornamental Greeks, but he also designed and cut a large number of Neoclassical fonts. Bauer Bodoni, Berthold Bodoni, and some of the other faces now sold in his name are based on his work. His punches are in the Museo Bodoniano, Parma.

LUDOLF BORCHTORP (*c.* 1470–*c.* 1510) Polish-trained German mathematician, astronomer and engraver. Author of the first fonts of Cyrillic type, which he cut in Kraków in 1491 for the Polish printer Szwajpolt Fiol.

CHRIS BRAND (1921–1998) Dutch calligrapher, the designer of the Albertina family. Some of his finest work – including the Hebrew face Zippora, the Elsschot family and the Denise italic – has yet to be released.

DAN CARR (1951–2012) American punchcutter, poet, typographer and printer. Designer and cutter of Regulus foundry roman and Parmenides foundry Greek; designer of the digital family Chêneau. He was proprietor of the Golgonooza Letter Foundry in Ashuelot, New Hampshire (and, for a time, the only punchcutter in the world elected to public office).

MATTHEW CARTER (1937–) English-born American type designer, punchcutter and scholar, based in Cambridge, Massachusetts. His text faces include Auriga, Charter, Galliard

and Manutius; his titling faces include Mantinia and Sophia. His historical revivals include Wilson Greek.

WILLIAM CASLON (1692–1766) English engraver, punchcutter and typefounder; author of many Baroque romans, italics, Greeks and other non-Latin faces. ATF Caslon, Monotype Caslon, and Carol Twombly's Adobe Caslon are closely based on his work. A collection of his punches is now in the St Bride Printing Library, London.

WARREN CHAPPELL (1904–1991) American book artist, trained in Germany by Rudolf Koch. His typefaces include Trajanus, Lydian and the still unpublished Eichenauer.

SIMON DE COLINES (*c.*1480–1547) French master printer, typographer and punchcutter. Author of a dozen or more roman fonts, several italics, several blackletters and a fine cursive Greek. Colines as much as any single person appears to be responsible for creating the typographic style of the French golden age. Garamond and Augereau were part of the same circle. To the best of my knowledge, none of Colines's faces has yet been translated to digital form.

CARL DAIR (1912–1967) Canadian book designer and typographer, working chiefly in Toronto. Designer of the Cartier family, which was left incomplete at Dair's death and later improved and completed by Rod McDonald.

GERARD DANIËLS (1966–) Dutch type designer and typographer, trained under Gerrit Noordzij. Designer of the Elzevir family (based on the work of Christoffel van Dijck) and of the sanserif Caspari.

ISMAR DAVID (1910–1996) German-born American book designer, architect, graphic artist and type designer. His David Hebrew was released in two weights by Intertype in 1954. The complete family – serif, sanserif and script fonts in three weights – was finally released by Monotype in 2012.

GIOVANNI DE FACCIO (1966–) Italian calligrapher. With Lui Karner, he is codesigner of the Rialto family, produced by their digital foundry *df*Type.

FRANÇOIS-AMBROISE DIDOT (1730–1804) Parisian printer and publisher. Designer of several Neoclassical romans and italics, cut under his supervision by Pierre-Louis Vafflard. Father of Firmin Didot and founder of the Didot dynasty in printing and typography.

FIRMIN DIDOT (1764–1836) Parisian printer and punchcutter; son of F.-A. Didot and student of Pierre-Louis Vafflard; father of

Ambroise Firmin-Didot. Author of several Neoclassical faces as well as the Romantic fonts for which he is posthumously known. Monotype Didot and Linotype's digital Didot (drawn by Adrian Frutiger) are based on his work.

BRAM DE DOES (1934–) Dutch typographer, formerly chief designer at Joh. Enschedé en Zonen, Haarlem. Designer of the Trinité and Lexicon families.

WILLIAM ADDISON DWIGGINS (1880–1956) American designer and typographer. Dwiggins designed typefaces exclusively for the Linotype machine. In the 1930s and 1940s, he also created the typographic house style at Alfred Knopf, New York. His serifed faces include Caledonia, Eldorado, Electra and Falcon. His only completed sanserif is Metro. His one uncial face is Winchester. Many of his type drawings are now in the Boston Public Library.

ANTONIO ESPINOSA DE LOS MONTEROS (1732–1812) Spanish typecutter working in Madrid, then in Segovia. Author of several Rococo and Neoclassical romans, italics and script types.

ALFRED FAIRBANK (1895–1982) English calligrapher and designer of Fairbank italic (the original narrow italic companion to Bembo roman).

MÁRIO FELICIANO (1969–) Portuguese designer working in Lisbon. Five of his text families – Geronimo, Rongel, Eudald, Monteros and Merlo – are reconstructed from the work of 18th-century Spanish punchcutters. He is also the author of a sanserif family known as Stella and a family of three related titling faces known as Garda.

AMBROISE FIRMIN-DIDOT (1790–1876) French scholar, typecutter and printer. He was the son of Firmin Didot (whose full name he took as his own surname) and grandson of François-Ambroise Didot. Author of the first Didot Greek fonts.

JOHANN MICHAEL FLEISCHMAN (1701–1768) German-born punchcutter and founder working in the Netherlands. A prolific and skilled cutter of romans, italics and ornamental blackletters. Also the author of several Arabic and Greek fonts. His early romans and italics are Baroque, but in the 1730s he cut a series of text fonts idiosyncratic and self-conscious enough to be called Rococo. Most of his surviving material is now at the Enschedé Museum in Haarlem.

KARL-ERIK FORSBERG (1914–1995) Swedish calligrapher and typographer, designer of the Berling text roman. His titling faces include Carolus, Ericus and Lunda.

PIERRE-SIMON FOURNIER (1712–1768) French printer and punchcutter. Author of many French Neoclassical fonts and typographic ornaments. Nearly all of his original material has been damaged or lost. Monotype Fournier and Barbou are based on his work, and W. A. Dwiggins's Electra owes much to the study of it.

HENRI FRIEDLAENDER (1904–1996) Israeli book and type designer, born in France to a Dutch father and English mother, and trained primarily in Germany. In 1950, after twenty years on the drawing table, a trial casting of his Hadassah Hebrew family was made by the Amsterdam Foundry. Working versions were first issued in 1958.

ADRIAN FRUTIGER (1928–2015) Swiss designer and graphic artist. A prolific and versatile designer of type and signage. He was involved in the early transition from metal type to phototype. His serifed faces include Apollo, Breughel, Glypha, Iridium and Méridien. His sanserifs include Avenir, Frutiger and Univers. His titling and script types include Herculanum, Ondine, Pompeijana and Rusticana.

CLAUDE GARAMOND (*c.* 1490–1561) French punchcutter, working chiefly in Paris. Author of many roman fonts, at least two italics, and a full set of chancery Greeks. His surviving punches and matrices are now at the Plantin-Moretus Museum, Antwerp, and the Imprimerie Nationale's Atelier du Livre near Paris. Stempel Garamond roman *and* italic, Linotype Granjon roman, Günter Gerhard Lange's Berthold Garamond roman, Robert Slimbach's Garamond romans, and Ronald Arnholm's Legacy *italic* are all based on his designs. Monotype Garamond is not. (See also pp 234–35.)

JERÓNIMO ANTONIO GIL (1732–1798) Spanish engraver and typecutter, working in Madrid until 1778, and thereafter in Mexico City. For Spain's royal librarian, Juan de Santander, and the calligrapher Francisco de Santiago Palomares, he cut some fine Neoclassical romans and italics – and it was almost certainly Gil who cut the new Otomí language font that appeared in Mexico in 1785. Some of his punches and matrices are now at the Disseny Hub in Barcelona.

ERIC GILL (1882–1940) English engraver and stonecutter, working in England and Wales. His serifed faces include Joanna, Perpetua and Pilgrim. His one unserifed face is Gill Sans. Perpetua Greek is also his, but Gill Sans Greek is by other hands. Gill's type drawings are now in the St Bride Library,

Type Designers

The spelling *Garamont* is now usual in France, and *Garamond* in the English-speaking world. Both are authentic, and both were used by those who knew the man.

Gil's name is now commonly spelled either Jerónimo or Gerónimo. But he and his most educated friends often spelled it Geronymo.

London. Some of the matrices and punches for his types are now at the University Library, Cambridge; others are in the Clark Library, Los Angeles – but none of these punches were cut by Gill himself.

Type Designers

FREDERIC GOUDY (1865–1947) American type designer and founder. His serifed faces include University of California Old Style (later adapted for machine composition as Californian), Deepdene, Italian Old Style, Kaatskill, Kennerley, Village Nº 1 and Village Nº 2. His blackletters include Franciscan, Goudy Text and Goudy Thirty. His titling faces include Forum, Goudy Old Style and Hadriano. Goudy Sans is his only unserifed face. His only uncial is Friar. Most of Goudy's original material was destroyed by fire in 1939. What survives is at the Rochester Institute of Technology.

ROBERT GRANJON (*c.* 1513–1590) French typecutter working at Paris, Lyon, Antwerp, Frankfurt and Rome. Author of many Renaissance and Mannerist romans, italics, scripts, several Greeks, a Cyrillic, some Hebrews, and the first successful fonts of Arabic type. Some of his punches and matrices survive at the Plantin-Moretus Museum, Antwerp and the Nordiska Museet, Stockholm. Matthew Carter's Galliard is based primarily on Granjon's Ascendonica roman and italic.

FRANCESCO GRIFFO (*c.* 1450–1518) Bolognese punchcutter, working in Venice, Bologna and elsewhere in Italy. Author of at least seven romans, three italics, four Greeks and a Hebrew. None of Griffo's actual punches or matrices are known to survive. His letterforms have nevertheless been patiently reconstructed from the printed books in which his type appears. Giovanni Mardersteig's Griffo type is an exacting replica of one of Griffo's fonts. Monotype Bembo roman is based more loosely on the same font. Monotype Poliphilus is a rough reproduction of the same lower case with different caps. Mardersteig's Dante roman and italic are also based on a close study of Griffo's work. The italics, overall, have received far less attention than the romans.

The finest published study of Griffo's work is in Mardersteig's *Scritti* (1988).

ARNALDO GUILLÉN DE BROCAR (*c.* 1460–1524) Spanish master printer and typographer working first in Pamplona, then at Alcalá de Henares, which is now a suburb of Madrid. Author of several romans and at least two Greek fonts. The most notable of these is the Complutensian Greek type, cut about 1510. (*Complutensian* means 'from Complutum' – which is the old Roman name for Alcalá.)

FRANÇOIS GUYOT (*c.* 1510–1570) French punchcutter and type-founder. He was born in Paris but moved to Antwerp in the 1530s and spent most of the rest of his life there, cutting type for the printer Christophe Plantin and others.

VICTOR HAMMER (1882–1967) Austrian-born printer working chiefly in Italy and the USA. All of Hammer's types are uncials. They include American Uncial, Andromache, Hammer Uncial, Pindar and Samson. His type drawings and punches are now at the University of Kentucky, Lexington.

SEM HARTZ (1912–1995) Dutch graphic artist and engraver. He was born in Leiden and spent much of his life working at Joh. Enschedé en Zonen in Haarlem. His faces include the foundry face Emergo, which he cut himself, and Juliana (for British Linotype).

PIERRE HAULTIN (*c.* 1510–*c.* 1577) French punchcutter and engraver born near Angers, working in Paris, Lyon, Geneva and elsewhere. Author of at least eleven romans, eight italics, three Greeks, four titling faces, and a dozen fonts of music.

CRISTÓBAL HENESTROSA (1979–) Mexican type designer and typographer. His Espinosa Nova family is based on the fonts cast and probably cut in Mexico City by Antonio de Espinosa between 1552 and 1566.

JONATHAN HOEFLER (1970–) American type designer and digital founder. He established the Hoefler Type Foundry, New York, in 1989. Designer of Hoefler Text, Hoefler Titling, Gestalt, the Requiem family, and other faces.

KRIS HOLMES (1950–) American calligrapher. Designer of Isadora and Sierra; codesigner with Janice Fishman of Shannon, and with Charles Bigelow of the Lucida family.

JOHN HUDSON (1968–) English/Canadian type designer and expert in multilingual digital encoding. Designer of Aeneas and Manticore. Cofounder, with Ross Mills, of Tiro Typeworks in Vancouver.

MARK JAMRA (1956–) American typographer and graphic artist, trained in Switzerland. Designer of several artful postmodern faces, including Latienne, Alphatier and Kinesis.

JEAN JANNON (1580–1658) French punchcutter and printer. His romans and italics, cut at Paris and Sedan, may be the first Baroque types ever made. Matrices for his romans and italics are at the Atelier du Livre d'Art, where his type is known as the *caractères de l'université*. Monotype 'Garamond,' Linotype 'Garamond 3,' ATF 'Garamond,' Simoncini 'Garamond' and

Frederic Goudy's 'Garamont' are all based on Jannon's work, not on that of Claude Garamond. (See pp 234–35.)

NICOLAS JENSON (*c.* 1420–1480) French punchcutter and printer, working in Venice. Author of at least one roman, one Greek and five rotundas. Jenson's punches and matrices have long vanished, but his type has often been copied from his printed books. Bruce Rogers's Centaur, Ronald Arnholm's Legacy roman and Robert Slimbach's Adobe Jenson roman are based on his. Karlgeorg Hoefer's San Marco is based in large part on Jenson's rotundas.

Type
Designers

GEORGE WILLIAM JONES (1860–1942) English printer and type designer. Author of Linotype Estienne, Linotype Granjon, and the Venezia roman, which was later mated with an italic by Frederic Goudy. All Jones's faces are historical reconstructions. Linotype Granjon was the first commercial reconstruction of a genuine Garamond roman, mated with a Granjon italic.

LUI KARNER (1948–) Austrian typographer and letterpress printer. Codesigner, with Giovanni de Faccio, of the Rialto family and partner in the digital foundry *df*Type.

MIKLÓS TÓTFALUSI KIS (1650–1702) Hungarian scholar, printer and typecutter. Kis was trained in Amsterdam and worked there and in Kolozsvár (now Cluj, Romania). Stempel Janson is struck and cast primarily from his surviving punches. Linotype Janson Text (both the metal and digital versions) and Monotype Erhardt are based on his work.

RUDOLF KOCH (1876–1934) German calligrapher and artist. His titling faces include Koch Antiqua and Neuland. His blackletters include Claudius, Jessen, Wallau and Wilhelm Klingspor Schrift. Kabel is his only sanserif. Much of his material, formerly in the Klingspor Archive, Offenbach, is now in the Abteilung für Schriftguss, Darmstadt.

HENK KRIJGER (1914–1979) Dutch typographer, artist and novelist, born and raised in Sumba, Indonesia. Designer of four titling faces: Bambu, Bourdon, Raffia and Tarquinia. Krijger's drawings for Raffia are now in the Tetterode Collection, Universiteitsbibliotheek, Amsterdam.

VADIM VLADIMIROVICH LAZURSKI (1909–1994) Russian calligrapher and book designer. His Lazurski family includes both Cyrillic and Latin alphabets. The Cyrillic also exists in a proprietary foundry version known as Pushkin.

GUILLAUME LE BÉ *the elder* (1525–1598) French punchcutter working in Paris, Florence, Venice and Rome. Author of many Hebrew fonts, some fine romans and music types. Not to be

confused with his son, the learned typefounder known as Guillaume Le Bé the younger or Guillaume II Le Bé.

HENRIC PIETERSZOON LETTERSNIDER (*fl.* 1492–1511) Dutch punchcutter working at Gouda, Antwerp, Rotterdam and Delft. Author of a substantial number of blackletter types and fonts of large initials.

ZUZANA LIČKO (1961–) Slovakian-born American designer. Cofounder of *Emigre* magazine and its offshoot, the Emigre digital foundry. Designer of Journal, Electrix, Modula and other faces. With John Downer, codesigner of Triplex.

RICHARD LIPTON (1953–) American graphic artist. Designer of Arrus and codesigner, with Jacqueline Sakwa, of the script face Cataneo.

MARTIN MAJOOR (1960–) Dutch graphic artist trained at the Arnhem Academy. Designer of the Scala and Seria families.

GIOVANNI MARDERSTEIG (1892–1977) German-born Italian master printer, typographer, type historian and type designer. Author of Dante, Fontana, Griffo and Zeno. His material is at the Stamperia Valdonega, Verona.

GABRIEL MARTÍNEZ MEAVE (1972–) Mexican type designer, working near Mexico City. His faces include Organica, Integra, Neocodex and Mexica.

ROD MCDONALD (1946–) Canadian graphic artist and type designer working in Toronto and, since 2002, in Halifax. His work includes the Laurentian family, Slate, Goluska, and Cartier Book, a family of type begun by Carl Dair.

EDUARDO MANSO (1972–) Argentine typographer and type designer working in Barcelona. His Relato family now includes both serif and sanserif forms.

HANS EDUARD MEIER (1922–) Swiss typographer. Designer of Barbedor, Syndor and the several versions of Syntax.

JOSÉ MENDOZA Y ALMEIDA (1926–) French graphic artist and type designer, working in Paris. His faces include Mendoza, Photina, Pascal, Fidelio (a chancery script), Sully Jonquières (an upright italic) and Convention.

OLDŘICH MENHART (1897–1962) Czech type designer and calligrapher. His serifed Latin faces include Figural, Menhart and Parliament. His Manuscript family includes both Latin and Cyrillic faces. His titling faces include Czech Uncial and Monument.

WILLIAM ROSS MILLS (1970–) Canadian type designer and cofounder with John Hudson of Tiro Typeworks in Vancouver. He has become one of the principal experts on typography

for Native American languages. Author of the Plantagenet and Huronia families and several families of Canadian Syllabic type. His historical revivals include the 1530 Garamond Roman (first issued as '1520 Garamond').

ANTONIO DI BARTOLOMEO MISCOMINI (*c.* 1445–*c.* 1495) Italian punchcutter and printer, probably born in Bologna. He did most of his work in Venice, Modena and Florence, where he printed during the early 1490s and brought his roman and orthotic Greek types to final form.

GERRIT NOORDZIJ (1931–) Dutch typographer and teacher. From 1960 to 1990 he was responsible for training type designers at KABK (Koninklijke Academie van Beeldende Kunsten: The Royal Academy of Fine Arts) in The Hague, and thereby profoundly affected the course of modern type design in the Netherlands and elsewhere. Only two of his own designs are publicly available at present: the Ruse family and the blackletter Burgundica, issued in digital form by the Enschedé Font Foundry. Several of his other faces are reproduced in Lommen & Verheul, *Haagse Letters* (1996).

PETER MATTHIAS NOORDZIJ (1961–) Dutch typographer and digital founder. Designer of PMN Caecilia and proprietor of the Enschedé Font Foundry.

FRIEDRICH PETER (1933–) Canadian calligrapher and visual artist, born in Dresden and trained in Berlin. Designer of the script faces Vivaldi and Magnificat.

ALEXANDER PHEMISTER (1829–1894) Scottish punchcutter. Author of the Old Style Antique issued by Miller & Richard, Edinburgh, beginning in 1858. In 1861 he moved to Boston where he worked for the Dickinson Foundry.

FRIEDRICH POPPL (1923–1982) German calligrapher. His serifed faces include Pontifex and Poppl Antiqua. His sanserif is Laudatio. His titling faces include Nero and Saladin. His script types include Poppl Exquisit and Residenz.

JEAN-FRANÇOIS PORCHEZ (1964–) French type designer; founder and proprietor of Porchez Typofonderie in Malakoff, near Paris. Designer of Angie, Apolline, Parisine, and the extensive Le Monde family, initially created for the Paris newspaper *Le Monde*.

RICHARD PORSON (1759–1808) English classical scholar. He designed the original Porson Greek, which was cut in steel by Richard Austin. Monotype Porson and the digital GFS Porson are based closely on his work.

JOSEP EUDALD PRADELL (1721–1788) Catalan punchcutter and typefounder, working in Barcelona and Madrid. Like Caslon, he was initially trained as a gunsmith. Some of the best eighteenth-century Spanish books are printed in his types, though it is said that he could neither read nor write.

VOJTĚCH PREISSIG (1873–1944) Czech artist, typographer and teacher, working in Czechoslovakia and in New York City. Preissig designed several text and titling faces, including the one that bears his name. His surviving drawings are in the Strahov Abbey, Prague.

ERHARD RATDOLT (1447–1528) German punchcutter and printer working at Augsburg and Venice. Author of at least ten blackletters, three romans and one Greek. In 1486 he issued the first known type specimen. (The one surviving copy is in the Munich State Library.)

IMRE REINER (1900–1987) Hungarian artist and designer working chiefly in Switzerland. He was a skilled wood engraver and book illustrator. Author of several Expressionist faces, including Matura, Mercurius, Pepita, and Reiner Script.

PAUL RENNER (1878–1956) German typographer, type designer and teacher. Designer of Futura, Renner Antiqua, Renner Grotesk and the blackletter Ballade. His drawings for Futura are now in the Fundición Tipográfica Bauer, Barcelona.

JIM RIMMER (1934–2010) Canadian punchcutter and type designer. He was a great admirer of the work of Frederic Goudy and made several new faces – notably Amethyst, Albertan, Loxley and Stern – in similar spirit. His other work includes the Canadian Syllabic face RTF Syllabics. Rimmer's digital fonts are now issued by P-22. His drawings and archival material are at Simon Fraser University in Burnaby, B.C.

BRUCE ROGERS (1870–1957) American typographer, working chiefly in Boston, London and Oxford. Designer of Montaigne and Centaur. The original drawings for Centaur are now in the Newberry Library, Chicago.

SJOERD HENDRIK DE ROOS (1877–1962) Dutch designer, typographer and printer. Author of the uncials Libra and Simplex, the Nobel sanserif, and De Roos roman and italic.

RUDOLPH RŮŽIČKA (1883–1978) Czech-born American typographer, wood engraver and illustrator. Designer of Linotype Fairfield and Primer. In the USA, where 'foreign accents,' graphic or acoustic, were then frowned upon, Růžička spelled his name Ruzicka and called himself 'Ruzeeka.'

JACQUES DE SANLÈCQUE *the elder* (1558–1648) French punch-cutter, student of Guillaume Le Bé the elder. Author of several fine romans and italics, music type, and a number of non-Latin faces, including Armenian, Samaritan and Syriac.

JACQUES DE SANLÈCQUE *the younger* (1613–1659) Son of the preceding. French punchcutter and founder revered for his technical finesse in cutting small sizes.

VICTOR SCHOLDERER (1880–1971) British classical scholar and librarian. Designer of the New Hellenic Greek.

FRANTSYSK HEORHII SKARYNA (*c.* 1488–*c.* 1540) Belarusian physician, translator and printer, educated at Kraków and Padova. Author of several fonts of Cyrillic type, with which he printed at Prague and Vilnius.

ROBERT SLIMBACH (1956–) American type designer, on staff at Adobe since 1987. His faces include Arno, Brioso, Cronos, Adobe Garamond and Garamond Premier, Giovanni, Kepler, Minion, Poetica, Slimbach, Utopia and Warnock. His script faces include Sanvito and Caflisch. The Myriad family is a joint design by Slimbach and Carol Twombly.

FRED SMEIJERS (1961–) Dutch typographer and type designer. Author of the Quadraat, Reynard and Haultin type families, and of the useful book *Counterpunch.*

ERIK SPIEKERMANN (1947–) German graphic artist and one of the founders of the FontShop digital foundry. Designer of the Meta and Officina families.

SUMNER STONE (1945–) American type designer; first director of the type department at Adobe Systems. Author of many faces including Cycles, Davanti, Magma, Munc (an uncial), Numa, Populus, Sator, Silica, and the Stone family, which includes a serifed, unserifed and 'informal' series.

FRANTIŠEK ŠTORM (1966–) Czech typographer, designer and musician working in Prague. Designer of Jannon, Jannon Sans, and many other faces.

KONRAD SWEYNHEYM (*c.* 1415–1477) German monk and letterpress printer, working in central Italy. Probable author of the two romans and one Greek which he and his partner Arnold Pannartz used at Subiaco and Rome from 1464 to 1473.

GIOVANANTONIO TAGLIENTE (*fl.* 1500–1525) Italian calligrapher and designer of at least one chancery italic type. Monotype Bembo italic is derived from this font.

AMEET TAVERNIER (*c.* 1522–1570) Flemish typecutter and printer working primarily at Antwerp. Author of many fine romans, italics, blackletters and civilité script types.

GEORG TRUMP (1896–1985) German artist and type designer, initially a pupil of Ernst Schneidler. His serifed text faces include Mauritius, Schadow and Trump Mediäval. His blackletters include Trump Deutsch. His titling faces and scripts include Codex, Delphin, Jaguar and Time.

JAN TSCHICHOLD (1902–1974) German immigrant to Switzerland. Designer of the Sabon family and the Saskia script. Several of Tschichold's unproduced phototype designs were destroyed in the Second World War.

CAROL TWOMBLY (1959–) American type designer and visual artist. From 1988 until 1999, when she retired, she was one of two type designers on staff at Adobe Systems. Her work includes the text family Chaparral and the titling faces Charlemagne, Lithos, Nueva, Trajan and Viva. Adobe Caslon is her digital revival of the work of William Caslon. With Robert Slimbach, she is the codesigner of the Myriad family. (The recently issued distortions of Trajan are not hers.)

GERARD UNGER (1942–) Dutch type designer and teacher. His serifed faces include Amerigo, Demos, Hollander, Oranda, Paradox and Swift. His unserifed faces include Argo, Flora and Praxis.

HENDRIK VAN DEN KEERE (*c.* 1540–1580) Flemish typecutter, working at Ghent and Antwerp. He cut many romans and blackletters, at least one script type (a civilité) and several fonts of music type, but no italic. DTL Van den Keere roman is based on his work.

CHRISTOFFEL VAN DIJCK (1606–1669) Dutch punchcutter. Author of several Baroque romans, italics and blackletters. Monotype Van Dijck and DTL Elzevir are based on his work. Jan van Krimpen's Romanée and Gerard Unger's Hollander echo it in various ways. Most of Van Dijck's material has perished. The few surviving punches and matrices are at the Enschedé Museum, Haarlem.

JAN VAN KRIMPEN (1892–1958) Dutch typographer and chief designer at Joh. Enschedé en Zonen, Haarlem. His faces include Lutetia, Romanée, Romulus, Sheldon, Spectrum, Haarlemmer, Cancelleresca Bastarda (a chancery italic), Romulus Sans, Antigone Greek, Dubbele Augustijn Open Capitals, Lutetia Open Capitals and Romulus Open Capitals. Except for Haarlemmer and Sheldon, all these were first cut at Enschedé by Paul Helmuth Rädisch. Some of his best work is still awaiting translation to digital form – and some of the best digital versions made thus far are restricted to private use.

JOVICA VELJOVIĆ (1954–) Calligrapher and type designer born in Kosovo, trained in Beograd, now working in Germany. His types include Gamma, Esprit, Ex Ponto, Sava, Silentium and Veljović.

JUSTUS ERICH WALBAUM (1768–1837) German typefounder and printer, author of several Neoclassical and Romantic faces. Both Berthold Walbaum and Monotype Walbaum are based on his surviving punches and matrices.

FREDERIC WARDE (1894–1939) American typographer, working chiefly in France, Italy and England. Designer of the Vicenza and Arrighi italics. Some of Warde's drawings are in the Newberry Library, Chicago. The Rochester Institute of Technology has punches and matrices for the early (handcut) Arrighi – Arrighi as it was before its marriage to Centaur roman.

EMIL RUDOLF WEISS (1875–1942) German poet, painter, calligrapher and type designer. Author of a fraktur, a textura (Weiss Gotisch), a rotunda (Weiss Rundgotisch), Weiss Antiqua roman and italic, a suite of typographic ornaments, and three series of titling caps or initials. All these were cut by Louis Hoell and issued by the Bauer Foundry, Frankfurt.

ALEXANDER WILSON (1714–1786) Scottish punchcutter, typefounder and astronomer, working at Camlachie, near Glasgow. Author of the best romans, italics and Greeks produced in the Scottish Enlightenment.

BERTHOLD WOLPE (1905–1989) German calligrapher and typographer who spent his later life in England. Pegasus is his text face. His titling faces include Albertus and Hyperion.

HERMANN ZAPF (1918–2015) German calligrapher, type designer, book designer and teacher. His types include the whiteletters Aldus, Comenius, Euler, Hunt Roman, Melior, Optima, Orion, Palatino, Zapf International and Zapf Renaissance; the blackletters Gilgengart, Winchester and Stratford; the titling faces Kompakt, Michelangelo, Phidias and Sistina; the Greeks Euler, Heraklit and Palatino Greek; and the script faces Venture, Zapf Chancery, Zapf Civilité and Zapfino.

GUDRUN ZAPF-VON HESSE (1918–) German calligrapher and book artist. Her text and titling faces include Alcuin, Carmina, Diotima, Nofret, Ariadne and Smaragd.

APPENDIX E: TYPEFOUNDRIES

A rigorous encyclopedia of the world's typefoundries – metal, photographic and digital, present and past – would be a very useful document. It would also be a thick one, always out of date and always riddled with lacunae because the news is intermittent and the records are incomplete. This brief list is limited to metal foundries, matrix engravers and digital foundries about which I have learned enough to say that they have originated, preserved or revived type designs of lasting value for setting text in Latin, Cyrillic or Greek.

Many of the punchcutters listed in appendix D once cast and sold the fonts they cut, and many type designers currently at work run digital foundries of their own. To avoid repetition, such one-man or one-woman foundries are omitted from this list – unless, like the foundries of William Caslon and Guillaume Le Bé, they outlived their own creators and evolved into separate institutions.

Two on-line foundry lists and an on-line list of type museums are mentioned in the bibliography (page 382). They too are always out of date and necessarily incomplete, but certainly worth checking.

Adobe Systems, San Jose, Calif. Fundamentally a software company, founded in 1982 by John Warnock and Charles Geschke. Adobe was the original developer of the PostScript computer language – one of the foundation stones of digital typography. It is also, with Microsoft, co-creator of the OpenType font format. In the early 1980s it established a digital foundry and an ambitious type development program directed by Sumner Stone. Adobe has issued digital versions of many historical types as well as original designs by Robert Slimbach, Carol Twombly, Jovica Veljović and many others.

Agfa, Wilmington, Mass. In 1988 Agfa-Gevaert NV absorbed the Compugraphic Corporation, a manufacturer of photosetting machines and film matrices. A digital foundry known as Agfa-Compugraphic was then formed and passed from hand to hand (e.g., it was for a time part of the Bayer Corporation). From 1998 to 2004 Agfa also owned the digital rump of Monotype. During its brief spell as a digital founder, Agfa issued new designs by Otl Aicher, David Siegel and others.

Amsterdam Foundry, Amsterdam. A metal foundry established in Rotterdam in 1851 by Nicolaas Tetterode with stock from the Broese Foundry in Breda. The firm moved to Amsterdam in 1856 and in 1892 changed its name from Lettergieterij N. Tetterode to Lettergieterij Amsterdam. Typecasting operations waned in the 1970s and ceased altogether in 1988. During the twentieth century it issued new designs by Sjoerd de Roos, Dick Dooijes, Imre Reiner and others. The surviving matrices and other materials are now at the library of the University of Amsterdam.

ATF (*American Type Founders*), Elizabeth, New Jersey. This was the largest metal typefoundry in North America, formed in 1892 by amalgamating a number of smaller firms. In its best days, it issued original designs by M.F. Benton, Lucian Bernhard, Frederic Goudy and many others. Though the company began to falter at the end of the 1920s, it clung to life until 1993. Its library is now at Columbia University, New York. Much of the older typographic material is in the Smithsonian Institution, Washington, DC.

For a raw account of ATF's last years, see Theo Rehak's *The Fall of* ATF (2004).

Bauer Foundry, Frankfurt. A metal foundry established in 1837 by Johann Christian Bauer. It expanded into an international network toward the end of the nineteenth century. The Bauer Foundry as such ceased to exist in 1972, but one branch of the old empire – the Fundición Tipográfica Bauer (FTB) in Barcelona – has survived (see page 365). Bauer issued original faces by its founder and later by Lucian Bernhard, Imre Reiner, Paul Renner, Emil Rudolf Weiss and others. The surviving punches and matrices are now at FTB in Barcelona and the Museum für Druckkunst in Leipzig.

Berlingska Stilgjuteriet, Lund, Sweden. A metal typefoundry and printing house founded in 1837. It ceased operation about 1980 but was typographically important in the twentieth century for casting the faces by Karl-Erik Forsberg.

Berthold Foundry, Berlin. Hermann Berthold's metalworks entered the typefounding business in 1893. It acquired the original punches and matrices of J. E. Walbaum and later issued original faces by Günter Gerhard Lange, Herbert Post, Imre Reiner and others. Berthold was involved in the creation of phototype as early as 1935. It ceased casting metal type in 1978 and turned to producing digital fonts in the 1980s. As a digital foundry, Berthold did not prosper, and in 2011 its digital operations were absorbed by Monotype Imaging. The

foundry's collection of punches and matrices is now in the care of the Museum für Verkehr und Technik, Berlin.

Bitstream, Cambridge, Mass. A digital foundry established in 1981 by Matthew Carter, Mike Parker, Cherie Cone and Rob Friedman – all of whom later left the company. Bitstream has issued digital revivals of many earlier faces and new designs by Carter, John Downer, Gerard Unger, Gudrun Zapf-von Hesse and others. As owner of the Myfonts website, it also became for a time the largest retailer of digital fonts. It was bought by Monotype Imaging in 2012.

Caslon Foundry, London. A metal typefoundry established by William Caslon about 1723 and maintained as a family business for four generations. It survived as the firm of H.W. [Henry William] Caslon until 1936. Most of the older surviving punches are now in the St Bride Printing Library, London. The newer material passed to Stephenson, Blake. In 1998, Justin Howes acquired rights to the name H.W. Caslon & Co. Under this name, his short-lived digital foundry in Northamptonshire issued the series known as Founder's Caslon.

Dale Guild Foundry, Howell, New Jersey. A metal foundry established in 1994 by Theo Rehak with equipment acquired largely from ATF. Since 2010, it has been owned and operated by Micah Slawinski Currier and Dan Morris.

Deberny & Peignot (D&P), Paris. Joseph Gaspard Gillé the elder, one of Fournier's apprentices, opened his own foundry in Paris in 1748 and left the business to his son in 1789. In 1827, the novelist Honoré de Balzac acquired this foundry as part of his intended writing, printing and publishing empire. The scheme failed at once, but the foundry was bought and rescued by Alexandre de Berny (or Deberny).

Gustave Peignot entered separately into the typefounding business in 1865. His own foundry began its first creative phase under his son Georges and grandson Charles Peignot, who issued historical revivals of the work of Jean Jannon and created a series of types based on the lettering of the eighteenth-century engraver Nicolas Cochin.

The Deberny and Peignot foundries merged in 1923. Under the guidance of Charles Peignot, the enlarged firm issued new designs by Adolphe Cassandre, Adrian Frutiger and others. When D&P closed in 1975, the type drawings went to the Bibliothèque Forney, Paris. Most of the typographic material – including a set of original Baskerville matrices – went to the

Haas (now Fruttiger) Foundry, Münchenstein. Baskerville's punches, also formerly held by D&P, were transferred to the University Library, Cambridge.

dfType, Texing, Austria. A digital foundry established in 1999 by the Venetian calligrapher Giovanni de Faccio and the Austrian printer-typographer Lui Karner. The foundry issues the Rialto family and other text and titling faces, rooted in De Faccio's calligraphy.

DTL (*Dutch Type Library*), 's-Hertogenbosch, Netherlands. A digital foundry established by Frank Blokland in 1990. It has issued original faces by Blokland, Chris Brand, Gerard Daniëls, Sjoerd de Roos, Gerard Unger and others, and historical revivals of types by Christoffel van Dijck, Jan van Krimpen, J.M. Fleischman and Hendrik van den Keere.

EETS (Εταιρεία Ελληνικών Τυπογραφικών Στοιχείων). Listed here under its English name, GFS: *Greek Font Society.*

Elsner & Flake, Hamburg. A digital foundry established in 1989 by Günther Flake and Veronika Elsner. The firm has produced a large number of digital revivals and made the original digital versions of a number of ITC faces.

Emigre, Sacramento. A digital foundry established in Berkeley in 1985 by Rudy VanderLans and Zuzana Ličko. In 1992, the office moved to Sacramento. The firm issues original faces by Ličko, VanderLans and others.

Joh. Enschedé en Zonen (Johann Enschedé & Sons), Haarlem, Netherlands. A printing plant and typefoundry operating from 1743 to 1990. In two and a half centuries of operation, the firm acquired material from many sources, including some of the punches and matrices of J.M. Fleischman and Christoffel van Dijck. During the early twentieth century, it issued in foundry form the types of its chief designer, Jan van Krimpen. In 1990, its stock of matrices and punches was transferred to the Enschedé Museum.

The Enschedé Font Foundry (TEFF), Hurwenen, Netherlands. A digital foundry established in 1991 under the direction of Peter Matthias Noordzij. It has issued original designs by Bram de Does, Gerrit Noordzij, Christoph Noordzij, Mário Feliciano and Fred Smeijers.

Fann Street Foundry, London. A metal foundry established in 1802 by Robert Thorne. In 1829 it absorbed the Fry Foundry of Bristol. Its creative period came in the 1850s, when it was owned by Robert Besley and issued original designs cut by Benjamin Fox. It was absorbed in 1905 by Stephenson, Blake.

Font Bureau, Boston. A digital foundry established in 1989 by David Berlow and Roger Black. It has issued both historical revivals and original designs by John Downer, Tobias Frere-Jones, Richard Lipton, Greg Thompson and others.

FontShop International, Berlin. A digital foundry established in 1989 by Erik Spiekermann. It has issued original designs by Spiekermann, Erik van Blokland, Martin Majoor, Just van Rossum, Fred Smeijers and many others, and it is now a major distributor of fonts from other sources.

Walter Fruttiger, Münchenstein, Switzerland. The foundry has operated under this name only since 1989 but traces its roots to an operation founded by Jean Exertier in 1580. For over two centuries it was known as the Haas Foundry, after Johann Wilhelm Haas, who acquired the company in 1740. It now possesses little material from before the eighteenth century, but its holdings include the original matrices for Helvetica and some original Baskerville matrices, acquired by Haas in the 1970s from D&P.

FTB (*Fundición Tipográfica Bauer*), Barcelona. A metal foundry established in 1885. It is the last surviving branch of the old Bauer network and now holds much of the Bauer Foundry's surviving typographic material. From 1922 to 1995 it was known as FTN, the Fundición Tipográfica Neufville – a name still used by the digital arm of the company.

Genzsch & Heyse, Hamburg. A metal foundry established in 1833 and absorbed by Linotype in 1963. It issued both blackletter and whiteletter types designed by Friedrich Bauer, Otto Hupp and others.

Rainer Gerstenberg, Frankfurt. This small metal foundry was established in 2012 by one of the last surviving craftsmen trained at the Stempel foundry. In affiliation with the Hessischen Landesmuseums, it runs a modest but steady casting program, drawing on matrices from Stempel, Deberny & Peignot, Haas, Nebiolo, Olive, and other sources.

Grafotechna, Prague. A metal typefoundry important for its castings of the work of Miloslav Fulín, Oldřich Menhart, Vojtěch Preissig and other Czech designers. It closed in 1990.

GFS (*Greek Font Society*), Athens. A digital foundry established in 1992. It has issued digital versions of many historically important Greek types, as well as new Greek designs by Takis Katsoulidis and George Matthiopoulos.

Haas Foundry. See *Walter Fruttiger.*

Hoefler & Co., New York. Jonathan Hoefler established his digital

foundry in Manhattan in 1989. Tobias Frere-Jones joined as a partner in 2004 and departed in 2014. The firm has produced important new designs and some admirable digital revivals of the Fell types.

Dr-Ing. Rudolf Hell. See *Linotype.*

Imprenta Real, Madrid. Spain's Royal Printing House was established by Carlos III in 1761, initially as a department of the Biblioteca Real. For a quarter century it was an enthusiastic patron of Jerónimo Gil, Eudald Pradell, Antonio Espinosa de los Monteros and other punchcutters. In 1793, it became a separate institution, but its intense, brief phase of typographic creativity was by then already over. In 1836 it was renamed the Imprenta Nacional. In 1930 its neglected but splendid collection of punches and matrices was transferred to the Escuela Nacional de Artes Gráficas. After several decades of further neglect, the collection was moved to Barcelona. It is now in the Gabinet de les Arts Gràfiques, a part of Barcelona's Disseny Hub Museum.

Imprimerie Nationale, Paris. A printing house and foundry established by Louis XIII in 1640 as the *Imprimerie Royale.* With the French Revolution (1789), it was renamed first *l'Imprimerie Nationale* and then *l'Imprimerie de la République.* With the coronation of Napoleon I in 1804, it became *l'Imprimerie Impériale.* After the Restoration of 1815, it was again called *Royale.* From 1848 to 1852 it was again *Nationale.* From 1852 to 1870, under Napoleon III, it was once more *Impériale.* It has remained *l'Imprimerie Nationale* since 1870 – but it was privatized in 1993, so the *meaning* of the name has recently changed, even if the name itself has not. (Its principal business nowadays is printing licenses, certificates, machine-readable passports and identity cards.) In 2005, the most precious equipment and material and a few staff, including the sole remaining punchcutter, Nelly Gable, were moved to temporary quarters on the outskirts of Paris under the name *Atelier du livre d'art et de l'estampe.* This atelier, whose future is uncertain, is the world's one surviving institution with a punchcutter on salary. Its invaluable collection includes many of Garamond's punches and Jannon's matrices, other punches and mats by Firmin Didot, Philippe Grandjean, Marcellin Legrand and Louis-René Luce, and much handcut type for the ancient scripts of Europe, Africa and Asia.

In the twentieth century, punches from D&P, FTB, Haas and other collections were donated to the Imprimerie Natio-

nale. When he retired in 2005 as senior punchcutter, Christian Paput estimated that the holdings included 230,000 handcut steel punches and 224,000 Chinese characters engraved in wood. Others have put the number of punches at over 300,000. Though protected in theory, this enormous resource now seems decidedly at risk.

Intertype (International Typesetting Machine Co.), New York. When the basic Mergenthaler Linotype patents expired in 1912, a group of investors had assembled in New York, ready to build a competing, and very similar, machine. Its matrices included new adaptations of foundry faces designed by Dick Dooijes and S.H. de Roos. The firm was involved in photo-typesetting as early as 1947. After a merger in the 1950s, it was known as the Harris Intertype Corporation and became a principal manufacturer of photographic matrices.

ITC (*International Typeface Corporation*), New York. Founded by Aaron Burns and Herb Lubalin in 1969 as a phototype licensing and distribution agency. In the 1980s, ITC began to license digital designs as well. Not until 1994 did it start to produce and market its faces directly. For more than a decade, there was a readily identifiable ITC style: a standardized large torso with interchangeable serifs that reduced the alphabet and its history to superficial costume. This Procrustean approach to type design faded in the 1980s. Coincidentally, the company was bought in 1986 by Esselte Letraset. It was bought again by Agfa Monotype in 2000. The list includes original designs by Ronald Arnholm, Matthew Carter, Robert Slimbach, Erik Spiekermann, Hermann Zapf and many others.

Klingspor Brothers, Offenbach. A metal foundry established in 1842 and operated under several different names before its acquisition in 1892 by Karl Klingspor. It issued original faces by Peter Behrens, Rudolf Koch and Walter Tiemann. After its closure in 1953, the library and drawings were transferred to the Klingspor Museum, Offenbach, and most of the matrices to the Stempel Foundry, Frankfurt. The museum now maintains a useful on-line archive of type designers.

Lanston Monotype Machine Co., Philadelphia. The Monotype machine as we know it was devised by John Sellers Bancroft of Philadelphia in 1900. It grew, however, from a series of earlier machines invented by Tolbert Lanston of Washington, DC, beginning in 1887. The American company created to manufacture and sell these devices started slowly and was soon outdistanced by its English counterpart, formed a decade

later with the same objective and almost the same name (see below: *The Monotype Corporation*). The American firm nevertheless remained in business, moving to Philadelphia in 1901 and pursuing on a smaller scale its own design agenda. This included cutting matrices for historical revivals and original designs by Frederic Goudy, Sol Hess and others. The master

Typefoundries

patterns and much of the specialized equipment went in 1966 to ATF, then passed from hand to hand until they perished through neglect. A separate firm known as the Lanston Type Co. – created by Gerald Giampa in 1983 specifically to digitize the Lanston patterns – struggled along until sold in 2004 to P-22. The patterns themselves are now lost, but many of the original drawings are in the Smithsonian.

Le Bé Foundry, Paris. Founded by the punchcutter Guillaume Le Bé the elder about 1560. It remained in the family until 1730, when it was sold to Jean-Pierre Fournier (father of Pierre-Simon Fournier). At that time, it included punches and matrices reliably attributed to Garamond, Granjon, and other sixteenth-century artists. The Fourniers took great pride in this collection, but it vanished without a trace in the 1790s, in the throes of the French Revolution.

Lettergieterij Amsterdam. See Amsterdam Foundry.

Linotype, Bad Homburg. In Brooklyn in 1886, Ottmar Mergenthaler began to sell his newly invented Linotype machine. This led in 1890 to the founding of two firms: Mergenthaler Linotype Co., Brooklyn, and Mergenthaler Linotype & Machinery Ltd., Manchester. Their German ally, Mergenthaler Setzmaschinen-Fabrik, was created in 1896 in Berlin and moved to Frankfurt in 1948. Linotype matrices were produced under contract by the Stempel Foundry, Frankfurt, from designs by artists such as Warren Chappell, Georg Trump and Hermann Zapf, and independently in England from the designs of George W. Jones and others, and in the USA from designs by W. A. Dwiggins, Rudolph Růžička and others.

AG = *Aktiengesellschaft* (joint-stock company). GmbH = *Gesellschaft mit beschränkter Haftung* (limited liability company).

Linotype began to make photosetting equipment in the 1950s, CRT (cathode ray tube) photosetters in the 1960s, and laser typesetters in the 1980s. In 1987, when the business had shifted well away from heavy machinery, the German firm was bought by a bank and restructured as Linotype AG. It merged in 1990 with Dr-Ing. Rudolf Hell GmbH of Kiel.

In 1997, Linotype's digital business was spun off to become first the Linotype Library, then (in 2005) simply Li-

notype GMBH. Its headquarters since 1998 have been in Bad Homburg, north of Frankfurt. It has issued many of the old Linotype faces in digital form, and new designs by Adrian Frutiger, Hermann Zapf and many others. In 2006, it was bought by Monotype Imaging, but it retains its own name and location (and its invaluable archive). Historical materials from the American branch of the company have been moved to the Rochester Institute of Technology, Rochester, NY, and to the University of Kentucky, Lexington.

The Ludlow Typograph Co., Chicago. Washington Ludlow of Chicago began making typecasting machinery in 1906, but the Ludlow caster which his company sold throughout the early twentieth century was a later device, designed and built by William Reade in 1909. The machine casts slugs from hand-set proprietary matrices and is therefore used primarily for display type, but several Ludlow faces have been successfully adapted for digital text composition. The company issued both historical revivals and original designs, chiefly by its director of typography, R.H. Middleton. It ceased operation in North America in 1986. The English arm, founded in the early 1970s, closed in 1990.

Ludwig & Mayer, Frankfurt. A metal foundry established in 1920 and closed in 1985. The surviving material went to FTB in Barcelona. During its heyday, the firm issued original designs by Jakob Erbar, Helmut Matheis, Ilse Schüle and others.

M&H, San Francisco. A metal foundry and type archive now at the Presidio of San Francisco. It began in 1915 as a San Francisco typesetting firm, known from 1926 to 1989 as Mackenzie & Harris. Andrew Hoyem acquired the company in 1989, renaming it M&H Type. In 2000 it was brought under the wing of the Grabhorn Institute.

Masterfonts, Tel Aviv. A digital foundry established in 1986 by Zvika Rosenberg. It has become the primary supplier of digital Hebrew fonts.

Mergenthaler. See *Linotype.*

Miller & Richard, Edinburgh. A metal foundry established in 1809 by George Miller, joined by Walter Richard in 1832. The foundry issued original designs by Richard Austin, Alexander Phemister and others. When it ceased operation in 1952, the surviving material went to Stephenson, Blake.

The Monotype Corporation, Redhill, Surrey (UK). An entity called the Lanston Monotype *Company* was first formed in the USA

in 1887. Its sister, the Lanston Monotype *Corporation* (later simply the Monotype Corporation), was formed in England a decade later. For the American firm, see *Lanston Monotype*.

The typographically creative phase of the English firm began in 1922 with the appointment of Stanley Morison as typographic advisor. Over the next few decades, English Monotype cut a number of meticulously researched historical revivals as well as new designs by Eric Gill, Giovanni Mardersteig, Jan van Krimpen and others. John Dreyfus succeeded Morison as typographic advisor in 1955 and remained in that position until 1982. Monotype began producing photosetting equipment and photographic matrices in the 1950s, and laser typesetting machines in the 1970s. It ceased operation in 1992. Metal matrices are in theory still made on demand in England by a separate entity, the Merrion Monotype Trust.

Monotype Imaging, Woburn, Mass. In 1992, a firm called Monotype Typography was spun from the dying Monotype Corporation to make and sell digital type, including digital versions of faces earlier made as metal matrices for the Monotype machine. When sold to Agfa in 1998, the firm was renamed Agfa Monotype. Two years later, Agfa Monotype bought ITC. Agfa Monotype was then sold in 2004 to an equity firm (TA Associates, Boston), which renamed it Monotype Imaging. In 2006 Monotype Imaging bought what was left of Linotype. Later it bought the Chicago digital foundry known as Ascender Corporation and the digital arm of Berthold. In 2012 it also bought Bitstream.

Museum für Druckkunst, Leipzig. A working typographic museum founded in 1994 by Eckehart Schumacher-Gebler. Its large stock of typographic material includes original punches and matrices by Johann Christian Bauer, Lucian Bernhard, Jakob Erbar, Paul Renner, Jacques Sabon and many others.

Nebiolo Foundry, Torino. A metal typefoundry established in 1878 by Giovanni Nebiolo through the amalgamation of several older and smaller firms. It is important for its castings of original designs by Alessandro Butti and Aldo Novarese. The firm ceased making type in the late 1970s.

Neufville Foundry, Barcelona. See FTB.

Norstedt Foundry, Stockholm. A metal foundry, formerly supplied with matrices by Robert Granjon, François Guyot, Ameet Tavernier and others. The surviving material is now in the Nordiska Museet, Stockholm.

Fonderie Olive, Marseilles. A metal foundry established in 1836. It was sold to Linotype and closed in 1978. Before its demise, it originated a number of designs by Roger Excoffon, François Ganeau and others. The surviving material is now at the Fruttiger firm in Münchenstein.

p-22, Buffalo, NY. A digital foundry created in 1994 by Richard Kegler and others. In 2004 it absorbed the remains of the Lanston Type Co. (digital successor to Lanston Monotype). Later it also absorbed the digital arm of Jim Rimmer's Pie Tree Foundry.

ParaType, Moscow. Successor (as of 1998) to the ParaGraph (or Parallel Graphics) digital foundry, which was founded in 1989. It issues original designs and historical revivals of Cyrillic, Latin, Georgian, Arabic, Hebrew and Greek faces.

Plantin-Moretus Museum, Antwerp. The printing house and foundry established by Christophe Plantin about 1555 was conserved for nearly three centuries by descendants of Plantin's son-in-law, Jan Moretus. It was converted to a museum in 1877. It includes a rich collection of original material by Claude Garamond, Robert Granjon, Hendrik van den Keere, Ameet Tavernier and other early artists.

Polygraphmash (НПО Полиграфмаш), Moscow. The Institute for Machine Printing. Its drawing office, active from 1938 to 1992, issued type designs by Galina Bannikova, Nikolai Kudryashev, Pavel Kuzanyan, Vadim Lazurski, Anatoli Shchukin and others.

Scangraphic, Hamburg. Formerly Mannesmann Scangraphic, a manufacturer of photosetting equipment. In the 1980s it began to issue digital fonts. These were poorly finished but included one important design by Hermann Zapf.

Schelter & Giesecke, Leipzig. Johann Gottfried Schelter and Christian Friedrich Giesecke established this foundry in 1819. Many of the early faces were designed by Schelter himself. In 1946 the firm was nationalized as Typoart.

D. Stempel, Frankfurt. After its foundation by David Stempel in 1895, this firm absorbed the holdings of many other German foundries. It also issued many original faces by Hermann Zapf, Gudrun Zapf-von Hesse and others, and sold type cast from the original matrices of Miklós Kis. The foundry closed in 1986, and most of its typographic material is now in the Abteilung für Schriftguss, Hessischen Landesmuseums (also known as the Haus für Industriekultur) in Darmstadt. The

tools of Stempel's last master punchcutter, August Rosenberger, are now in the Gutenberg Museum, Mainz.

Stephenson, Blake, Sheffield (UK). A metal foundry established in 1819 by John Stephenson, James Blake and William Garnet, using materials acquired chiefly from William Caslon IV. Over time, the firm added further material from the Fann Street Foundry, the original Caslon Foundry, and elsewhere. It ceased operation in 2004. Much of the inherited typographic material is now in the Type Museum, Hackford Road, London – which is itself now closed and whose future is in doubt.

Tetterode. See *Amsterdam Foundry.*

Tiro Typeworks, Vancouver. A digital foundry established in 1994 by John Hudson and William Ross Mills. It is named for Marcus Tullius Tiro, the Roman slave (freed in 53 BCE) who served as Cicero's scribe. Tiro has developed extensive expertise in the design and encoding of non-Latin faces, especially those involving many contextual alternates.

Typoart, Dresden & Leipzig. A metal foundry formed in 1946 by nationalizing the existing operations of Schelter & Giesecke and Schriftguss. From 1964 until 1995, when operations ceased, the head of design was Albert Kapr. The surviving material is now in the Museum für Druckkunst.

URW (*Unternehmensberatung Karow Rubow Weber*), Hamburg. Established as a software firm in 1971, URW was diverted into digital typography by Peter Karow, a physicist excited by typography, who joined it in 1972. It was the original developer of the Ikarus system for digitizing type and of the HZ system for paragraph-based justification. It issued a large number of historical revivals as well as original faces by Hermann Zapf, Gudrun Zapf-von Hesse and others. The firm entered receivership in 1995. Its library has since been distributed by a corporate successor known as 'URW++.'

Johannes Wagner, Ingolstadt. Established at Leipzig in 1902 by Ludwig Wagner and relocated to Ingolstadt in 1949 by his son Johannes. It has acquired matrices from Berthold, Johns, Weber and other foundries, and continues to cast type.

C.E. Weber Foundry, Stuttgart. A metal foundry established in 1827. It issued original faces by Georg Trump and others before it closed in 1971. The surviving material was bought by the Stempel and Wagner foundries.

Typography, like language, is more important to me for what it allows to happen than for anything it accomplishes on its own. I hope that in writing a book on the subject I have not given the impression that either typography or design is an end in itself.

A few old friends and typographic mentors are mentioned in the foreword. I owe thanks to many others. They include Christian Axel-Nilsson, Charles Bigelow, Frank Blokland, Fred Brady, Michael Caine, Matthew Carter, Sebastiano Cossia Castiglioni, Bur Davis, Luc Devroye, James Đỗ Bá Phước, Bram de Does, John Downer, Peter Enneson, Mário Feliciano, Christer Hellmark, Richard Hendel, Richard Hopkins, John Hudson, Peter Karow, John Lane, Ken Lunde, Linnea Lundquist, Rod McDonald, George Matthiopoulos, William Ross Mills, Thomas Milo, Gerrit Noordzij, Peter Matthias Noordzij, José Ramon Penela, Thomas Phinney, Robert Slimbach, Mirjam Somers, Jack Stauffacher, Sumner Stone, Carol Twombly, Gerard Unger, Ken Whistler, and some others no longer alive – Dan Carr, Paul Hayden Duensing, Richard Eckersley, Sjaak Hubregtse, Michael Macrakis, Will Powers and Jim Rimmer – who have made this a much better book, and its author a less ignorant human being, in a variety of ways.

Translations of the work – especially those into Polish, Russian and Greek – have put me increasingly in touch with typographers whose training and experience is a good deal different from mine. Their careful reading and engagement with the text has taught me many things. Translators and their publishers have also, over the years, spotted a number of errors and obscurities that I myself was blind to. In this regard, I'm especially grateful to Robert Oleś, André Stolarski, Adam Twardoch, Vladimir Yefimov and Maxim Zhukov. And I am grateful above all, for her sharp eye and sharp questions, to Jan Zwicky.

Most of the drawings were made by hand for the original edition and recreated in digital form by Glenn Woodsworth.

Over the past twenty years, many readers have asked about the epigraph from Kimura Kyūho. The full text can be found in the Budōsho Kankōkai anthology *Shinpen bujutsu sōsho* (New Library of the Martial Arts). Typography is not a martial art, but Kimura's dialogue has remarkably little to say that is not germane to the practice of typography. The only translation I have ever seen

新編武術叢書 [Tokyo, 1968], pp 345–62.

373

appeared quite recently (in Christopher Hellman's *The Samurai Mind,* Tokyo, 2010). I hope that other attempts to interpret this subtle text will follow.

For those concerned about such things, I might also record that the first edition of this book was set in Ventura Publisher software, the second edition in Quark, the third and fourth in successive versions of InDesign. With each such shift has come a marked increase in technical capability. I have nevertheless, in every case, been obliged at times to subvert the software, forcing it to do things its makers didn't foresee, or things they did foresee and tried to exclude.

The book has involved the close testing of many fonts of type, most of them digital, some of them metal or film. These have come from nearly all the active foundries listed in appendix E, and from some whose operations have now ceased.

It remains the case that I have never yet tested a perfect font, no matter whether it came in the form of foundry metal, a matrix case, a strip of film or digital information. I have tested very beautiful and powerful designs, and extraordinary feats of hardware and software engineering, but no font has crossed my path that could not be improved by sensitive editing. One reason is, the task is never done completely: no designer can foresee the inner logic of all possible texts and languages, nor all the other uses to which type is rightly put. Another reason is that setting type is a collaborative exercise, like acting from a script or playing from a score. The editing of type, like the editing of music, and the tuning of fonts, like the tuning of instruments, will end when everything else does, but not sooner.

Meantime, there are those who dream of a perfect world in which copyrighted text is translated into copyrighted glyphs through copyrighted rules with no more human intervention than it takes to feed a tape to a machine, while money flows in perpetuity to everyone involved. There are also those who think that putting chairs and air-conditioners in hell will make it just as good as heaven. Actually, working with type is an earthly task, much less like sitting down and turning on TV than like walking on your hands across an ever-varied, never-ending landscape that is otherwise too far away to see.

FURTHER READING

1. BOOKS & ARTICLES

Adobe Systems Inc. *PostScript Language Reference Manual.* 3rd ed. Reading, Mass. 1999. [Errata & supplements online at *http:// partners.adobe.com/public/developer/ps/index_specs*]

Amert, Kay. *The Scythe and the Rabbit: Simon de Colines and the Culture of the Book in Renaissance Paris.* Rochester, N.Y. 2012.

Anderson, Donald M. *The Art of Written Forms.* New York. 1969.

Avrin, Leila. *Scribes, Script and Books: The Book Arts from Antiquity to the Renaissance.* Chicago & London. 1991.

∗ Balsamo, Luigi, & Alberto Tinto. *Origini del corsivo nella tipografia italiana.* Milan. 1967.

Barker, Nicolas. *Aldus Manutius and the Development of Greek Script and Type in the Fifteenth Century.* 2nd ed. New York. 1992.

Benjamin, Walter. "The Work of Art in the Age of Mechanical Reproduction," in Benjamin, *Illuminations.* London. 1970.

Bennett, Paul A., ed. *Books and Printing: A Treasury for Typophiles.* Cleveland. 1951.

Berry, John, ed. *Language Culture Type: International Type Design in the Age of Unicode.* New York. 2002.

∗ Bigelow, Charles, & Donald Day. "Digital Typography." *Scientific American* 249.2 (August 1983): 106–19.

Bloomfield, Leonard. *Language.* New York. 1933.

Blumenthal, Joseph. *Art of the Printed Book, 1455–1955.* New York. 1973.

Bringhurst, Robert. "On the Classification of Letterforms" et seq. Parts 1–5. Claremont, Calif.: *Serif* 1–5 (1994–97).

———. *The Solid Form of Language: An Essay on Writing and Meaning.* Kentville, Nova Scotia. 2004.

———. *The Surface of Meaning: Books and Book Design in Canada.* Vancouver. 2008.

———. *Palatino: The Natural History of a Typeface.* San Francisco: Book Club of California / Boston: David Godine. 2016.

Burke, Christopher. *Paul Renner.* New York. 1998.

∗ Carter, Harry. *A View of Early Typography.* Oxford. 1969.

Carter, Sebastian. *Twentieth-Century Type Designers.* London. 1987.

Carter, Thomas F. *The Invention of Printing in China and Its Spread Westward.* 2nd ed., revised by L.C. Goodrich. New York. 1955.

∗ Casamassima, Emanuele. *Trattati di scrittura del cinquecento italiano.* Milan. 1966.

Catalogue of Books Printed in the XVth *Century Now in the British Museum.* 12 vols. London. 1908–85.

The thirty or so items in this list that are flagged with a large asterisk seem to me essential works of reference or benchmark publications in the field.

Chappell, Warren, & Robert Bringhurst. *A Short History of the Printed Word.* 2nd ed. Vancouver. 1999.

Chiang Yee. *Chinese Calligraphy: An Introduction to Its Aesthetic and Technique.* 3rd ed. Cambridge, Mass. 1973.

Chicago Manual of Style. 16th ed. Chicago. 2010.

Corbeto, Albert. *Especímenes tipográficos españoles.* Madrid. 2010.

———. *Daniel B. Updike y la historia de la tipografía en España.* Valencia. 2011.

———. *Tipos de imprenta en España.* Valencia. 2011.

Dair, Carl. *Design with Type.* 2nd ed. Toronto. 1967.

* Daniels, Peter T., & William Bright, ed. *The World's Writing Systems.* New York. 1996.

Day, Kenneth, ed. *Book Typography 1815–1965.* London. 1966.

DeFrancis, John. *Visible Speech: The Diverse Oneness of Writing Systems.* Honolulu. 1989.

Degering, Hermann. *Lettering.* New York. 1965.

Diringer, David. *The Hand-Produced Book.* London. 1953. Reprinted as *The Book Before Printing*, New York. 1982.

Dowding, Geoffrey. *Finer Points in the Spacing and Arrangement of Type.* 3rd ed. London. 1966.

Dreyfus, John. *Into Print: Selected Writings on Printing History, Typography, and Book Production.* Boston. 1995.

———, ed. *Type Specimen Facsimiles.* 2 vols. London. 1963–72.

———. *The Work of Jan van Krimpen.* The Hague. 1952.

Dreyfus, John, & Knut Erichson, ed. *ABC-XYZapf.* London & Offenbach. 1989.

Duncan, Harry. *Doors of Perception.* Austin, Texas. 1987.

* Eisenstein, Elizabeth L. *The Printing Press as an Agent of Change.* 2 vols. Cambridge, UK. 1979.

———. *The Printing Revolution in Early Modern Europe.* Cambridge, UK. 1983.

Enschedé, Charles. *Typefoundries in the Netherlands,* translated with revisions and notes by Harry Carter. Haarlem, Netherlands. 1978.

Fairbank, Alfred, & Berthold Wolpe. *Renaissance Handwriting.* London. 1960.

Felici, James. *The Complete Manual of Typography.* Berkeley. 2003.

Febvre, Lucien, & Henri-Jean Martin. *The Coming of the Book.* London. 1976.

Fine Print on Type: The Best of Fine Print Magazine on Type and Typography. San Francisco. 1988.

Fournier, Pierre-Simon. *Fournier on Typefounding,* translated & edited by Harry Carter. London. 1930.

Gaur, Albertine. *A History of Writing.* London. 1984.

* Gill, Eric. *An Essay on Typography.* 2nd ed. London. 1936.

Goudy, Frederic W. *Goudy's Type Designs.* 2nd ed. New Rochelle, NY. 1978.

————. *Typologia: Studies in Type Design and Type Making.* Berkeley
& Los Angeles. 1940.

＊Gray, Nicolete. *A History of Lettering.* Oxford. 1986.

————. *Lettering as Drawing.* 2nd ed. Oxford. 1971.

[Grinevald, Paul-Marie.] *Les Caractères de l'Imprimerie nationale.*
Paris. 1990.

Haiman, György. *Nicholas Kis: A Hungarian Punch-cutter and Printer,
1650–1702.* San Francisco. 1983.

Haley, Allan, et al. *Typography Referenced.* Beverly, Mass. 2012.

Handbook of the International Phonetic Association. Cambridge, UK.
1999.

Haralambous, Yannis. *Fonts & Encodings,* translated by P. Scott Horne.
Sebastopol, Calif. 2007.

Harling, Robert. *The Letter Forms and Type Designs of Eric Gill.*
[Westerham, Kent.] 1976.

[Hart, Horace, et al.] *Hart's Rules for Compositors and Readers.* 39th
ed. Oxford. 1983.

Henestrosa, Cristóbal. *Espinosa: Rescate de una tipografía
novohispana.* Mexico City. 2005.

Hlavsa, Oldřich. *A Book of Type and Design.* New York. 1961.

Hopkins, Richard L. *Tolbert Lanston and the Monotype.* Tampa,
Florida. 2012.

Huntley, H. E. *The Divine Proportion: A Study in Mathematical Beauty.*
New York. 1970.

Huss, Richard E. *The Development of Printers' Mechanical Typesetting
Methods 1822–1925.* Charlottesville, Virginia. 1973.

Hutner, Martin, & Jerry Kelly, ed. *A Century for the Century: Fine
Printed Books from 1900 to 1999.* New York. 1999.

International Organization for Standardization. *Information
Processing: Eight-bit Single-byte Coded Graphic Character Sets.*
ISO 8859. Parts 1–15. Geneva. 1987–99.

————. *Information Technology: Universal Multiple Octet Coded
Character Set.* ISO 10646. Parts 1–3. [Rev. ed.] Geneva. 2000–
2003.

Искусство шрифта: Работы московских художников книги.
Moscow. 1977.

Itten, Johannes. *The Art of Color,* translated by Ernst von Haagen.
New York. 1961.

Jammes, André. *La Réforme de la typographie royale.* Paris. 1961.

＊Jaspert, W. Pincus, et al. *Encyclopedia of Typefaces.* 5th ed. London.
1983.

Jeffery, Lilian H. *The Local Scripts of Archaic Greece.* 2nd ed. Oxford.
1990.

Jensen, Hans. *Sign, Symbol, Script,* translated by George Unwin.
London. 1970.

* Johnson, Alfred F. *Selected Essays on Books and Printing.* Amsterdam. 1970.

———. *Type Designs.* 3rd ed. London. 1966.

Johnston, Edward. *Formal Penmanship and Other Papers,* edited by Heather Child. London. 1971.

* ———. *Writing and Illuminating, and Lettering.* Rev. ed., London. 1944.

Kapr, Albert. *The Art of Lettering.* Munich/New York. 1983.

———. *Fraktur: Form und Geschichte der gebrochenen Schriften.* Mainz. 1993.

———. *Johann Gutenberg.* Aldershot, Hants. 1996.

Karow, Peter. *Digital Typefaces: Description and Formats.* 2nd ed. Berlin. 1994.

Kenney, Edward J. *The Classical Text: Aspects of Editing in the Age of the Printed Book.* Berkeley. 1974.

Kinross, Robin. *Modern Typography: An Essay in Critical History.* 2nd ed. London. 2004.

———. *Unjustified Texts: Perspectives on Typography.* London. 2002.

Knight, Stan. *Historical Scripts.* 2nd ed. New Castle, Delaware. 1998.

———. *Historical Types.* New Castle, Delaware. 2012.

* Knuttel, Gerard. *The Letter as a Work of Art.* Amsterdam. 1951.

Koch, Peter, et al. *Carving the Elements: A Companion to the Fragments of Parmenides.* Berkeley. 2004.

Lane, John A. *Early Type Specimens in the Plantin-Moretus Museum.* London. 2004.

Lange, Gerald. *Printing Digital Type on the Hand-Operated Flatbed Cylinder Press.* 2nd ed. Marina del Rey, Calif. 2001.

Lawson, Alexander. *Anatomy of a Typeface.* Boston. 1990.

Layton, Evro. *The Sixteenth Century Greek Book in Italy.* Venice. 1994.

Le Bé, Guillaume [the younger]. *Sixteenth-Century French Typefounders,* edited by Harry Carter. Paris. 1967.

Le Corbusier. *The Modulor.* 2nd ed. Cambridge, Mass. 1954.

* Legros, Lucien A., & John C. Grant. *Typographical Printing Surfaces.* London. 1916.

Lewis, M. Paul, ed. *Ethnologue: Languages of the World.* 16th ed. Dallas. 2009. [Updated online at *www.ethnologue.com.*]

Lommen, Mathieu, & John A. Lane. *Letterproeven van Nederlandse gieterijen / Dutch Typefounders' Specimens.* Amsterdam. 1998.

———. *Bram de Does: Letterontwerper & typograaf / Typographer & Type Designer.* Amsterdam. 2003.

Lommen, Mathieu, & Peter Verheul, ed. *Haagse letters.* [Amsterdam.] 1996.

Lunde, Ken. *CJKV Information Processing.* 2nd ed. Sebastopol, Calif. 2008.

McGrew, Mac. *American Metal Typefaces of the Twentieth Century.* New Castle, Delaware. 1993.

McLean, Ruari. *Jan Tschichold: Typographer*. London. 1975.

Macrakis, Michael S., ed. *Greek Letters: From Tablets to Pixels*. New Castle, Delaware. [1997.]

March, Lionel. *Architectonics of Humanism*. Chichester, West Sussex. 1998.

*Mardersteig, Giovanni. *Scritti di Giovanni Mardersteig sulla storia dei caratteri e della tipografia*. Milano. 1988.

Martin, Douglas. *Book Design: A Practical Introduction*. New York. 1989.

Martin, Henri-Jean. *The History and Power of Writing*. Chicago. 1994.

————. *Histoire de l'édition française*. 4 vols. Paris. 1982–6.

Massin, [Robert]. *Letter and Image*. London. 1970.

Meggs, Philip B. *A History of Graphic Design*. New York. 1983.

Middendorp, Jan. *Dutch Type*. Rotterdam. 2004.

Millington, Roy. *Stephenson Blake: The Last of the Old English Typefounders*. London. 2002.

*Morison, Stanley. *First Principles of Typography*. New York. 1936.

————. *Letter Forms: Typographic and Scriptorial*. New York. 1968.

————. *On Type Designs, Past and Present*. 2nd ed. London. 1962.

*————. *Politics and Script*. Oxford. 1972.

*————. *Selected Essays on the History of Letter-forms*. 2 vols. Cambridge, UK. 1981.

Morison, Stanley, & Kenneth Day. *The Typographic Book, 1450–1935*. London. 1963.

Morison, Stanley, et al. *A Tally of Types*. 2nd ed. Cambridge, UK. 1973.

Mosley, James. *The Nymph and the Grot*. London. 1999.

————, et al. *Le Romain du roi: La Typographie au service de l'état*. Lyon. 2002.

Mumford, Lewis. *Art and Technics*. New York. 1952.

*Noordzij, Gerrit. *The Stroke of the Pen*. The Hague. 1982.

————. *De Streek: Theorie van het schrift*. Zaltbommel, Netherlands. 1985.

————. *Letterletter*. Vancouver. 2001.

Pankow, David, ed. *American Proprietary Typefaces*. [Rochester, NY.] 1998.

Panofsky, Erwin. *Perspective as Symbolic Form*. New York. 1991.

Paput, Christian. *La Gravure du poinçon typographique*. Paris. 1990.

Parkes, M.B. *Pause and Effect*. Berkeley. 1993.

Prestianni, John, ed. *Calligraphic Type Design in the Digital Age*. San Francisco. 2001.

Pullum, Geoffrey K., & William A. Ladusaw. *Phonetic Symbol Guide*. 2nd ed. Chicago. 1996.

Pye, David. *The Nature and Art of Workmanship*. Cambridge, UK. 1968.

Re, Margaret, et al. *Typographically Speaking: The Art of Matthew Carter*. Baltimore. 2002.

Further Reading

Much of James Mosley's essential writing on typographic history is now published on his website. See part 3 of this bibliography (page 382).

Rehak, Theo. *The Fall of* ATF: *A Serio-Comedic Tragedy.* [Howell, NJ.] 2004.

———. *Practical Typecasting.* New Castle, Delaware. 1993.

Ribagorda, José María, et al. *Imprenta real: Fuentes de la tipografía española.* Madrid. 2009.

Rogers, Bruce. *Report on the Typography of the Cambridge University Press.* Cambridge, UK. 1950.

Ryder, John. *Flowers and Flourishes.* London. 1976.

Sampson, Geoffrey. *Writing Systems: A Linguistic Introduction.* Stanford, Calif. 1985.

Sapir, Edward. *Language: An Introduction to the Study of Speech.* New York. 1921.

Scholderer, Victor. *Greek Printing Types 1465–1927.* London. 1927.

Senner, Wayne M., ed. *The Origins of Writing.* Lincoln, Nebraska. 1989.

Шицгал, А.Г. *Русский типографский шрифт.* Moscow. 1985.

Smeijers, Fred. *Counterpunch.* London. 1996.

———. *Type Now.* London. 2003.

Snyder, Gertrude, & Alan Peckolick. *Herb Lubalin.* New York. 1985.

Son Po-Gi. *Han'guk ŭi ko hwalcha / Kankoku no kokatsuji / Early Korean Typography.* Rev. ed., Seoul. 1982.

Spencer, Herbert. *Pioneers of Modern Typography.* Rev. ed., Cambridge, Mass. 1982.

*Steinberg, S.H. *Five Hundred Years of Printing.* 3rd ed., rev. by James Moran. London. 1974. 4th ed., rev. by John Trevitt. London. 1996.

*Stevens, Peter S. *Patterns in Nature.* Boston. 1974.

Stevick, Robert D. *The Earliest Irish and English Bookarts.* Philadelphia. 1994.

*Sutton, James, & Alan Bartram. *An Atlas of Typeforms.* London. 1968.

Thompson, Bradbury. *The Art of Graphic Design.* New Haven, Connecticut. 1988.

*Thompson, D'Arcy. *On Growth and Form.* Cambridge, UK. 1917. Rev. ed., 1942; abridged by J.T. Bonner, 1961.

Tracy, Walter. *Letters of Credit.* London. 1986.

Tschichold, Jan. *Asymmetric Typography.* New York. 1967.

———. *The Form of the Book,* edited by Robert Bringhurst. Vancouver. 1991.

*Tufte, Edward R. *Envisioning Information.* Cheshire, Connecticut. 1990.

* ———. *The Visual Display of Quantitative Information.* 2nd ed. Cheshire, Connecticut. 2001.

———. *Visual Explanations: Images and Quantities, Evidence and Narrative.* Cheshire, Connecticut. 1997.

Twitchett, Denis. *Printing and Publishing in Medieval China.* London. 1983.

Type and Typography: Highlights from Matrix. West New York, NJ. 2003.

✳ Unicode Consortium. *The Unicode Standard.* Version 6.1. Boston. 2012. [Updated online at *www.unicode.org.*]

✳ Updike, Daniel Berkeley. *Printing Types: Their History, Forms and Use.* 2nd ed. 2 vols. Cambridge, Mass. 1937.

✳ Vervliet, Hendrik D.L., ed. *The Book through Five Thousand Years.* London. 1972.

———. *French Renaissance Printing Types: A Conspectus.* London. 2010.

✳ ———. *The Palaeotypography of the French Renaissance.* 2 vols. Leiden. 2008.

———. *Sixteenth-Century Printing Types of the Low Countries,* translated by Harry Carter. Amsterdam. 1968.

Veyrin-Forrer, Jeanne. *La Lettre et la texte.* Paris. 1987.

Warde, Beatrice. *The Crystal Goblet.* London. 1955.

✳ Wardrop, James. *The Script of Humanism.* Oxford. 1963.

✳ Washburn, Dorothy K., & Donald W. Crowe. *Symmetries of Culture: Theory and Practice of Plane Pattern Analysis.* Seattle. 1988.

West, Martin L. *Textual Criticism and Editorial Technique Applicable to Greek and Latin Texts.* Stuttgart. 1973.

Wilson, Adrian. *The Design of Books.* New York. 1967.

Wittkower, Rudolf. *Architectural Principles in the Age of Humanism.* 3rd ed. London. 1962.

Zapf, Hermann. *Alphabet Stories.* Rochester, NY. 2007.

———. *The Fine Art of Letters.* New York. 2000.

✳ ———. *Hermann Zapf and His Design Philosophy.* Chicago. 1987.

———. *Manuale Typographicum.* Frankfurt. 1954. Rev. ed., Cambridge, Mass. 1970.

———. *Manuale Typographicum 1968.* Frankfurt & New York. 1968.

———. *Typographic Variations.* New York. 1963.

Zimmer, Szczepan K. *The Beginning of Cyrillic Printing.* New York. 1983.

2. PERIODICALS

Fine Print. San Francisco. Quarterly. 16 vols, 1975–90. [Complete index published as issue 16.4, 2003. See also *Fine Print on Type* (1988).]

The Fleuron. Cambridge, UK. Annual. 7 vols, 1923–30.

Journal of the Printing Historical Society. London. Annual, 1965– .

Letter Arts Review. Published 1982–93 as *Calligraphy Review.* Norman, Oklahoma. Quarterly, 1982– .

Letterletter. Journal of the Association Typographique Internationale. Münchenstein, Switzerland. Semiannual through 1990, then biennial. 15 issues in all, 1985–96. [See also Gerrit Noordzij, *Letterletter* (2001).]

Matrix. Andoversford, Glos., UK. Annual, 1981– . [See also *Type and Typography: Highlights from Matrix* (2003).]

Parenthesis. Journal of the Fine Press Book Association. London, San Francisco, etc. Irregular, then semiannual, 1993– .

Printing History. Journal of the American Printing History Association. New York. Semiannual, 1979– .

Serif. Claremont, Calif. Irregular. 6 issues, 1994–8.

Typografische Monatsblätter. St Gallen, Switzerland. Monthly, then bimonthly, 1881– .

Typographica. London. Irregular, then semiannual. 13 + 16 issues. 1949–59; new series, 1960–67.

Typography Papers. Reading, Berks., UK. Annual, 1996– .

Visible Language. Published 1967–70 as the *Journal of Typographic Research.* Cleveland, then Providence, Rhode Island. Quarterly, 1967– .

Periodicals appears in the left margin beside *Parenthesis.*

3 · A SAMPLING OF WEB RESOURCES

Alphabets of Europe: www.evertype.com/alphabets
Luc Devroye, McGill University: http://luc.devroye.org/fonts.html
Digital Foundry List: www.microsoft.com/typography/links/links. aspx?type=foundries&part=1 [+ *four additional parts*]
Ethnologue: www.ethnologue.com/web.asp
Klingspor: www.klingspor-museum.de/Kuenstler.html
James Mosley: http://typefoundry.blogspot.com
Omniglot: www.omniglot.com/writing/index.htm
Type Club of Toronto Foundry List: www.typeclub.com/type-foundries/
Type Libraries & Museums: www.tug.org/museums.html
Unicode: www.unicode.org

INDEX

The names of typefaces are italicized in this index, but no distinction is made between generic names, such as *Garamond* or *Bodoni*, and specific ones, such as *Bembo* or *Aldus*.

☙

This book was designed by Robert Bringhurst.
It was edited and set into type in Canada, and was
printed and bound by C&C in Shenzhen, Guangdong.

The text face is Minion Pro, designed by Robert Slimbach. This
is an enlargement and revision of Slimbach's original Minion family,
issued by Adobe Systems, Mountain View, California, in 1989.

The captions are set in Scala Sans, part of a family of type
designed in the Netherlands by Martin Majoor, initially issued
by FontShop International, Berlin, and its affiliates in 1994.

The paper in this book is of archival quality and acid-free,
produced from sustainable plantations.

408777